HENRY MOORE

Sculpture and Drawings 1921–1969

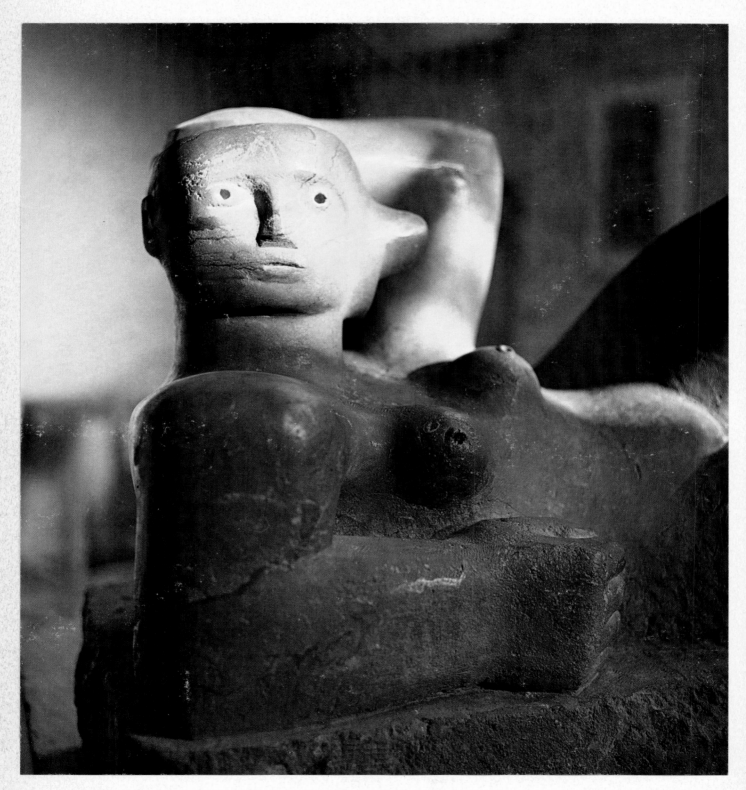

I Reclining Figure, 1929. L. 83.8 cm

HENRY MOORE

Sculpture and Drawings 1921–1969

Text by ROBERT MELVILLE

HARRY N. ABRAMS, INC., PUBLISHERS, NEW YORK

STANDARD BOOK NUMBER: 8109-0332-6
LIBRARY OF CONGRESS CATALOGUE CARD NUMBER: 68-28381
ALL RIGHTS RESERVED. NO PART OF THE CONTENTS OF THIS BOOK MAY BE
REPRODUCED WITHOUT THE WRITTEN PERMISSION OF THE PUBLISHERS
HARRY N. ABRAMS, INCORPORATED, NEW YORK
PRINTED IN WEST GERMANY AND THE NETHERLANDS. BOUND IN WEST GERMANY

Contents

Foreword

My introduction to the present volume in no way replaces Herbert Read's long, sustained essay, *Henry Moore: a study of his life and work*. There is little doubt that Read's book, published in 1965 while Moore was still at the height of his creative powers, will remain for a very long time the most authoritative study of the sculptor's formal procedures, and one can be certain that if Read had lived, he would have acknowledged the remarkable variety and vitality of the sculpture which Moore has produced since 1965 by preparing a second and enlarged edition.

My emphasis is upon the strangeness of Moore's work. Read perceived the formal organization of a sculpture more clearly and described the visual data more objectively than I do. I tend to look at Moore's work as if it had never been analyzed, and feel free to go by appearances. I don't see solutions of formal problems, but strange presences, some of which are beautiful and some macabre.

It's the illustrations that matter. They have been selected to cover each period of Moore's sculpture and drawings without repeating every variation in scale or form of a single idea (these can be studied in the multi-volume catalogue raisonné of Moore's sculpture published by Lund Humphries, London). This book offers the largest and most comprehensive selection of the work of Britain's greatest sculptor ever to be brought together in a single volume.

I am indebted to Henry Moore's secretary, Mrs Betty Tinsley, for meeting so many demands on her photographic files and other invaluable records, and would like to express my warmest thanks to Mrs Patricia Mueller of Thames and Hudson for her firm advice and patient assistance from first to last.

R.M.

Object and Effigy in the art of
HENRY MOORE

IN THE ART OF HENRY MOORE, the geography of woman mingles with vegetable and mineral substances to form personifications of the natural world. His sculpture seems to spring from the instinct to attribute a soul to inanimate nature, and when James Johnson Sweeney spoke of Moore's power to find in a block of stone or billet of wood 'forms that symbolize the life he feels in them . . . as if he were merely stripping away the concealing shell', he was paying tribute to the sculptor's animistic vision. But because animism represents a primitive stage in human development, Sir Herbert Read specifically rejected the idea that modern art could be in any way identified with animism, and considered the work of Moore to be 'inherently humanist'.[1]

It is evident of course that the reclining figures which Moore carved in stone in 1929 and 1930 after seeing a photograph of an ancient Mexican 'Chac Mool' were not intended to revive the worship of a Mayan rain god, but Moore himself spoke of his desire, kindled by the 'stoniness' of pre-Columbian carvings, to make sculpture which gave out 'something of the energy and power of great mountains', and this is not the language of Humanism. In this respect, some of the drawings of the Thirties which disclose his propensity for day-dreaming about sculpture as if it were leading its own life, free from human interference, are peculiarly revealing. One of them contrasts the elegant white marble columns of Greek temples with the monumental solidity of huge, unhewn standing stones. These monoliths are strung across a landscape in an enveloping movement that threatens to annihilate the fragile temples, and the drawing conveys the impression that the stones have arisen since the temples were built and that civilization is the past and the primordial the present. Another drawing, *Sculptural Object in Landscape* depicts a gigantic bone-like structure straddling a field: three cows grazing in the distance suggest that human beings are not far away and that such a useless but sinister construction could only have been erected to be venerated. This is so far from a humanistic conception that it

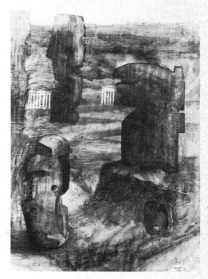

Stones in Landscape, 1936

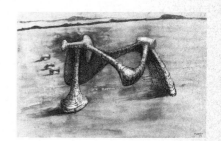

Sculptural Object in Landscape, 1939

9

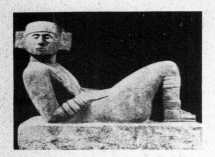
Chac Mool, A.D. 948–1697. Museo Nacional de Antropologia, Mexico

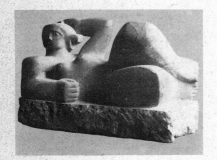
Reclining Figure, 1929

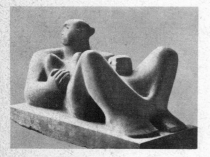
Reclining Woman, 1930

might even be said to link the religion of art with what the early fathers of the Church denounced as the worship of sticks and stones. The imaginative artist, as Marcuse has pointed out, 'preserves the "memory" of the subhistorical past when the life of the individual was the life of the genus, the image of the immediate unity between the universal and the particular'.[2] Sculpture has to make some claim to be sacred if it is not to be valued as the higher knick-knackery, and it seems to me that throughout his career, Moore has created works which provide a kind of animistic shield against the purely human level of existence.

A two-way evolutionary process is at work in Moore's shaping of sculptural forms. Natural objects tend to refer to the human figure, and the human figure tends to refer to natural objects. 'The human figure is what interests me most deeply', he has said, 'but I have found principles of form and rhythm from the study of natural objects, such as pebbles, rocks, bones, trees, plants.' He is not saying, however, that he makes sculptural copies of pebbles, rocks and so on. His sculptures are products of the act of perceiving which are not to be confused with the thing perceived, and there is a powerful bias in his studies of natural objects that springs from an obsessive awareness of human (female) shape.

The relationship with the forms created by natural forces is not limited to the objects he has mentioned above; it includes the configurations of the land – hills and valleys, hollows and ridges, caves and pot-holes and the concavities of coastal erosion. The radical transformation of the forms of the 'Chac Mool' which are to be seen in his early reclining figures includes his first references to woman as landscape. The 'Chac Mool' is a male figure, discovered in the deserted city of Chichén Itzá in Northern Yucatan, and considered to be intimately connected with human sacrifice. It lies on its back with its knees drawn up and its head turned sharply away. It has a receptacle cut in its stomach for offerings, but its face is averted as if to signify that it is impervious to every gesture of propitiation. Moore's early reclining figures are female, and he does not hide the warmth of his response to the forms of woman. He admired the massiveness of the 'Chac Mool', and the vitality and power with which its forms underpin belief in supernatural powers, but he was less sympathetic to the implications of implacability and did not retain the tight, clenched posture. Paradoxically enough, he made his figures look more 'human' than the 'Chac Mool' by breaking down its anthropomorphism and drawing analogies between the female figure and a landscape of hills.

The idea of woman as landscape is not new. In *The Song of Solomon* she is the land flowing with milk and honey, in Donne she is 'my America! my new-found-land', in Beardsley she is the Sacred Wood ... 'this dark wood – some times it is called a thicket – is triangular in

shape, and in its midst is a dark romantic chasm. In this chasm the wonders of nature abound'. In paintings of the school of Arcimboldo, in paintings by Dali and drawings by Masson she takes pot-luck in a double image; sometimes one sees a landscape, sometimes a woman: but these are fanciful ingenuities. In the early work of Munch the relationship is more profound; woman stands at the centre of his universe, and the curves of her body or the flowing lines of her gown send out waves of energy which create the undulating lines of the seashore and the turbulence in the sky: she governs the landscape but remains distinct from it. Moore, on the other hand, conceived a woman who obeys geological rather than biological laws. He was thinking in terms of living stones. The early reclining figures were demonstrations of his ideas about 'retaining the sense of the block' and 'collaborating with the material'.

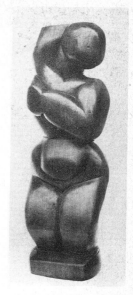

Standing Woman, 1923

Moore says that it was Roger Fry's essay on Negro sculpture that made him aware of the importance of this doctrine of 'truth to material', which insists that the substance of which a sculpture is made must retain its identity and not imitate another substance. It may well be true, although Fry only remarked that the negro 'has an exquisite taste in his handling of material', and it seems more likely that it was another aspect of Fry's essay that made an impression on him – the contention that it was the 'three-dimensionalness' that gave Negro forms their 'disconcerting vitality, the suggestion that they make of being not mere echoes of actual figures, but of possessing an inner life of their own. If the negro artist wanted to make people believe in the potency of his idols he certainly set about it in the right way.'[3] Moore was twenty-two when Fry's essay appeared in *The Athenaeum* of 1920. About a year later he left Leeds to become a student at the Royal College of Art. It was at this time that he began to haunt the Ethnographical Department of the British Museum, and it was his own direct study of Negro sculpture there that enabled him to write at a much later date: 'One of the first principles of art so clearly seen in primitive work is truth to material: the artist shows an instinctive understanding of his material, its right use and possibilities. Wood has a stringy, fibrous consistency and can be carved into thin forms without breaking and the Negro sculptor was able to free arms from the body, to have a space between the legs and give his figures long necks when he wished.' The first work in which he paid homage to negro sculpture was carved in walnut wood in 1923, but the arms were not freed from the body, there was no space between the stumpy bent legs and the neck was short and thick. It disclosed a stone-carver's sense of 'truth to material'.

In the following year he made two stone carvings, one of them only nine inches high, in which the idea of 'retaining the sense of the block' was given full rein. They are mother-and-child images, with the

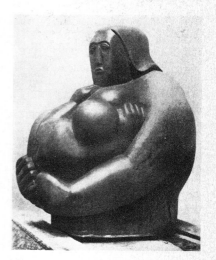

Maternity, 1924

11

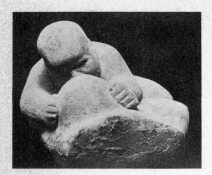

Suckling Child, 1927

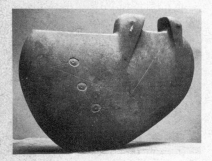

Suckling Child, 1930

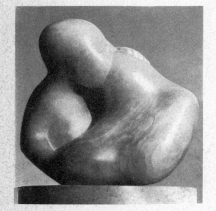

Carving, 1936

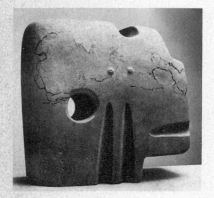

Square Form, 1936

mother cut off at the waist, and they show so much concern with the weight and density and immovability of stone that there is no point at which mother and child are not joined. The effect of massiveness thus created is almost too powerful. They intensify one's sense of the impacted nature of stone by creating the impression that mother and child are being pressed tightly together by some implacable force.

A curious treatment of the mother-and-child theme occurred in 1927, made in concrete and called *Suckling Child*. The mother is represented only by one breast, a bell-shaped form with the base left rough to emphasize the fact that it is a fragment. The child is sucking the breast and clutching it with both hands. In 1930, Moore made another version in alabaster, but instead of treating the breast as a fragment turns it into a form complete in itself, and it is probably the first of his organic abstractions. In treating a part-object as a whole object, Moore lends support to Melanie Klein's theory that the infant's relationship with its mother as a separate entity is preceded and conditioned by its good and bad relations with parts of the parental body. Besides being an image of the Kleinian 'good' breast, the sculptor's conception of it as a sort of inexhaustible drinking cup reminds one that the grail legend in its earliest versions was a search for a magic food-providing vessel, and it seems possible that the legend might have its unconscious origin in the infant's sense of deprivation when the breast is withheld. Be that as it may, it is altogether appropriate that Moore should have made his second and deeply reconsidered version when he was engaged on his first great series of reclining figures and reconstituting the female form as a grave and remote image of bountifulness, freed from all implications of avidity for its parts.

During the period from 1931 to the beginning of the war, Moore carved a superb series of organic abstractions. They are as 'shape-conscious' as the sculpture of Brancusi and Arp, but they are more persistently penetrated by human associations, and they reveal his connections with Surrealism. He belongs to the Surrealist generation. He was born two years after André Breton and André Masson, two years before Yves Tanguy, three years before Giacometti and the same year as René Magritte. He was thirteen when Picasso and Braque brought Analytical Cubism to a conclusion of hermetic signs and he was still at school when some of its consequences split the art of painting down the middle. Mondrian stripped the sign for an art of geometrical abstraction. Chirico, taking the opposite course, placed dramatic emphasis upon objects conceived as signs, and by the early Twenties the Surrealists were treating the works of his visionary period (1910–1917) as signposts to the future of painting.

Moore contributed four carvings and three drawings to the huge International Surrealist Exhibition held in London in 1936, and when,

later in the same year, the International Surrealist Bulletin announced the formation of an English Surrealist group, Moore was named as a member. He took no part in the doctrinal discussions, but like the artists in the French group he perceived one of the tasks of the artists of his generation to be the intensification of content, and long before the English group was formed he was sharply aware of Chirico's pictorial system for conferring inexplicable yet tremendous and sometimes intimidatory meaning upon ordinary, inanimate objects. But the re-evaluation of the object in the art of Chirico was obtained primarily by compositional means, and the great series of sculptural objects in which Moore gave three dimensions to the enigmatical and magical properties of the sign were of a biomorphic nature which owed little or nothing to Chirico.

Nevertheless, Chirico's use of statuary in his paintings of deserted Italian squares must have been of particular interest to Moore. The effigies themselves – an equestrian hero, a frock-coated statesman, a draped reclining figure based on a Hellenistic *Ariadne* – were antipathetic to Moore's sense of sculptural form, but their air of having reasons of their own for occupying the squares may well have started him visualizing imaginary situations, and some of the drawings he made at the time he was carving his organic abstractions disclose his Surrealist leanings more obviously than the carvings themselves.

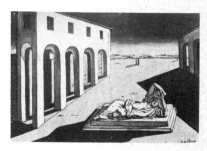

Chirico, Solitude of an Autumn Afternoon, 1912

These drawings of sculpture in imaginary situations are in a sense marginal to the sheets of ideas for sculpture, but they make a notable contribution to English graphic art and foreshadow the shelter drawings. They are a kind of inspired day-dreaming and have some of the fascination of a private journal. The sculptures that occupy these imaginary interiors and landscapes are of course intimately connected with his carvings of the same period, but within the terms of pictorial illusionism they assume a more sinister significance than the actual carvings. They lead a communal life based on human ways, but they are like an invasion from another world and are conceived as alternatives to the human race.

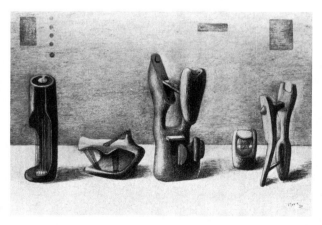

Five Figures in a Setting, 1937

13

II Seated Figures, 1940

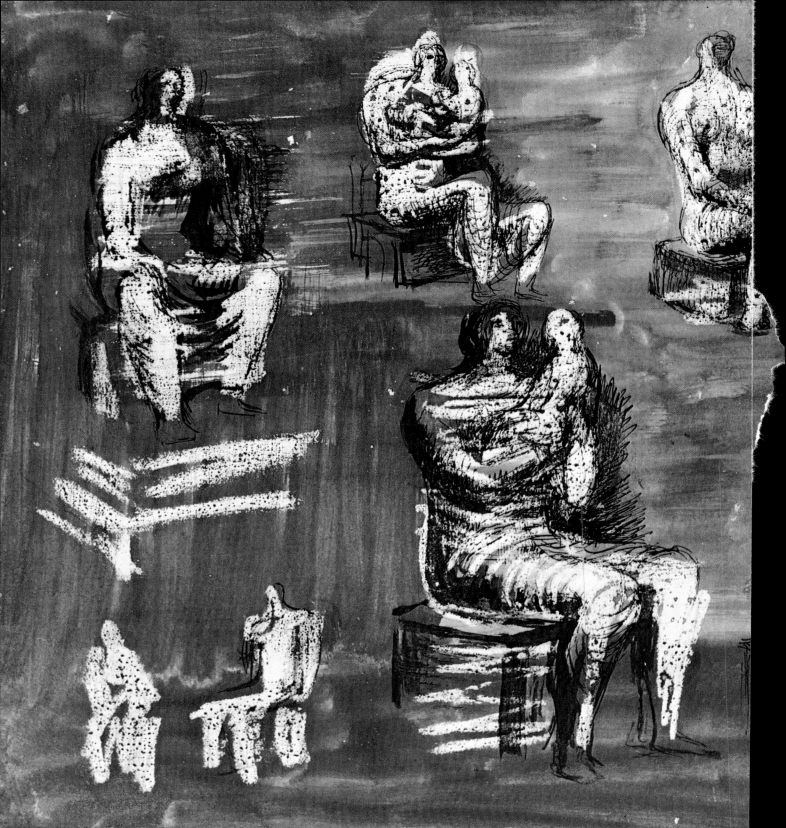

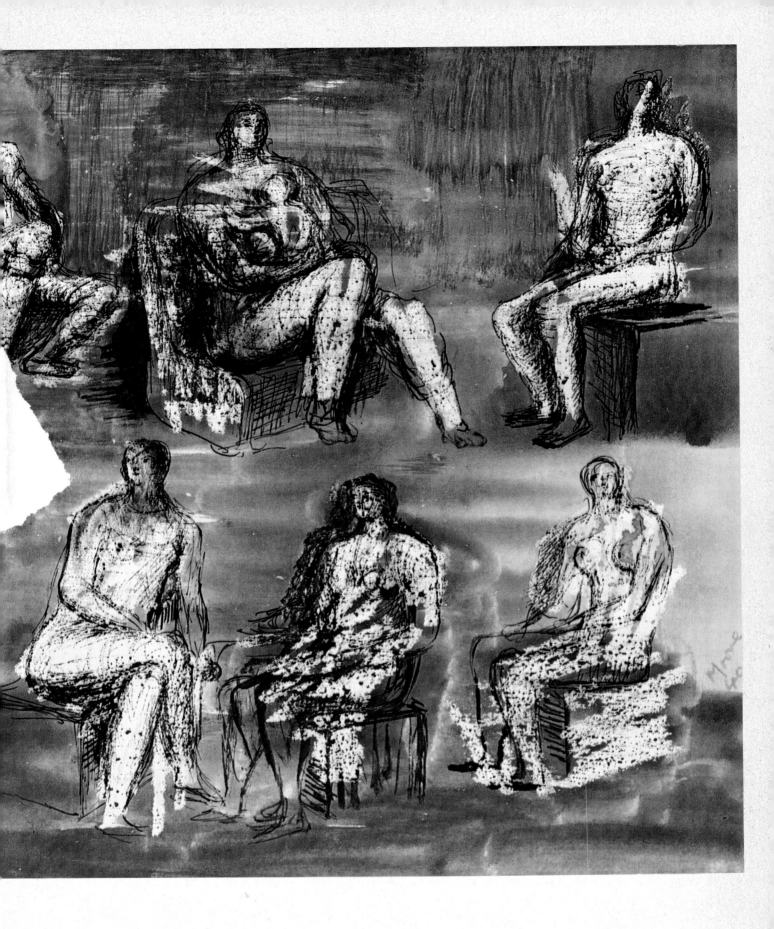

The Death of the Suitors, 1944
(detail)

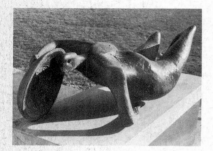

Falling Warrior, 1956–7

Seated Figure and Pointed
Forms, 1939

The idea of a statuary 'taking over' or 'settling in' is implicit in the early studies of nudes. The figures in these life studies have assumed an effigial grandeur; they have become larger than life and are composed of a substance harder than flesh: the slight indications of the room in which the model posed – a stool, the edge of a table, part of a window – seem faint reminders of a human being who has been replaced.

An extreme example of a statuary imitating a human situation is the scene of violence called *The Death of the Suitors* (an illustration for Edward Sackville-West's *The Rescue*, a radio version of *The Odyssey*, published in 1945), which presents the fascinating spectacle of terra-cottas dying in a blood-red room. The figures in this drawing are not typical in that they are depicted in dramatic postures, but the bronze *Falling Warrior* made some ten years later and characterized by an unusually dramatic pose, evokes the same atmosphere of violence and the same archaic past.

Among the sheets of ideas for sculpture, crowded with invented forms, it needs only the barest suggestion of linear perspective to involve the figures in the idea of a 'take over'. There is, for instance, an extremely fine drawing devoted to a multitude of variations on an idea for a reclining figure in metal in which the figures, lying on their own shadows, are arranged in orderly receding rows, as if they might be experienced in making the best possible use of cramped quarters. They are like a bivouacked army that will resume its forward thrust in the morning. In another sheet, hectic with macabre forms, a settlement of statuary is being invaded from the air by an alien species. The humanoid figures on the ground are accompanied by pointed forms which have the appearance of defensive weapons. The invaders filling the sky are huge pebble-like objects with gaping holes.

A drawing dated 1938 innocuously entitled *Ideas for Sculpture* is perhaps the most Surrealist of all the drawings. Two vertical figures which give the impression that they are made of lead and wire are standing beside an enigmatical stringed object lying on the ground. The background is a wooden hoarding reminiscent of the clapboard background of René Magritte's painting of a pair of boots with human toes, and in both cases this simple pictorial device brings to mind the poor quarter of a city. The situation of the standing figures suggests that they have been approaching one another from opposite directions and having finally come face to face are now engaged in conversation. They stand on a thick stem instead of legs and although one does not know how they will propel themselves one does not doubt that when their conversation is concluded they will go their separate ways. One surmises that the object lying on the ground has been put there temporarily by one of them and that it will be carried away when they leave.

16

The object depicted on the ground is an oblique view of an elm wood carving, *Head*, made earlier in the same year. The carving bears a definite if remote relationship to a mask of the human face: three saucer-lip projections stand for eyebrows, nose and mouth and four circular depressions stand for a double stare of eyes. But the view of it in the drawing severs the slender connection with human appearance and becomes an object with an unknown function. The same sculptural object appears in another drawing called *Four Forms*, where it stands upright like the elm wood carving. The four forms stand in a row against a stormy background, and in this context the sculptural object has somehow become a complete personage. In three other drawings closely associated with *Four Forms*, the object-presences are even more powerfully charged with malevolence. They have gone indoors and stand about in bare rooms where the walls have curious slots cut into them (a deliberate reference to the slotted walls in the architectural backgrounds of Masaccio's frescoes). The rooms could be the basement galleries of an imaginary museum, but the objects do not comport themselves like exhibits. They look as if they have been shaped by seizures and convulsions and convey the impression that they might suddenly break into overt and destructive action. In some slightly later drawings the figures are less precisely drawn; they are sometimes dark silhouettes improvised by the brush, and numberless shadowy figures teem in the background like restless hordes of phantoms.

Macabre conversation pieces are frequent in Surrealist painting. There is mysterious intercourse between lay figures in some of Chirico's early canvases, and the paintings of Tanguy abound with biomorphic forms which are evidently in touch with one another even when far apart. Moore's 'conversation pieces' were not confined to the drawings. His *Two Forms*, carved in ironstone in 1934 and inspired perhaps by his study of pebbles, antedates the Surrealist drawings. One form is evidently talking; the other listening, somewhat pensively. Another carving bearing the same title and made two years later presents a similar meeting, but there are more concavities in the forms and the confrontation carries implications of a meeting between male and female. Both couples powerfully convey the sense of being in communication, but they are marked by an austere simplicity of form and an air of serenity untouched by the macabre.

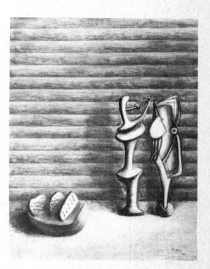

Head, 1938

Ideas for Sculpture, 1938

Four Forms, 1938

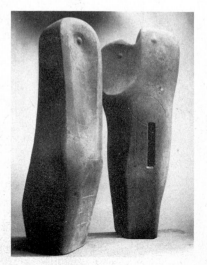

Two Forms, 1934

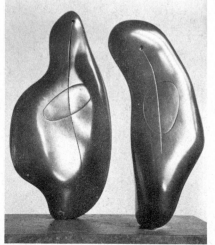

Two Forms, 1936
(cast in bronze 1967)

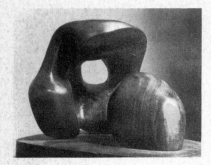

Two Forms, 1934

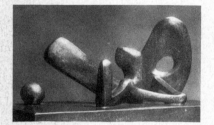

Composition, 1934

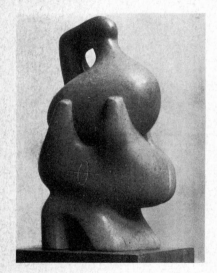

Composition, 1931

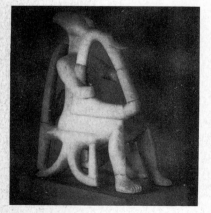

Lyre Playing Idol, Cycladic Period

The bringing together of two or more sculptural objects took on a different significance in some other groupings of the same period. Yet another *Two Forms*, a wood carving of 1934, is considered by Read to be one dislocated figure: 'the piece that one may assume represents the head and breast curves over the small detached piece that represents the rest of the body (belly and legs)'.[4] But it seems to me to have a stronger connection with the mother and child motive and to range up and down the scale of creation between bird and egg and woman and child. The in-swooping curve of the larger form is expressive of a fierce concern with the smaller form, and its protectiveness contains a cannibalistic element: it might devour the smaller form under the threat of being parted from it. But a four-piece *Composition* of 1934, carved in reinforced concrete, is certainly a one-figure conception. It seems, at first sight, to be utterly divorced from human associations. It consists of four elements, two of which are joined although obviously conceived separately. They are all abstract forms based on the study of natural objects, and Moore's profound appreciation of natural objects is perhaps an inheritance from that host of 19th-century Englishmen who turned to Natural Philosophy and examined the wonders of nature in the expectation of multiplying the evidence of divine purpose. But the four objects are not nature specimens and their disposition on the rectangular slab is anything but arbitrary. The guiding principle here is the posture of his reclining figures. Once this is acknowledged, one begins to perceive references to head, breast and raised knee, and it becomes clear that the egg-like form placed at some distance from the others is a kind of full stop, marking the place where the feet would be.

One of the earliest and certainly one of the most inventive of the object-presences, the Blue Hornton stone *Composition*, carved in 1931, is generally considered to have been influenced by the famous Cycladic *Lyre Playing Idol* in the Athens museum and by Picasso's bronze *Metamorphosis* of 1928. The forms of the Cycladic carving establish a curious organic relationship between the simplified figure and the reptilian tubularity of chair and lyre, and I suppose that a train of thought could eventually have led Moore from the figure supporting the lyre to the idea of making a hybrid out of two separate organisms. The connection with the Picasso bronze is more specific, and Moore probably saw the photograph of it published in *Cahiers d'Art* in 1929. David Sylvester has pointed out that both works are squat figures with tiny heads, that they both have linear signs incised in the surface, and that in both figures an arm raised up to the head forms a kind of handle. But the differences are fundamental. Whereas the Picasso is obviously a distorted female figure, the Moore brings the female figure to mind by analogy, and I doubt if the term 'distortion' is relevant to it. The Picasso is a calculated misrepresentation of the human figure but the Moore is

primarily a sculptural object, with something of the self-sufficiency of a pottery vessel. The stress in the Picasso is on displacement; in the Moore it is on integration. The Picasso displays a ferocious disparity between the attenuation of certain parts and the inflation of others. The Moore, on the other hand, presents a consistent vision of plumpness: allowing for its Surrealist inventiveness, it is closer to the spirit of Picasso's neo-Classical giantesses than to the sadistic *Metamorphosis*, and the cupping of one form in another imparts to the whole object a remarkable effect of sensual self-awareness.

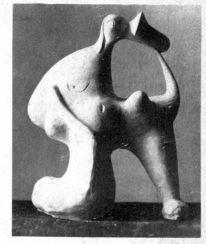

Picasso, Metamorphosis, 1928
Collection the artist

The curvaceous *Figure*, 1933–34, in Corsehill stone the colour of terracotta, is even more pot-like in appearance than *Composition*. John Russell has remarked of it that 'the swelling is the subject, to a degree not paralleled elsewhere, and all other themes and incidents are subordinate to it . . . all accords with the mysterious, even, powerful and yet perfectly contained swelling of the stone, which seems, however irrationally, to have been modelled outwards from within.'[5] (D. H. Lawrence made a similar observation about Cézanne's apples, and it applies with equal force to Courbet's apples, and to the magnificent backside of the Courbet nude in Moore's own collection, which is very nearly an example of a part-object becoming a whole object.) Russell's description is sensitive but too 'pure'; it reads like an attempt to channel our responses into a purely aesthetic appreciation. If the swelling had been as 'even' as he suggests, and if there had been no 'incidents' during the form-making, Moore's object would have had the symmetry proposed by the unbroken curve of the flank and would have been indistinguishable from a well-shaped pot. As it is, the protuberances and concavities, which Russell regards as subordinate, are the source of its power. The uptilted breast-forms leave us in no doubt of its gender; the hole in its otherwise featureless head is a mouth; the object thus assumes the significance of a biomorphic sibyl, a giver-out of carnal wisdom. The smooth, plump, rounded forms which characterize so many of Moore's sculptural objects make a direct call upon our intimate physical experience, so that however remote from human appearance they may be, we recognize their sensuality and the sculptor's commitment to what Marcuse calls 'the primary Eros', inseparable from his commitment to form.

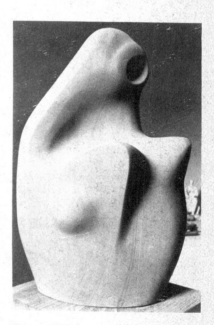

Figure, 1933–4

There is an admirable directness about the title *Hole and Lump* which he gave to a wood carving of 1934; it is a short sharp declaration of an intent fulfilled. But some of his titles seem unduly reticent. The term 'carving', for instance, simply means 'a work by one who carves', and its use as a title has a period ring about it, reminding us of the time when the avant-garde was in continual conflict with a public which expected a work of art to look exactly like something else. One of several carvings which is entitled *Carving*, carved out of Blue Ancaster

Courbet, Une Femme Couchée dans l'Herbe, 1868

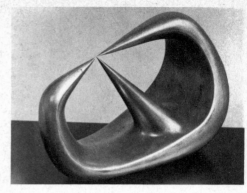

Three Points, 1939–40

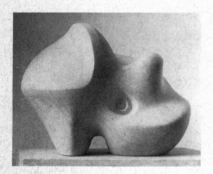

Carving, 1934

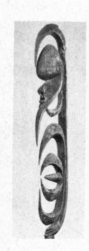

Sculpture in wood,
Sepik River,
New Guinea

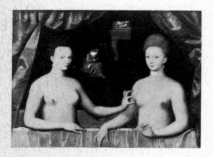

Fontainebleau School,
Gabrielle d'Estrées and her Sister
in the Bath, 16th century. Louvre

Stone in 1934, has become for me 'La Belle Hollandaise'. It looks like a highly enriched version of a Dutch clog, as if it might have been inspired by a chocolate-filled souvenir of a visit to Holland. But the filling has feminine bulges, and invites the thought that a nice, plump Dutch girl has been radically compressed to fill and partly overflow one of her own clogs. It is a kind of overloaded cornucopia, and at the same time the most compact of the reclining figures.

Kandinsky's bold claim that 'the impact of the acute angle of a triangle on a circle produces an effect no less powerful than the finger of God touching the finger of Adam in Michelangelo'[6] is an interesting intellectual idea for which I can find no support in Kandinsky's geometrical abstracts. Pure geometry lacks the atmosphere of tension and sensitivity to touch on which such a contact depends for its emotive effect. Moore's *Three Points* makes an approach to geometry, but the needle-sharp spikes look as if they can retract after making contact. They even convey the impression that their function is to impale, and that they can take likely prey by surprise by withdrawing entirely into the body from which they project. Read had referred to this object as a 'good illustration of the possibility of endowing an abstract form with an almost vicious animation', but it is significant that its heterogeneous sources are all organic. There is a connection with Picasso's studies of a screaming horse and a screaming woman in which the tongue stands up like a spike in the open mouth, and with certain New Guinea carvings of skeletal male figures where two sharp prongs curve round from the backbone like extra ribs, to guard a projecting penis. Rather more unexpectedly, Sylvester states categorically that 'in fact Moore's source of inspiration was the School of Fontainebleu double portrait of Gabrielle d'Estrées and her sister in the bathtub'.[7] The painting is a delectably erotic illustration of a 'conceit' which compares Gabrielle's nipple with the ruby in her ring, and Sylvester goes on to say that it was the 'fastidious pinching' of the nipple between her sister's forefinger and thumb that gave Moore the idea of three points converging. It could well be so, and although there is no sign of a direct reminiscence of the painting in the sheet devoted to studies of pointed forms which

20

Drawing for Sculpture:
Pointed Forms, 1940

immediately preceded the sculpture, all the studies are based on the female breast, and one of them (top row, second from the left) is practically a working drawing for the sculpture. This could explain its fascination: shape-consciousness and idea are inextricably involved in the creation of an image of a 'cruel' breast. We are in the presence of a biomorphic *femme fatale*.

The holes bored in the pre-war sculptural objects are characterized by a kind of circumspection. They usually stand for eyes or mouths. They tend to be neat and tubular. They remain incurious about the body they are entering, and when the hole passes clean through to the other side the goal is the bright exit. The outstanding exception is the stringed object called *Bird Basket*, a wood carving of 1939. In the process of hollowing out this object, Moore took full advantage of what he himself called – when praising the Negro carvers – the 'stringy, fibrous consistency of wood', and his drastic excavations reduced the arch and parts of the outer wall to a rind-like thinness. A penial form rising from the floor of the object serves as a peg for some of the coloured strings and looks as if it has been revealed by the excavations – a revelation which seems to imply an invasion of privacy.

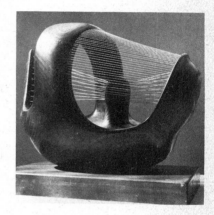

Bird Basket, 1939

The effigial figures carved in Elm wood in the late Thirties were taking a similar course, and the burrowing came to a climax in a large *Reclining Figure* of 1939. Light and air pour into and through the figure, yet we perceive it more as an image of darkness. The tunnelling of the figure is a violation, a transgression. The avant-garde process of styliza-tion assumes the significance of an act of ritual licence. 'The profane world is the world of taboos. The sacred world depends on limited acts of transgression. It is the world of celebrations. . . .'[8]

As the war approached, the figures in the drawings remained stonily impassive but tended to resume a more human appearance. Draped female figures sit upright on stools in shadowy interiors, or in armchairs like extensions of their own substance; or they stand like groups of mummy cases in ambiguous open spaces, and I think that there can be little doubt that these examples of his pre-war imagery are a partial explanation of the extraordinary speed and assurance with which he

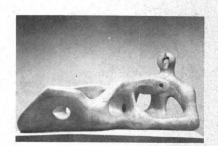

Reclining Figure, 1939

21

Tube Shelter Perspective, 1941

discovered an element of the marvellous and the mythical in the nightly descent of women and old men to the underworld of the deep shelters during the aerial bombardment of London. He created a series of drawings which is one of the greatest graphic achievements in the history of English art. It is relevant too that the last sculptures he carved before making the shelter drawings for the War Artists' Commission disclosed a compulsive concern with tunnelling. Gordon Onslow-Ford, who was the first owner of the large Elm wood *Reclining Figure*, has recalled that Moore told him of the immense satisfaction it gave him when boring into the wood to see the first speck of daylight coming from the other side. It reminds one that the first sign of an oncoming train in the Underground is a pinprick of light far back in the darkness of the tunnel, and it now seems natural and inevitable that some of the finest of the shelter drawings depict the Liverpool Street Extension, where the laying of lines had been postponed and the tunnel was a dormitory along its entire length for a double row of people.

The figures are not imitative of sculpture, and if occasionally they have the look of a somewhat harder substance than flesh it is because the shelterers themselves tended to assume an effigial stillness, a static patience. The large simplicity of forms brought Moore's deep-rooted regard for some of the Renaissance masters to the surface, and some of the drawings of sleepers seemed a new contribution to the theme of the sleeping disciples.

That was the only time his figures slept. A large carving called *Three Standing Figures*, started soon after the war ended, pays tribute to the women of the deep shelters by celebrating their return from the underworld. The figures are well over life size, the bodies matronly, the heads small and alert. They stand in a rough semi-circle, gazing at the sky. They drink in the light and air, but they are watchful, as if they have not yet lost the habit of scanning the sky for hostile aircraft. It was the first of his sculptures to be given a permanent public setting, but it occupies an obscure and inadequate site in Battersea Park. It demands an open position on the crest of a rise, but has been placed in a narrow border as if it were some sort of plaque. I remember seeing these figures before they went to Battersea Park. They were nearing completion and stood outside one of the studios at Much Hadham. It was a sunny day and the Darley Dale stone from which they are carved was honey-coloured against a blue sky, and it was obvious that they had been created to be seen against the sky. Moore's own photograph of their heads and shoulders is confirmation enough; it discloses their mysterious questioning presence in a way that is denied them in their present setting.

After *Three Standing Figures*, he began to work more frequently in bronze than in stone or wood, and Moore seemed to think that his

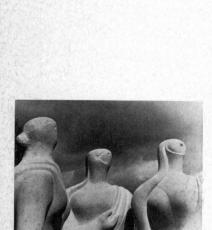

Three Standing Figures, 1947–8 (detail)

22

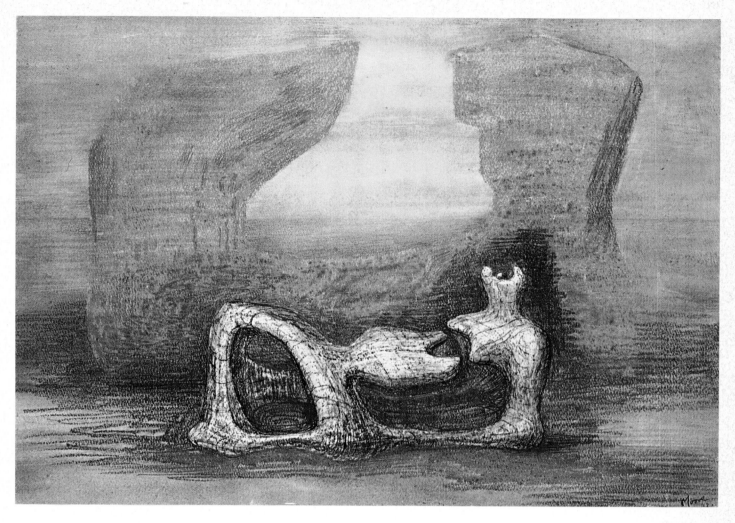

III Reclining Figure, 1942

preoccupation with bronzes required him to modify his views on truth to material. It is a doctrine that is obviously more relevant to carving than to modelling if only because the final outcome of modelling in clay or plaster is a metal reproduction. But the casting into bronze is a purely technical matter. The material that Moore actually works is clay or plaster – chiefly plaster, sometimes in a wet state, but more frequently when it has dried and hardened and can be chopped and filed instead of modelled – and he has the same instinctive feeling for their right use and possibilities as for wood and stone.

His use of liquid plaster in his treatment of the drapery for the bronze *Draped Reclining Figure* of 1952–53 was a brilliant exploitation of its pourability. The folds and creases of the fabric are composed of countless furrows, streams and modules as active as ice-clad hillsides caught in a sudden thaw, and the partial automatism parallels the drip technique of Jackson Pollock. It is a textural vivification of a surface, and it is

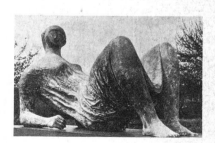

Draped Reclining Figure, 1952–3

23

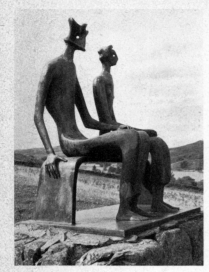

King and Queen, 1952–3

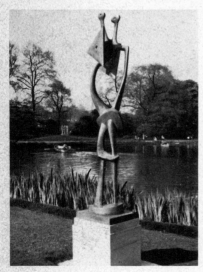

Standing Figure, 1950

evident that the bust, arms and legs of the figure took their final shape when the plaster was hard.

Moore's vision is essentially that of a carver, and his bronzes do not pursue the more demonstrative possibilities of the armature, but many of the figures have a leanness and litheness for which the only precedents in his earlier work are some small pulled-out figures in lead. Furthermore the shelter drawings had introduced a new attitude to subject-matter, and some of the bronzes show a more explicit concern with human situations. Perhaps the most famous of them is *King and Queen*. If Moore had followed his usual practice this sculpture would have been given a noncommital title, such as 'Two Seated Figures', but in this case he has evidently considered that the processes of formal invention have brought out an aspect of the content which is explicit enough to be nameable. The stylistic juxtapositions have been handled with immense skill to create a convincing composite: the extraordinary head of the king was perhaps suggested by a piece of bone; his torso is influenced by pre-Columbian pottery figures, the robes falling in vertical pleats from the knees of both figures bring to mind some ancient Egyptian seated couples, their hands and feet appear to be studies from life. The sculpture as a whole is a brilliant resolution of a conflict between a static, hieratic approach to form and a dynamic, humanist one, with intimations of a pre-Christian era in the ascendant, as if Moore were still trying to avoid the purely human level of existence by envisaging an archaic people steeped in magic. In this respect, the 'clue' to the group, as Moore himself has said, is the king's head, 'a combination of a crown, beard and face symbolizing a mixture of primitive kingship and a kind of animal, Pan-like quality.' The general demeanour of the couple is beautifully conceived. They are evidently watching a procession or display, and they are set apart by their high skill in deportment. The regality of their bearing doesn't depend upon stateliness but upon a reserved informality. They look *through* us with a lively concern.

Stone sculpture was uppermost in Moore's thoughts when he declared, some years ago: 'Sculpture is an art of the open air. Daylight, *sunlight* is necessary to it, and for me its best setting and complement is nature.' But it was one of the post-war bronzes which I first saw in a Battersea Park exhibition during a dull wet summer that convinced me that sculpture comes into its own when it finds the right open air setting. The tall, lean *Standing Figure* has a somewhat stridently avant-garde appearance in a museum; one is made too aware of the problems involved in making an 'opened-out sculpture that is neither a mass pierced by voids, nor a linear structure in space'. It was transformed when it was situated heron-like on the grass verge of the pool in Battersea Park and was at its best on the days when it rained and a mist crept over the surface of the pool. At such times a queer, uneasy life

24

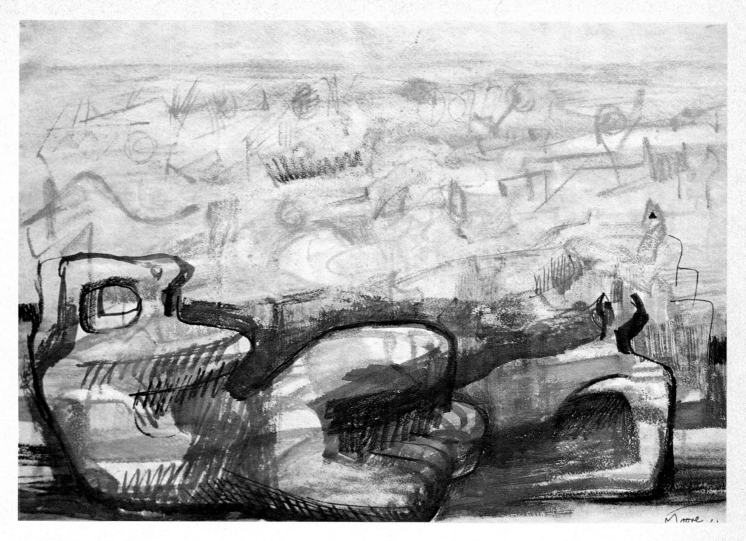

IV Drawing for Sculpture, 1961

seemed to mount through its knotty forms, as if it were stimulated by the melancholy scene. It looked as if it were in its element.

In the early Fifties, a year or two after the casting of *Standing Figure*, Moore's preoccupation with natural objects underwent a striking change. Hitherto, his study of such things as pebbles and flints had provided only formal suggestions for sculpture, but in 1952 he found a jagged piece of pebble on a holiday beach and used the actual object itself, without altering it in any way, as the initial form in a small sketch-model. It reminded him of the stump of a human leg amputated at the hip, and by adding another leg, an arm, a body, a head and finally attaching a shield to the arm he produced the image of a badly wounded warrior who had raised himself up and was still ready to defend himself. The bronze *Warrior with Shield* does not look like an assemblage. Although quite unmodified, the pebble has acquired an

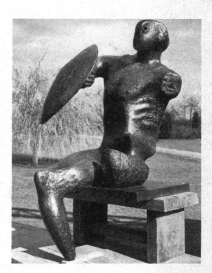

Warrior with Shield, 1953–4

25

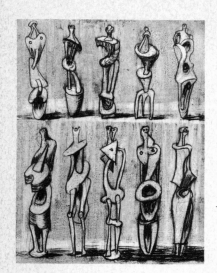

Standing Figures, 1948

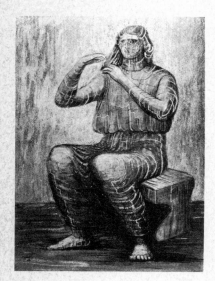

Seated Woman Doing Her Hair, 1948

anatomical identity in its new context; but it is a two-way process of integration because the additions take their cue from the shape and texture of the pebble and could themselves be found objects which accidentally resemble the parts they stand for. It became a usual practice to include natural objects in the sketch-models, and since the sculptor's discovery that a patch of land adjoining his garden had once been the site of a butcher's shop and that, just below the surface, the ground was littered with bones, fragments of animal bone structure have provided the point of departure for some of his most important bronzes of the Sixties.

The sketch models have taken over the function of the preparatory drawings and ideas for sculpture are now seldom elaborated on paper. In answer to a question put to him in 1963, Moore said that he thought the last important works to start from drawings were the family groups of 1944–45, but in fact the tall *Standing Figure* of 1950 was based on a very small drawing made in 1948. It is the third figure in the second row in a late example of those remarkable sheets of ideas for sculpture which were so vital an aspect of his graphic production in the pre-war years.

In the later drawings there are fewer examples of the day-dreaming flights of draughtsmanship, enchanting in themselves, which depicted communities of statuary in pictorial settings. The last important series, made in 1948–49, was devoted to massive female figures, reading or knitting in domestic interiors. They are seemingly made of a kind of brickwork, and bring to mind his large wall relief at Bouwcentrum in Rotterdam, carried out by highly-skilled bricklayers, in which the central motifs suggest partly exposed fossils, as if the wall itself held the secrets of pre-history.

The 'handwriting' in his drawings and sketchbooks became more restless and impulsive and there was less concern to create an illusion of solidity, but in the sketchbooks the debate between object and effigy and between the claims and counterclaims of carving and modelling continued. Two facing pages of hands in one of the sketchbooks disclose something of the oppositions at work. The page on the left contains two studies of hands gnarled and twisted by rheumatism, in which the sense of aging, stiffening, pain-ridden flesh and bone is brilliantly conveyed by long zigzags of line running up the fingers and overlapping the outlines. The additive aspect of modelling is implicit in the draughtsmanship, and the effect could only be translated into sculpture by trickles of wet plaster. The opposite page is devoted to studies of 'stumped and mutilated' hands, some of which are closed forms and could be rendered in stone, but the form at the top of this page combines both carving and modelling characteristics. The thumb and one of the fingers are free forms; they point inwards but branch clear of the main 'stem'. At the same time, the sketch suggests a pot-like object without

26

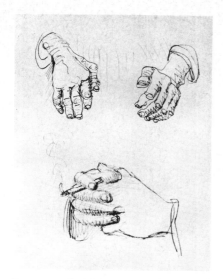
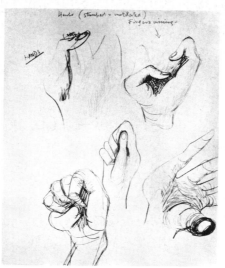
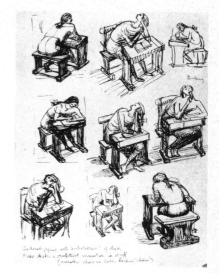

Two pages from Heads, Figures and Ideas, 1956

Girl Doing Homework, 1956

losing resemblance to a hand; it postulates a human and sculptural entity. His studies of his daughter doing her homework at a desk introduce a literal juxtaposition of object and effigy. The drawings do not propound a sculptural solution and the theme has not been treated in sculpture, but it is evident from the notes in the margin that Moore, as always, had sculptural problems in mind. 'Contrast figure with "architecture" of desk,' he writes at the end of the sequence. 'Make desk a sculptural invention in itself (remember chair in Ladder Rocking Chair).'

Some of the architectural settings which became a feature of several of the bronzes of 1957 and 1958 bear a fascinating resemblance to the slotted walls of interiors in the pre-war drawings, but I think that the most telling of these settings is the flight of steps which supports the figures in his working model for *Draped Seated Figure*. It is more purely functional than the wall settings, and remains outside the dialectic between object and effigy, yet manages to evoke a more spacious environment.

Working model for Draped Seated Woman, 1956

A drawing of a Surrealist situation made by Moore in 1942, soon after completing the shelter drawings, proved to be in some measure prophetic. It is obviously connected with his desire to resume his sculptural activities, which were suspended when he was engaged as a war artist, and is conceived in terms of an enigmatic promise. It is called *Crowd Looking at a Tied-up Object* and the wrapping evidently hides a new sculpture by Henry Moore although the sculptor himself only knows that it is vertical and of a colossal size. One could now easily be convinced that the wrappings hide a version of one of the *Upright Motives* of 1955–56, the tallest and grandest of which is called *Glenkiln Cross*. They derive from the vertical forms in a series of maquettes for

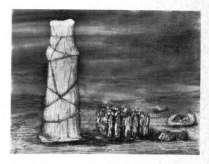

Crowd Looking at a Tied-up Object, 1942

27

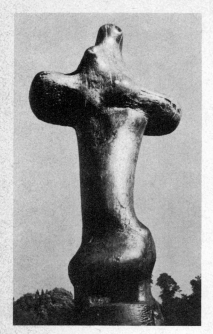

Glenkiln Cross, 1955–6 (detail)

a wall relief but make constant reference to female figures. *Upright Motive No. 8*, for instance, suggests a naked child merging with a female torso, and seems to have a remote connection with Millet's famous painting of a child ramming his head into his mother's lap. They are all partly column and partly figure and powerfully suggest a totem pole turning into human flesh. The figure in *Glenkiln Cross* has vestigial arms which form a sort of cross-piece, and Moore says that it is 'meant to be a rudimentary, worn-down cross – the cross and the figure on the cross being merged together'. I do not think he means to imply that he started to make this piece of sculpture with a crucifixion in mind, but is simply telling us what the finished work suggests to him. This splendid bronze does not contain for me the intimations of a crucifixion that Moore himself finds in it, but Read held the view that any comparison with a totem-pole is misleading, since a totem-pole has 'a precise function, i.e. to represent a particular animal (or plant) with which a man's or a tribe's ancestors were indivisibly linked in remote times'.[9] Moore, nevertheless, is peculiarly sensitive to the sculptural objects of primitive peoples, and his response to them has nothing to do with true or false interpretations of their tribal function. It would be surprising if he were unaware of the relationship of his *Upright Motives* to totem-poles, and a monument to woman in terms of a carved and modelled post which takes account of masculine pride seems, both formally and psychologically, to show more leaning towards totem-poles than to crucifixes.

His concern with female flesh itself, considered as a pliable erogenous mass, revealed for the first time in the *Upright Motives*, is disclosed in its most formidable and somewhat scarifying aspect in *Seated Woman* of 1957 and the armless *Woman* completed in 1958. But his interest in feminine masses took on an altogether different significance when he returned to the theme of woman as landscape in two large divided reclining figures, first exhibited in 1960. Together with the two-piece and three-piece reclining figures that followed, they are among his most monumental statements of the theme. There is, however, a sense in which they present the theme in reverse, since the emphasis is upon the landscape element.

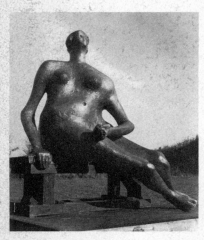

Seated Woman, 1957

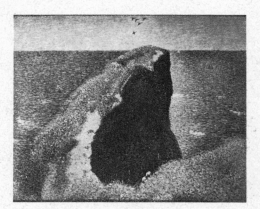

Seurat, Le Bec du Hoc, Grandchamp, 1885
Tate Gallery, London

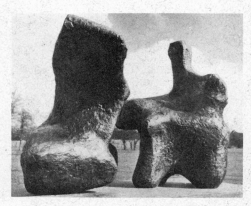

Two-piece Reclining Figure No. 1, 1959

In connection with *Two-piece Reclining Figure No. 1*, Moore has said that when he was working on it he kept being reminded of Seurat's painting of a cliff jutting out into the sea, *Le Bec du Hoc, Grandchamp*, and the lower limbs of *Two-piece Reclining Figure No. 2* bear a remarkable resemblance to the cliffs at Etretat in paintings by Courbet and Monet. There is no doubt about their monumentality. They are large in themselves and convey the impression of being infinitely larger. They are conceived as colossi, and in the mind's eye the distant peak of a head is a day's journey from the legs. They are images of rocky landscape which bear an 'accidental' resemblance to woman, so that one has the feeling, peculiarly reassuring, that there has been no interference with human appearance. They are bronzes, but they look like outcrops of stone (and this takes us a long way from the concept of 'truth to material'). Even the division into two or three parts makes its contribution to the sense of being in the presence of great rock formations, and we tend to attribute these breaks to convulsions in the earth itself, far back in geological time. The resemblances to woman assume the significance of a prediction in pre-history.

The large carving of a *Reclining Figure* in Roman Travertine marble for Unesco evokes the prehistorical in another way. It is a version of humanity that puts us back among the dinosaurs. Conceived with immense poetic assurance, its huge nether limbs indicate that it is slow-moving, but its tiny lizard-like head is alert, conveying the impression that it snaps its food out of the air with terrible swiftness. It has no armour of scales, plates or spines, so one can only surmise that its survival depends upon its resemblance to the terrain it inhabits.

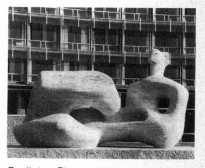

Reclining Figure, 1957

'I like wood and I like clay too,' Moore once remarked, but 'a piece of stone, any piece of stone in a landscape, I just love.' Five years after the experience of working in a quarry near Rome, where he roughed out the Unesco figure, he began to spend his summers in Italy and now has a house near the Carrara quarries and a workshop in a fabulous stone yard stocked with marble from half the quarries of the world. But his return to the carving of sculptural objects is not involved in the stylistic circumspections associated with the doctrine of truth to material. He brings to the carvings in marble not only his temperamental pre-

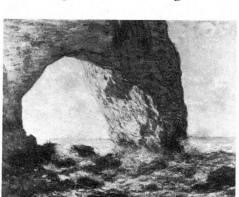

Monet, The Cliff at Etretat, 1883
Metropolitan Museum of Art, New York

Two-piece Reclining Figure No. 2, 1960 (detail)

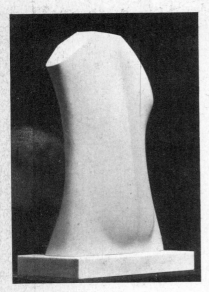

Torso, 1966

ference for working with hard materials but his long experience of what can be done in bronze and, above all, a relaxed intrepidity careless of all doctrines. The tapering of some of the planes to a blade-sharp thinness that permits the passage of light is signalled by the 'Knife Edge' bronzes, but the opening up of some of the objects is more radical than ever before, and the modelling technique which squeezed and kneaded the female figures in the *Upright Motives* into the appearance of living flesh ('clay is wonderful stuff to punch and feel that the imprint of your fist is left in it') is paralleled in the marble by the exploitation of its sleek sumptuousness to give it the appearance of a soft and sensitive substance. In this respect, the spinal cord and two little buttocks which have come with a certain diffidence to the surface of the otherwise abstract *Torso* make the back of this object look as pink and warm and sweet-smelling as a Boucher nude. The front of *Torso* is severe and sexless and the marble on that side looks noticeably colder and whiter.

Three Rings carved out of Red Soraya marble is a masterpiece of organic abstraction. Red Soraya is a spectacularly beautiful material, and the surfaces of *Three Rings* have been tenderly polished to make the most of its rose-coloured strata. Marble has never looked more precious, but the state of voluptuousness to which it has been brought is no more than a reflection of the organic splendour of the forms. Their only formal connection with the reclining figures is their horizontality. They are like large fruits that have been so thoroughly hollowed and tunnelled that all that remains is part of the outer covering of thick rind; but the rind has softly rounded edges as if the rings have come to this shape from inside themselves, as if nothing has been taken out or cut away. It has taken on the look of the substance that turned into the smooth, firm, rounded bodies of the women in Ingres' *Le Bain Turc* or the strangely amiable coils of carved Aztec rattlesnakes. One of the rings stands out in front and the other two stand close behind it to make a complex of passages and to cast shadows into interior space. It presents an intimate vision of femininity beyond the means of representationalism. It is an image of sexual readiness to which we are privileged to respond in terms of our own aesthetic gratification.

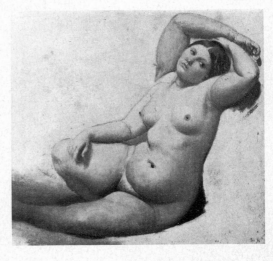

Ingres, Study for Le Bain Turc, 1864
Museum of Montauban

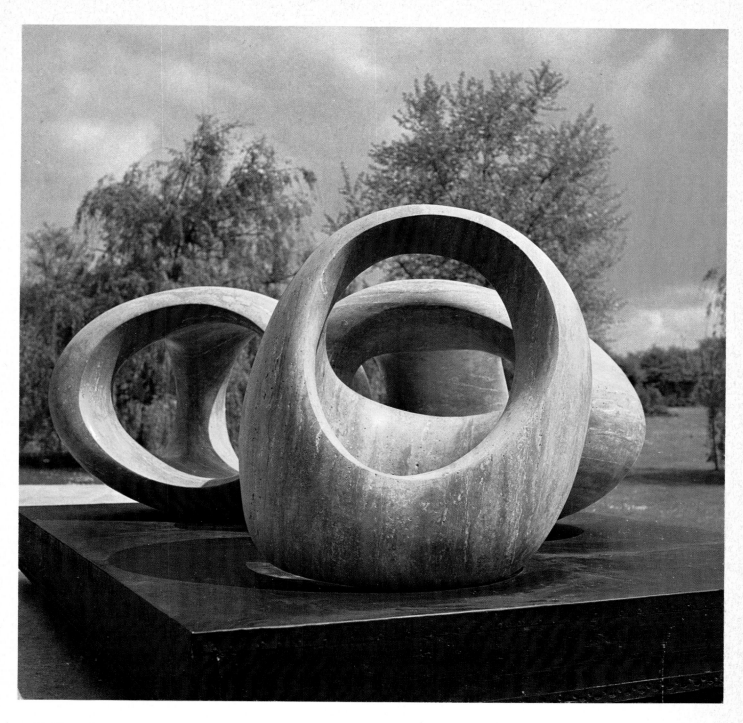

V Three Rings, 1966. L. 2.69 m

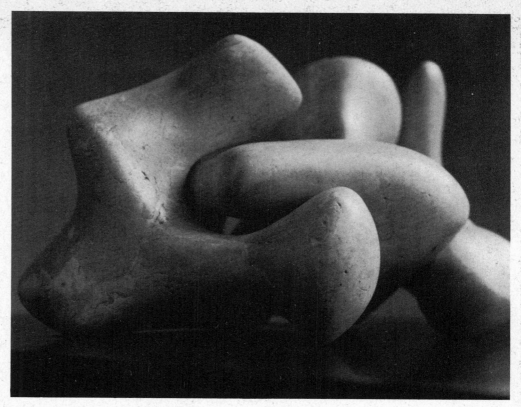

Three-piece No. 3: Vertebrae, 1968–9

Locking Piece, 1963–4

The bronze *Three-piece No. 3: Vertebrae*, the last of his works to be finished in time for the exhibition at the Tate Gallery on the occasion of his seventieth birthday, has been given the colour and gleam of gold and has the same jewel-like sumptuousness as the Red Soraya *Three Rings*. The title acknowledges his treasure house of bones, the horizontal spread of the forms acknowledges his ubiquitous Reclining Figure. The forms fit into one another with something of the thrust and counter-thrust of *Locking Piece*, but more impetuously. The tunnelling that in the past served a 'conception of the body as a magic vessel' is now presented as an intention instead of a result, for the forms are involved in acts of penetration. The reclining figure has been transformed into a bacchanalia of golden biomorphs, emblematic of universal coition.

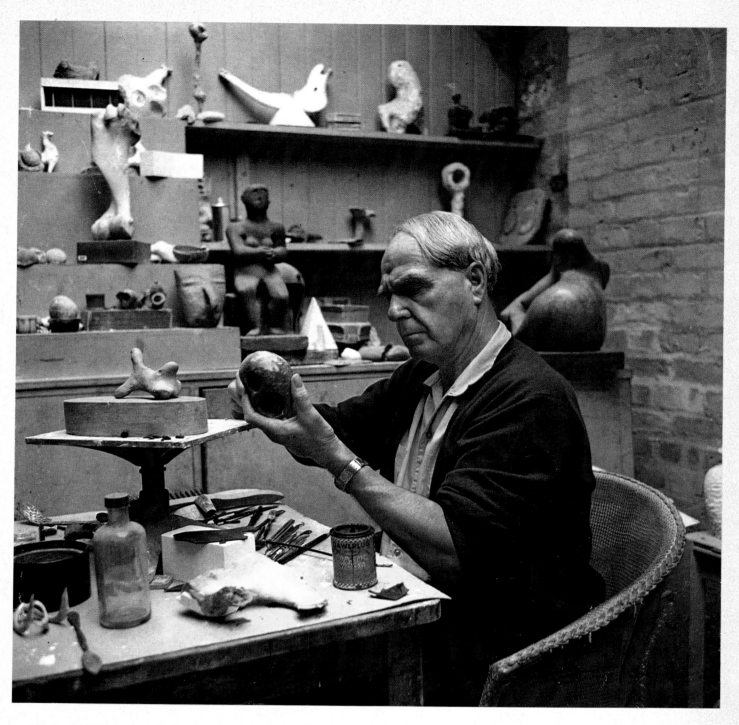

VI Henry Moore in small studio, Much Hadham, 1966

TEXT REFERENCES

1 Herbert Read: *Henry Moore: Sculpture and Drawings*, Vol. I, 4th edition, London, 1957, p. XXVII.

2 Herbert Marcuse: *Eros and Civilization*, London, 1969, p. 120.

3 Roger Fry: *Vision and Design*, Essay on Negro Sculpture. Phoenix Edition, London, 1928.

4 Herbert Read: *Henry Moore: a study of his life and work*, London, 1965, p. 112.

5 John Russell: *Henry Moore: Stone and Wood Carvings*, London, 1961, p. 18.

6 Wassily Kandinsky: *Réflexions sur l'art abstrait, Cahiers d'art*, Paris, 1931.

7 David Sylvester: *Henry Moore*. Catalogue of an exhibition at the Tate Gallery, London, 1961, p. 36.

8 Georges Bataille: *Eroticism*, London, 1962, pp. 67–8.

9 Herbert Read: *Henry Moore: a study of his life and work*, London, 1965, p. 206.

THE PLATES

1921–1935

HENRY MOORE WAS A STUDENT at the Royal College of Art when he carved *Head of a Girl (1)* and *Standing Woman (3)* in emulation of African wood sculpture, and, with the 'stoniness' of ancient Mexican sculpture in mind, the first of a series of *Mother and Child* carvings *(2)*. By this time he had come to the conclusion that 'art is a universal continuous activity with no separation between past and present'.

In 1924, whilst temporarily in charge of the sculpture school at the RCA, pending the appointment of a successor to Professor Derwent Wood, he created two very powerful stone carvings on the *Mother and Child* theme *(6 and 7)*; the dramatic *Woman with Upraised Arms (9)*; and the small marble *Snake (5)*, a lovely example of sculpture conceived totally in the round, which can be cupped in the hands like a large, intricate pebble. One of the problems that he had to overcome when carving small works like *Snake* was how to prevent the block of stone slipping about under the impact of hammer and chisel: after finding that clamping it between his knees was less than satisfactory, he hit on the idea of half-burying it in a box of sand.

The *Reclining Figure* theme became his major preoccupation soon after taking the tenancy of 3 Grove Studios, Hammersmith, in 1926. In the astonishingly inventive period that followed, the *Reclining Figure* underwent a series of transformations which Herbert Read described as 'a new mythology of the unconscious', and in 1935 Moore carved perhaps the strangest Reclining Figure he has ever conceived *(137)*. It is a base supporting five objects and at the same time a body with five protuberances. It is analogous to a mummy-case, a woman taking a bath, a pitch or course laid out for an archaic game of golf and a site for ceremonial sacrifice, where victims are brought over the hill and down the ramp, to be thrown into the gaping hole of the burial mound – a sacrificial site that forms a recumbent image of the goddess to which the sacrifice is made.

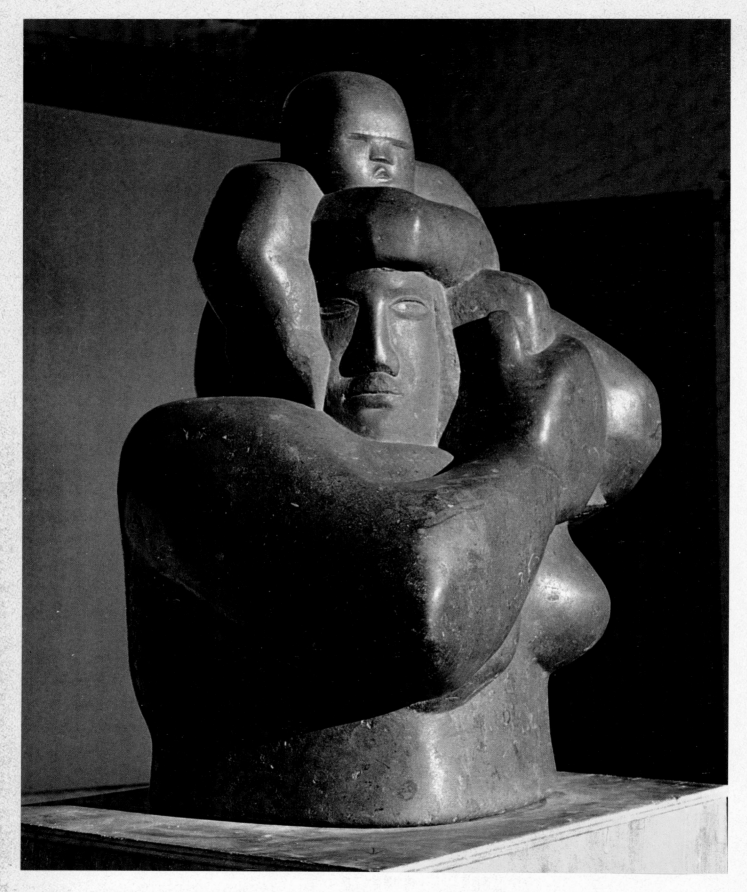

VII Mother and Child, 1924–5. H. 57.2 cm

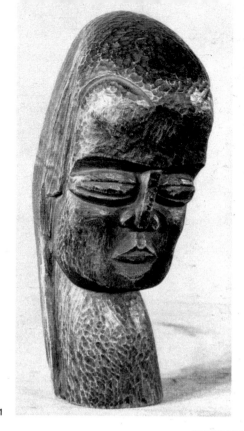

1 Head of a Girl · Tête de jeune fille
Mädchenkopf · 1922 · H. 24.1 cm

2 Mother and Child · Mère et enfant
Mutter und Kind · 1922 · H. 27.9 cm

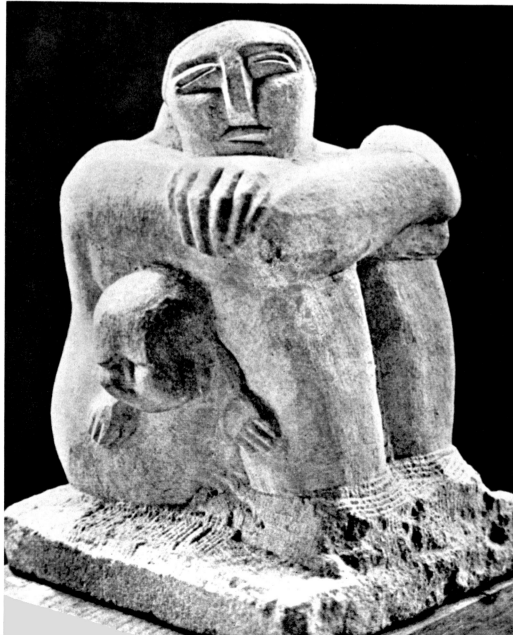

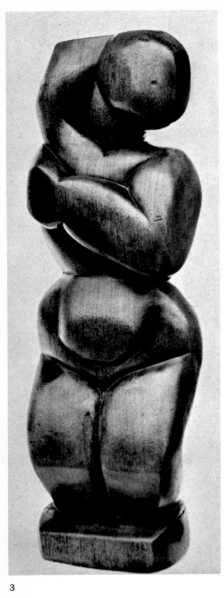

3

4

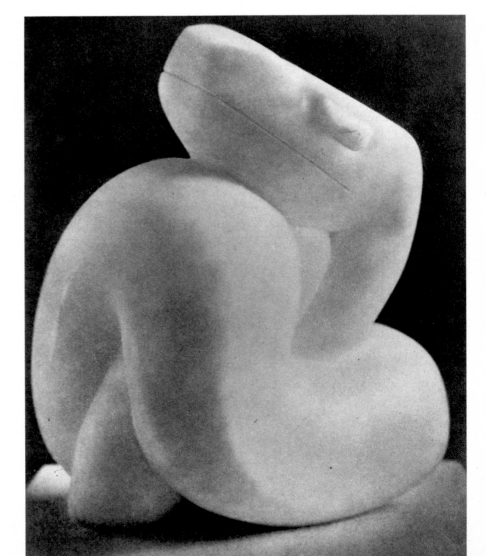

5

3 Standing Woman · Femme
 debout · Stehende Frau
 1923 · H. 30.5 cm

4 Mask · Masque · Maske
 1924 · H. 17.8 cm

5 Snake · Serpent
 Schlange · 1924
 H. 15.3 cm

6 Mother and Child · Mère
 et enfant · Mutter und
 Kind · 1924–25 · H. 57.2 cm

7 Maternity · Maternité
 Mutterschaft · 1924
 H. 22.9 cm

8 Figure · Figure · Figur
 1923 · H. 39.4 cm

9 Woman with Upraised
 Arms · Femme aux bras
 levés · Frau mit
 erhobenen Armen
 1924–25 · H. 43.2 cm

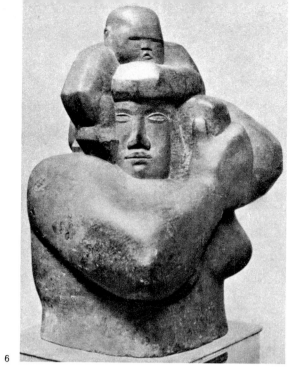

6

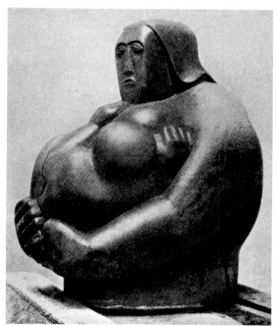

7

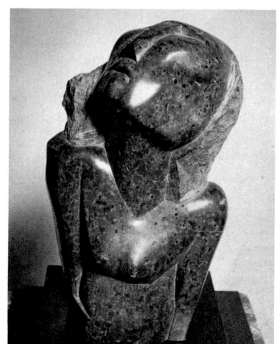

8

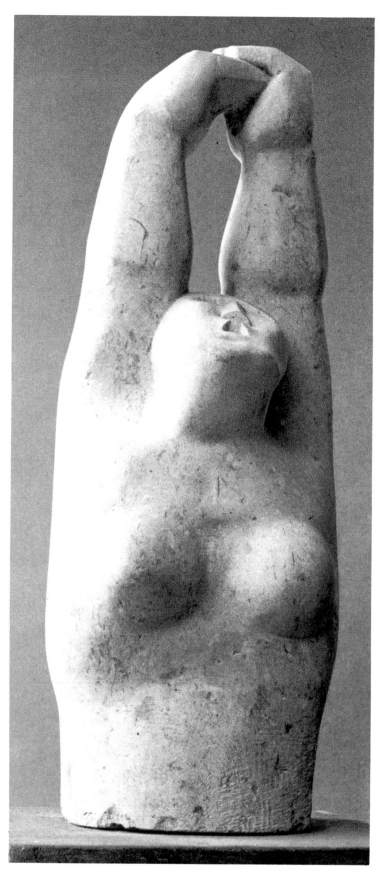

9

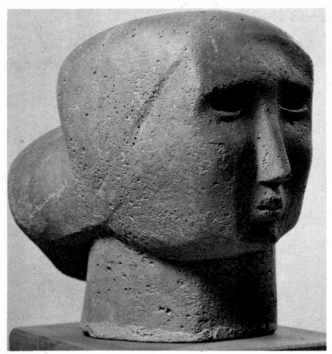

10

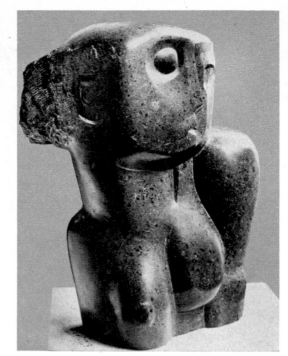

11

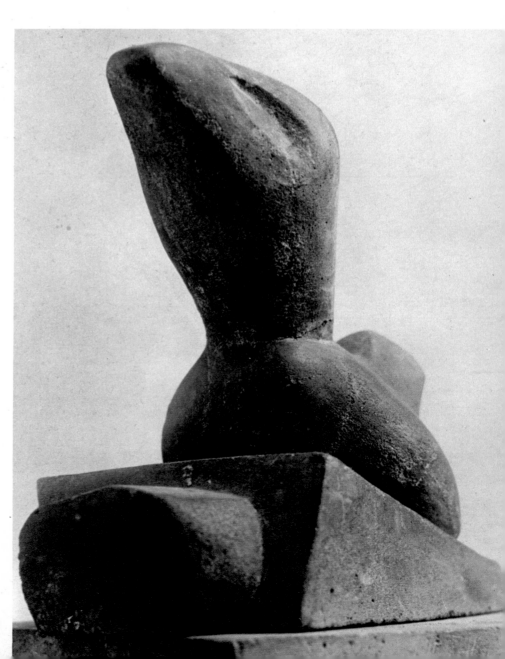

10 Head of a Woman · Tête de femme
Frauenkopf · 1926 · H. 22.9 cm

11 Head and Shoulders · Tête et
épaules · Kopf mit Schultern
1927 · H. 45.7 cm

12 Duck · Canard · Ente · 1927
H. 15.3 cm

13-14 Suckling Child · Enfant au
sein · Saugendes Kind · 1927
L. 43.2 cm

12

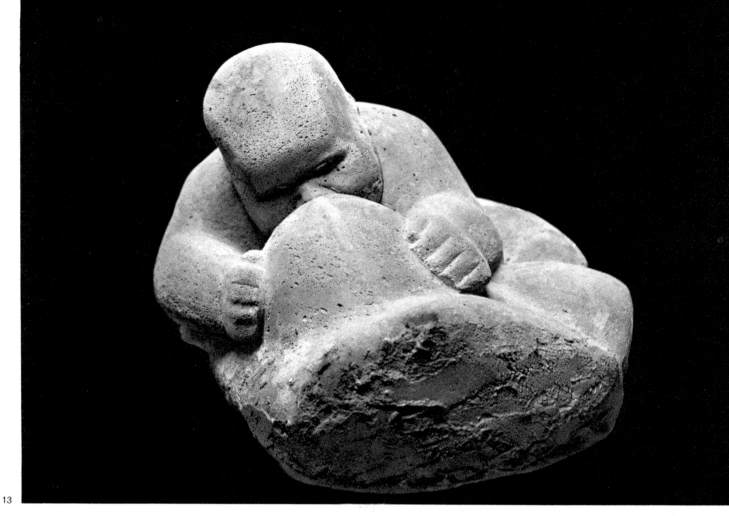

13

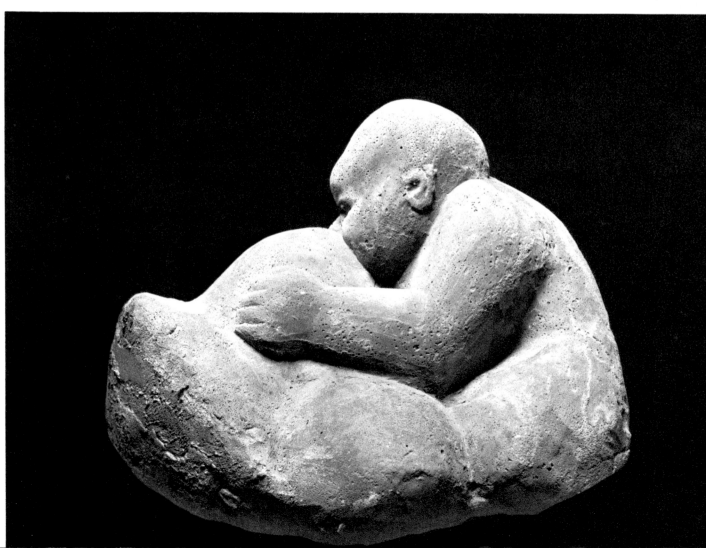

14

15

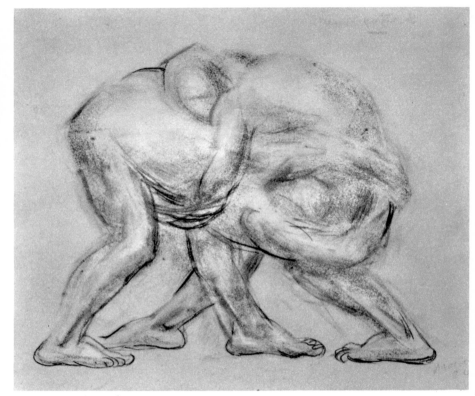

16

15 Spring · Printemps · Frühling · 1921
16 The Wrestlers · Les lutteurs · Die
 Ringer · 1924
17 Woman Reading · Liseuse · Lesende
 1926
18 Portrait of the Artist's Mother
 Portrait de la mère de l'artiste
 Porträt der Mutter des Künstlers
 1927
19 Seated Figure with Necklace · Figure
 assise au collier · Sitzende Figur
 mit Halskette · 1928

17

18

19

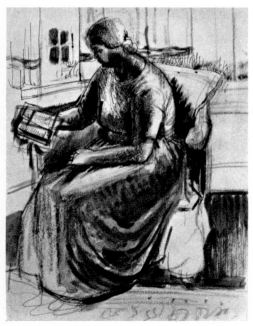

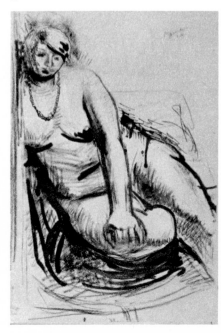

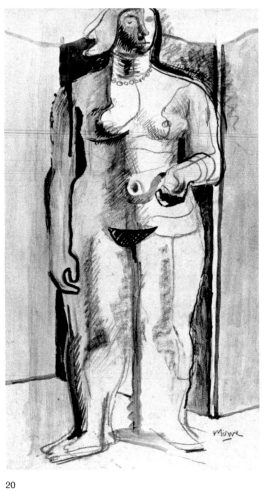

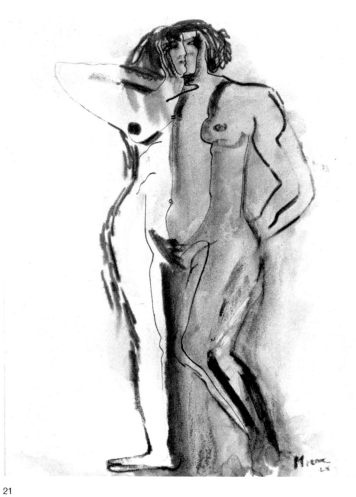

20

21

20 Standing Figure · Figure debout · Stehende
 Figur · 1928

21 Section Line Drawing · Dessin au trait
 avec section · Längsschnittzeichnung · 1928

22 Girl · Jeune fille · Mädchen · 1928

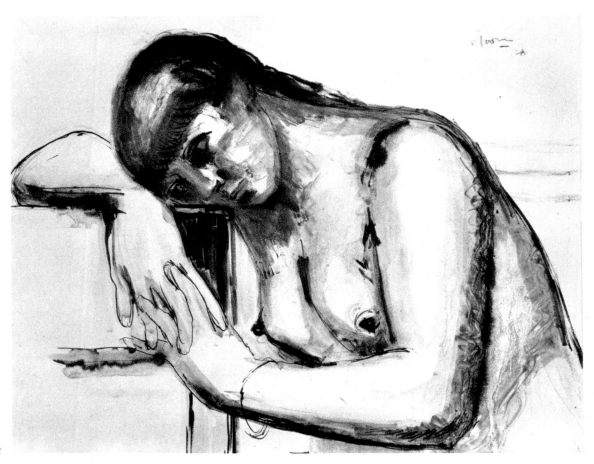

22

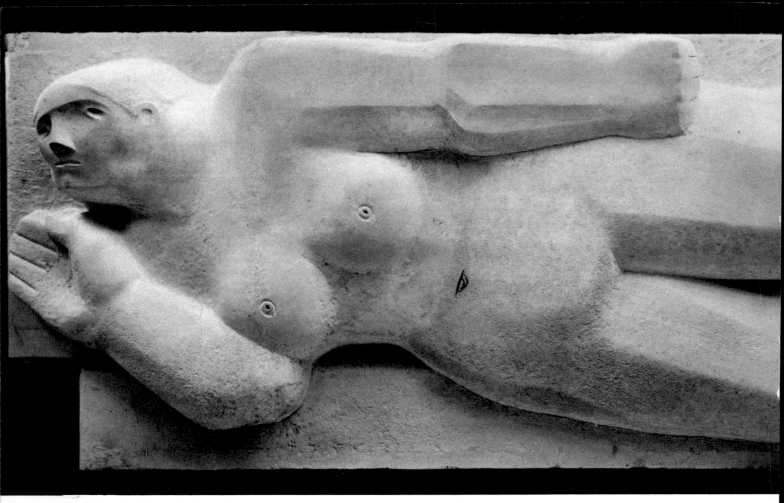

23

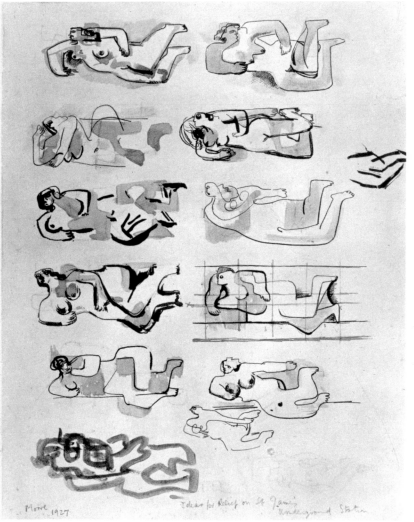

23 North Wind · Vent du nord · Nordwind · 1928–29
L. 2.46 m

24 Ideas for Relief on St James's Underground
Station · Idées pour un bas-relief à la station
de Métro St-James · Skizzen zu einem Relief
an der U-Bahnstation St. James · 1927

25 Mother and Child · Mère et enfant · Mutter und
Kind · 1929 · H. 12.7 cm

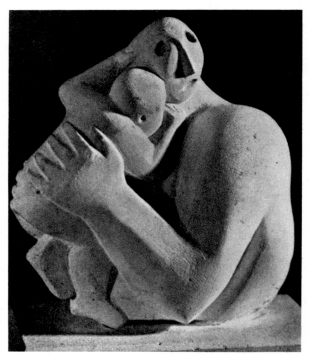

25

24

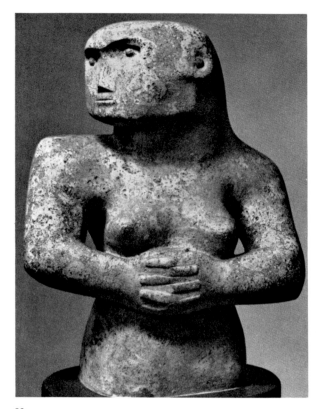

26

26 Figure with Clasped Hands · Figure aux mains
jointes · Figur mit gefalteten Händen · 1929
H. 45.7 cm

27 Reclining Woman · Femme couchée · Liegende
1927 · L. 63.5 cm

27

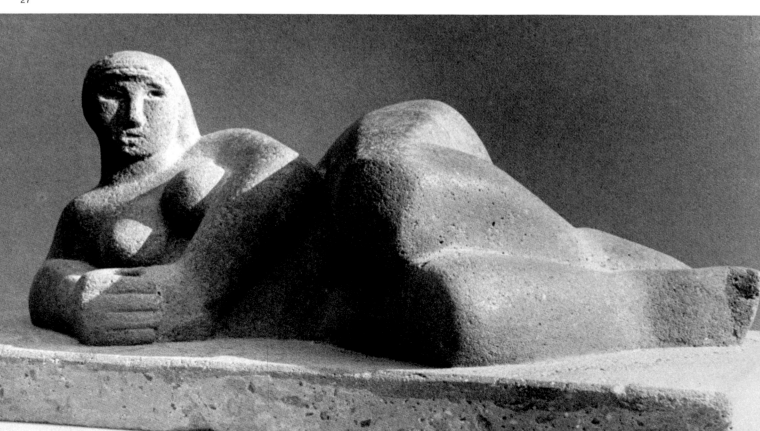

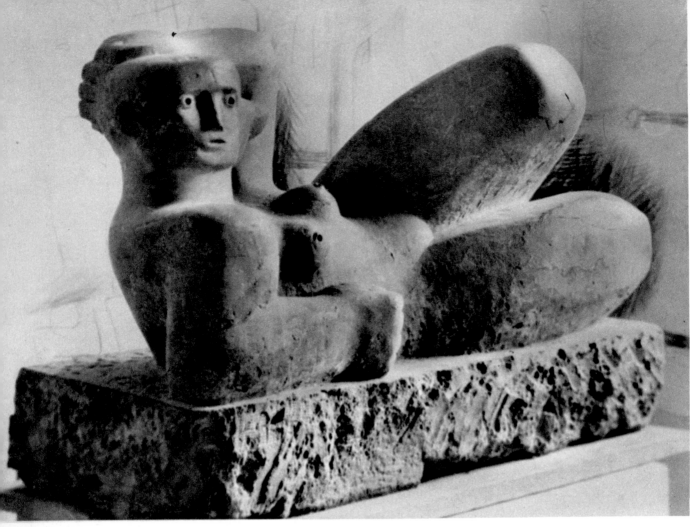

28

28 Reclining Figure · Figure couchée
 Liegende Figur · 1929 · L. 83.8 cm

29 Mask · Masque · Maske · 1929
 H. 21.6 cm

30 Torso · Torse · Torso · 1927
 H. 21.6 cm

29

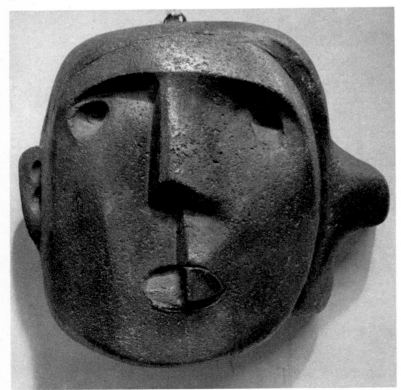

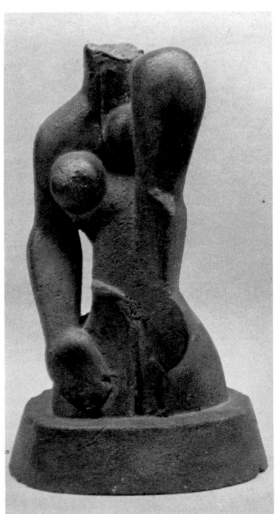

30

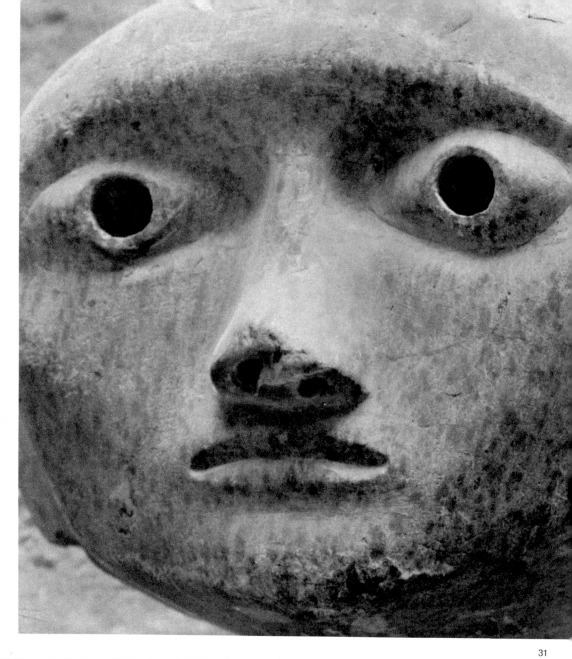

31 Mask (detail) · Masque
(détail) · Maske
(Ausschnitt) · 1929
L. 12.7 cm

32 Reclining Figure · Figure
couchée · Liegende Figur
1929 · L. 46.7 cm

31

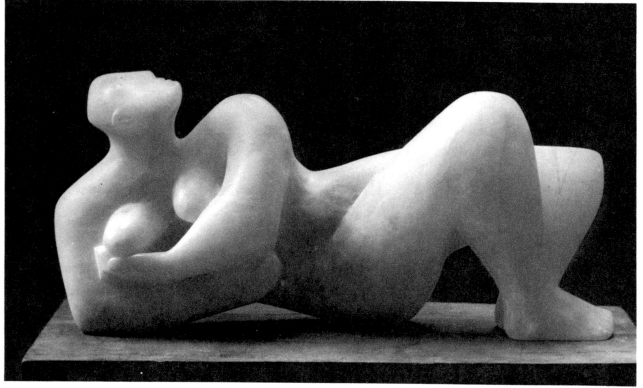

32

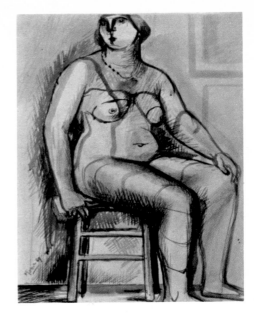

34

33

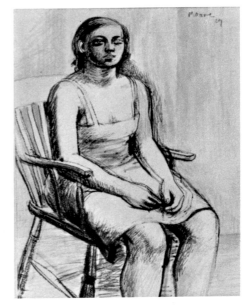

35

· 36

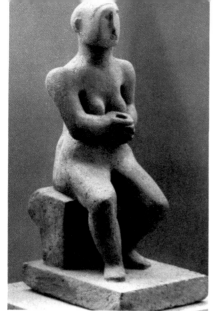

37

38

39

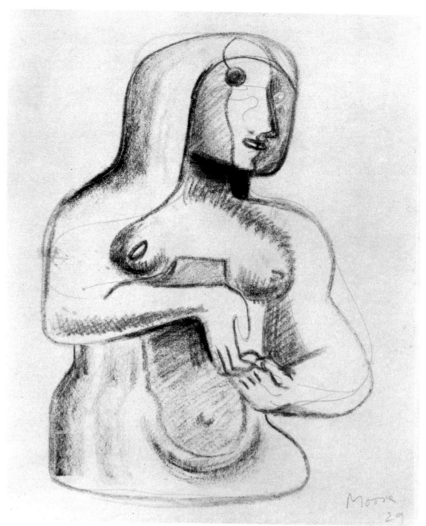

40

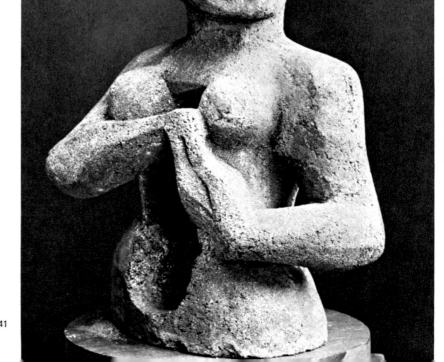

41

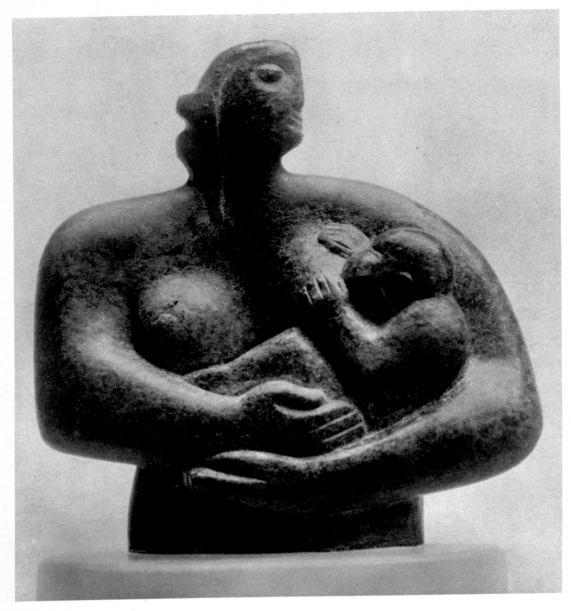

42

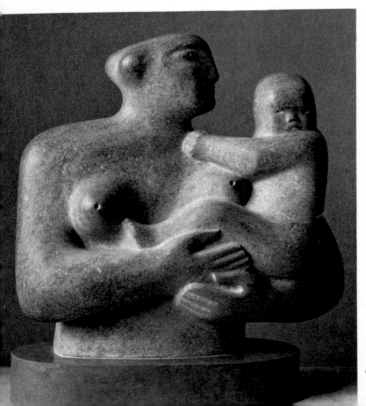

43

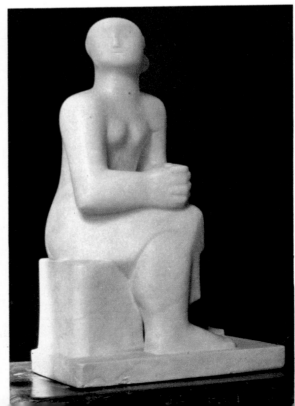

44

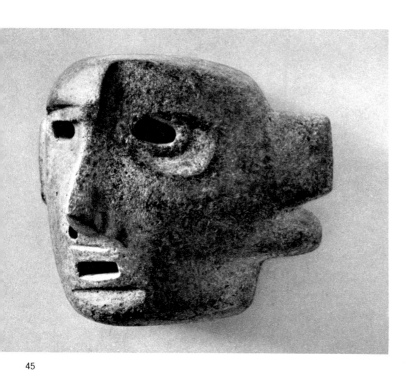

45

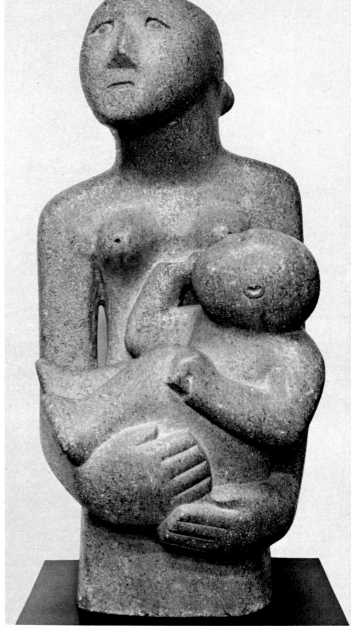

46

42 Mother and Child · Mère et enfant · Mutter
und Kind · 1929 · H. 12.1 cm

43 Mother and Child · Mère et enfant · Mutter
und Kind · 1930 · H. 25.4 cm

44 Seated Figure · Figure assise · Sitzende
Figur · 1930 · H. 38.1 cm

45 Mask · Masque · Maske · 1930 · H. 16.5 cm

46 Mother and Child · Mère et enfant · Mutter
und Kind · 1930 · H. 78.8 cm

47 Mother and Child · Mère et enfant · Mutter
und Kind · 1930 · H. 25.5 cm

48 Girl with Clasped Hands · Jeune fille aux
mains jointes · Mädchen mit gefalteten
Händen · 1930 · H. 38.1 cm

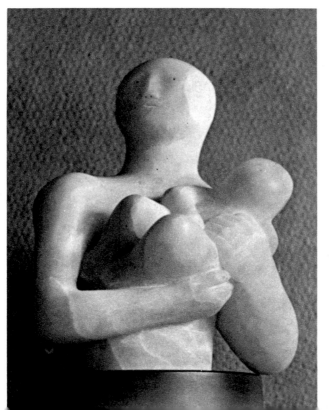

47

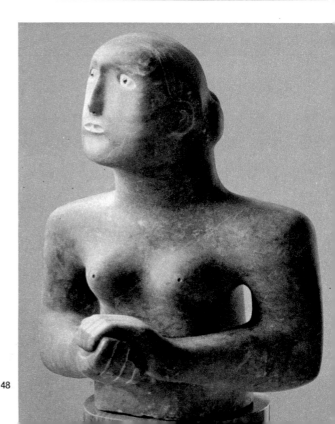

48

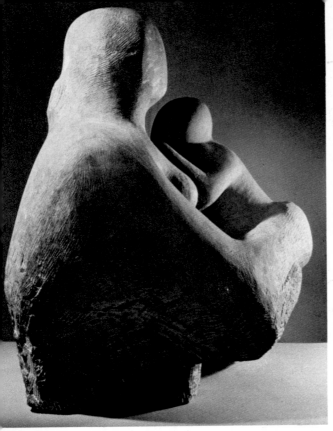

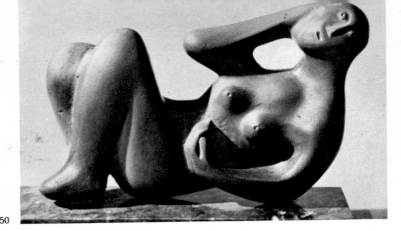

50

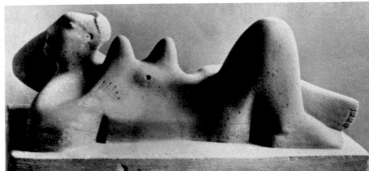

51

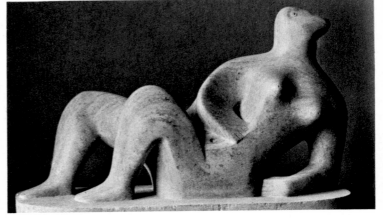

52

49

49 Mother and Child · Mère et enfant · Mutter und
Kind · 1930–31 · H. 40.7 cm

50 Reclining Figure · Figure couchée · Liegende
Figur · 1930 · L. 17.8 cm

51 Reclining Figure · Figure couchée · Liegende
Figur · 1930 · L. 49.6 cm

52 Reclining Figure · Figure couchée · Liegende
Figur · 1930 · L. 53.4 cm

53 Reclining Woman · Femme couchée · Liegende
1930 · L. 94.0 cm

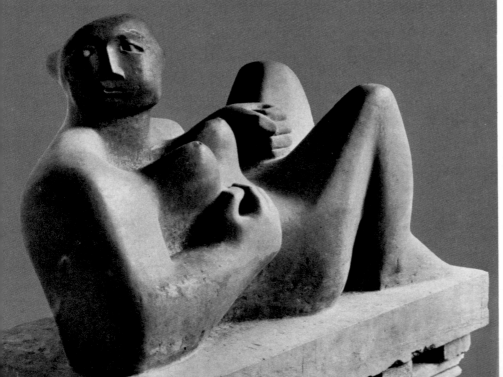

53

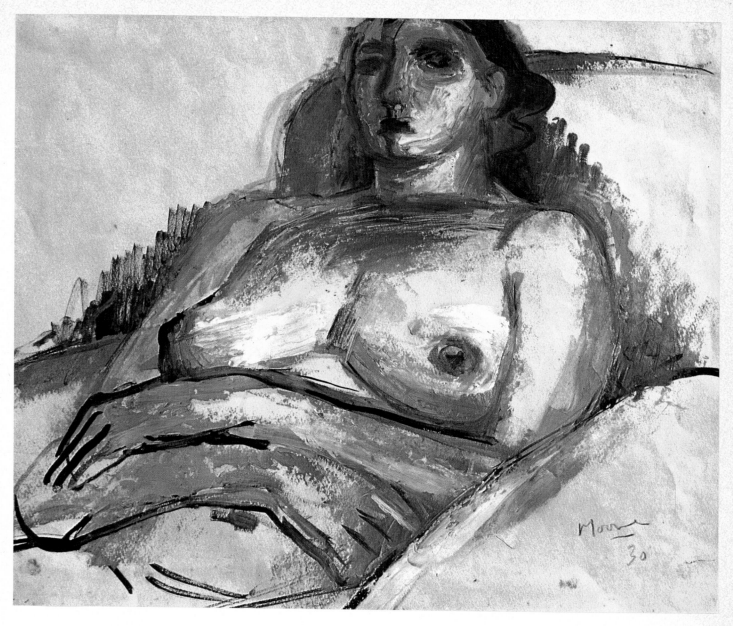

VIII Woman in Armchair, 1930

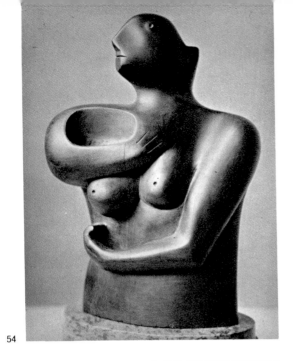

54

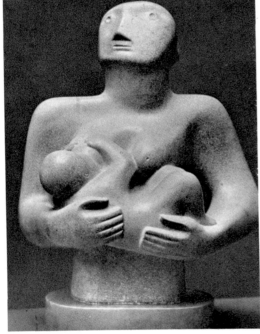

55

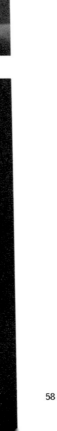

56

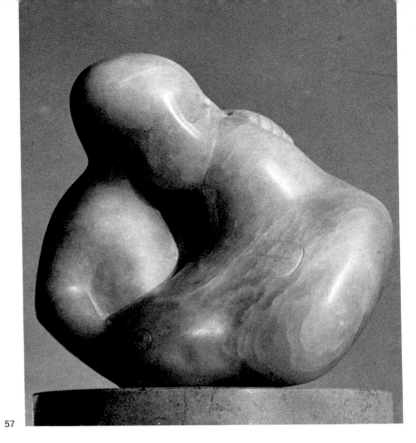

57

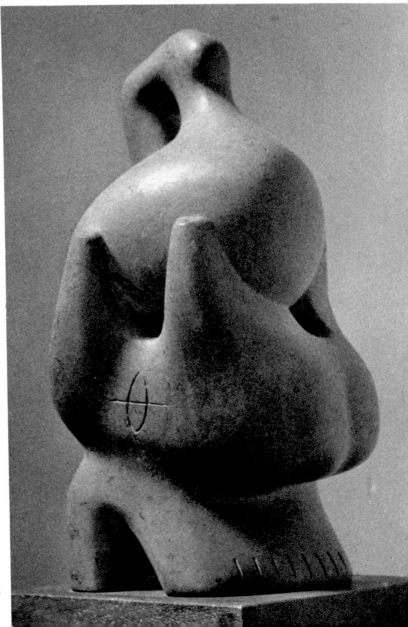

58

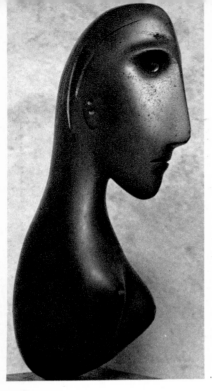

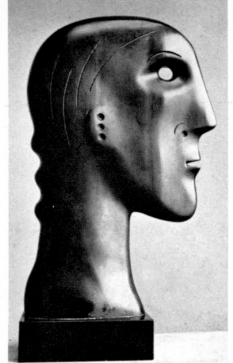

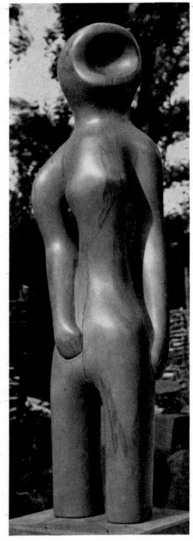

59

60

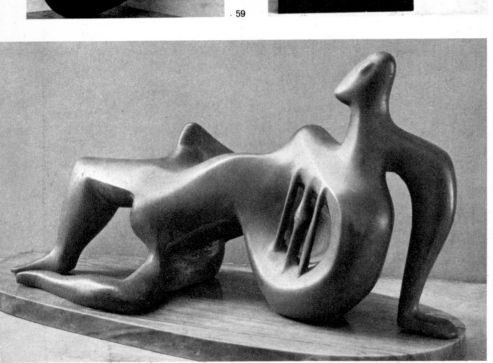

62

61

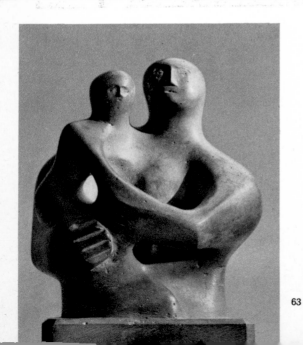

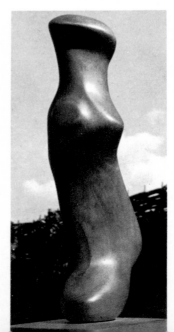

63

64

59 Head · Tête · Kopf · 1930
H. 20.4 cm

60 Head · Tête · Kopf · 1930
H. 25.5 cm

61 Reclining Figure · Figure
couchée · Liegende Figur
1931 · L. 43.2 cm

62 Figure · Figure · Figur
1932 · H. 43.2 cm

63 Mother and Child · Mère et
enfant · Mutter und Kind
1932 · H. 17.8 cm

64 Figure · Figure · Figur
1932 · H. 33.0 cm

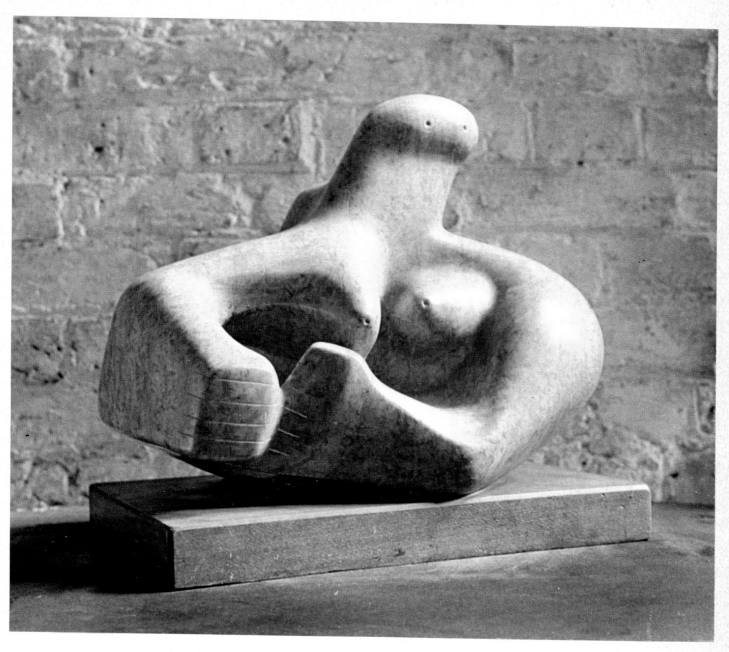

IX Composition, 1931. L. 41.9 cm

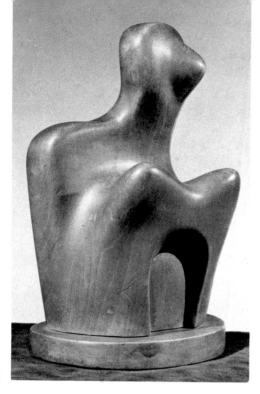

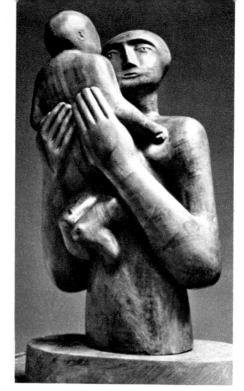

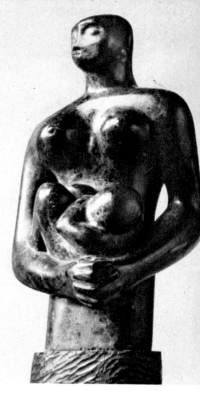

65

66

67

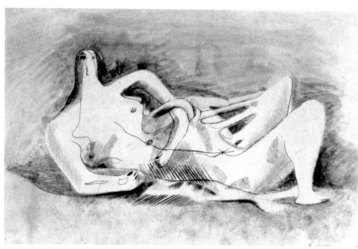

65 Figure · Figure · Figur · 1931 · H. 24.2 cm

66 Mother and Child · Mère et enfant · Mutter und Kind · 1931 · H. 76.2 cm

67 Mother and Child · Mère et enfant · Mutter und Kind · 1931 · H. 20.3 cm

68 Drawing for Figure in Metal or Reinforced Concrete · Dessin pour une figure en métal ou en béton armé · Studie für eine Figur in Metall oder Eisenbeton · 1931

69 Composition · Composition · Komposition · 1932 H. 44.5 cm

70 Composition · Composition · Komposition · 1932 H. 38.8 cm

69

68

70

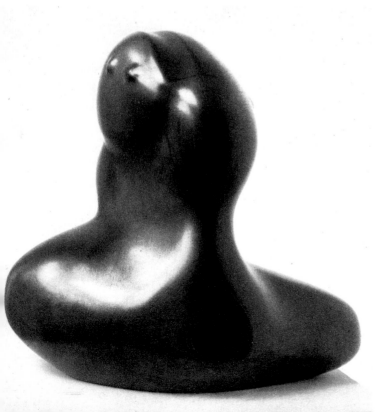

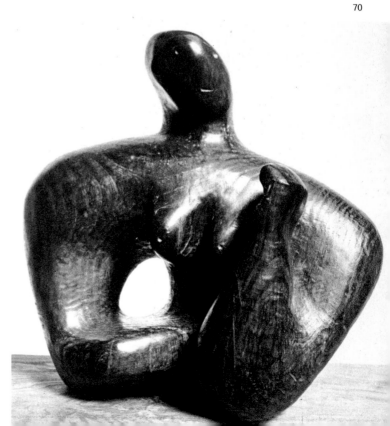

71

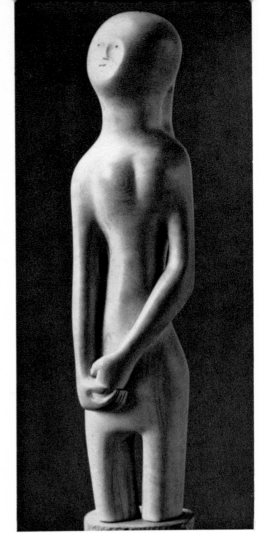

72

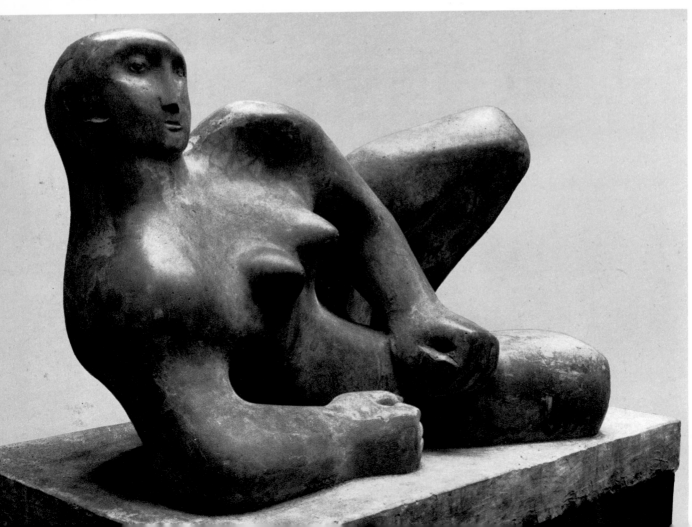

73

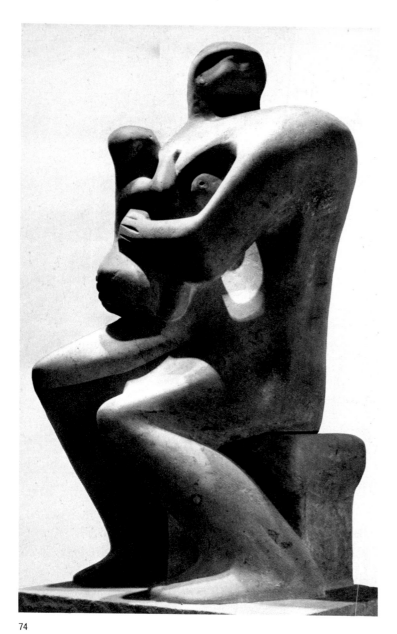

74

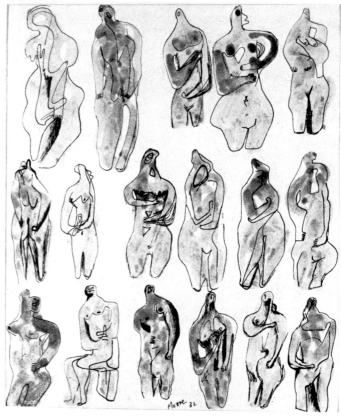

75

71 Half Figure · Demi-figure · Halbfigur · 1932
H. 83.9 cm

72 Girl · Jeune fille · Mädchen · 1932 · H. 31.8 cm

73 Reclining Figure · Figure couchée · Liegende
Figur · 1932 · L. 1.09 m

74 Mother and Child · Mère et enfant · Mutter
und Kind · 1932 · H. 88.9 cm

75 Drawing · Dessin · Zeichnung · 1931

76 Standing Figures · Figures debout
Stehende Figuren · 1932

76

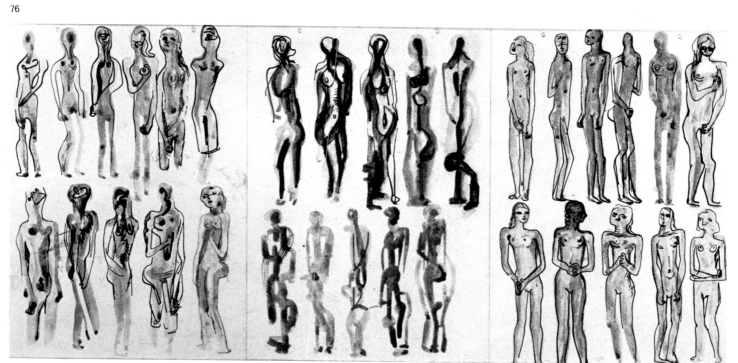

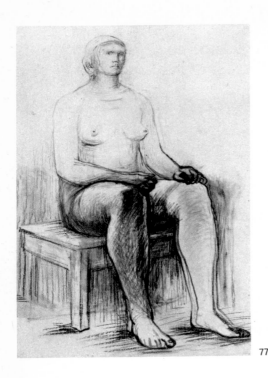

77

78

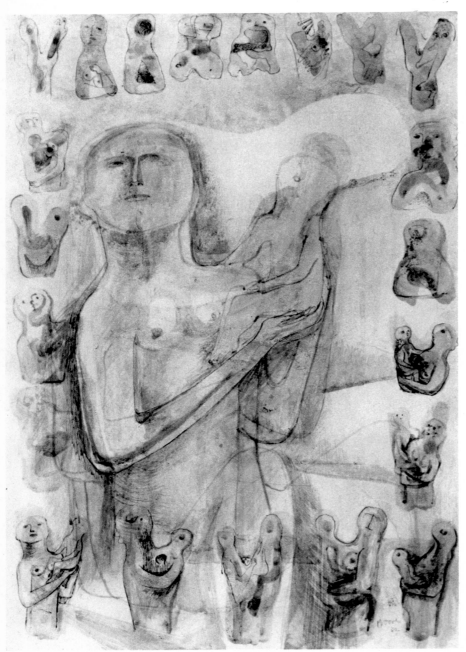

77 Study of a Seated Nude · Etude de nu
assis · Studie eines sitzenden Aktes
1932

78 Standing Figure and Head · Figure
debout et tête · Stehende Figur und
Kopf · 1932

79 Mother and Child · Mère et enfant
Mutter und Kind · 1932.

80 Life Drawing, Seated Woman · Dessin,
femme nue assise · Sitzender weiblicher
Akt · 1928

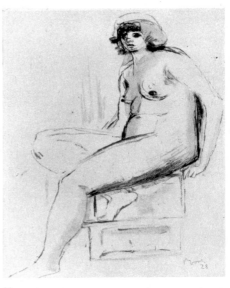

80

79

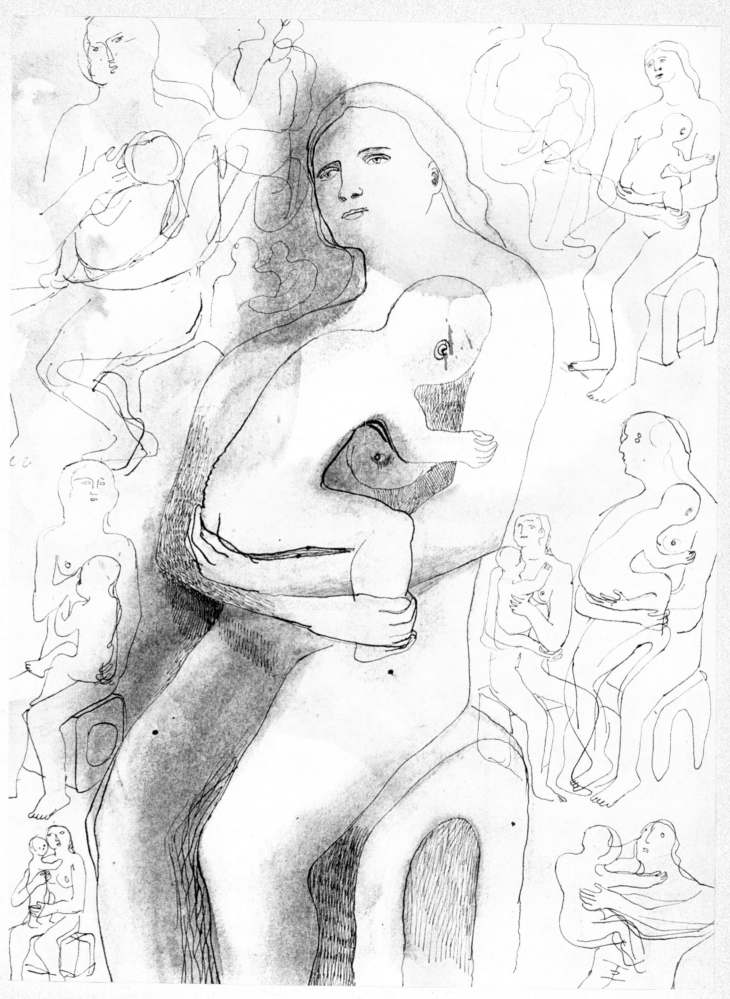

X Mother and Child, 1933

81

82

81 Drawings of Shells · Dessins de
coquillages · Zeichnungen von
Muscheln · 1932

82 Drawing for Sculpture · Croquis
pour sculpture · Entwurf für eine
Plastik · 1932

83 Seated Figures: Studies for
Sculpture · Figures assises: études
pour sculpture · Sitzende Figuren:
Studien für Plastiken · 1932

83

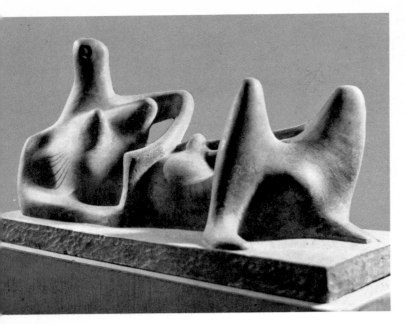

84

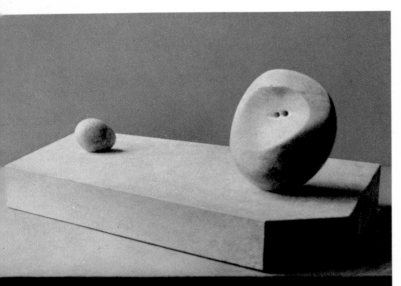

85

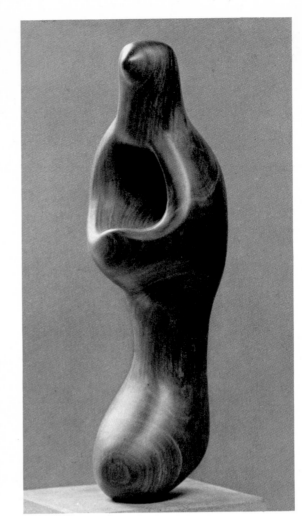

87

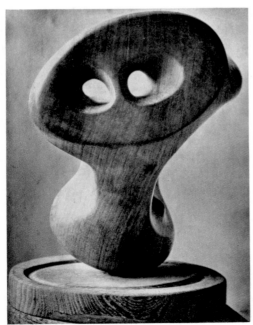

86

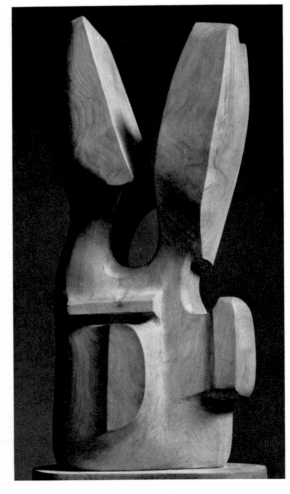

88

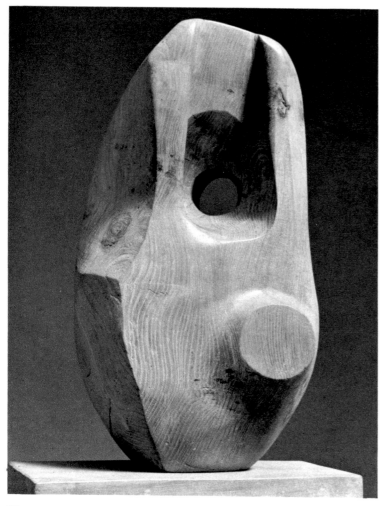

89

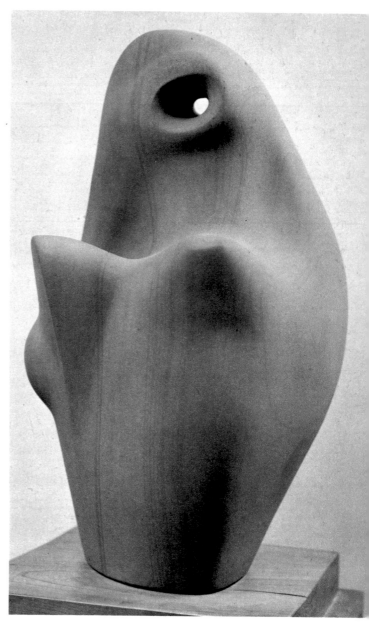

91

90

84 Reclining Figure · Figure couchée
Liegende Figur · 1933 · L. 77.5 cm

85 Head and Ball · Tête et boule
Kopf und Kugel · 1934 · L. 50.8 cm

86 Composition · Composition
Komposition · 1933 · H. 34.6 cm

87 Composition · Composition
Komposition · 1933 · H. 45.8 cm

88 Family · Famille · Familie · 1935
H. 1.02 m

89 Hole and Lump · Trou et bosse
Loch und Klotz · 1934 · H. 55.9 cm

90 Figure · Figure · Figur · 1933–34
H. 40.7 cm

91 Figure · Figure · Figur · 1933–34
H. 76.2 cm

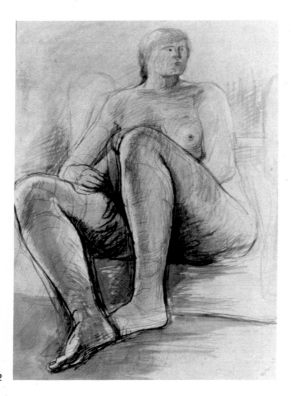

92

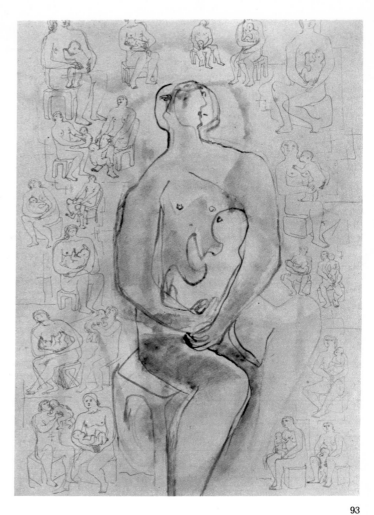

93

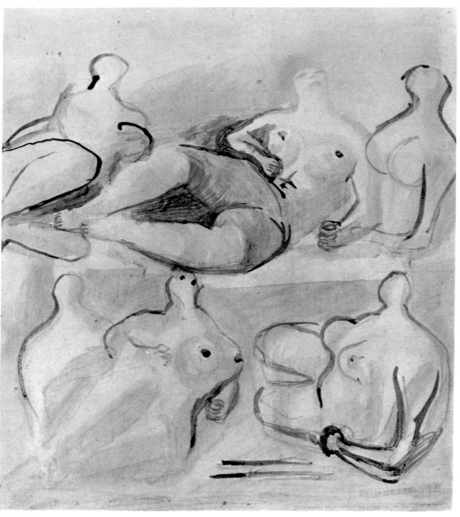

94

92 Seated Figure · Figure assise
Sitzende Figur · 1933

93 Mother and Child · Mère et enfant
Mutter und Kind · 1933

94 Reclining Forms · Formes couchées
Liegende Figuren · 1933

95 Ideas for Bronze Standing Figure
(detail) · Idées pour une figure
debout en bronze (détail)
Skizzen zu einer stehenden Bronze-
figur (Ausschnitt) · 1933

96 Montage · Montage · Montage · 1933

97 Reclining Figure · Figure couchée
Liegende Figur · 1933

98 Reclining Figures · Figures
couchées · Liegende Figuren · 1933

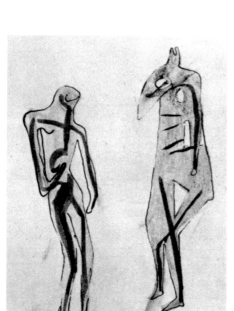

95

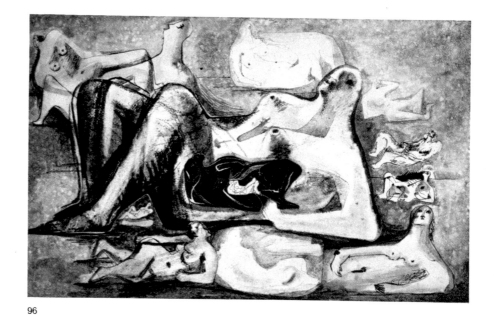

96

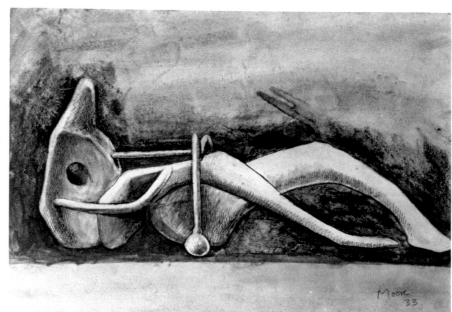

97

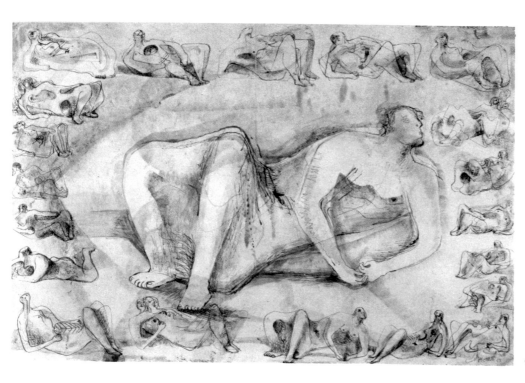

98

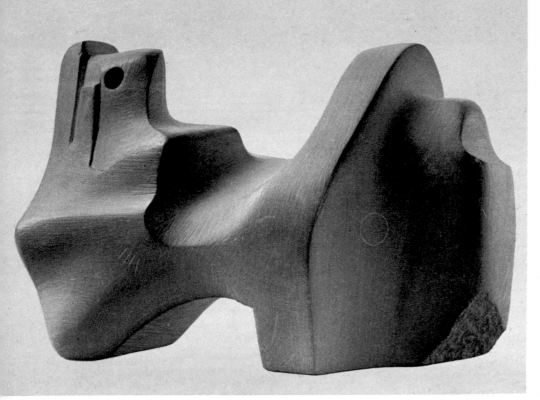

99

99 Reclining Figure · Figure couchée · Liegende Figur · 1934 · L. 15.3 cm
100 Carving · Sculpture · Plastik · 1934 · H. 10.2 cm
101 Carving · Sculpture · Plastik · 1934 · L. 40.7 cm

100

101

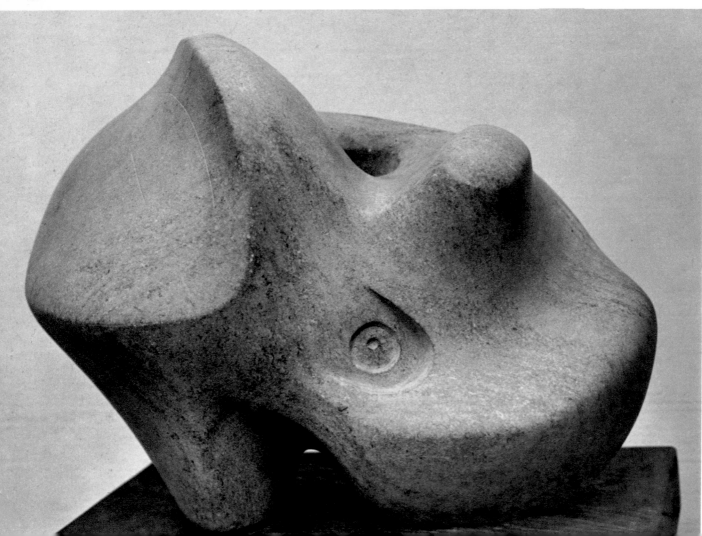

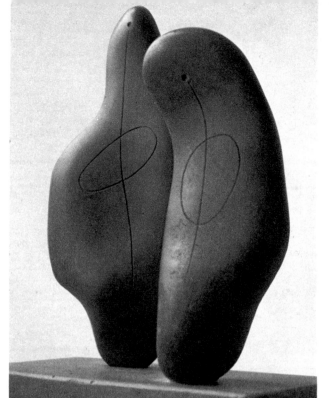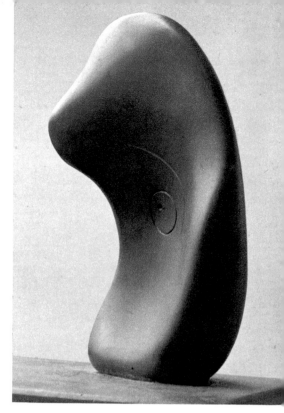

102

103

102 Two Forms · Deux formes · Zwei Formen · 1934 · H. 18.4 cm
103 Carving · Sculpture · Plastik · 1934 · H. 12.7 cm
104 Two Forms · Deux formes · Zwei Formen · 1934 · L. 53.4 cm

104

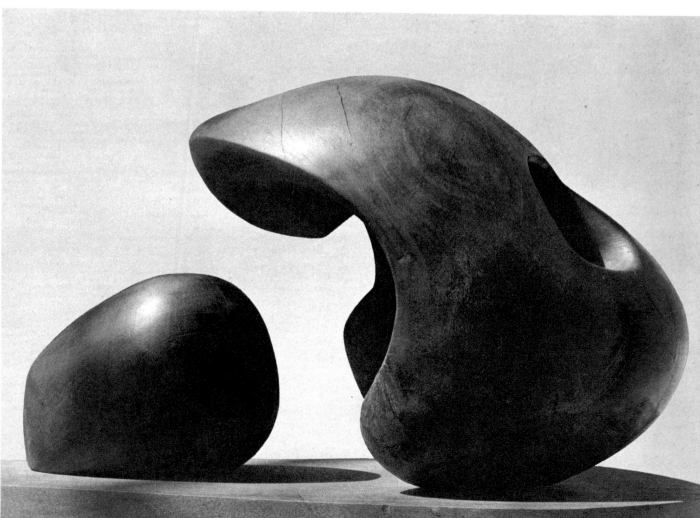

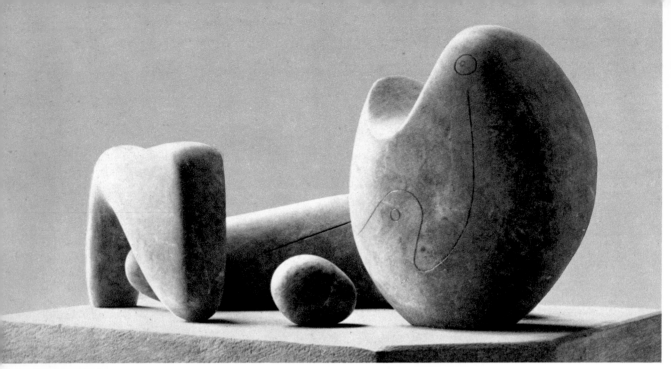

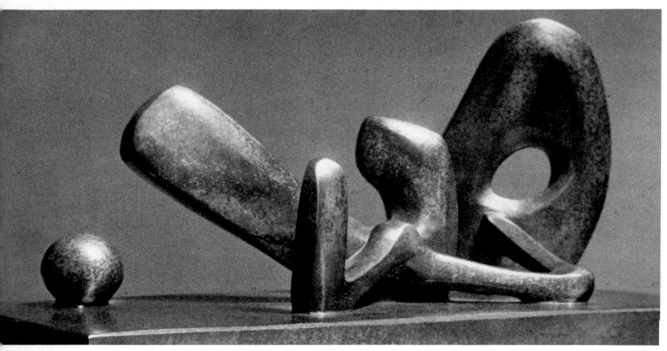

105 Four-piece Composition: Reclining Figure · Composition
en quatre pièces: figure couchée · Vierteilige Komposition:
Liegende Figur · 1934 · L. 50.8 cm

106 Composition · Composition · Komposition · 1934 · L. 44.5 cm

107 Bird and Egg · Oiseau et
oeuf · Vogel und Ei · 1934
L. 55.9 cm

108 Three Forms · Trois formes
Drei Formen · 1934 · H. 40.7 cm

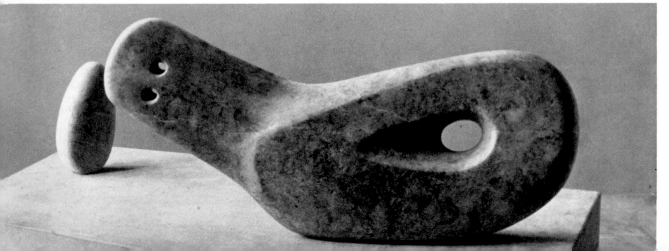

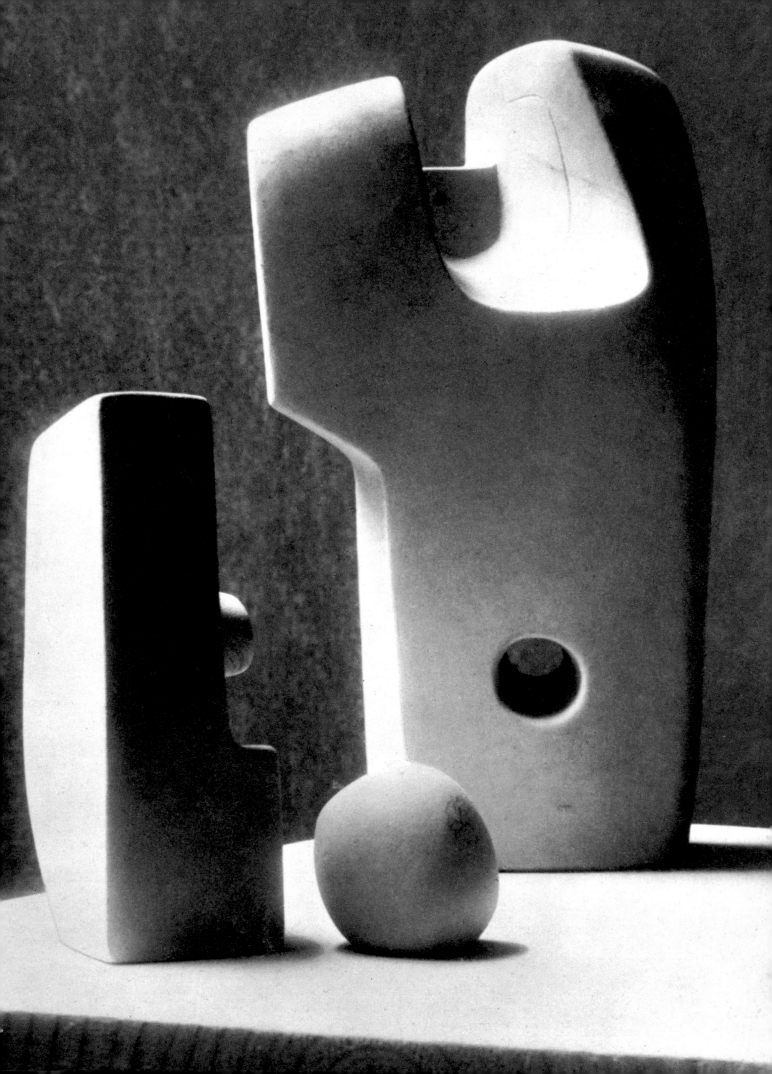

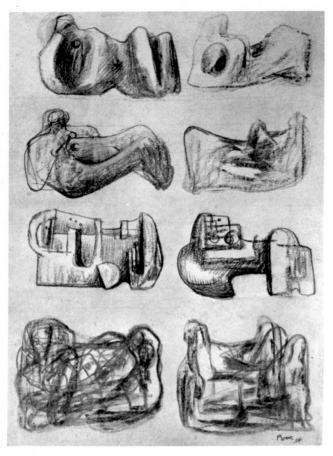

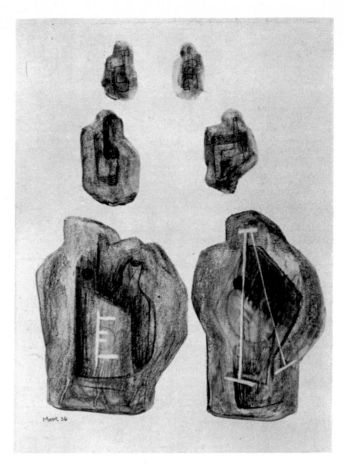

109 Study for Sculpture I · Etude pour une sculpture I
Studie für eine Plastik I · 1934

110 Stone Forms · Formes en pierre · Steinformen
1934

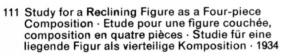
111 Study for a Reclining Figure as a Four-piece
Composition · Etude pour une figure couchée,
composition en quatre pièces · Studie für eine
liegende Figur als vierteilige Komposition · 1934

112 Ideas for Metal Sculpture · Idées pour sculptures
en métal · Skizzen zu Metallplastiken · 1934

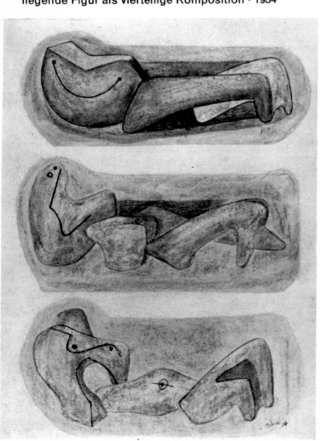

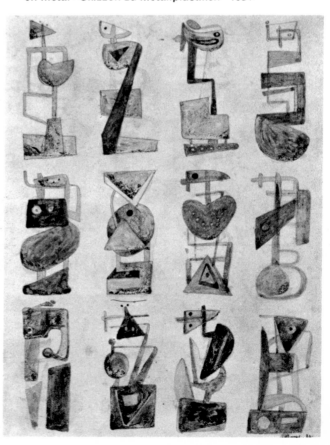

113

113 Ideas for Metal Sculpture · Idées
 pour sculptures en métal
 Skizzen zu Metallplastiken · 1934

114 Drawing for Sculpture: Bird Head
 Croquis pour une sculpture: tête
 d'oiseau · Zeichnung für eine
 Plastik: Vogelkopf · 1934

115 Seated Figure · Figure assise
 Sitzende Figur · 1934

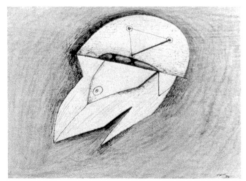

114

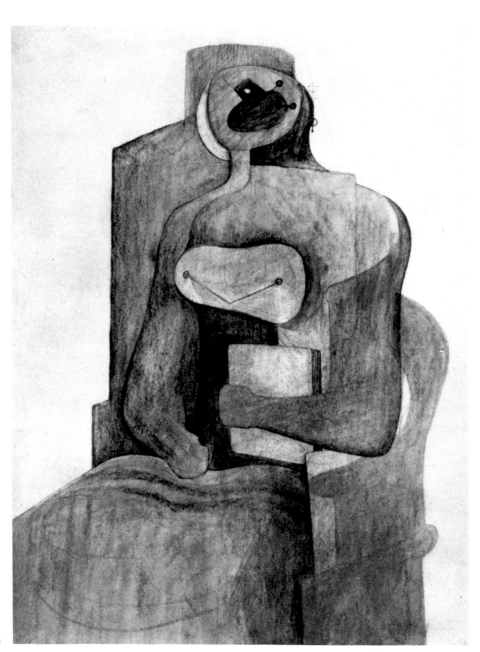

115

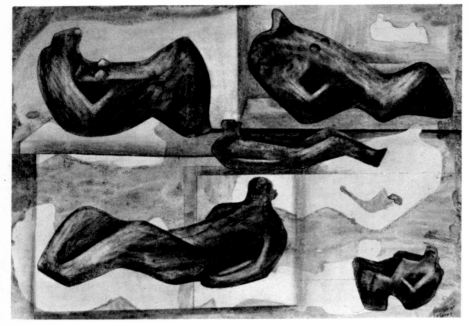

116

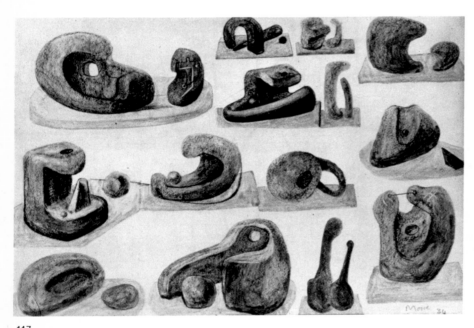

117

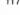

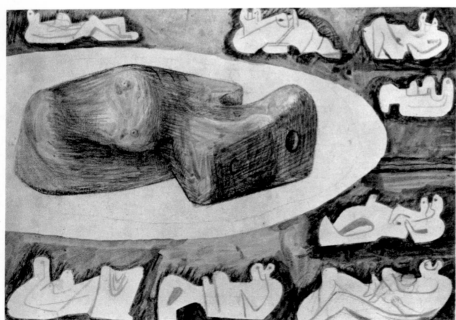

118

119

116 Recumbent Figures · Figures couchées
Liegende Figuren · 1934

117 Ideas for sculpture · Idées pour
sculptures · Skizzen zu
Plastiken · 1934

118 Study for Recumbent Figure · Etude
pour une figure couchée · Studie
für eine liegende Figur · 1934

119 Drawing for Sculpture · Dessin pour une
sculpture · Zeichnung für eine Plastik
1934

120 Ideas for Stone Seated Figures
Idées pour figures assises en
pierre · Skizzen zu sitzenden Figuren
aus Stein · 1934

121 Ideas for Sculpture · Idées pour
sculptures · Skizzen zu Plastiken · 1934

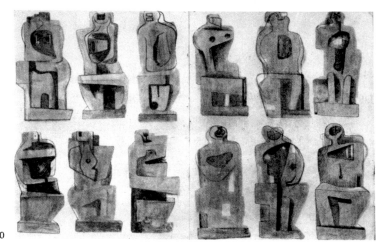

120

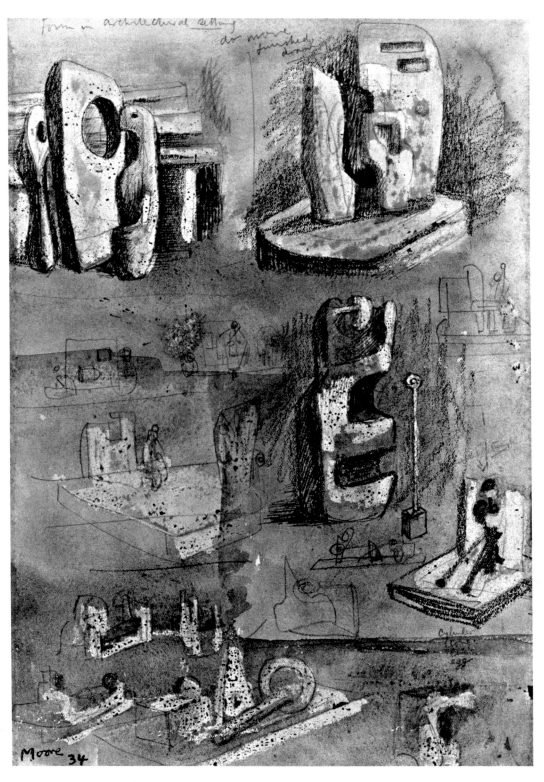

121

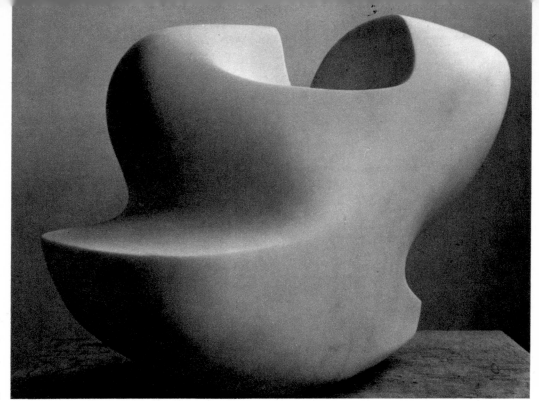

122

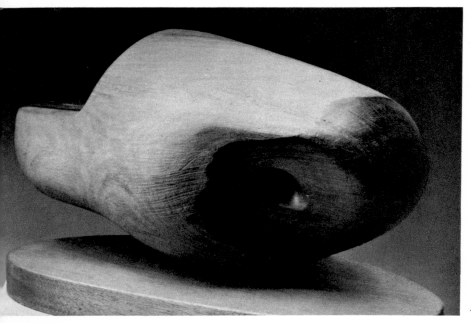

123

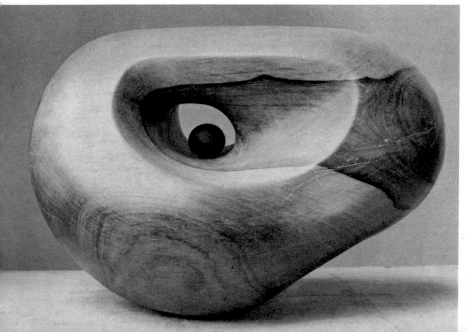

122 Sculpture · Sculpture · Plastik
1935 · L. 55.9 cm

123 Carving · Sculpture · Plastik
1935 · L. 40.7 cm

124 Carving · Sculpture · Plastik
1935 · L. 40.7 cm

125 Drawing · Dessin · Zeichnung
1934–35

126 Carving · Sculpture · Plastik
1935 · H. 34.3 cm

124

125

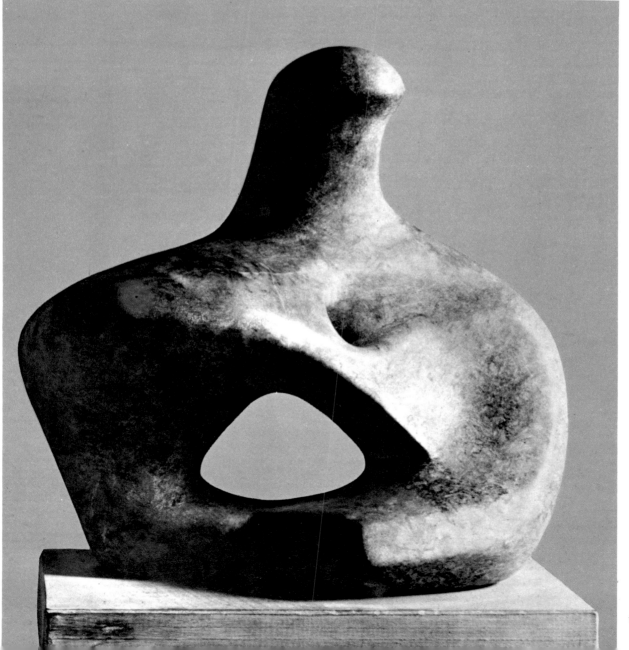

126

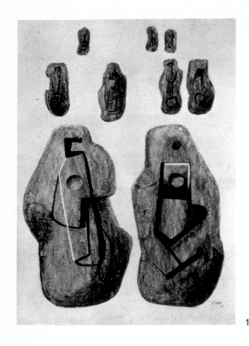

127

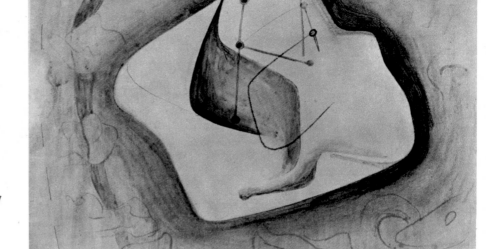

130

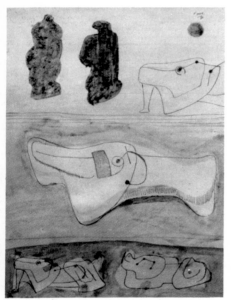

128

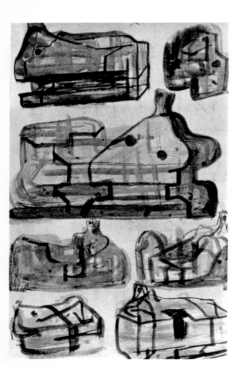

129

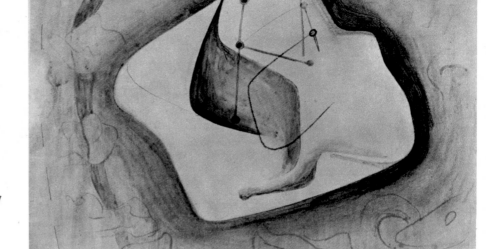

131

127 Ideas for Stone Carving · Idées pour
 sculptures en pierre · Skizzen zu
 Steinplastiken · 1934

128 Drawing · Dessin · Zeichnung · 1935

129 Drawing for Sculpture · Dessin pour
 une sculpture · Zeichnung für eine Plastik
 1935

130 Drawing · Dessin · Zeichnung · 1935

131 Drawing · Dessin · Zeichnung · 1935

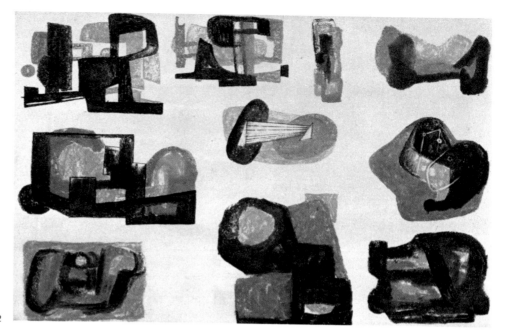

132

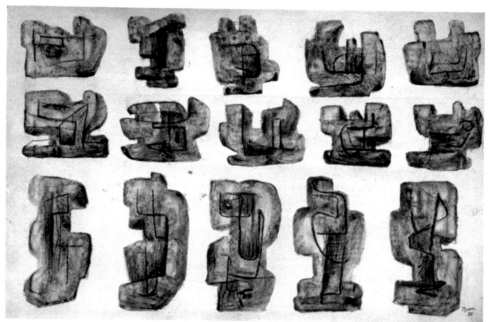

133

132 Drawing for Metal Sculpture
Dessin pour une sculpture
en métal · Zeichnung für
eine Metallplastik · 1935

133 Ideas for Stone Carving
Idées pour sculptures
en pierre · Skizzen
zu Steinplastiken · 1935

134 Drawing for Metal Sculpture
Dessin pour sculptures en
métal · Zeichnung für
Metallplastiken · 1935

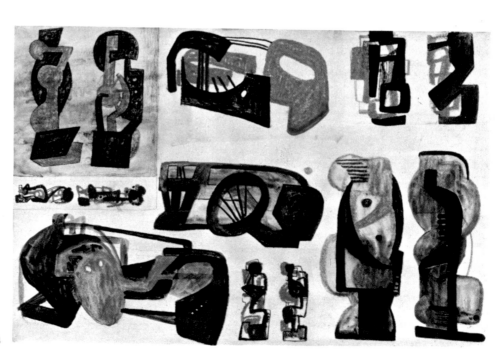

134

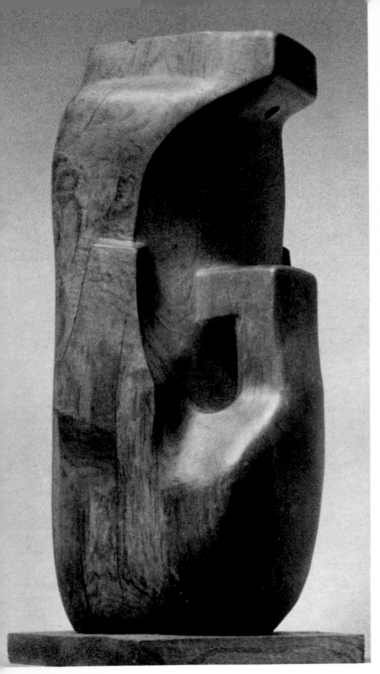

135

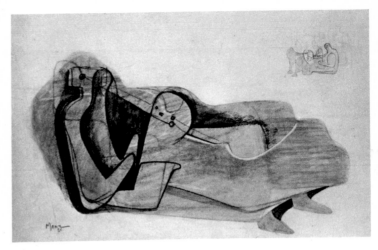

136

135 Carving · Sculpture · Plastik · 1935
 H. 96.5 cm

136 Reclining Figure · Figure couchée
 Liegende Figur · 1935

137 Reclining Figure · Figure couchée
 Liegende Figur · 1934–35

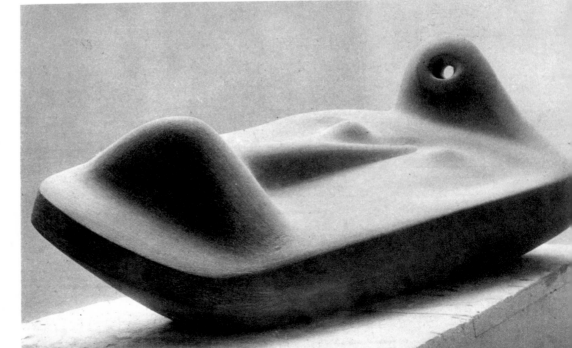

137

1936–1940

THIS IS THE PERIOD in which Moore's drawings began to disclose his interest in pictorial values. Forms intended as ideas for sculpture are situated in landscapes and interiors. Complex textural effects are obtained by the use of mixed media. The romantically sinister atmosphere of the settings highlights the Surrealist element in the sculptural objects made in this period and in the previous five years, but the sculptor himself declared that the quarrel between the Abstractionists and Surrealists was unnecessary. 'All good art,' he wrote, 'has contained both abstract and surrealist elements, just as it has contained both classical and romantic elements – order and surprise, intellect and imagination, the conscious and the unconscious.'

After seeing at the Science Museum some models which introduced coloured threads into mathematical configurations, Moore exploited their sculptural possibilities in a series of stringed figures made between 1937 and 1939. He considered them to be 'too much in the nature of experiments to be really satisfying', but time has not devalued them, and one of them, at least, is a masterpiece. It is called *Bird Basket (Pl. XIII)* and is carved out of a very hard wood with swirling grain. Many strands of blue twine are strung across the space between the strong, central arch and a lip of the outer wall, and another set of strings, coloured red, rays out from the knob-like form in the centre of the floor to be fastened to the two ends of the object which are described by Moore as a head and a tail. ('It's basically a bird.') The play between curvilinear grain and straight, taut twine, between the warm, plump, tranquil seatedness of the object and the flight of the strings is quite magical. The drastic excavation of the interior of the block seems to have coincided with the major operation performed on the *Reclining Figure* in Elm wood *(202–3)*.

Moore had established a Department of Sculpture at Chelsea School of Art in 1932, and until 1939 was teaching there two days a week,

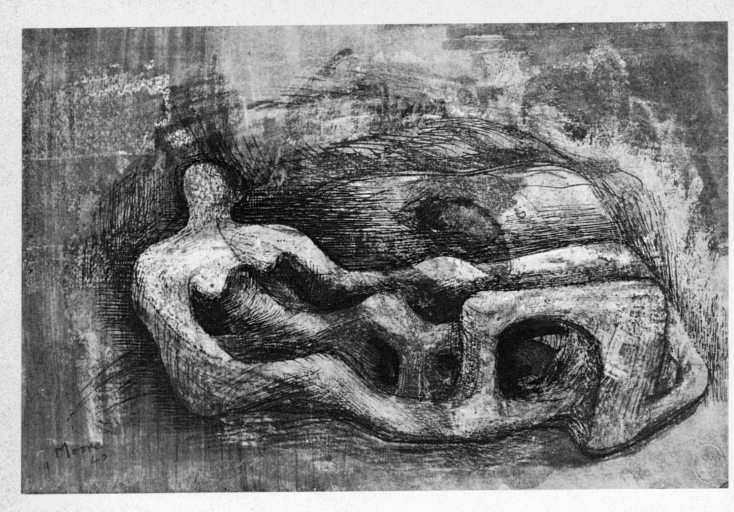

XI Study for a Reclining Figure in Wood, 1940

but he gave up teaching for good when the School was evacuated in the early days of the war. In 1940, the sale of the Elm wood *Reclining Figure* to the Surrealist painter Gordon Onslow-Ford enabled him to buy the house in Hertfordshire where he still lives. He was appointed an official war artist in the same year, and in September began to make the shelter drawings which were to be his chief preoccupation throughout 1941.

138 Mother and Child · Mère et enfant
Mutter und Kind · 1936 · H. 1.14 m
139 Head · Tête · Kopf · 1936 · H. 26.7 cm

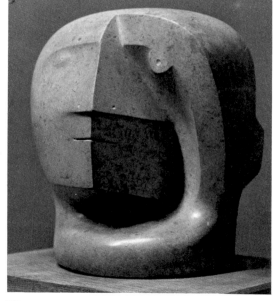

139

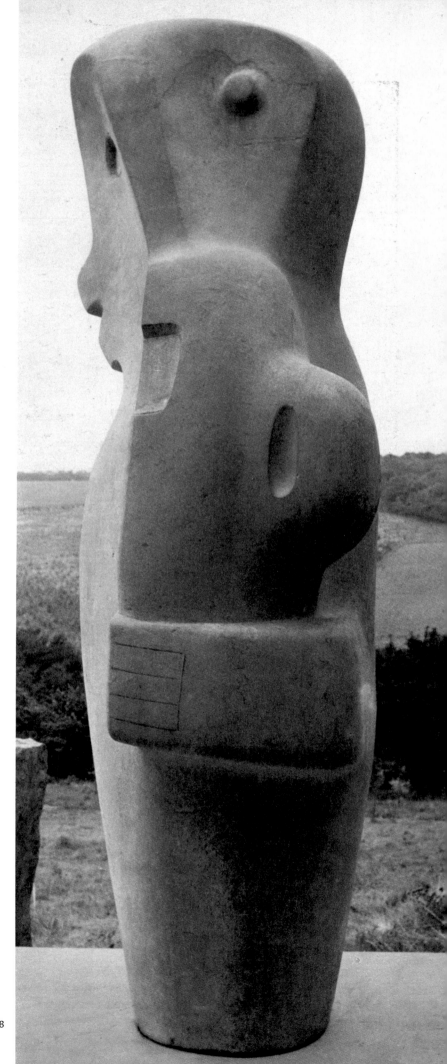

138

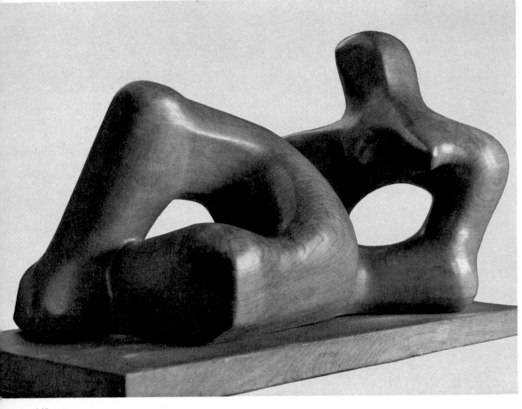

143

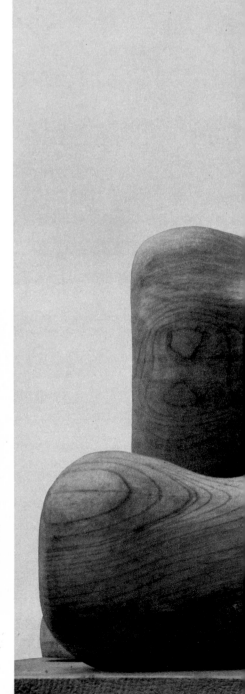

140

140 Reclining Figure · Figure couchée · Liegende Figur · 1936 · L. 1.07 m

141 Reclining Figure · Figure couchée · Liegende Figur · 1935–36 · L. 88.9 cm

142 Four Forms · Quatre formes · Vier Formen · 1936 · L. 55.9 cm

143 Another view of Plate 141 · Autre vue de la fig. 141 · Andere Ansicht von Abb. 141

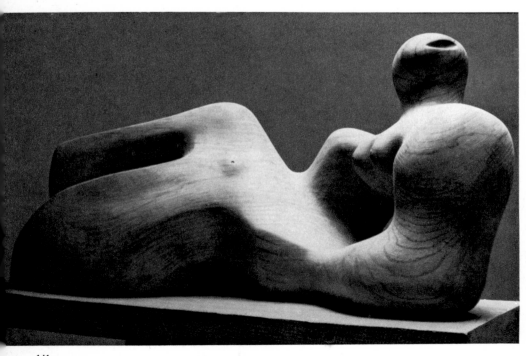

141

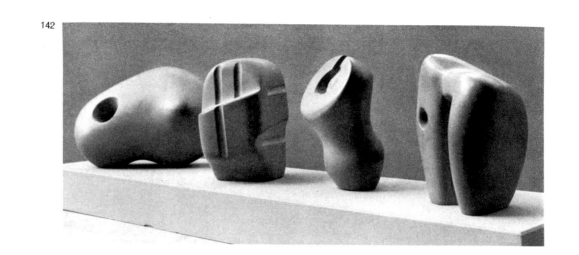

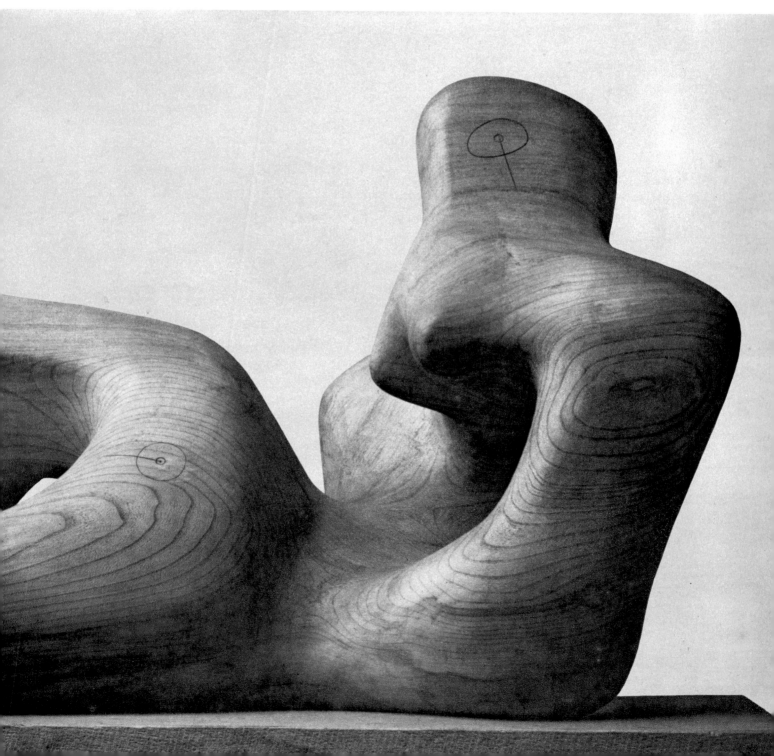

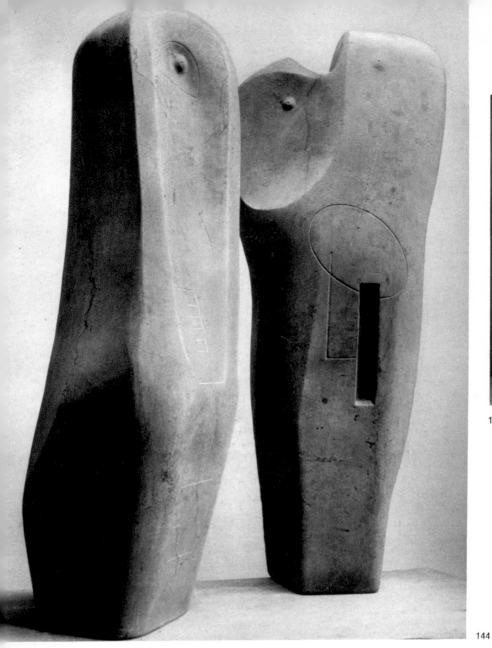

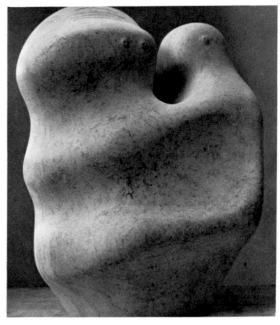

145

144

146

147

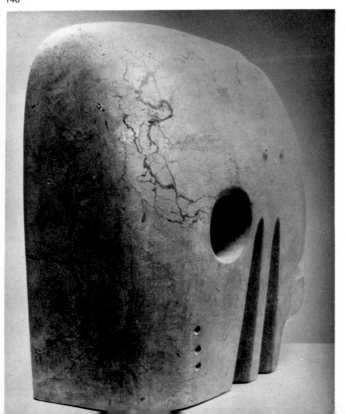

144 Two Forms · Deux formes · Zwei Formen
1936 · H. 1.07 m

145 Mother and Child · Mère et enfant
Mutter und Kind · 1936 · H. 50.8 cm

146 Square Form · Forme carrée · Rechteckige
Form · 1936 · L. 53.4 cm

147 Carving · Sculpture · Plastik · 1936
H. 45.7 cm

148 Stones in Landscape · Pierres dans un
paysage · Steine in einer Landschaft
1936

149 Carving · Sculpture · Plastik · 1936
L. 50.8 cm

150 Carving · Sculpture · Plastik · 1936
L. 50.8 cm

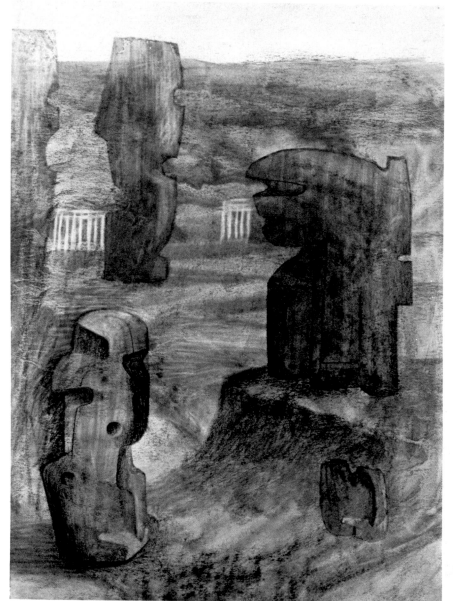

148

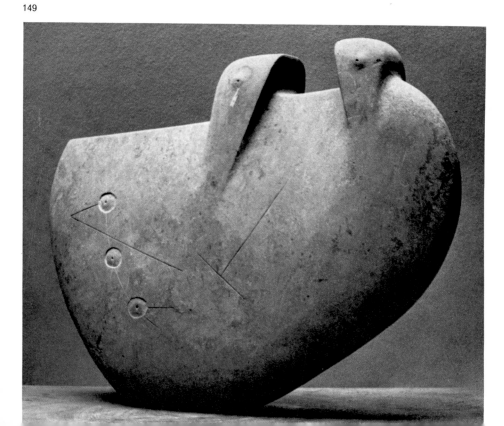

149

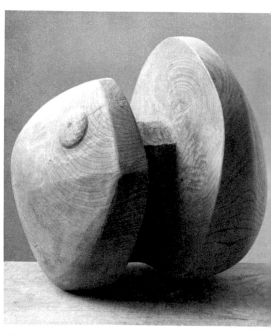

150

151

154

152

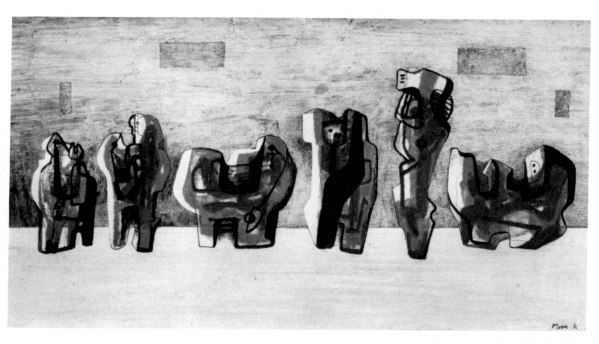

153

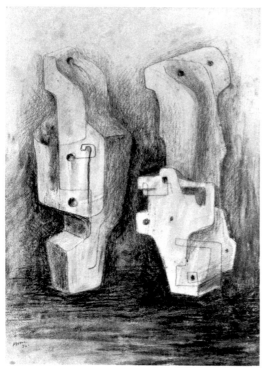

155

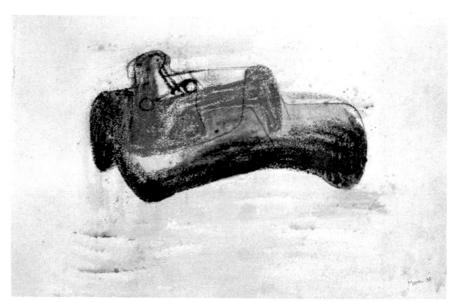

156

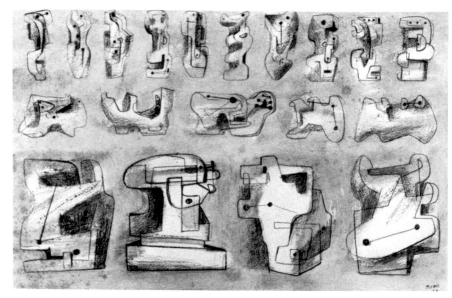

157

158

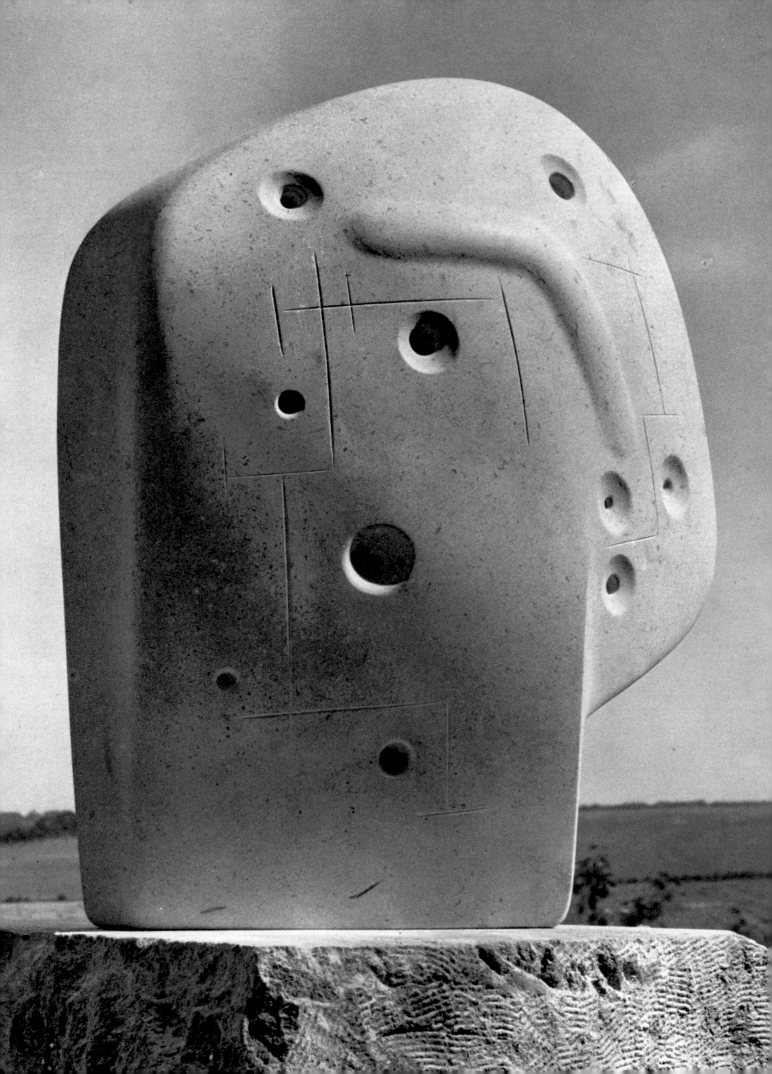

159

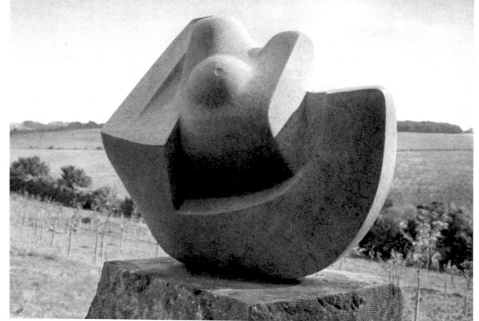

160

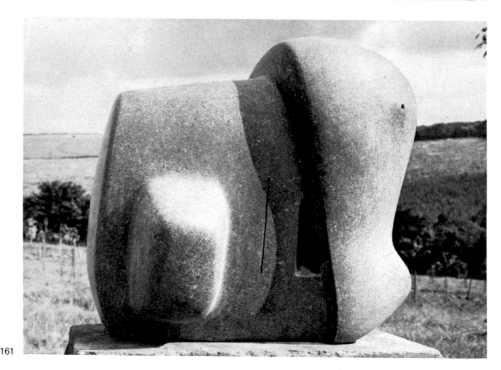

159 Head · Tête · Kopf · 1937
H. 53.4 cm

160 Sculpture · Sculpture
Plastik · 1937 · L. 50.8 cm

161 Figure · Figure · Figur
1937 · H. 50.8 cm

162 Reclining Figure · Figure
couchée · Liegende Figur
1937 · L. 83.8 cm

161

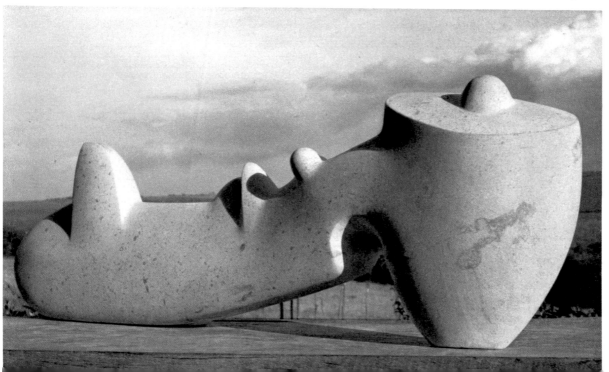

162

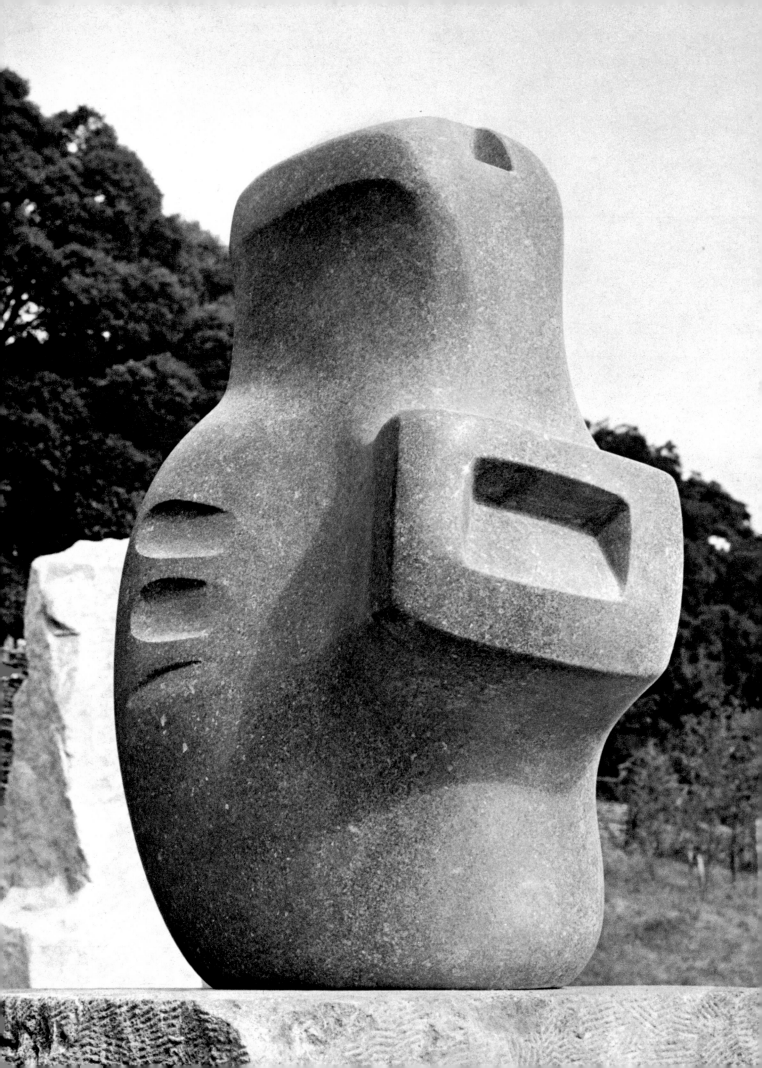

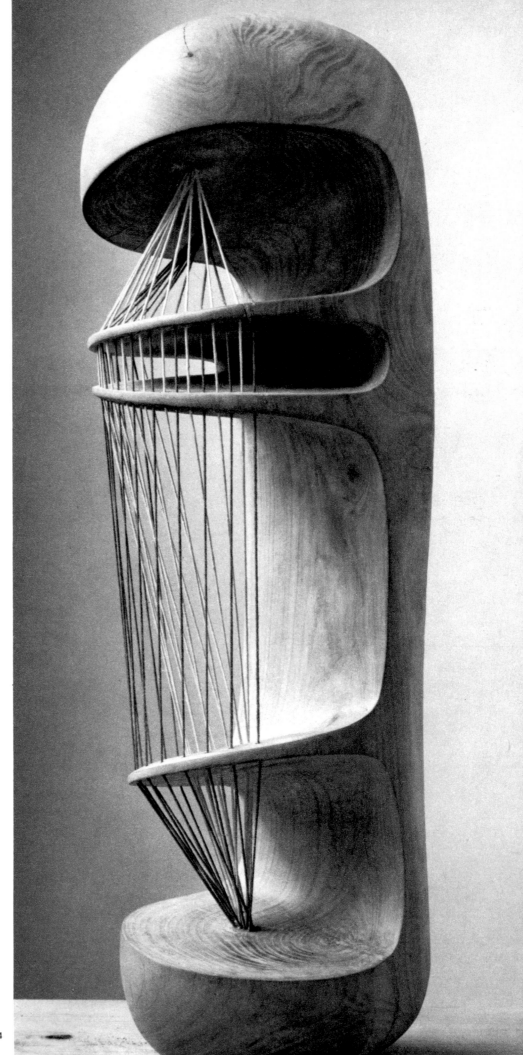

163 Figure · Figure · Figur
1937 · H. 50.8 cm

164 Stringed Figure No. 1
Sujet en ficelle nº 1
Saitenfigur Nr. 1
1937 · H. 50.8 cm

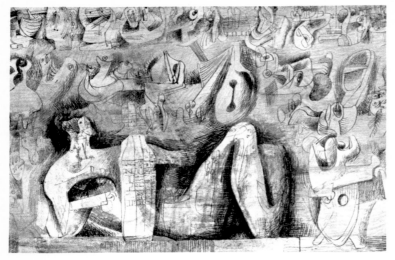

165

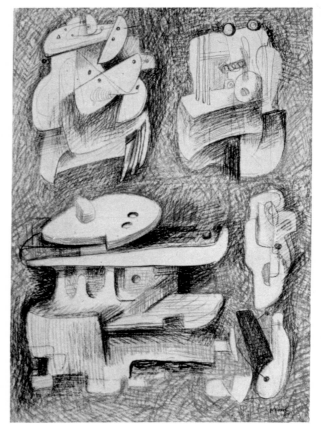

168

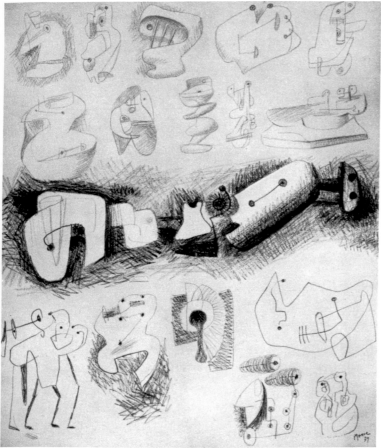

166

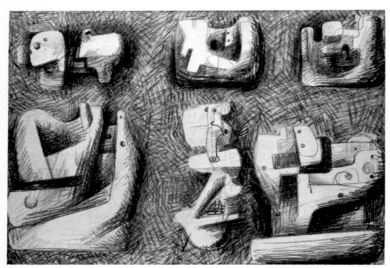

167

165 Reclining Figure and Ideas for Sculpture
Figure couchée et idées pour sculptures
Liegende Figur und Skizzen zu Plastiken · 1937

166 Ideas for Sculpture · Idées pour sculptures
Skizzen zu Plastiken · 1937

167 Drawing · Dessin · Zeichnung · 1938

168 Ideas for Sculpture · Idées pour sculptures
Skizzen zu Plastiken · 1937

169 Drawing · Dessin · Zeichnung · 1937

170 Drawing · Dessin · Zeichnung · 1937

171 Ideas for Metal Sculpture · Idées pour
sculptures en métal · Skizzen zu
Metallplastiken · 1937

172 Drawing for Metal Sculpture · Dessin pour
une sculpture en métal · Zeichnung für eine
Metallplastik · 1937

173 Drawing for Stone Sculpture · Dessin pour
une sculpture en pierre · Zeichnung für eine
Steinplastik · 1937

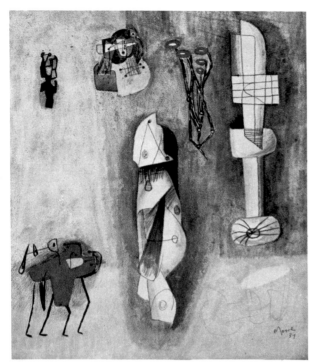

169

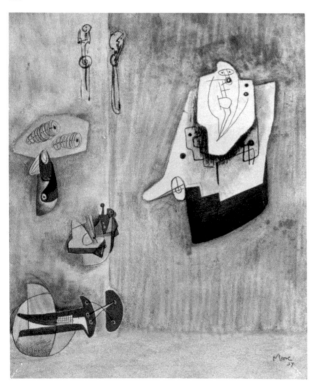

170

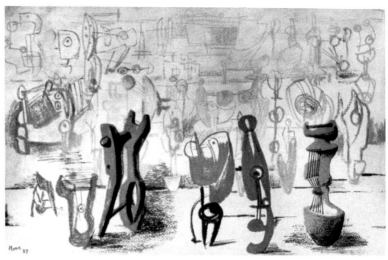

171

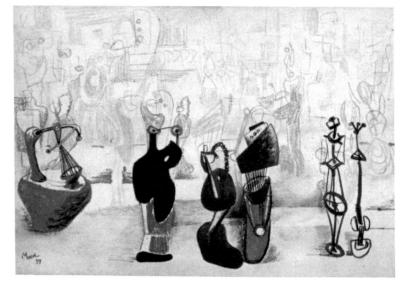

172

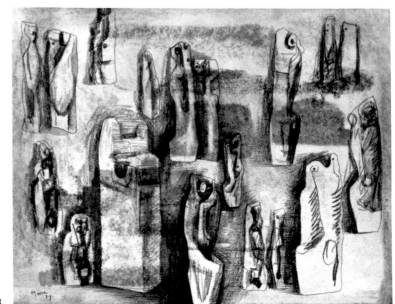

173

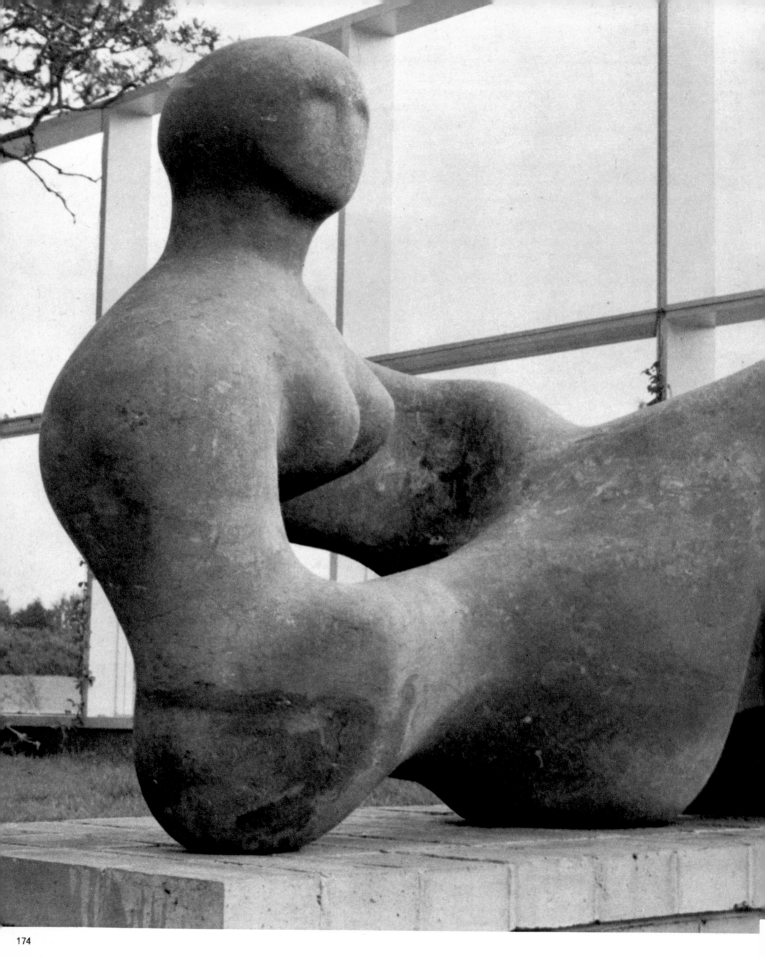

174 Recumbent Figure · Figure couchée · Liegende Figur · 1938 · L. 1.40 m
175 Mother and Child · Mère et enfant · Mutter und Kind · 1938 · H. 91.4 cm

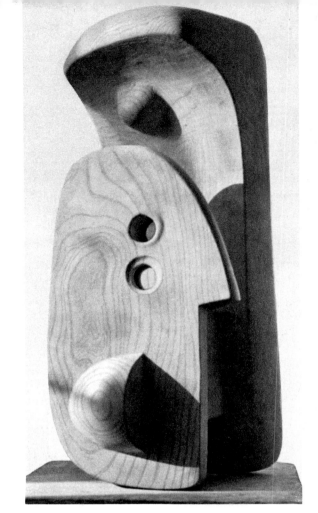

175

176

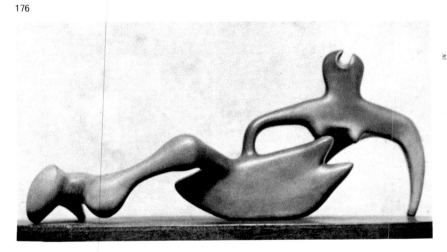

176 Reclining Figure · Figure couchée
Liegende Figur · 1938 · L. 33.0 cm

177 Reclining Figure · Figure couchée
Liegende Figur · 1938 · L. 14.0 cm

177

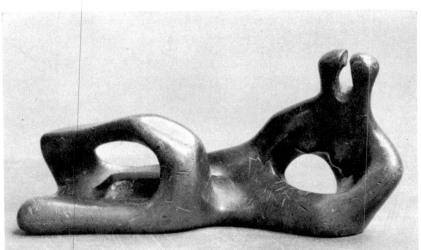

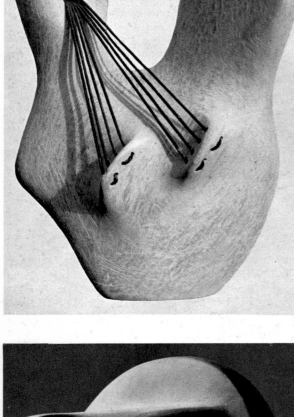

178 Mother and Child · Mère et enfant
Mutter und Kind · 1938 · H. 12.7 cm

179 Head · Tête · Kopf · 1938 · H. 20.3 cm

180 Stringed Figure · Sujet en ficelle
Saitenfigur · 1938 · L. 15.2 cm

181 Stringed figure No. 4 · Sujet en
ficelle nº 4 · Saitenfigur
Nr. 4 · 1938 · H. 38.6 cm

181

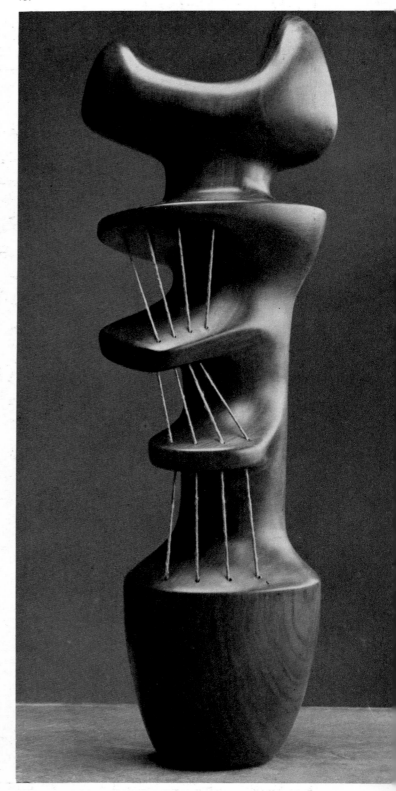

178

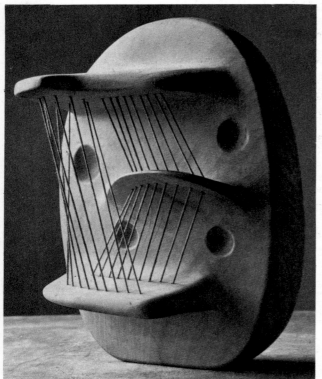

179

180

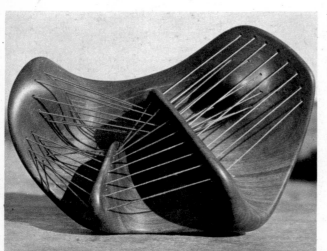

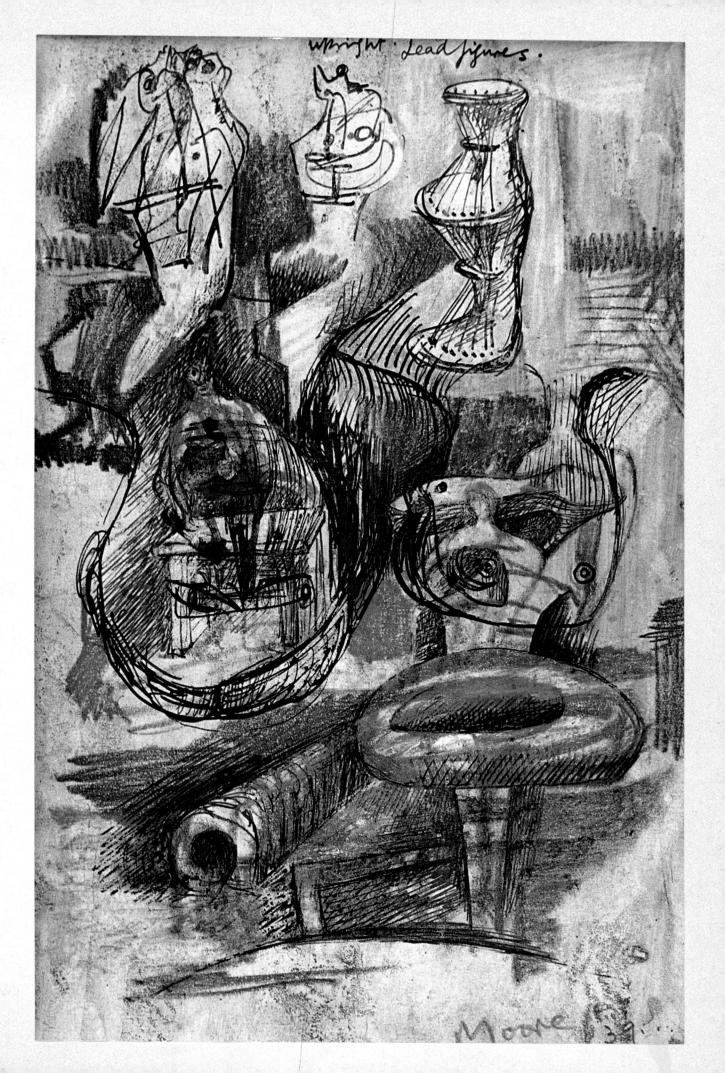

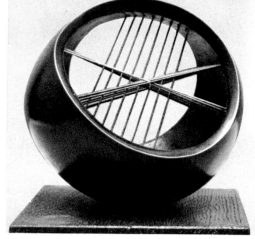

182 Stringed Ball · Boule en ficelle
Saitenkugel · 1939 · H. 8.9 cm

183 Ideas for Sculpture · Idées pour
sculptures · Skizzen zu Plastiken · 1938

182

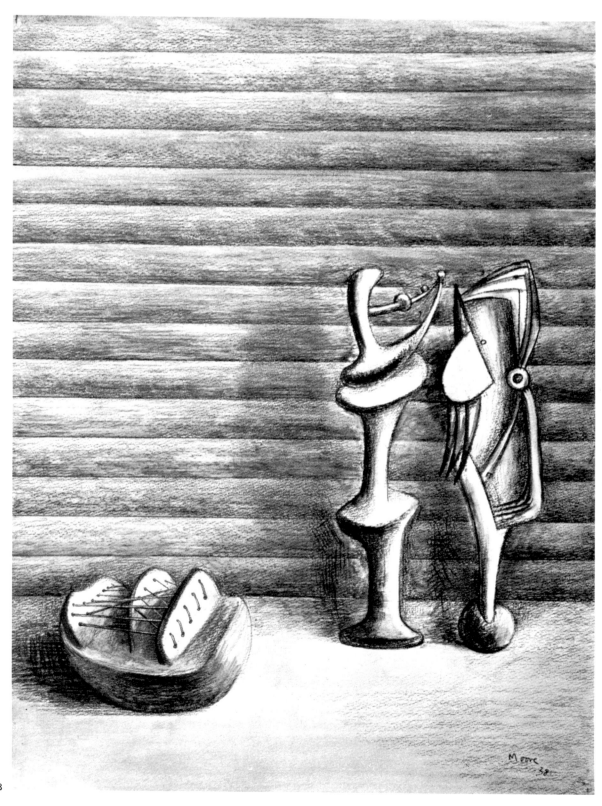

183

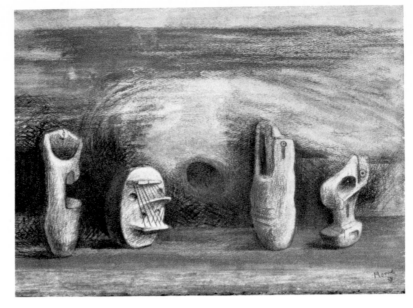

184

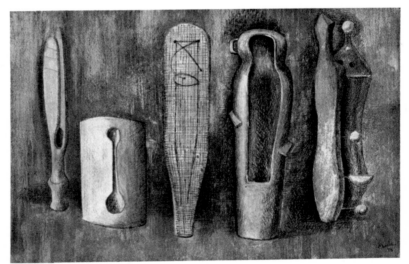

185

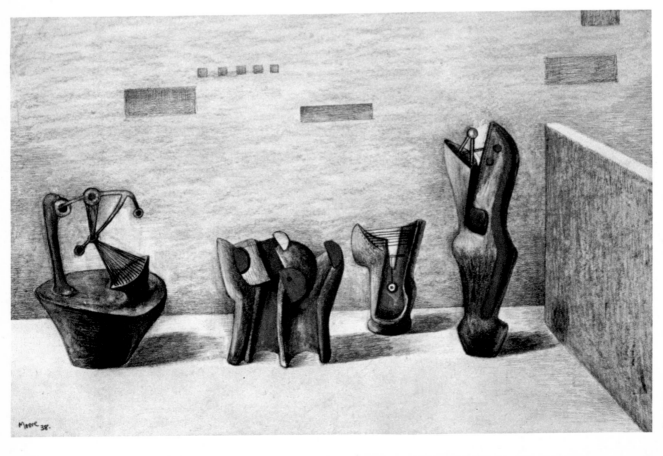

186

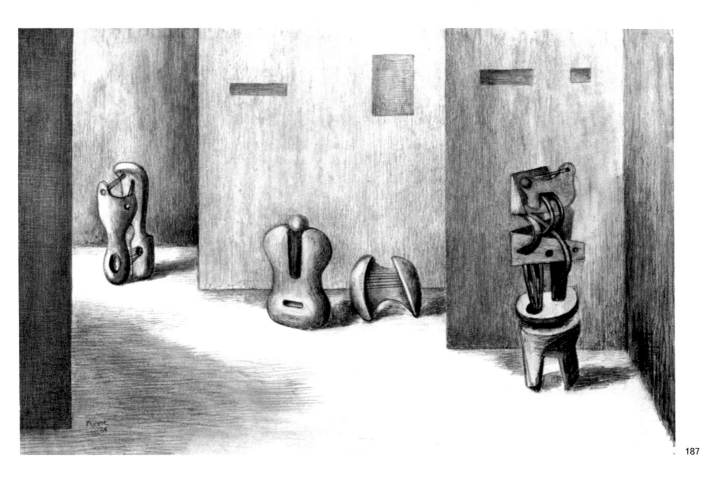

187

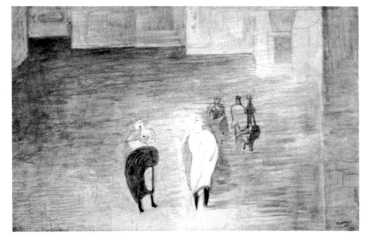

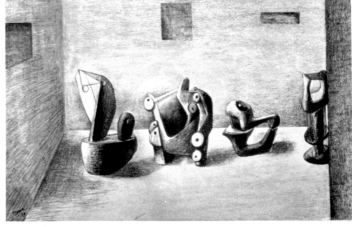

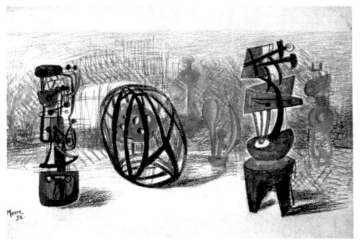

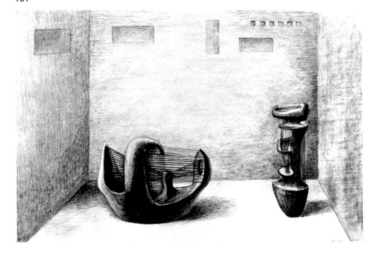

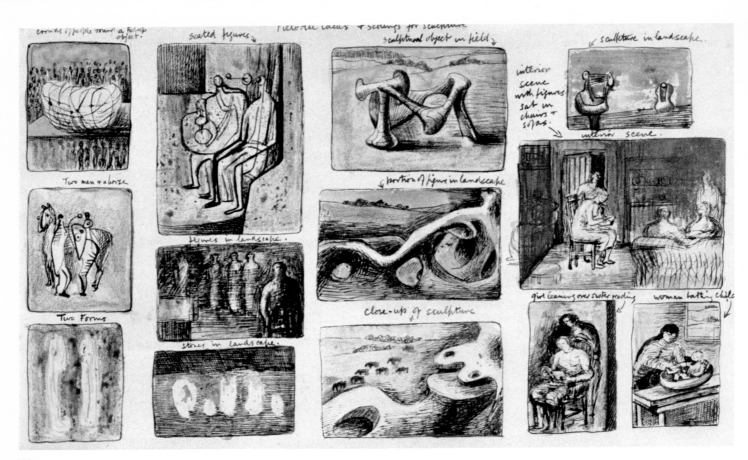

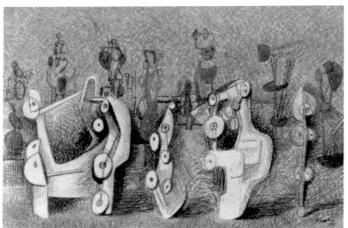

193

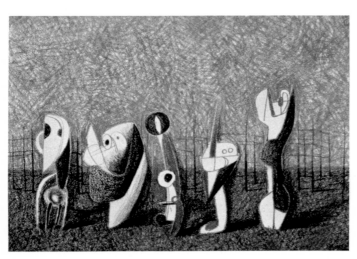

194

192 Pictorial Ideas · Idées picturales
Bildskizzen · 1938

193 Mechanisms · Mécanismes
Mechanismen · 1938

194 Five Metal Forms · Cinq formes en
métal · Fünf Metallformen · 1938

195 Project for Relief Sculptures · Projet
de panneaux en relief · Entwurf für
Reliefplastiken · 1938

196 Drawing · Dessin · Zeichnung · 1938

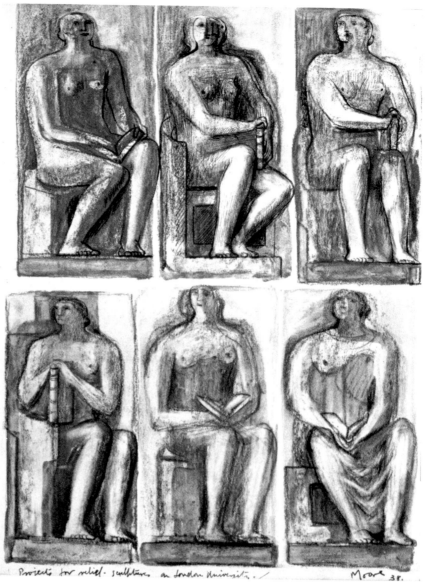

195 Projects for relief sculptures on London University. Moore 38.

196

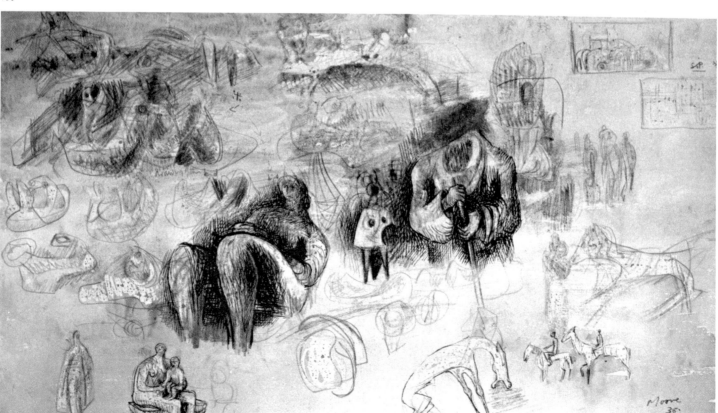

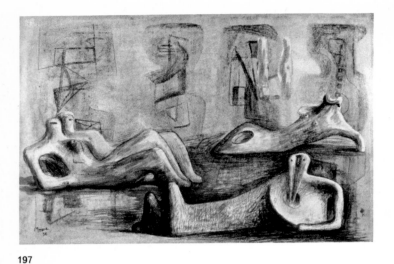

197

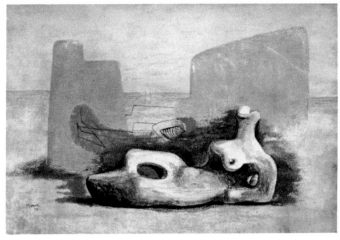

198

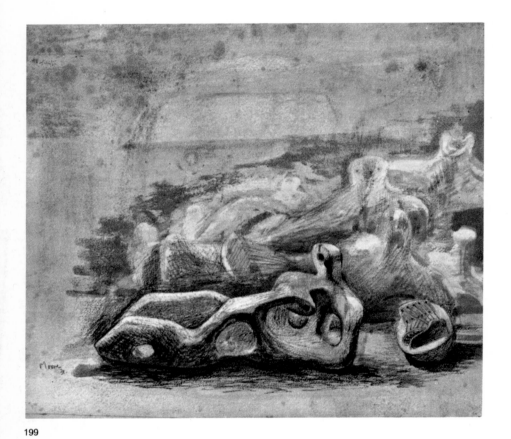

199

197 Drawing · Dessin · Zeichnung
1938

198 Project for Figure in Lead
Projet de figure en plomb
Entwurf für eine Bleifigur
1938

199 Landscape with Figures · Paysage
avec figures · Landschaft mit
Figuren · 1938

200 Reclining Figure · Figure couchée
Liegende Figur · 1938

201 Ideas for Metal Sculpture
Idées pour sculptures en métal
Skizzen zu Metallplastiken · 1938

202-203 Reclining Figure · Figure
couchée · Liegende Figur · 1939
L. 2.08 m

200

201

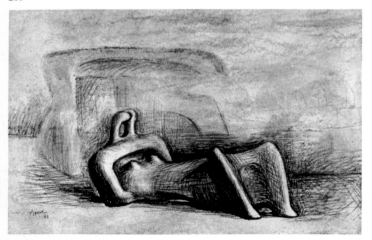

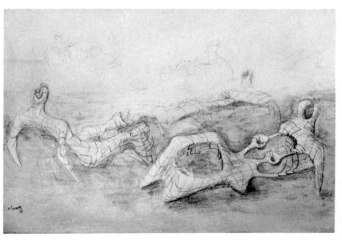

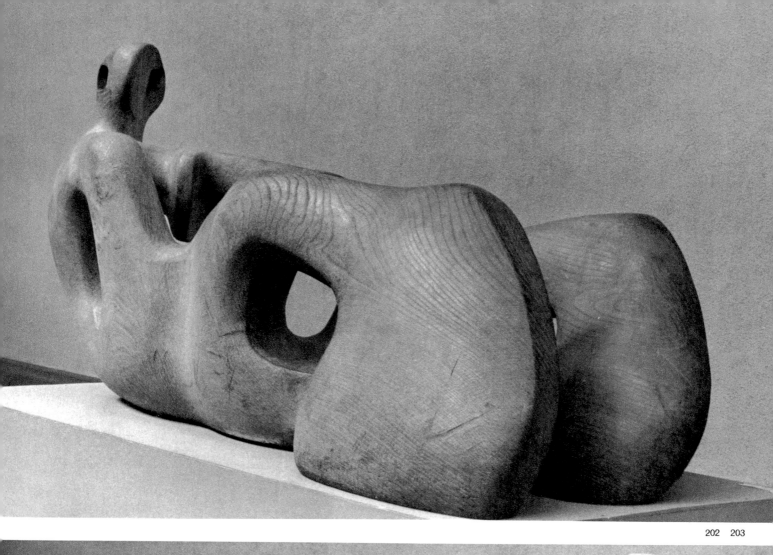

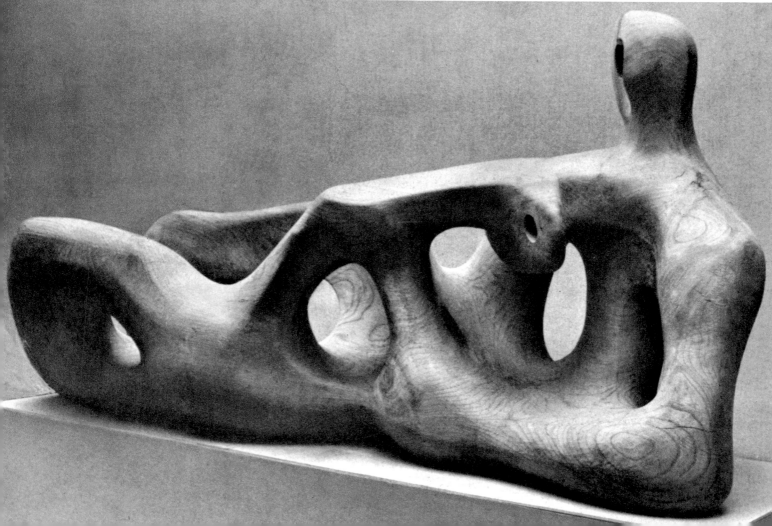

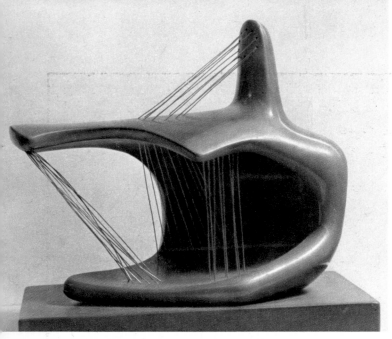

204

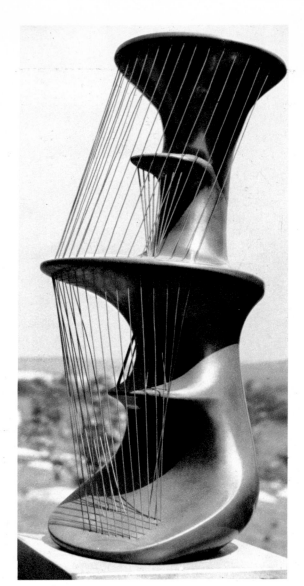

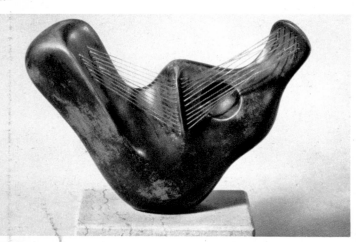

205

206

207

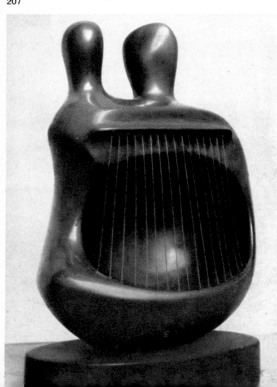

208

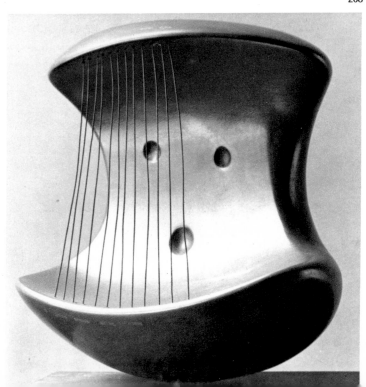

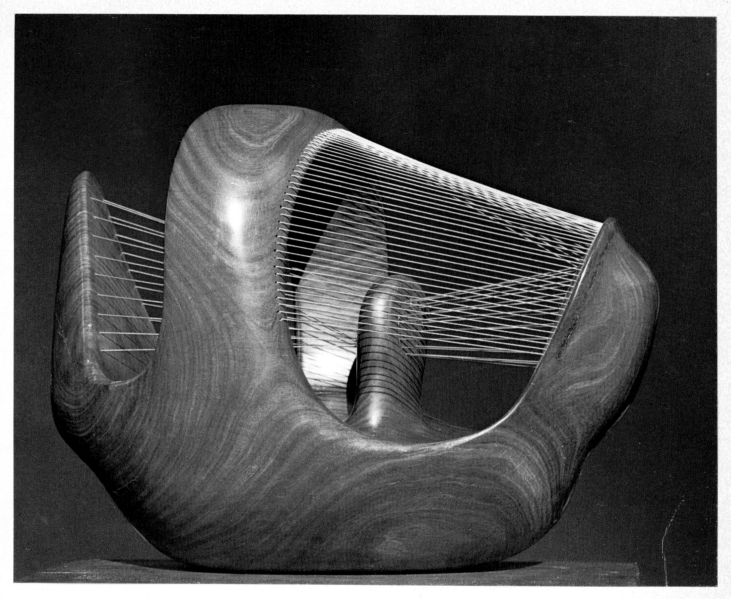

XIII Bird Basket, 1939. L. 41.9 cm

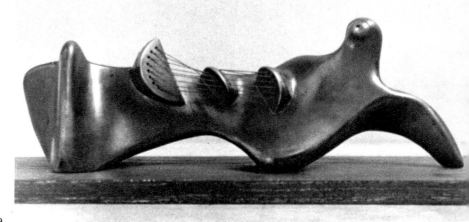

209

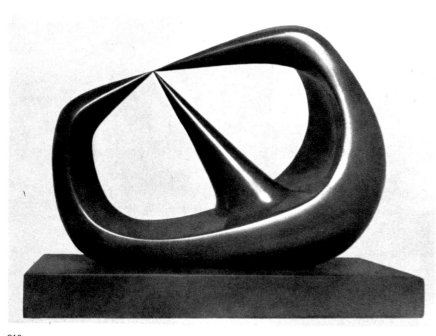

210

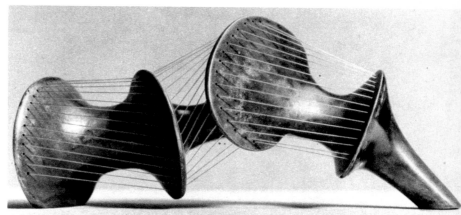

211

209 Stringed Reclining Figure
Figure couchée en ficelle
Liegende Saitenfigur
1939 · H. 28.6 cm

210 Three Points · Trois pointes
Drei Spitzen · 1939–40
L. 19.1 cm

211–12 Stringed Figure · Sujet
en ficelle · Saitenfigur
1939 · L. 25.4 cm

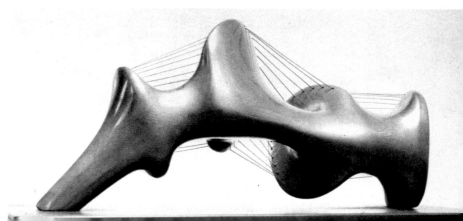

212

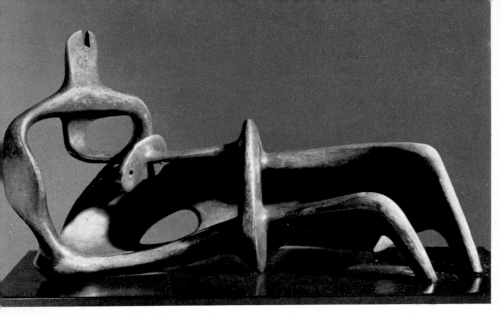

213

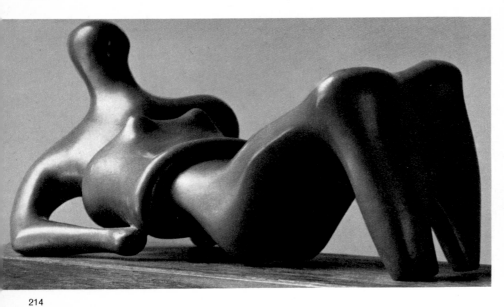

214

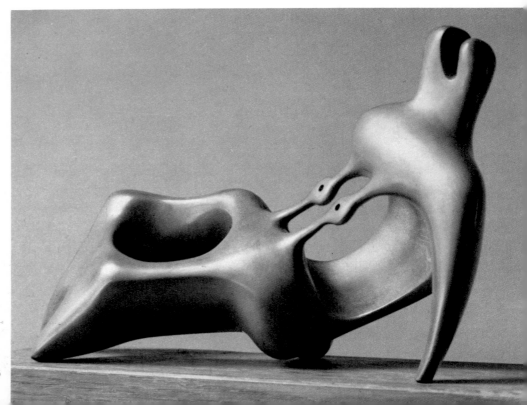

216

213 Reclining Figure · Figure
 couchée . Liegende Figur
 1939 · L. 33.0 cm

214 Reclining figure · Figure
 couchée · Liegende Figur
 1939 · L. 22.9 cm

215 Reclining Figure · Figure
 couchée · Liegende Figur
 1939 · L. 25.4 cm

216 Ideas for Sculpture in Metal
 Idées pour sculptures en
 métal · Skizzen zu Metall-
 plastiken · 1939

217 Reclining Figure · Figure
 couchée · Liegende Figur
 1939 . L. 29.9 cm

215

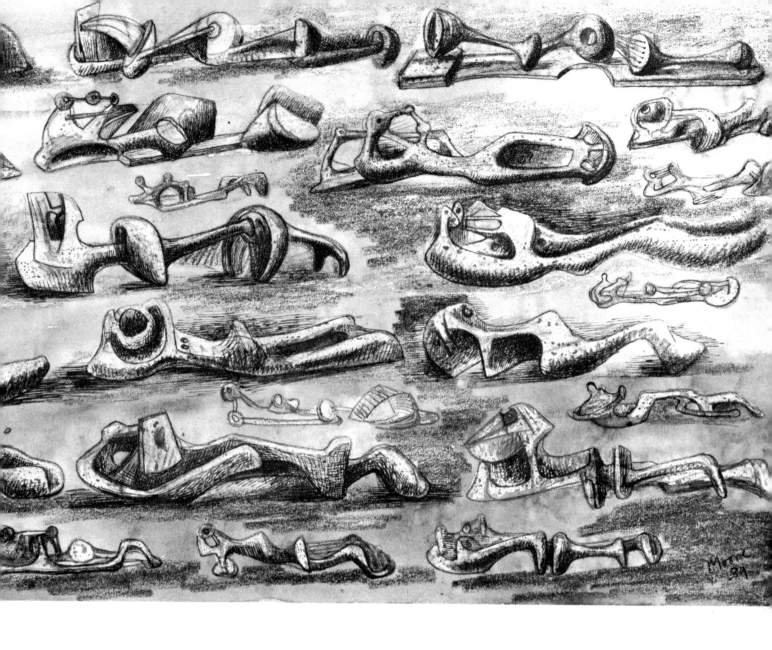

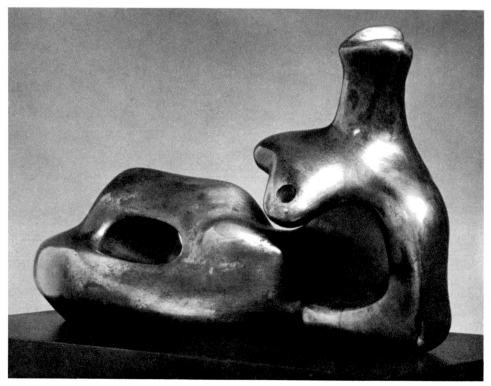

217

218

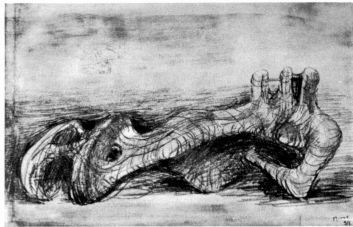

222

219

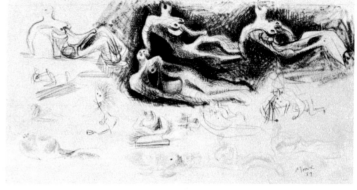

223

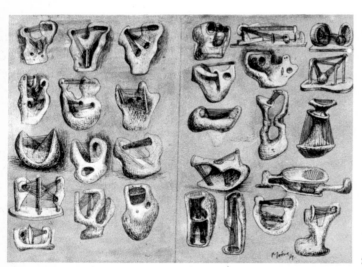

221

220

218 Ideas for Sculpture · Idées pour sculptures
Skizzen zu Plastiken · 1939

219 Reclining Figures · Figures couchées
Liegende Figuren · 1939

220 Ideas for Metal and Wire Sculpture
Idées pour sculptures en métal et en
fil de fer · Skizzen zu Metall-
und Drahtplastiken · 1939

221 Reclining Figures · Figures couchées
Liegende Figuren · 1939

222 Study for a Reclining Figure in Wood
Etude pour une figure couchée en bois
Studie für eine liegende Holzfigur · 1939

223 Drawing for Sculpture · Dessin pour une
sculpture · Zeichnung für eine Plastik · 1939

224 Reclining Figures · Figures couchées
Liegende Figuren · 1939

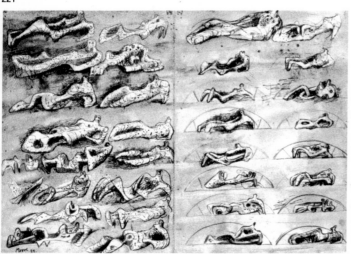

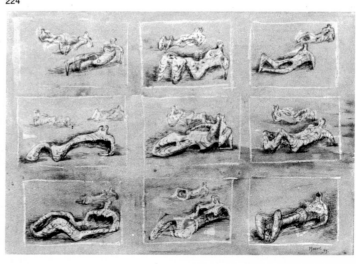

224

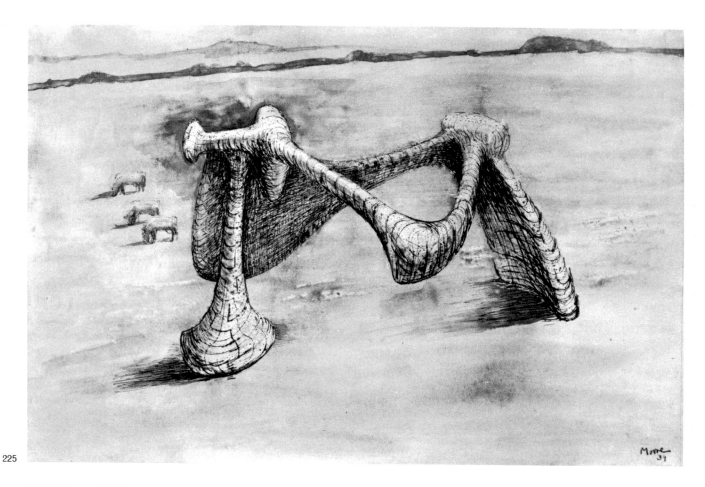

225

225 Sculptural object in Landscape · Objet sculptural dans un paysage
Skulptur in einer Landschaft · 1939

226 Figures in a Setting · Figures dans un site
Figuren vor einem Hintergrund · 1939

226

227

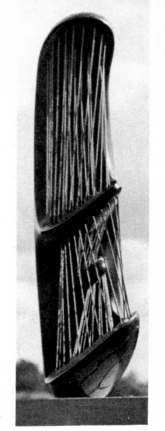

228

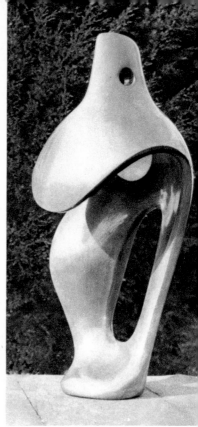

229

230

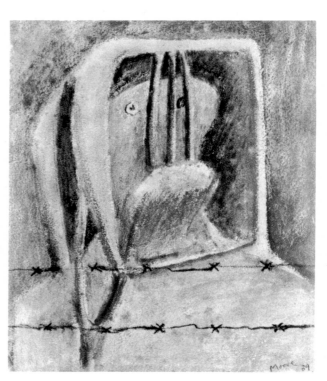

231

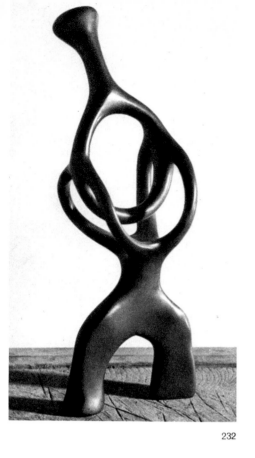

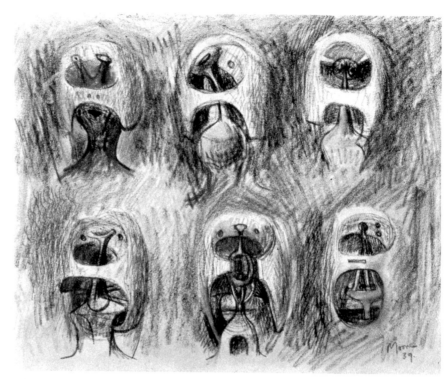

232 233

227 Two Women · Deux femmes · Zwei
 Frauen · 1939

228 Stringed Figure · Sujet en ficelle
 Saitenfigur · 1939 · H. 22.9 cm

229 Figure · Figure · Figur · 1939
 H. 40.7 cm

230 Heads · Têtes · Köpfe · 1939

231 Drawing: Sketch for Lithograph
 Dessin: croquis pour une
 lithographie · Zeichnung:
 Skizze für eine Lithographie · 1939

232 Interior Figure · Figure Intérieure
 Innenfigur · 1940 · H. 26.7 cm

233 Heads: Drawing for Metal Sculpture
 Têtes: dessin pour une sculpture
 en métal · Köpfe: Zeichnung für
 eine Metallplastik · 1939

234 The Helmet · Le casque · Der Helm
 1940 · H. 29.2 cm

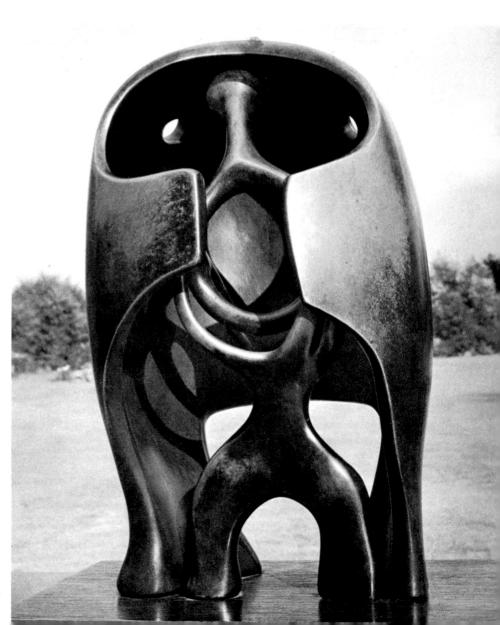

234

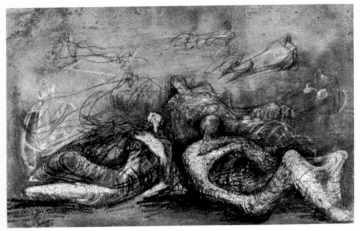

235

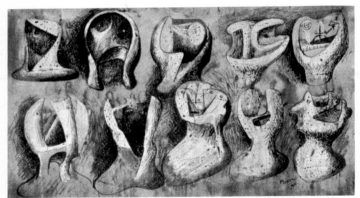

236

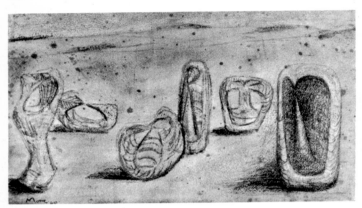

237

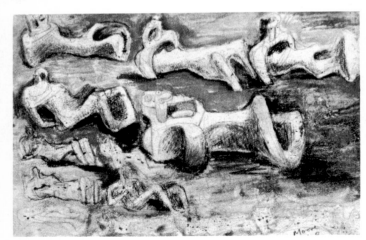

238

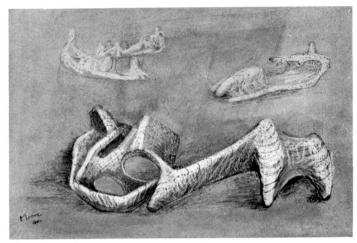

239

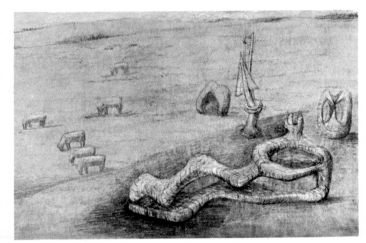

240

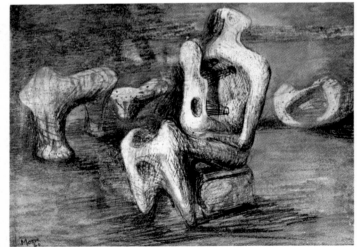

241

235 Reclining Figures · Figures couchées
Liegende Figuren · 1940

236 Pointed Forms · Formes pointues
Spitze Formen · 1940

237 Heads: Drawing for Sculpture · Têtes:
Dessin pour une sculpture · Köpfe:
Zeichnung für eine Plastik · 1940

238 Reclining Figures · Figures couchées
Liegende Figuren · 1940

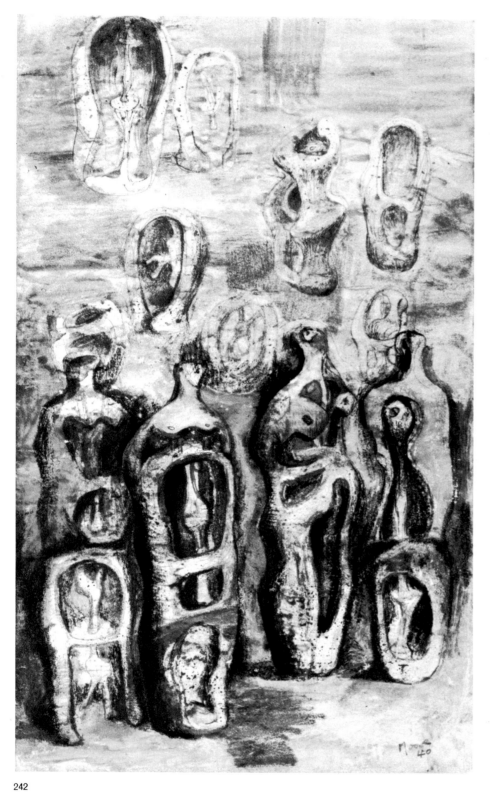

242

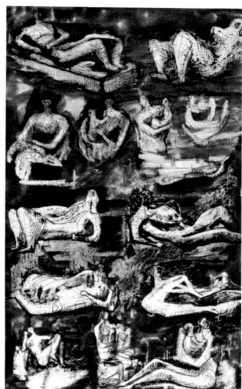

243

239 Reclining Figures · Figures couchées · Liegende Figuren · 1940

240 Sculpture in Landscape · Sculptures dans un paysage · Plastiken in einer Landschaft · 1940

241 Mother and Child · Mère et enfant · Mutter und Kind · 1940

242 Standing Figures · Figures debout · Stehende Figuren · 1940

243 Ideas for Sculpture · Idées pour sculptures · Skizzen zu Plastiken · 1940

244 Seated Figure and Pointed Forms · Figure assise et formes pointues Sitzende Figur und spitze Formen · 1939

244

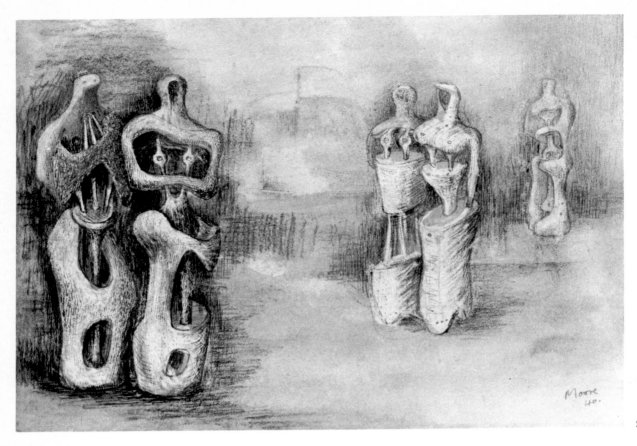

245

245 Standing Figures · Figures debout
Stehende Figuren · 1940

246 Three Women with a Child · Trois
femmes avec un enfant · Drei
Frauen mit einem Kind · 1940

247 Two Standing Figures · Deux figures
debout · Zwei stehende Figuren · 1940

248 Two Women and a Child · Deux
femmes et enfant · Zwei
Frauen mit einem Kind · 1940

246

247 248

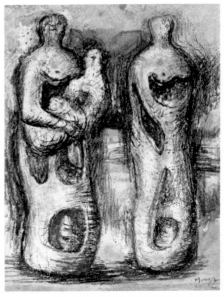

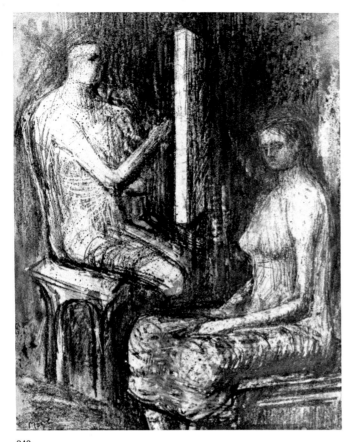

249

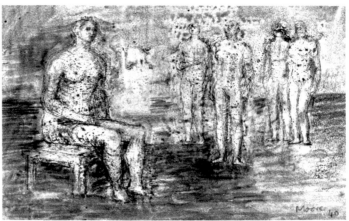

251

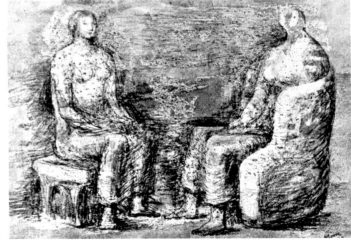

252

249 Artist and Model · Artiste et modèle
Künstler und Modell · 1940

250 Two Standing Figures · Deux figures debout
Zwei stehende Figuren · 1940

251 Study of One Seated and Four Standing Figures
Etude: une figure assise et quatre figures
debout · Studie einer sitzenden und vier stehender
Figuren · 1940

252 Standing, Seated and Reclining Figures against
Background of Bombed Buildings · Figures debout,
assises et couchées, sur un fond de maisons
détruites par des bombardments aériens
Stehende, sitzende und liegende Figuren vor
dem Hintergrund zerbombter Gebäude · 1940

253 Two Seated Women · Deux femmes assises · Zwei
sitzende Frauen · 1940

254 Two Seated Women · Deux femmes assises
Zwei sitzende Frauen · 1940

250

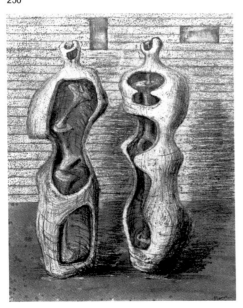

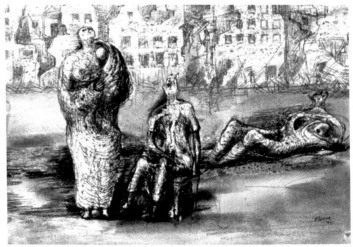

253

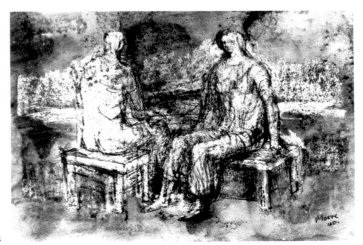

254

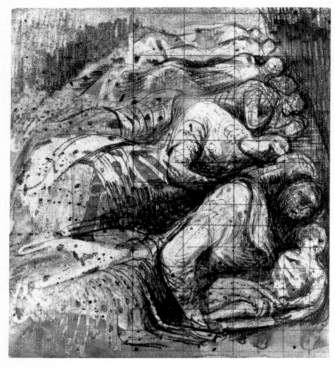

255

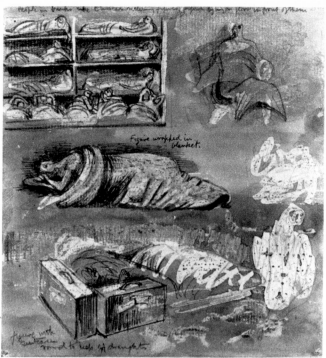

258

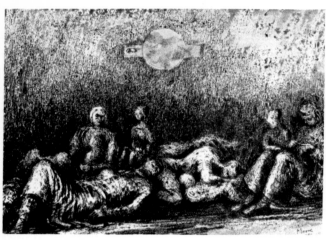

256

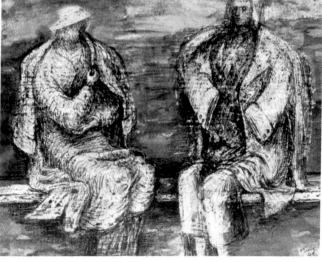

259

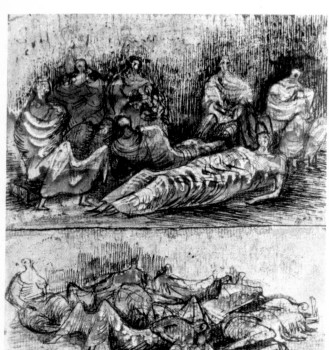

257

255, 257–58 Pages from Shelter Sketchbook · Pages
du carnet de croquis tenu dans les abris
Seiten aus dem Bunker-Skizzenbuch · 1940–41

256 Brown Tube Shelter · Abri dans le Métro, brun
Luftschutzkeller in der U-Bahn, braun · 1940

259 Two Women on a Bench in a Shelter · Deux femmes
sur un banc dans un abri · Zwei Frauen auf einer
Bank im Luftschutzkeller · 1940

260 Shadowy Shelter · Abri obscur · Dunkler
Luftschutzkeller · 1940

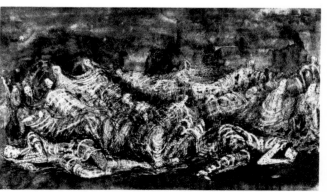

260

1941-1946

THE SHELTER DRAWINGS dominate this period. The figures in these drawings are often sculptural in feeling, but for the first time in his career are not intended as ideas for sculpture. His task was to provide a realistic record of some of the provisions made for the protection of civilians during the aerial bombardment of London, but he was too profoundly moved by what he saw in the deep shelters to leave it at that. He would agree with Delacroix's contention that every master owes his most sublime effects to pictorial licence; and in the process of depicting the patient disquiet and uneasy sleep of the shelterers, Moore achieved a graphic poetry that has rarely been equalled.

The shelter drawings were followed in 1942 by a series depicting miners at work in the colliery at Castleford where his father had been employed. They brought his service as a war artist to a close, and the drawings made later in the same year indicate that he was again thinking in terms of sculpture. In 1943, he was commissioned to carve a Madonna and Child for St Matthew's Church in Northampton. His drawings engaged the theme immediately and broadened out into a series of family groups. The carving was completed in 1944 *(314)*. (David Sylvester has pointed to a remarkable resemblance between *Madonna and Child* in its roughed-out stage *(313)* and the seated figures from the Sacred Way at Miletus in the British Museum.)

Towards the end of this period, Moore completed two sharply contrasted reclining figures. One of them, the *Memorial Figure (352)* for the garden at Dartington Hall, has a calmness and remoteness ideally suited to its purpose. The other, a large *Reclining Figure* in elm wood *(342)* turns a female figure in a very similar posture into something strange and disquieting, an effect created by what would seem to be the figure's calm acceptance of a condition of interior violence. The slotted chest form appears to have hurled itself at the figure with a force that has lifted the breasts and given them a sudden horizontal thrust. The chest form is evidently part of the figure, but its slot is a

127

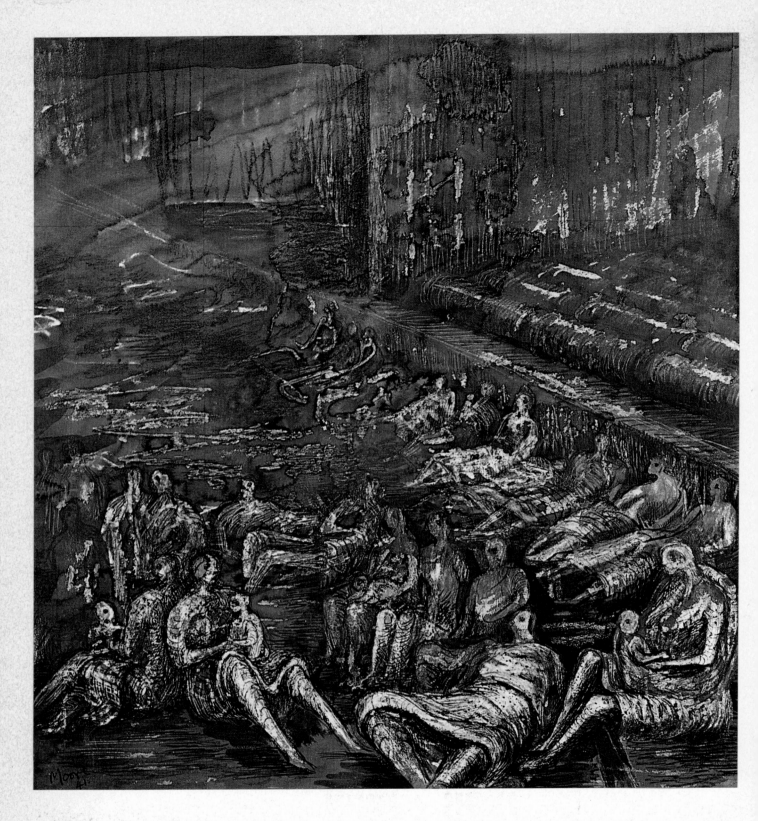

larger version of the slot in the head and conveys the impression that it is a figure with a separate identity, and a voracious mouth, living inside the other. It introduces into Moore's treatment of the *Reclining Figure* the 'internal/external' concept which took its first form in the *Helmet (234)* made just before he started work on the shelter drawings.

XIV Tilbury Shelter · Abri à Tilbury · Luftschutzkeller in Tilbury · 1941

261 Group of Figures in Underground Shelter · Groupe
 dans un abri du Métro · Figurengruppe in einem
 Luftschutzkeller der U-Bahn · 1941

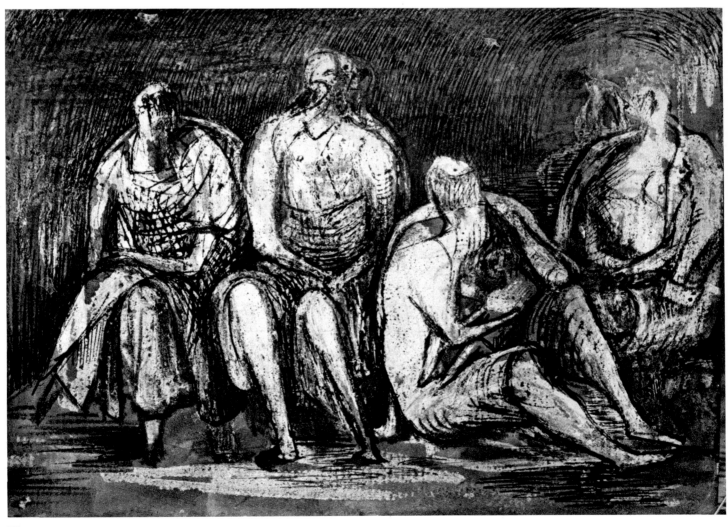

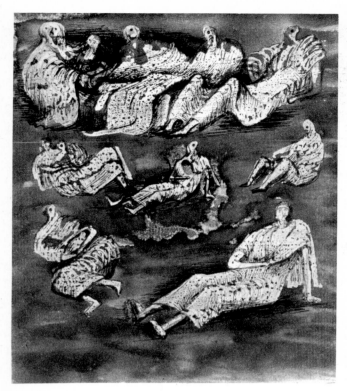

262

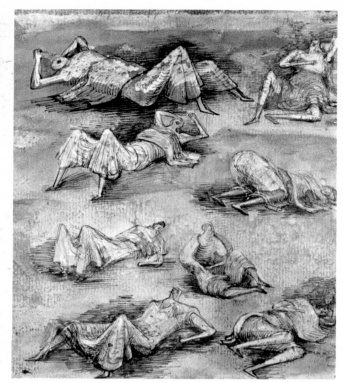

263

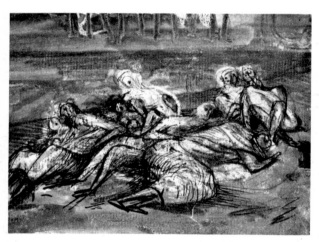

264

262–66 Pages from Shelter Sketchbook · Pages du carnet de croquis tenu dans les abris Seiten aus dem Bunker-Skizzenbuch · 1941

265

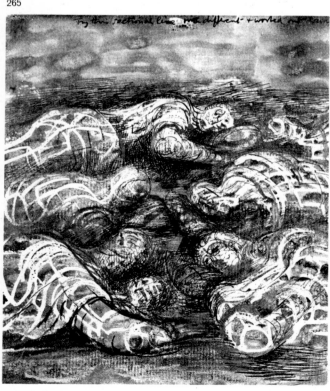

266

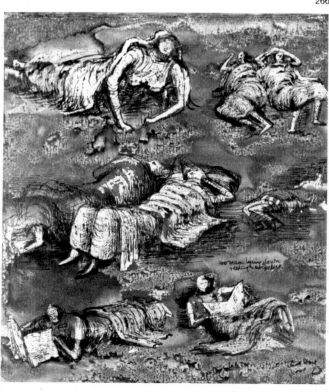

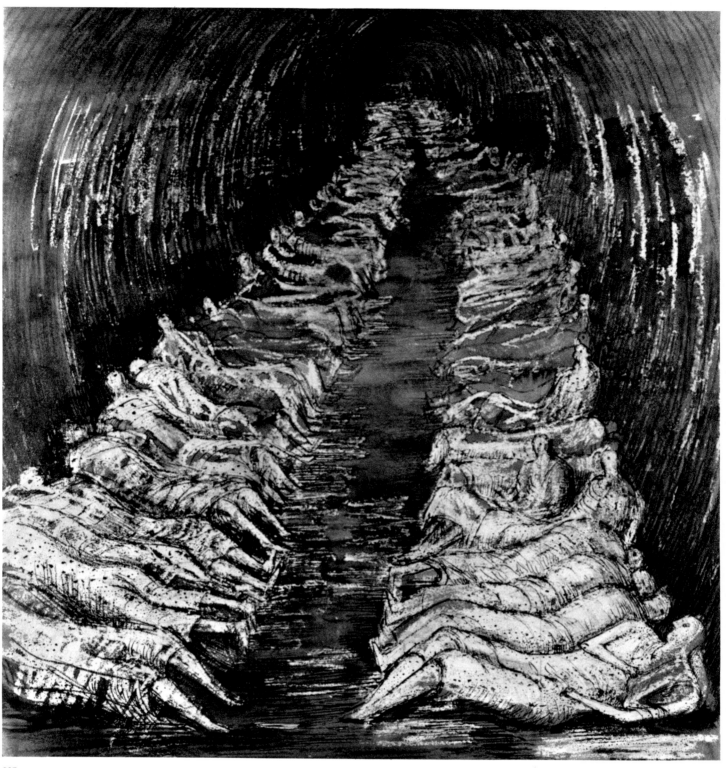

267

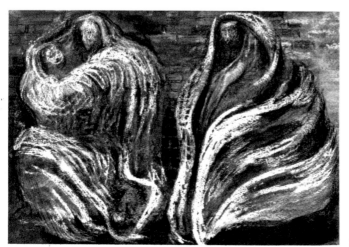

267 Tube Shelter Perspective · Perspective d'un
abri dans le Métro · Blick in den Luftschutz-
keller der U-Bahn · 1941

268 Shelter Scene: Two Swathed Figures · Dans
l'abri : deux personnages emmitouflés
Bunker-Szene: zwei verhüllte Gestalten · 1941

268

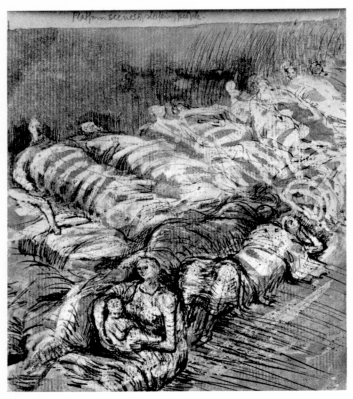

269

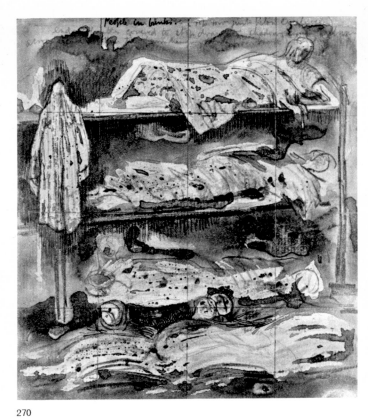

270

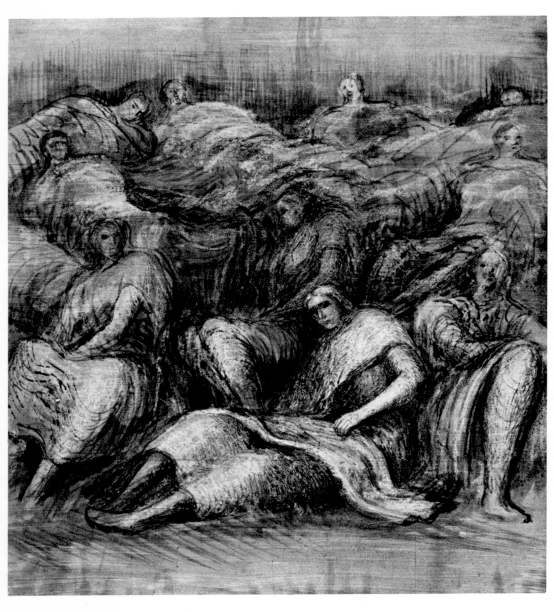

271

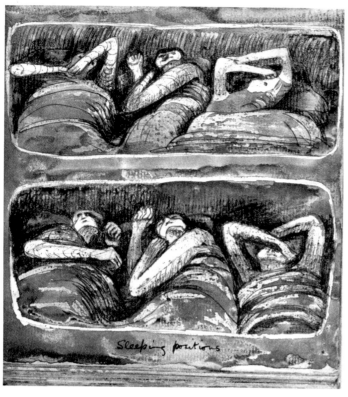

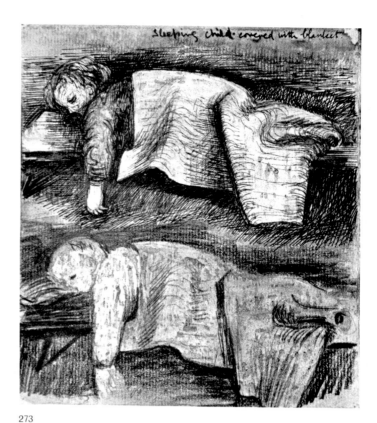

272

273

269–70 Pages from Shelter Sketchbook · Pages
du carnet de croquis tenu dans les abris
Seiten aus dem Bunker-Skizzenbuch · 1941

271 Women in a Shelter · Femmes dans un abri
Frauen im Bunker · 1941

272–75 Pages from Shelter Sketchbook · Pages
du carnet de croquis tenu dans les abris
Seiten aus dem Bunker-Skizzenbuch · 1941

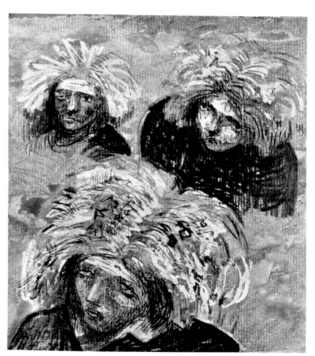

275

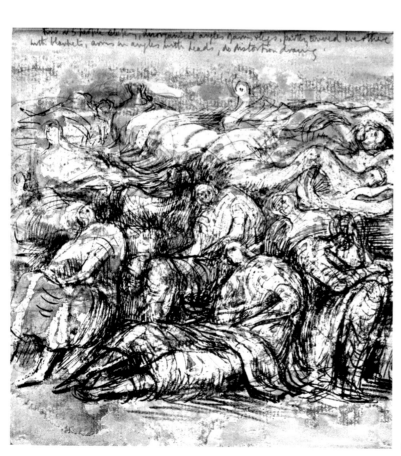

274

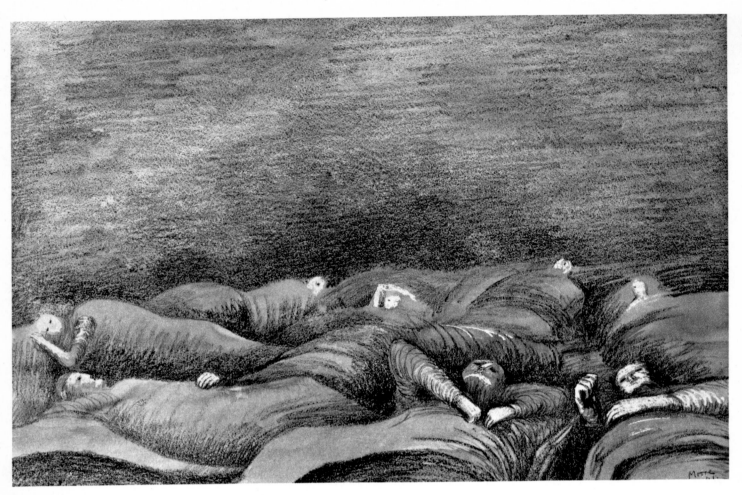

276

277

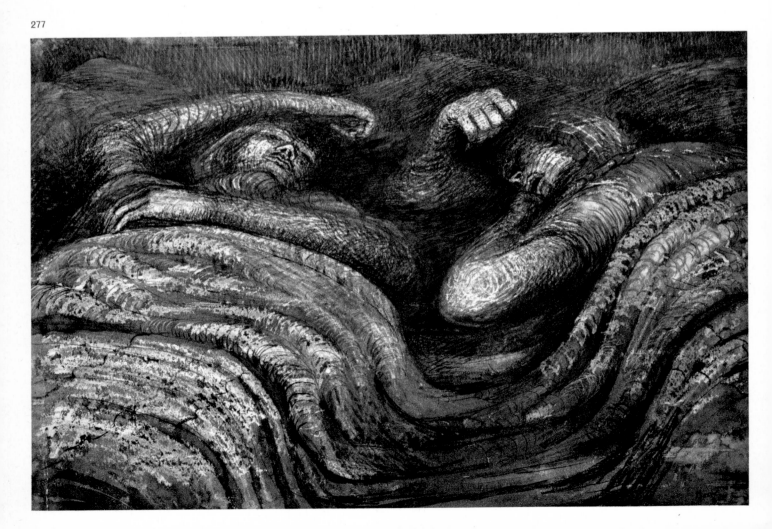

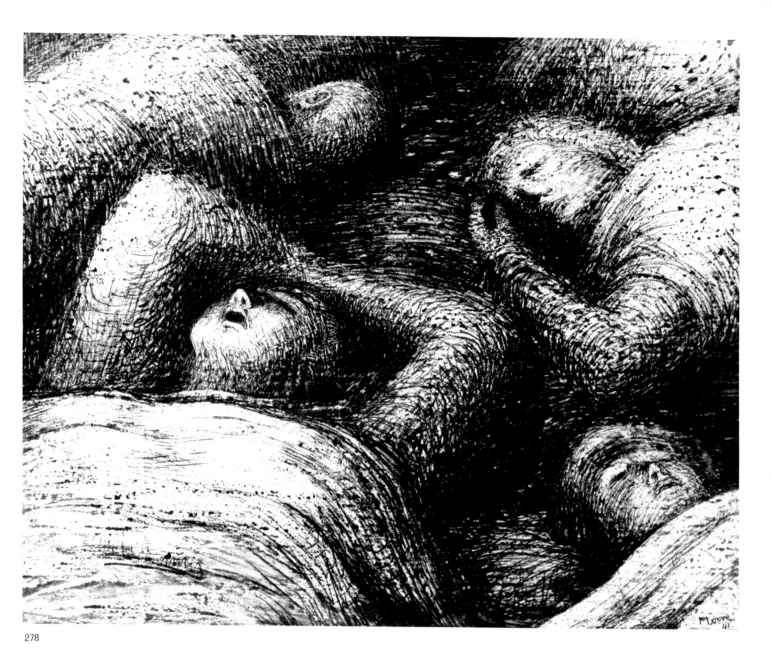

278

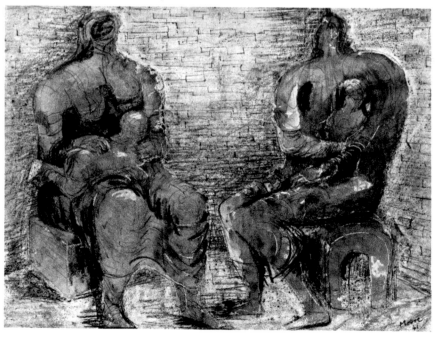

279

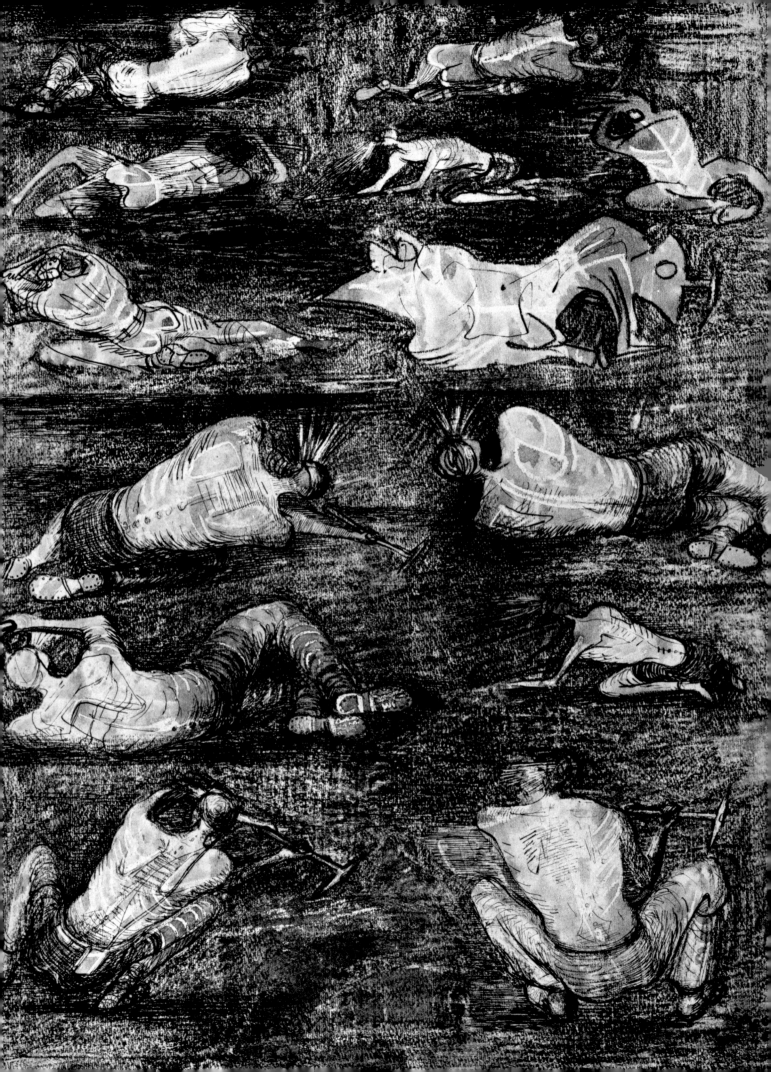

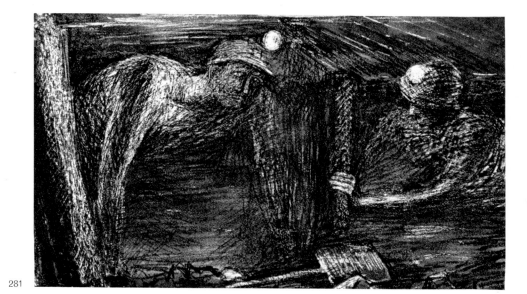

281

280 Studies of Miners at Work
 Etudes de mineurs au travail
 Studien von arbeitenden
 Bergleuten · 1942

281 At the Coal Face. Miners Fixing
 Prop · Dans la mine. Mineurs
 mettant en place un poteau · Im
 Stollen. Bergleute beim Aufstellen
 des Grubenholzes · 1942

282 At the Coal Face. Miner
 Pushing Tub · Dans la mine.
 Mineur poussant une berline
 Im Stollen. Bergmann, einen
 Förderkarren schiebend · 1942

283–84 Studies of Miners (two pages
 from sketchbook) · Etudes de
 mineurs (deux pages de carnet de
 croquis) · Studien von Bergleuten
 (zwei Skizzenbuchblätter) · 1942

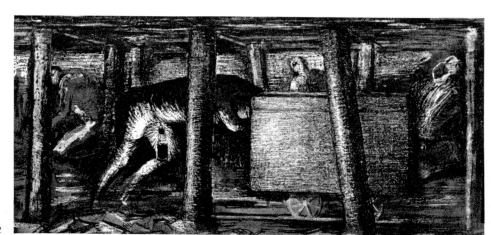

282

283

284

285 Figures in Settings · Figures dans des sites
Figuren in Umgebungen · 1942

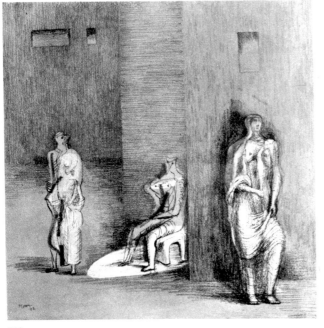

286

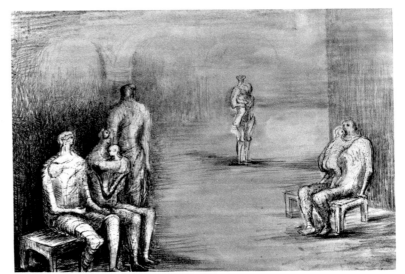

287

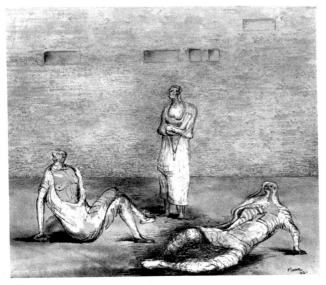

288

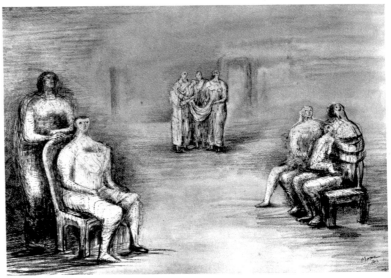

289

286 Figures in a Setting · Figures dans un site
 Figuren in einer Umgebung · 1942

287 Figures in a Setting · Figures dans un site
 Figuren in einer Umgebung · 1942

288 Three Figures · Trois Figures · Drei Figuren · 1942

289 Figures in a Room · Figures dans une salle
 Figuren in einem Raum · 1942

290 Crowd looking at a Tied-up Object · Foule
 qui regarde un objet empaqueté · Menge, die
 ein verschnürtes Objekt betrachtet · 1942

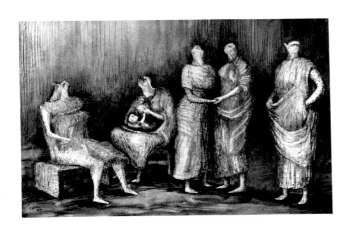

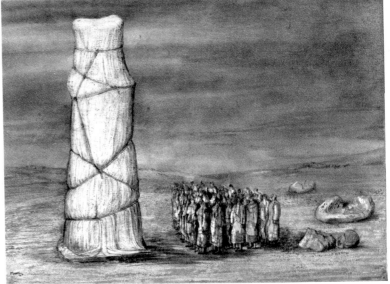

290

291 Group of Women · Groupe de femmes · Frauen · 1942

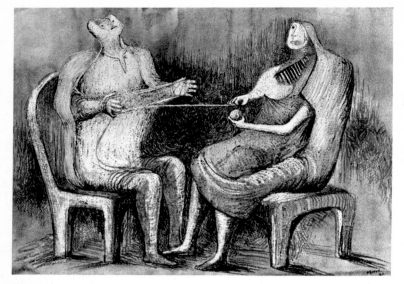

292

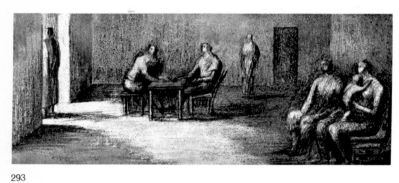

293

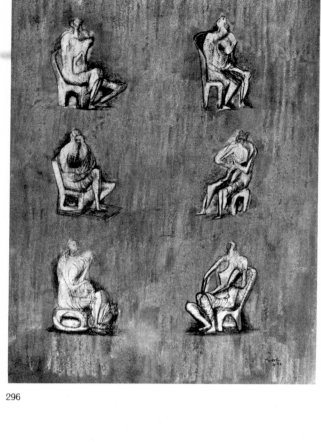

296

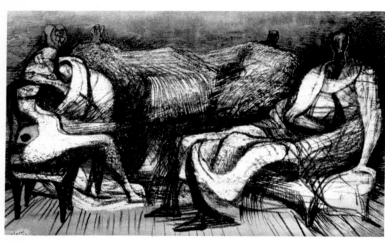

294

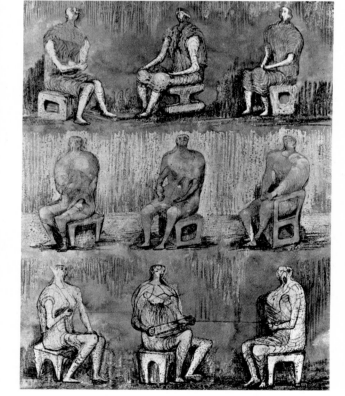

297

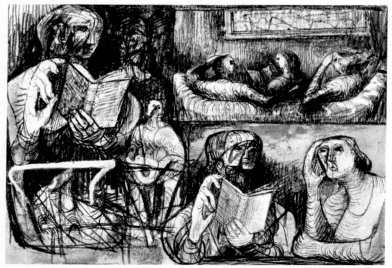

295

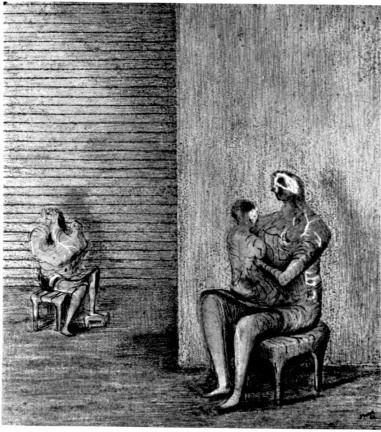

299

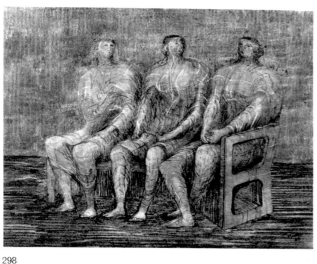

298

292 Two Women Winding Wool · Deux femmes mettant
en pelote un écheveau de laine · Zwei Frauen
beim Wollewickeln · 1942

293 Figures in a Setting · Figures dans un site
Figuren vor einem Hintergrund · 1942

294 Arrangement of Figures · Disposition de figures
Figurengruppe · 1942

295 Women Reading · Liseuses · Lesende Frauen · 1942

296 Seated Figures · Figures assises · Sitzende
Figuren · 1942

297 Seated Figures · Figures assises · Sitzende
Figuren · 1942

298 Three Seated Women · Trois femmes assises
Drei sitzende Frauen · 1942

299 Seated Woman with Children · Femme assise avec
enfants · Sitzende Frau mit Kindern · 1942

300 Reclining Figures against a Bank · Figures
couchées devant un talus · Liegende Figuren
vor einer Anhöhe ·1942

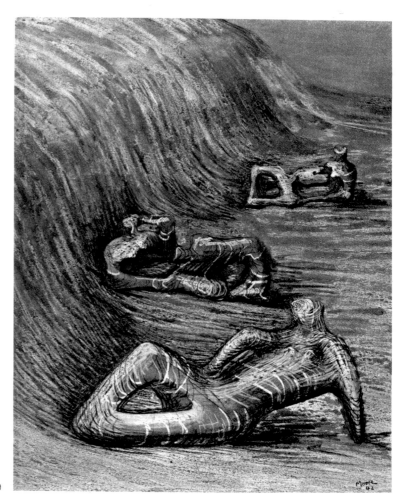

300

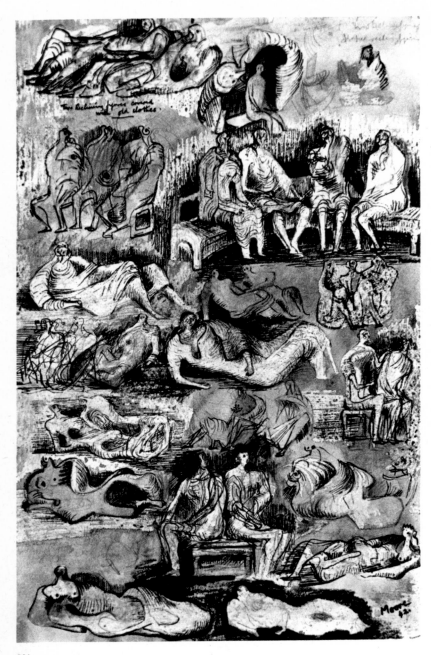

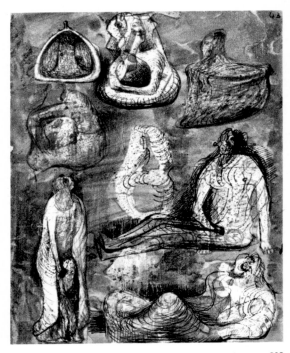

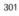
301

302

301 Drawing · Dessin · Zeichnung · 1942

302 Ideas for Sculpture · Idées pour sculptures
Skizzen zu Plastiken · 1942

303 Ideas for Sculpture · Idées pour sculptures
Skizzen zu Plastiken · 1943

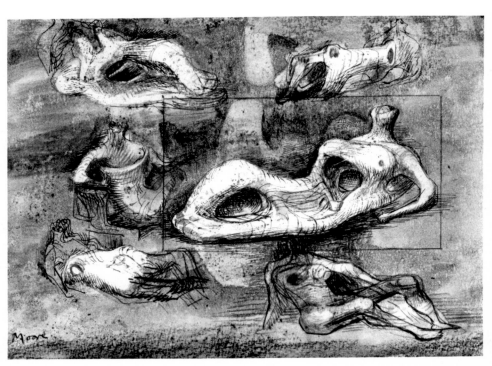

303

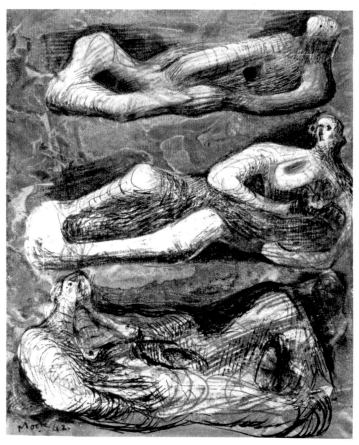

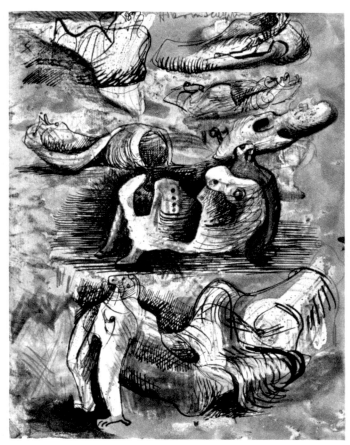

304

305

304 Three Reclining Figures · Trois figures couchées · Drei liegende Figuren · 1942

305 Ideas for Sculpture · Idées pour sculptures · Skizzen zu Plastiken · 1942

306 Group of Figures with Architectural Background · Figures groupées sur un fond architectonique
Figurengruppe vor einem architektonischen Hintergrund · 1943

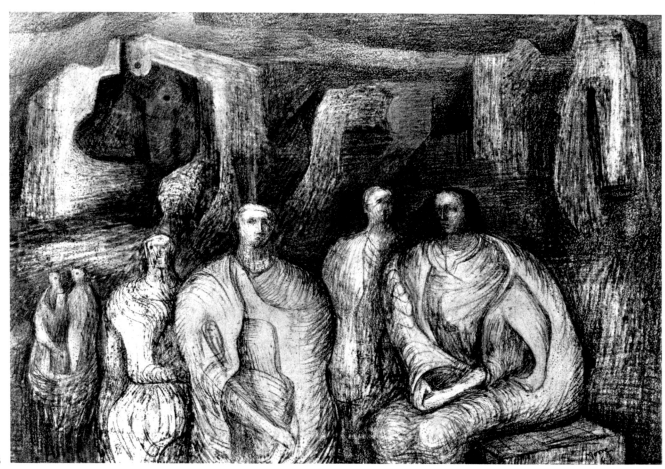

306

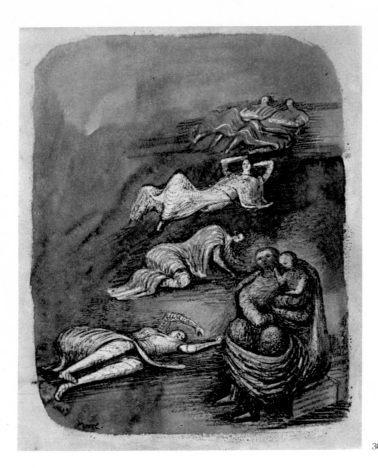

307 Mother and Child with Reclining Figures
Mère et enfant avec figures couchées
Mutter und Kind mit liegenden Figuren
1942–43

308 Madonna and Child · Vierge à l'Enfant
Madonna mit Kind · 1943 · H. 14.6 cm

309 Madonna and Child · Vierge à l'Enfant
Madonna mit Kind · 1943 · H. 15.9 cm

307

308

309

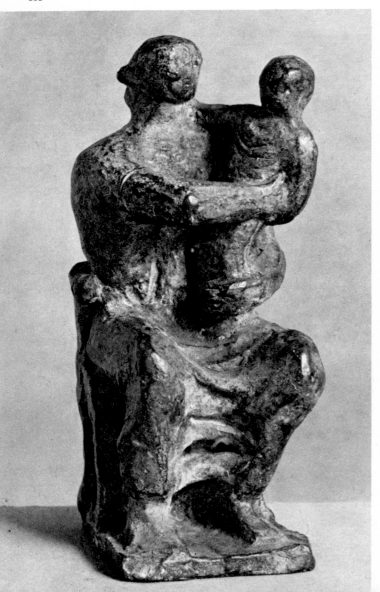

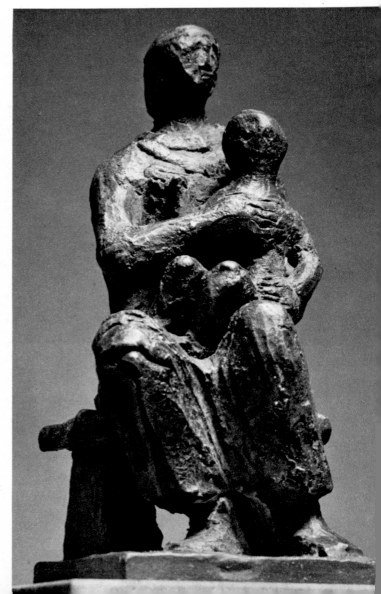

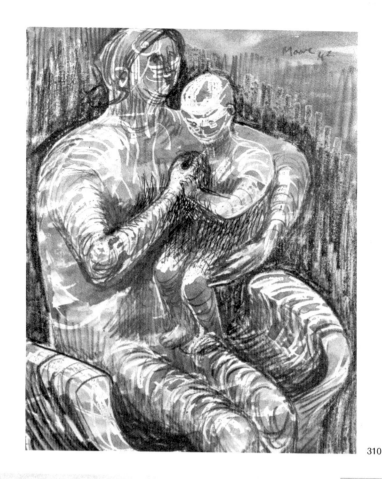

310 Study for Northampton Madonna and Child
Etude pour la Vierge à l'Enfant de
Northampton · Studie für die Madonna
mit Kind in Northampton · 1942

311 Madonna and Child · Vierge à l'Enfant
Madonna mit Kind · 1943 · H. 15.9 cm

312 Madonna and Child · Vierge à l'Enfant
Madonna mit Kind · 1943 · H. 14.0 cm

310

311

312

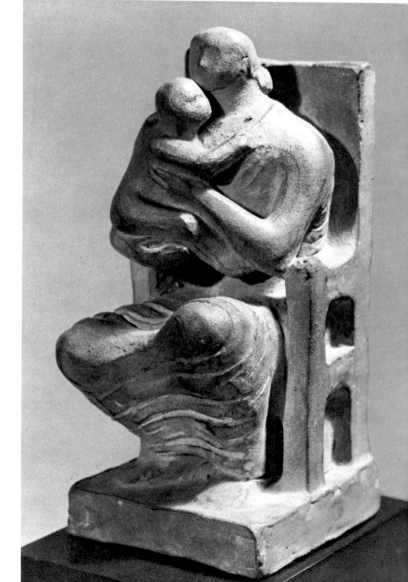

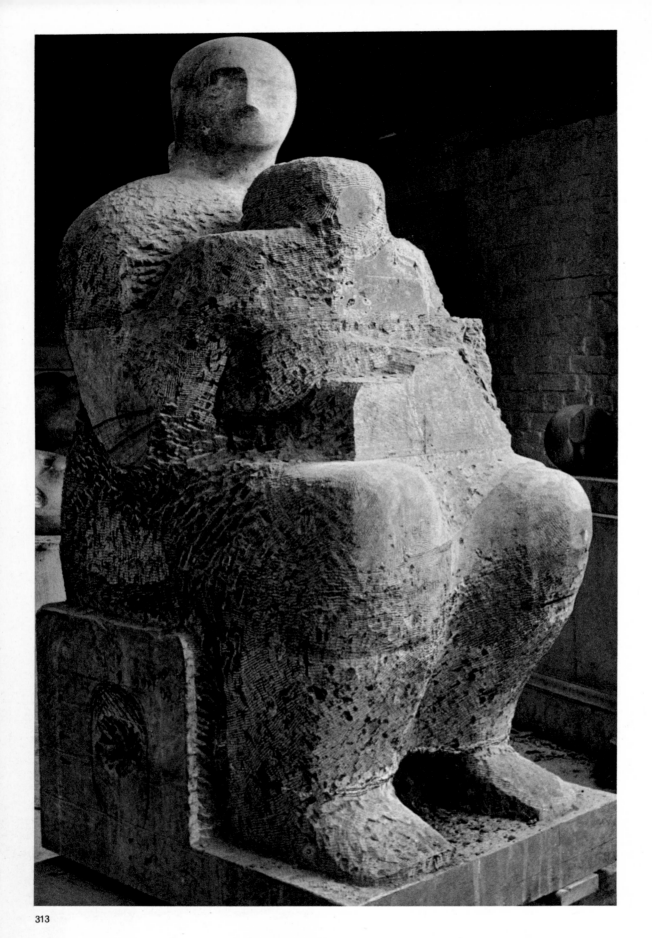

313

313 Madonna and Child (in progress) · Vierge à l'Enfant (en cours de réalisation) · Madonna mit Kind (in unvollendetem Zustand)
1943–44 · H. 1.50 m

314 Madonna and Child · Vierge à l'Enfant · Madonna mit Kind
1943–44 · H. 1.50 m

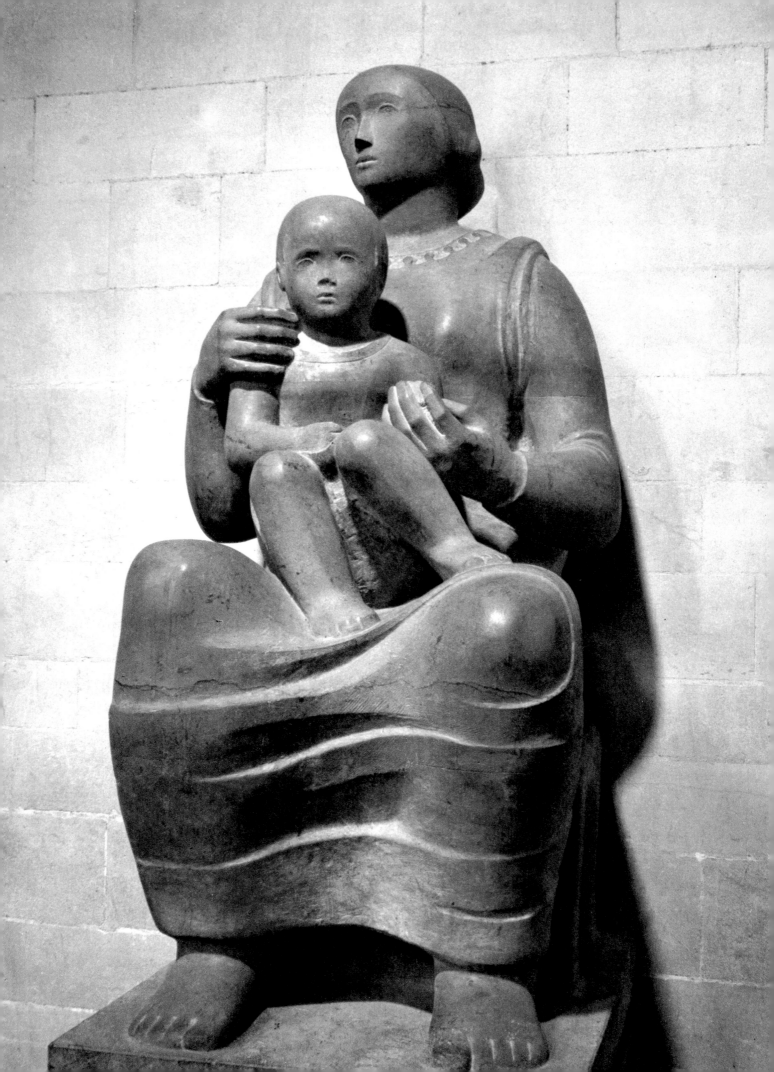

315

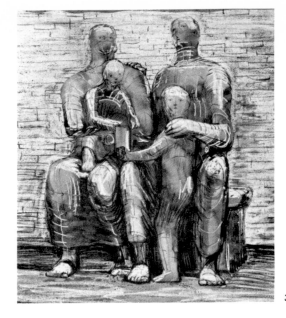

317

315 Two Seated Figures · Deux figures assises
Zwei sitzende Figuren · 1944

316 Family Group · Famille · Familiengruppe · 1944
H. 15.6 cm

317 The Family · La famille · Die Familie · 1944

318 Family Group · Famille · Familiengruppe · 1944

319 Family Group · Famille · Familiengruppe · 1944

316

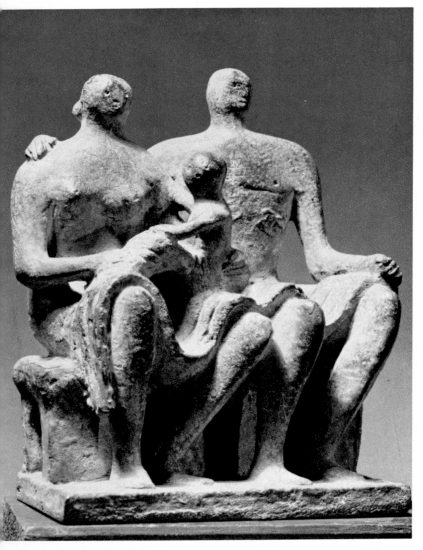

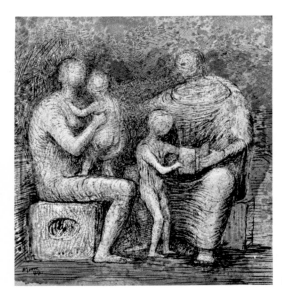

318

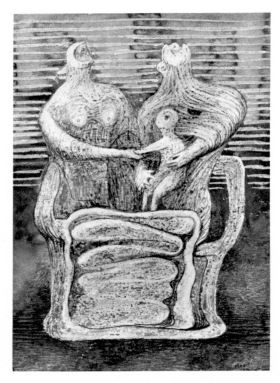

319

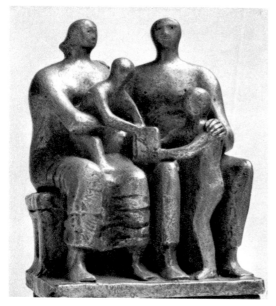

320

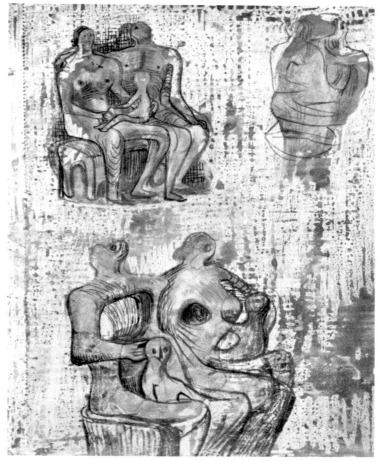

323

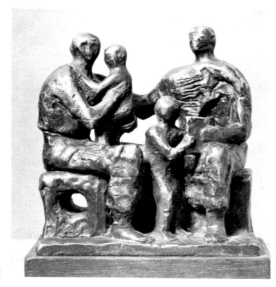

321

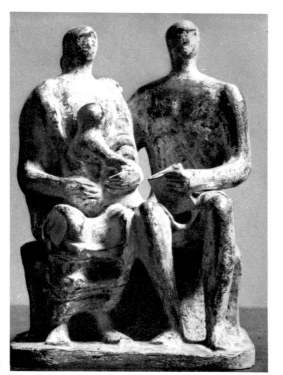

322

320 Family Group · Famille · Familiengruppe · **1944**
 H. 19.0 cm

321 Family Group · Famille · Familiengruppe
 1944 · H. 16.2 cm

322 Family Group · Famille · Familiengruppe
 1944 · H. 15.6 cm

323 Family Groups · Familles · Familiengruppen
 1944

324 Family Group · Famille · Familiengruppe
 1944

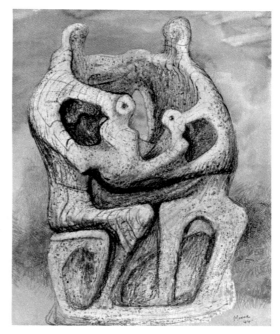

324

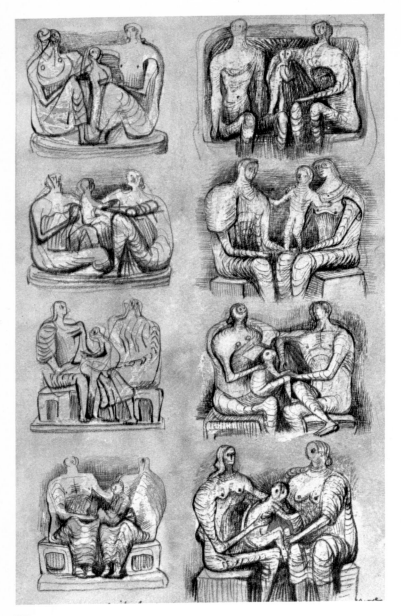

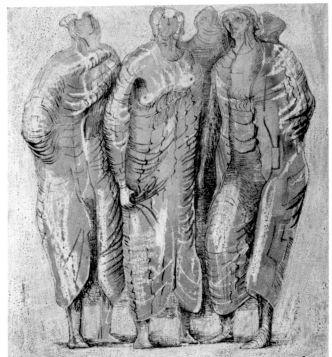

325

325 Family Groups · Familles · Familiengruppen · 1944

326 Three Women and Child · Trois femmes et
enfant · Drei Frauen mit einem Kind · 1944

327 Draped Standing Figures in Red · Figures drapées,
debout. Rouge · Bekleidete stehende Figuren
in Rot · 1944

328 Woman and Child with Bath · Femme et enfant avec
baignoire · Frau und Kind mit Badezuber · 1944

329 The Toilet · La toilette · Bei der Toilette · 1944

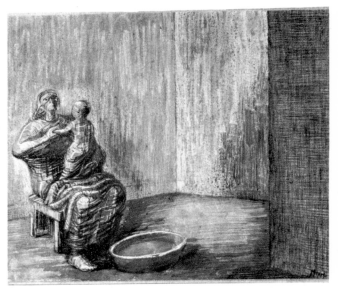

328

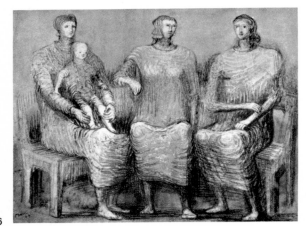

326

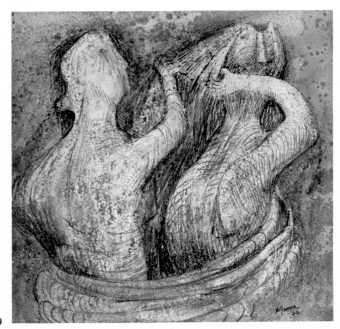

329

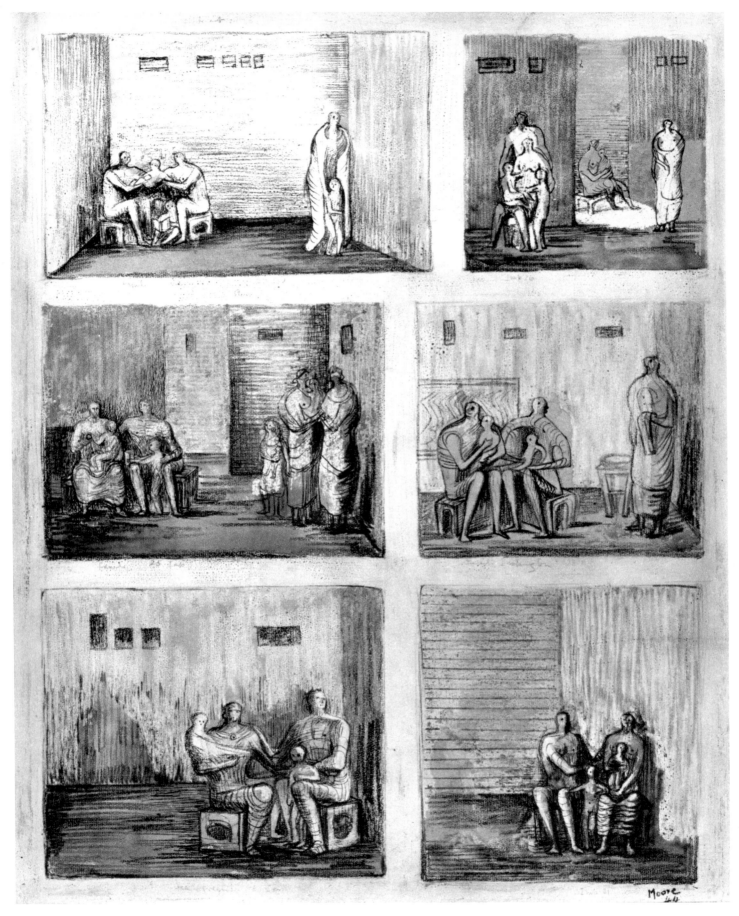

330 Family Groups in Settings · Familles dans décors
Familiengruppen in Räumen · 1944

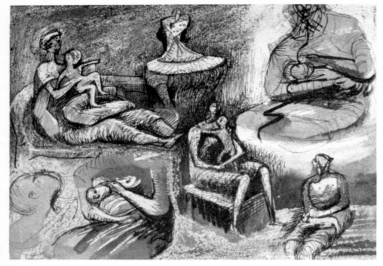

331

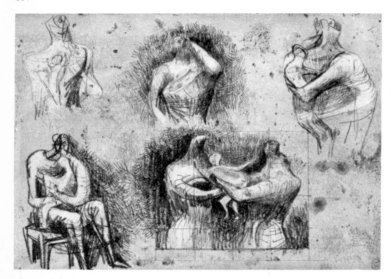

332

333

331 Mother and Child · Mère et enfant · Mutter und Kind · 1945

332 Mother and Child · Mère et enfant · Mutter und Kind · 1944

333 Family Groups · Familles · Familiengruppen · 1944

334 Three Women and a Child · Trois femmes et enfant · Drei Frauen mit einem Kind · 1944

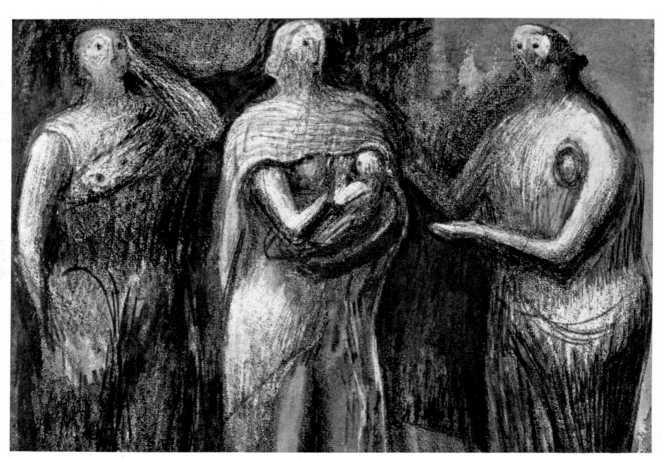

334

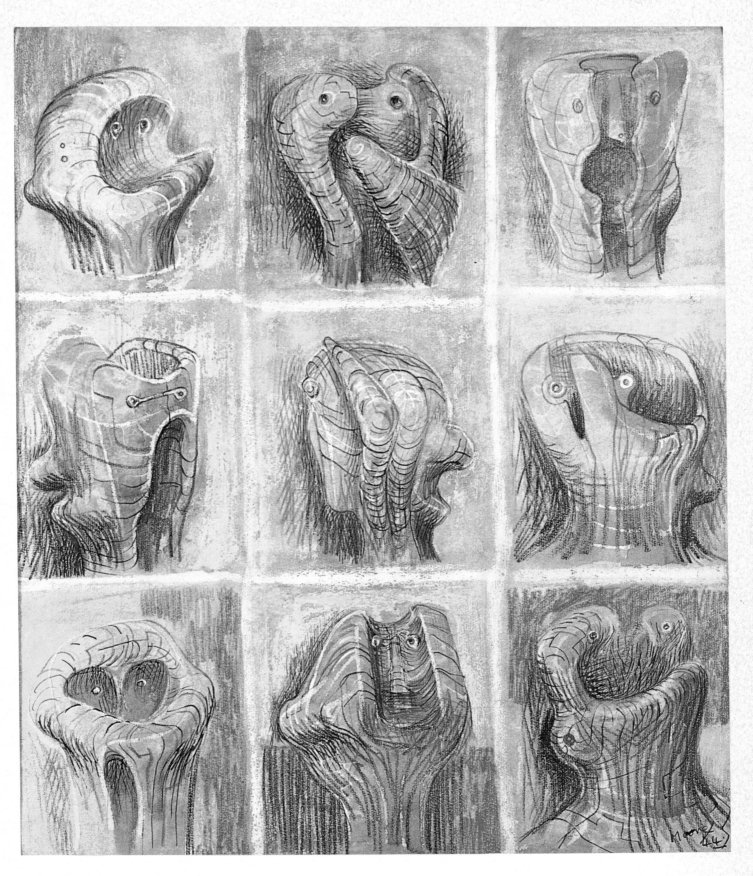

XV Nine Heads, 1944

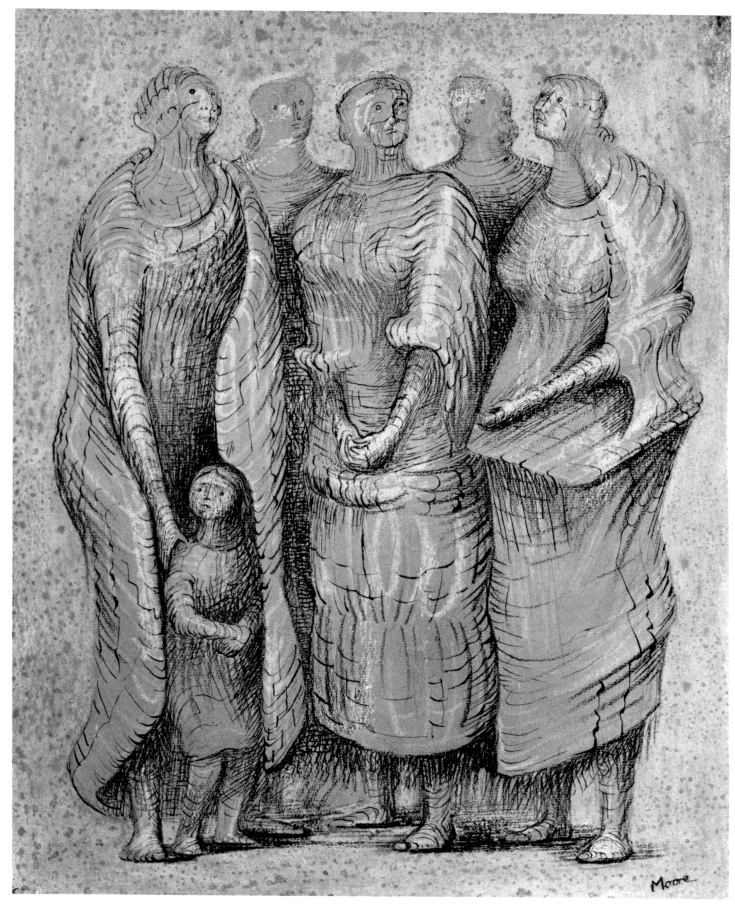

335 Group of Red-draped Figures · Groupe de figures
drapées de rouge · Gruppe rotgekleideter Figuren
1944

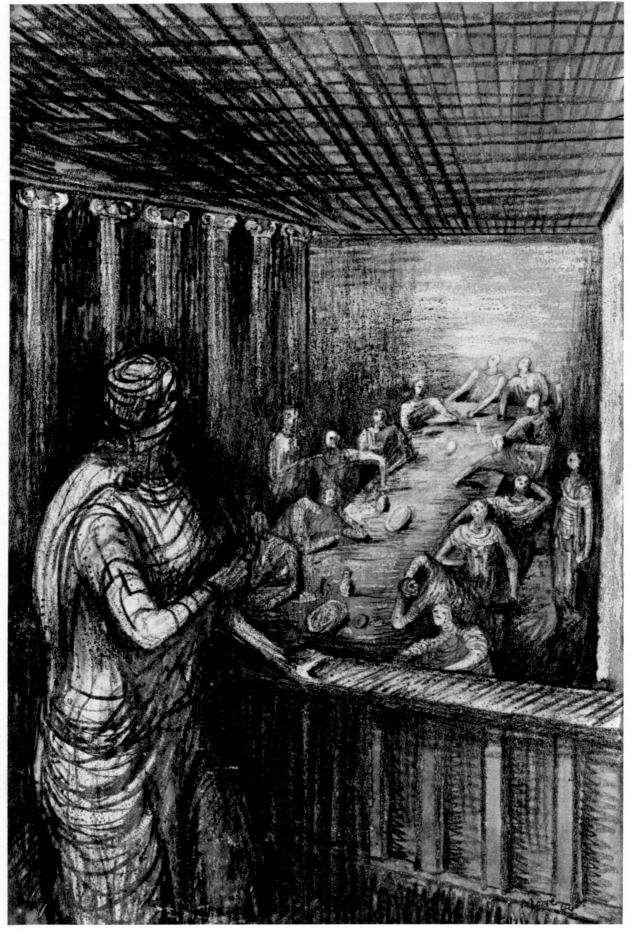

336

336-37 Illustrations for 'The Rescue' by Edward Sackville-West
Illustrations pour 'The Rescue' d'Edward Sackville-West
Illustrationen zu 'The Rescue' von Edward Sackville-West · 1944

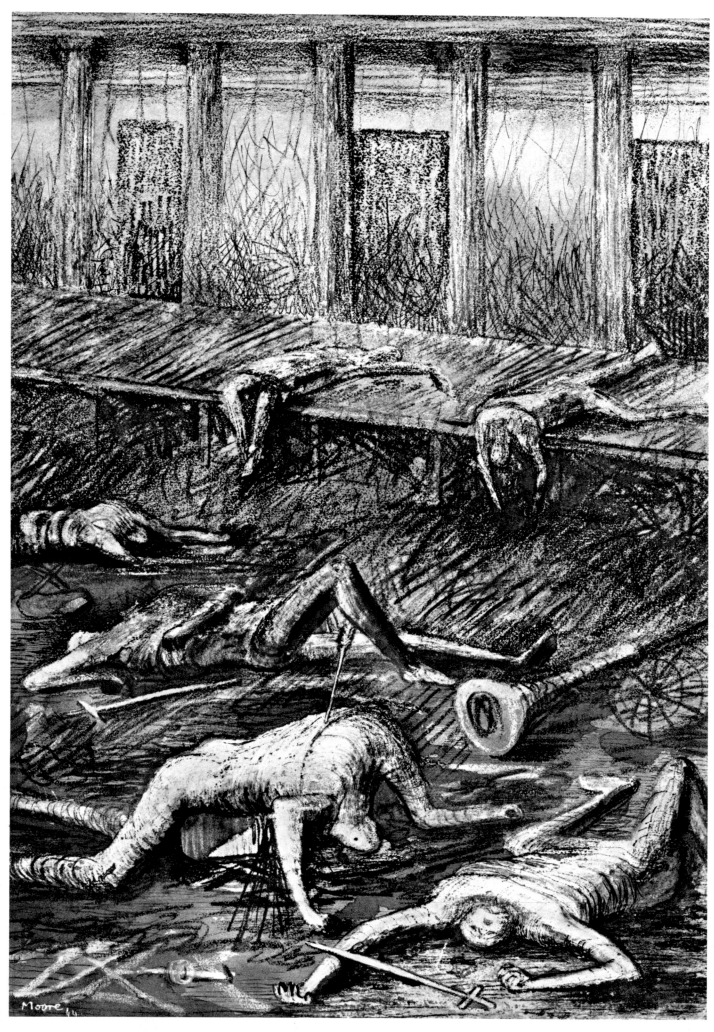

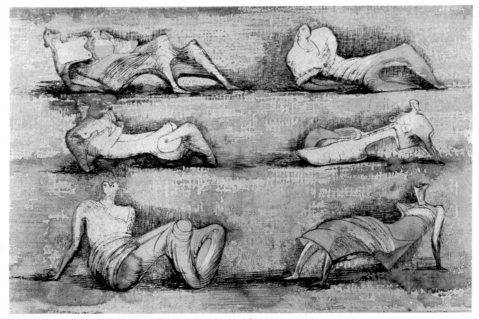

338

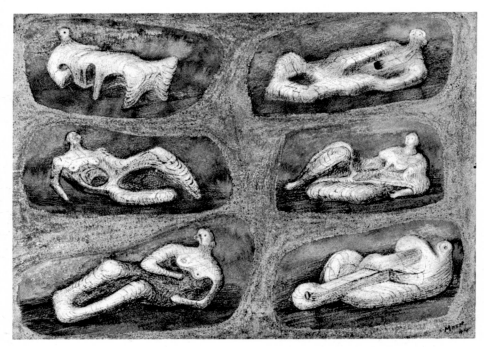

339

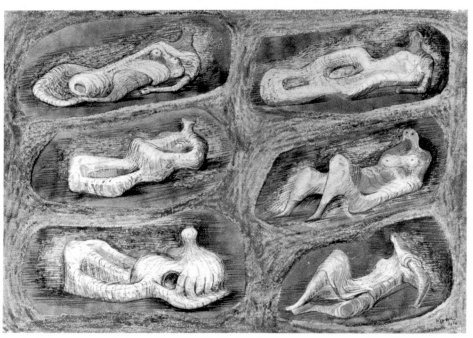

340

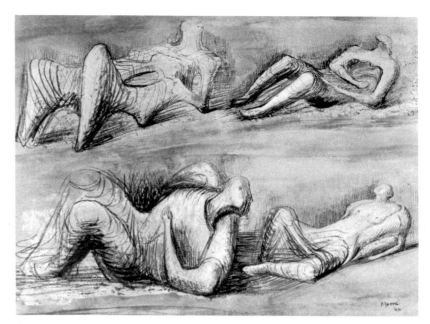

338-41 Reclining Figures · Figures
couchées · Liegende Figuren
1944

342 Reclining Figure · Figure
couchée · Liegende Figur
1945–46 · L. 1.90 m

341

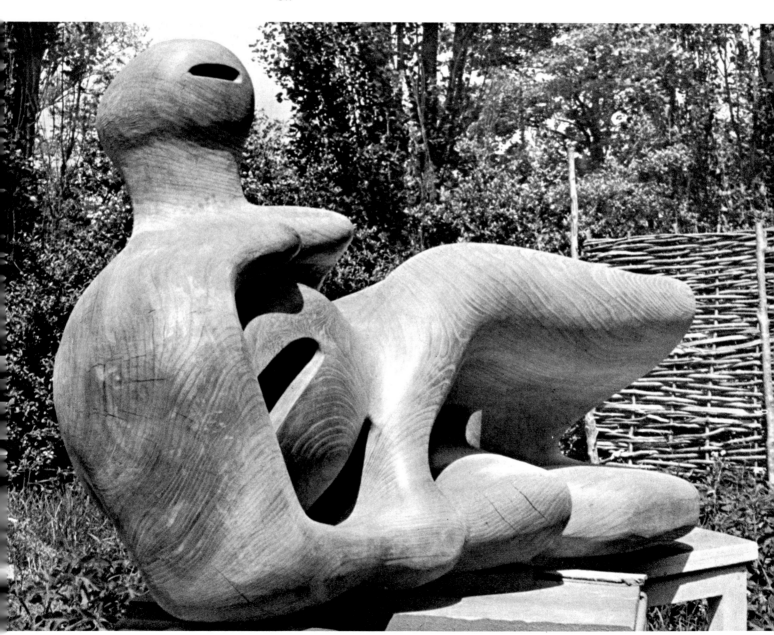

342

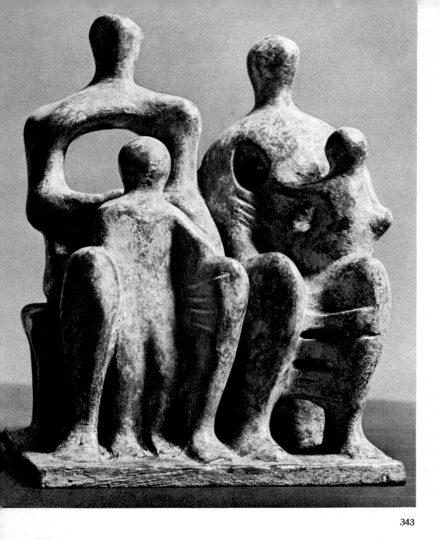

343 Family Group · Famille · Familiengruppe
1945 · H. 14.6 cm

344 Seated Figures · Figures assises · Sitzende
Figuren · 1945

345 Two Seated Women and a Child · Deux femmes
assises et enfant · Zwei sitzende Frauen
mit einem Kind · 1945 · H. 17.1 cm

346 Two Seated Women with Child · Deux femmes
assises et enfant · Zwei sitzende Frauen
mit einem Kind · 1945

347 Four Figures in Setting · Quatre figures dans
un décor · Vier Figuren im Raum · 1945

348 Sketches · Croquis · Skizzen · 1945

343

344

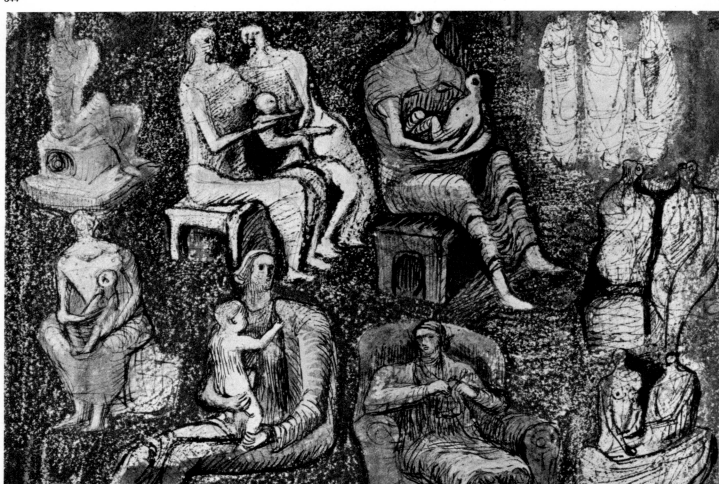

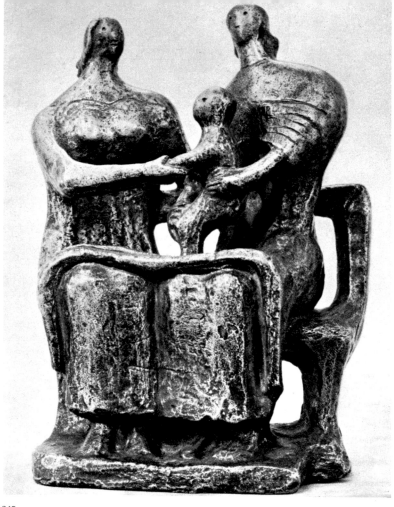

345

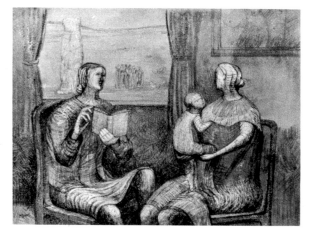

346

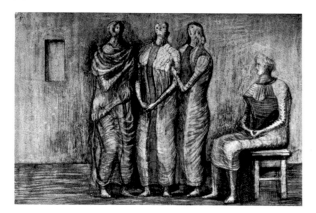

347

348

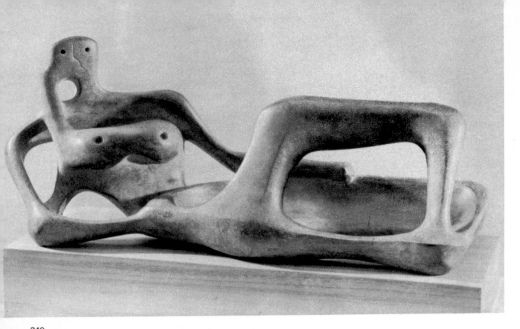

349

350

352

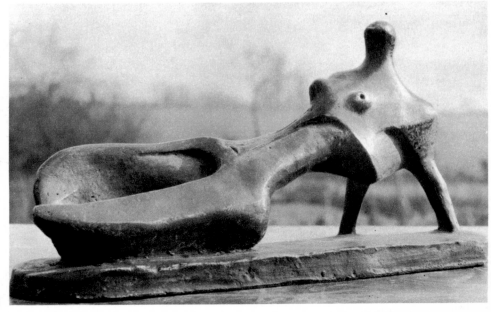

351

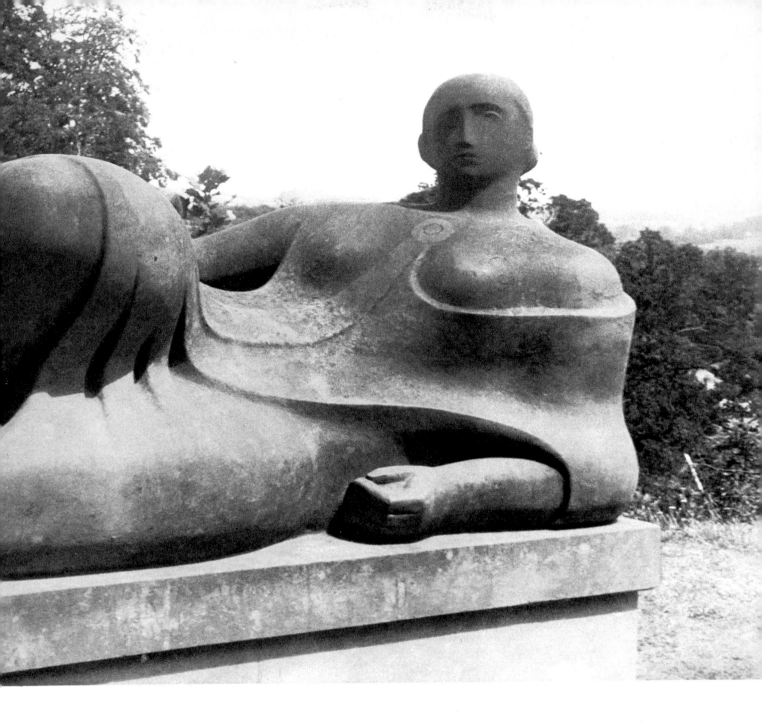

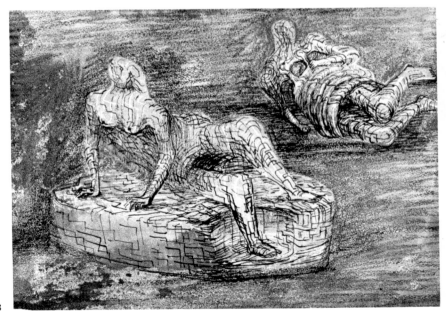

353

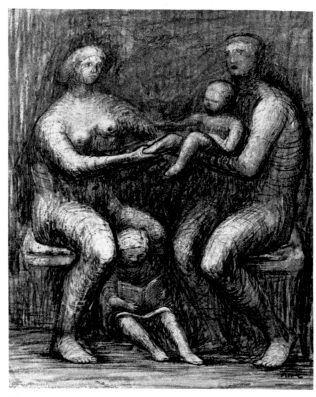

355

354 Family Group · Famille · Familiengruppe
1946 · H. 44.2 cm

355 Family Group · Famille · Familiengruppe
1946

356 Family Group · Famille · Familiengruppe
1945 · H. 24.2 cm

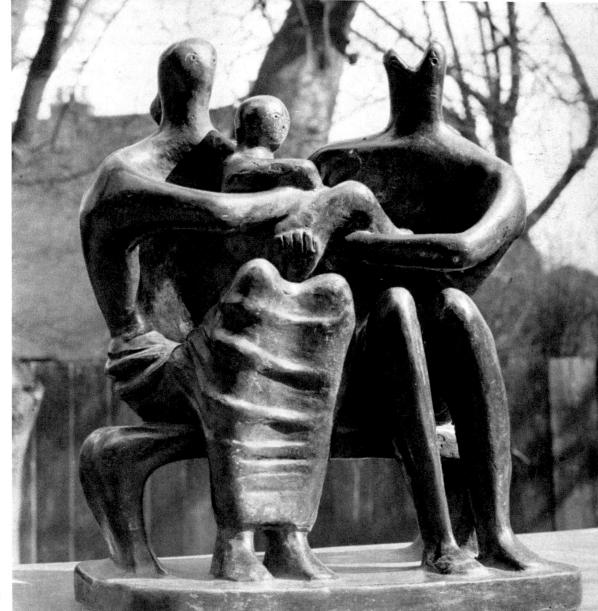

356

357

358

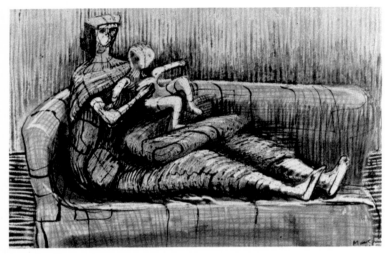

359 Three Women Round a Table · Trois femmes autour d'une table · Drei Frauen um einen Tisch · 1946

358 Two Women Bathing a Baby · Deux femmes baignant un bébé · Zwei Frauen, die ein Kind baden · 1946

359 Mother and Child on a Sofa · Mère et enfant sur un canapé · Mutter und Kind auf einem Sofa · 1946

360 Standing Figures with Rock Background · Figures debout sur un fond de rochers · Stehende Figuren vor einem Felsenhintergrund · 1946

359

360

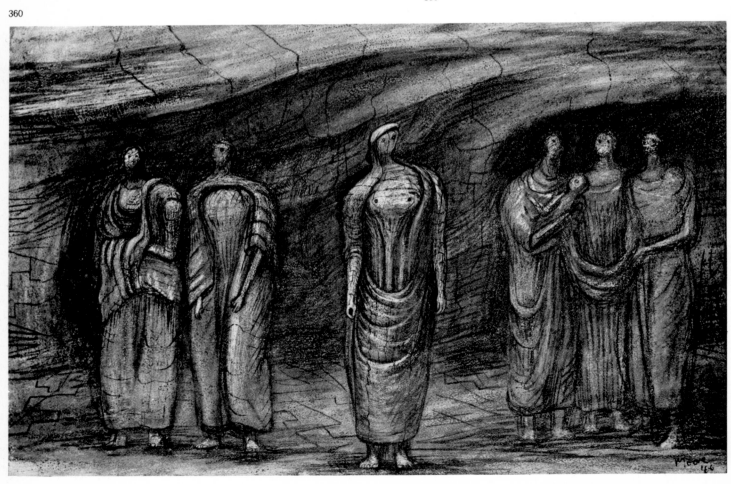

1947–1952

No period in Moore's work is without new developments in his treatment of the *Reclining Figure*. The present period opens with a *Reclining Figure* in stone *(361–2)* which is notable for its rhythmically flowing lines. It has the smoothness of his small lead figures, and to some extent emulates their extruded forms.

His daughter Mary was born in 1947. Domestic scenes continued to appear in his drawings, and led to the *Rocking Chair* bronzes *(398–400)*. A large bronze *Family Group* was completed in 1949 *(390–1)*.

He returned to the *Helmet* theme *(401–2* and *407)* in which a kind of openwork casque encloses a separate form representing not only the features of the face but a standing figure, as shown in the photograph of five figures for *Helmet* interiors *(406)*. The double function of the interior figures lends the *Helmet* form a fascinating ambiguity of scale. The exploration of the Internal/External theme entered a new phase in 1951, with the *Working Model for Reclining Figure (Internal and External Forms) (420–1)*, where the figure within a figure, implied in *342*, becomes explicit. But in *420–1* the figure seated in an upright position inside the reclining outer shell completes a two-part reclining figure: it can be taken out of the shell, but it is not intended as a separate personage.

Another large bronze *Reclining Figure*, raising itself on its elbows, was cast in 1951. The use made of linear markings in some of the earlier stone carvings *(159*, for example) is here elaborated into an all-over decoration of raised lines. The plaster for this bronze is a particularly beautiful example of his plasterwork: the substance has the look and feel of ivory and the linear tracery, made with thin string, is even more delicate than in the bronze.

The tall *Standing Figure (408–9* and *411)* was the last important work to be closely related to a drawing (see *387)*. The sculptor produced *Double Standing Figure (410* and *412)* by placing two identical casts in a relationship which enabled him to present different views of the figure simultaneously.

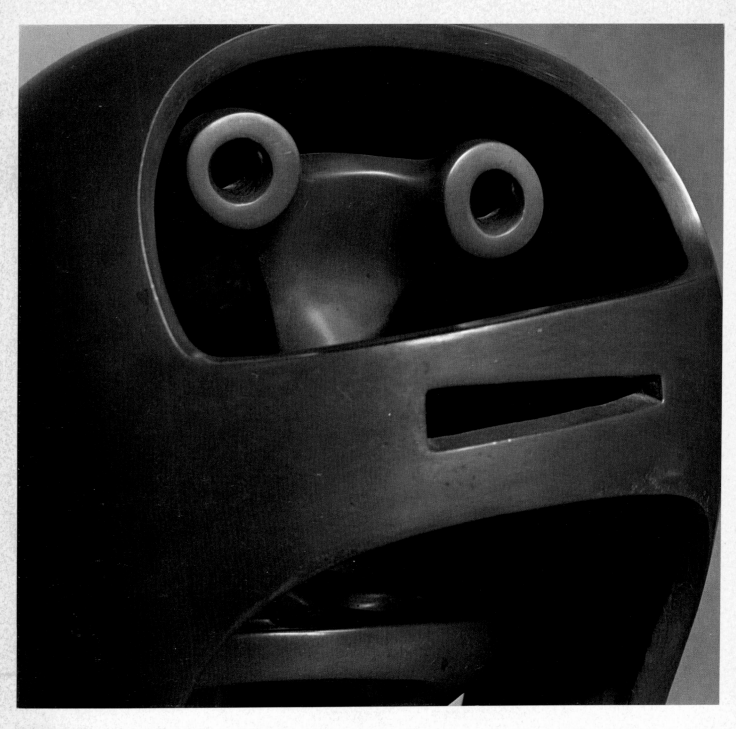

XVI Helmet Head No. 2, 1950 (detail). H. 39.4 cm

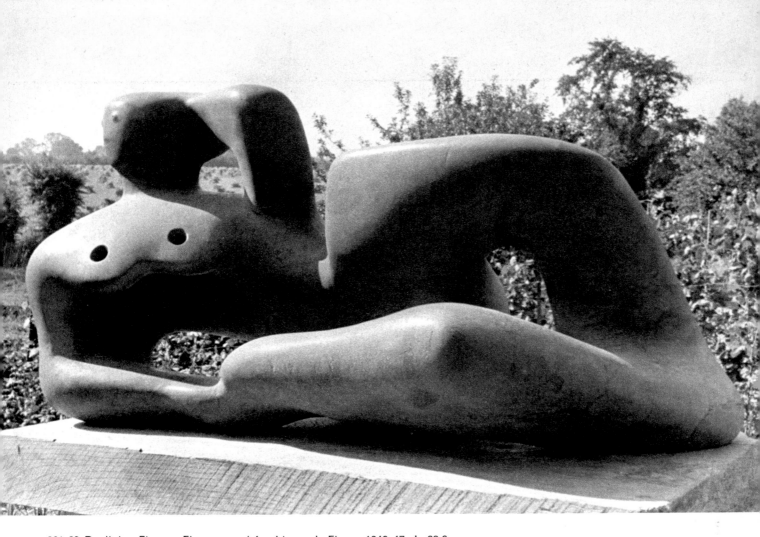

361-62 Reclining Figure · Figure couchée · Liegende Figur · 1946–47 · L. 68.6 cm

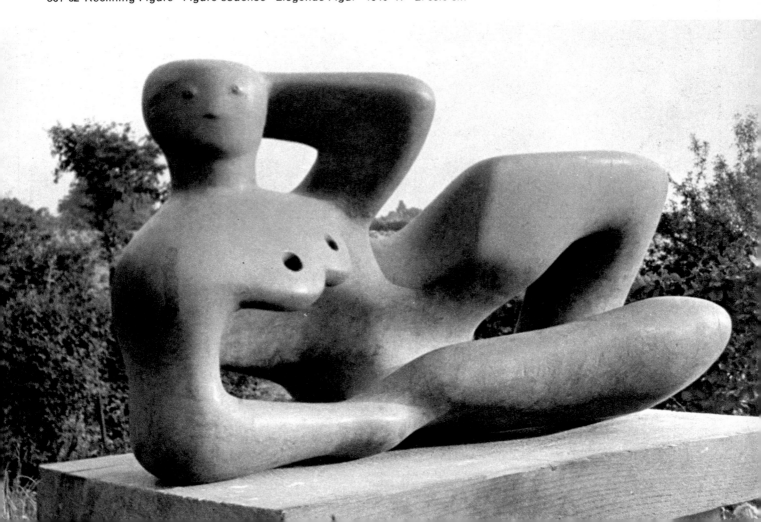

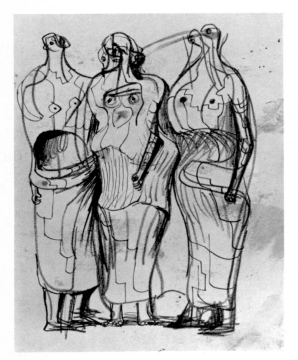

363

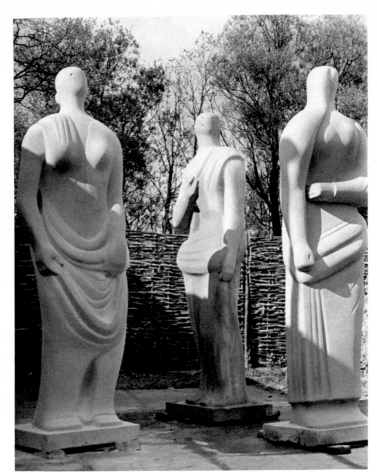

365

363 Three Standing Figures · Trois figures
debout · Drei stehende Figuren · 1947

364 Family Group · Famille · Familiengruppe
1947 · H. 40.7 cm

365-67 Three Standing Figures · Trois
figures debout · Drei stehende Figuren
1947–48 · H. 2.15 m

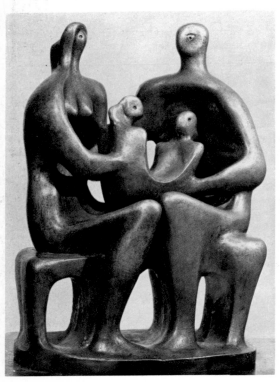

364

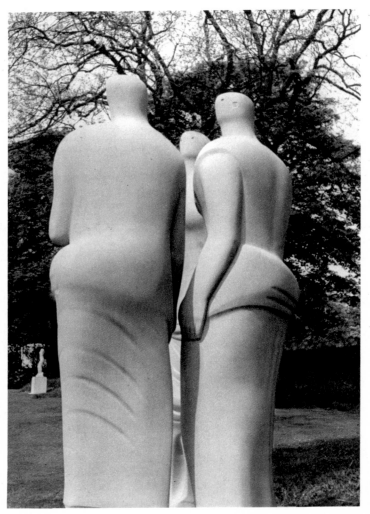

366

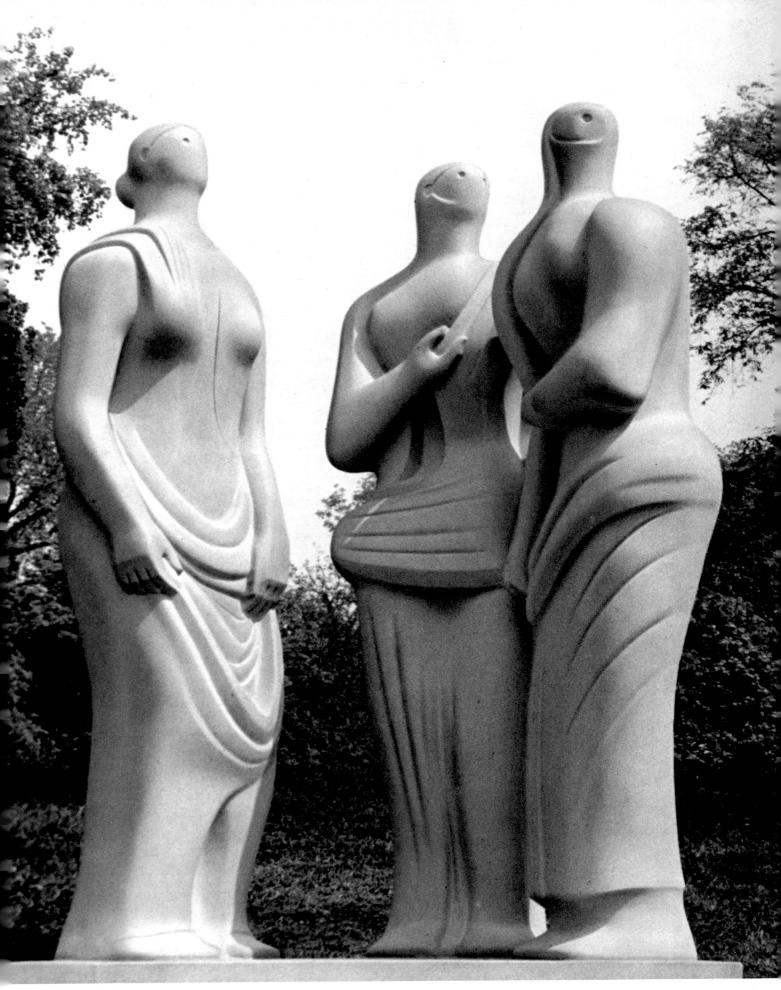

368

369

368 Studies of the
Artist's Child
Etudes de l'enfant
de l'artiste
Das Kind des
Künstlers,
Skizzen · 1947

369 Studies of the
Artist's Child
Etudes de l'enfant
de l'artiste
Das Kind des
Künstlers,
Skizzen · 1946

370 Studies of Hands
Etudes de mains
Hände, Skizzen
1947

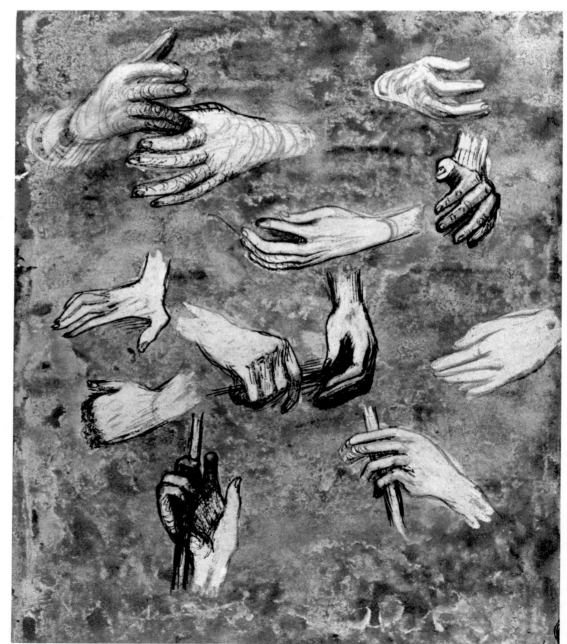

370

371

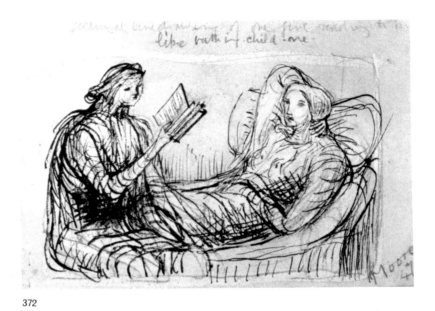

372

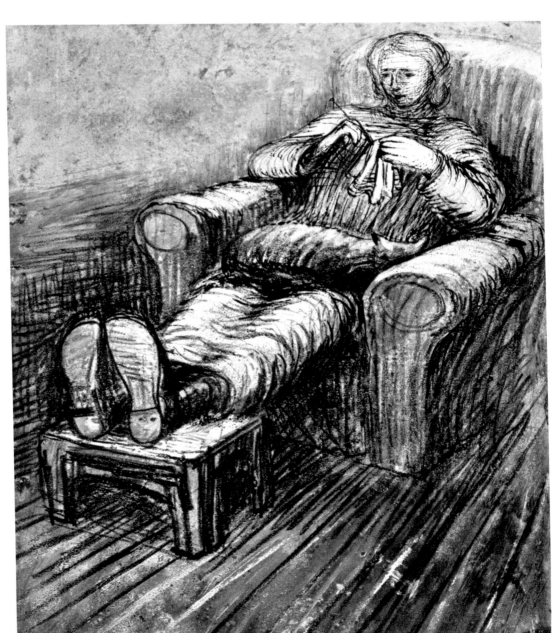

371 Girl Reading
Liseuse
Lesende · 1947

372 Girl Reading to a
Friend · Jeune
fille lisant à
haute voix
Vorlesendes
Mädchen · 1947

373 Seated Figure
Knitting
Tricoteuse
assise
Sitzende
Figur beim
Stricken · 1950

373

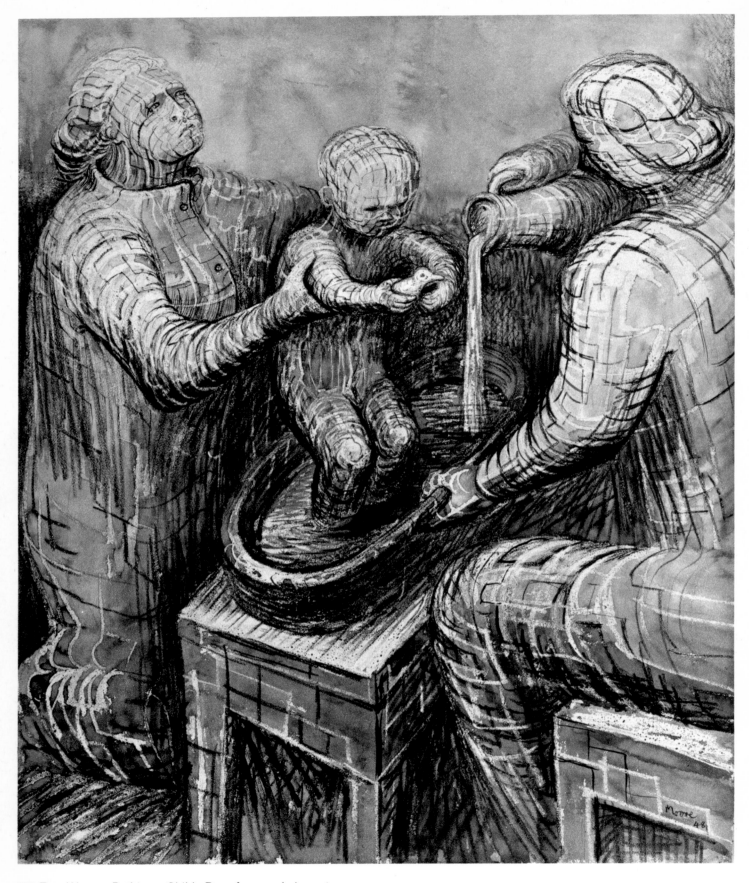

374 Two Women Bathing a Child · Deux femmes baignant
un enfant · Zwei Frauen, die ein Kind baden · 1948

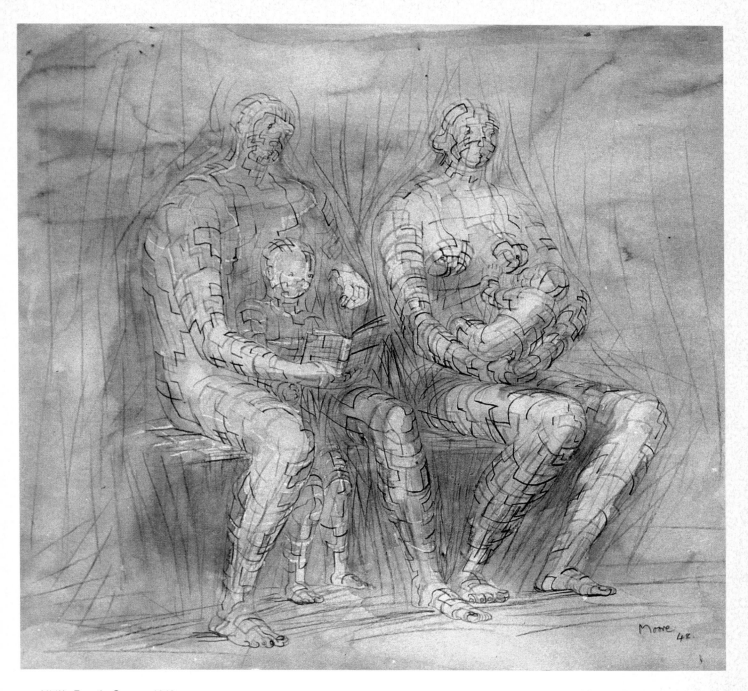

XVII Family Group, 1948

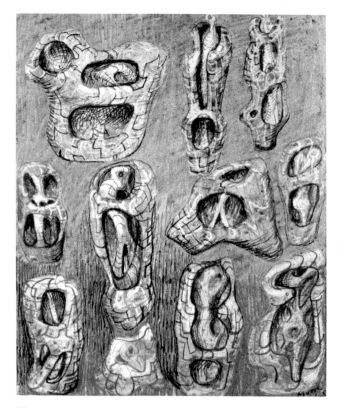

375

377

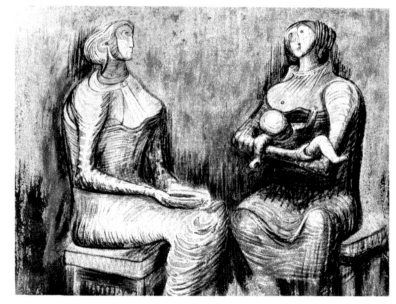

378

375 Ideas for Sculpture: internal and external forms
Idées pour sculptures: formes intérieures et
extérieures · Skizzen zu Plastiken: innere und
äußere Formen · 1948

376 Drawing for Metal Sculpture: internal and external
forms · Dessin pour sculptures en métal: formes
intérieures et extérieures · Zeichnung für
Metallplastiken: innere und äußere Formen · 1948

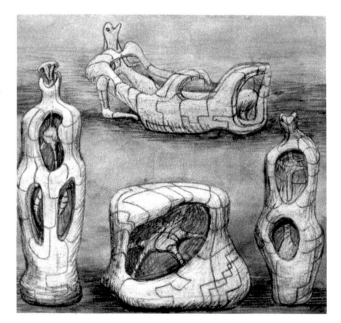

376

377 Seated Figure · Figure assise · Sitzende Figur · 1948

378 Two Women and Child · Deux femmes et un enfant
Zwei Frauen und ein Kind · 1948

379 Women Winding Wool · Femmes qui enroulent de
la laine · Wolle wickelnde Frauen · 1948

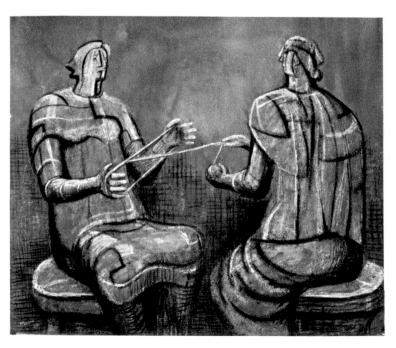

379

380 The Rocking Chair · La chaise
à bascule · Der Schaukelstuhl
1948

381 Seated Figures · Figures assises
Sitzende Figuren · 1948

382 Seated Figure · Figure assise
Sitzende Figur · 1948

383 Family Group · Famille
Familiengruppe · 1948

384 Seated Woman Doing her Hair
Femme assise se coiffant
Sitzende Frau beim
Kämmen · 1948

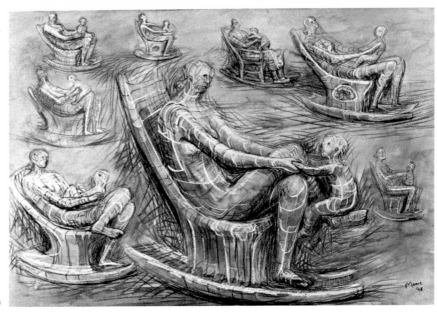

380

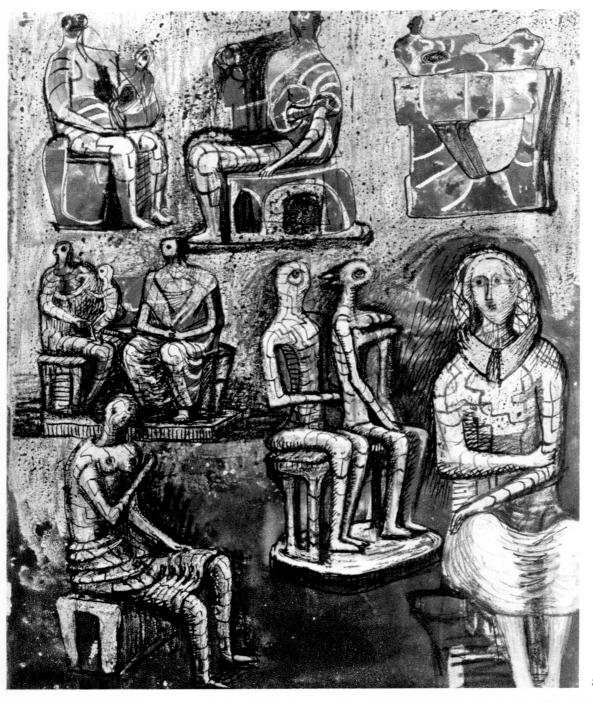

381

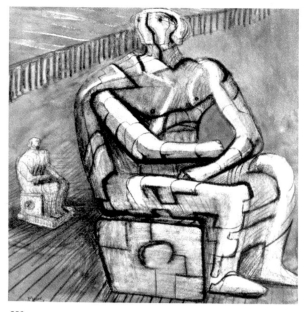

382

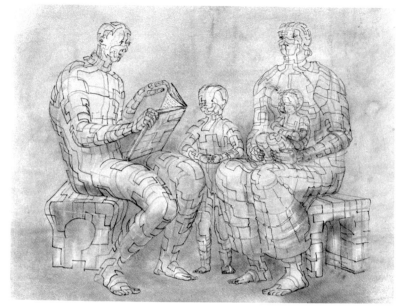

383

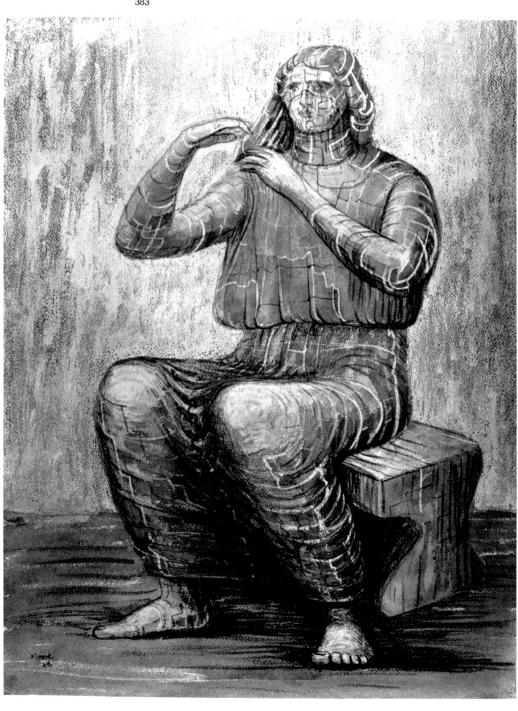

384

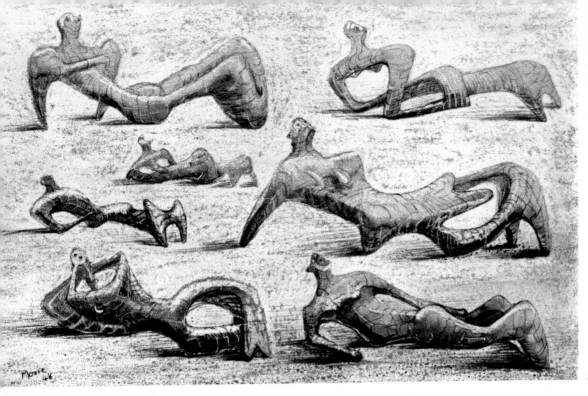

385

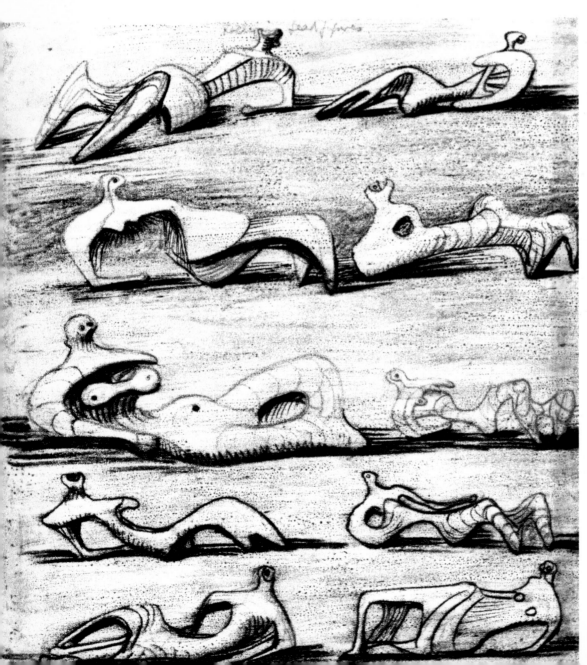

385 Ideas for Metal
Sculpture · Idées
pour sculptures
en métal
Skizzen zu
Metallplastiken
1948

386 Reclining Figures
Figures couchées
Liegende Figuren
1948

386

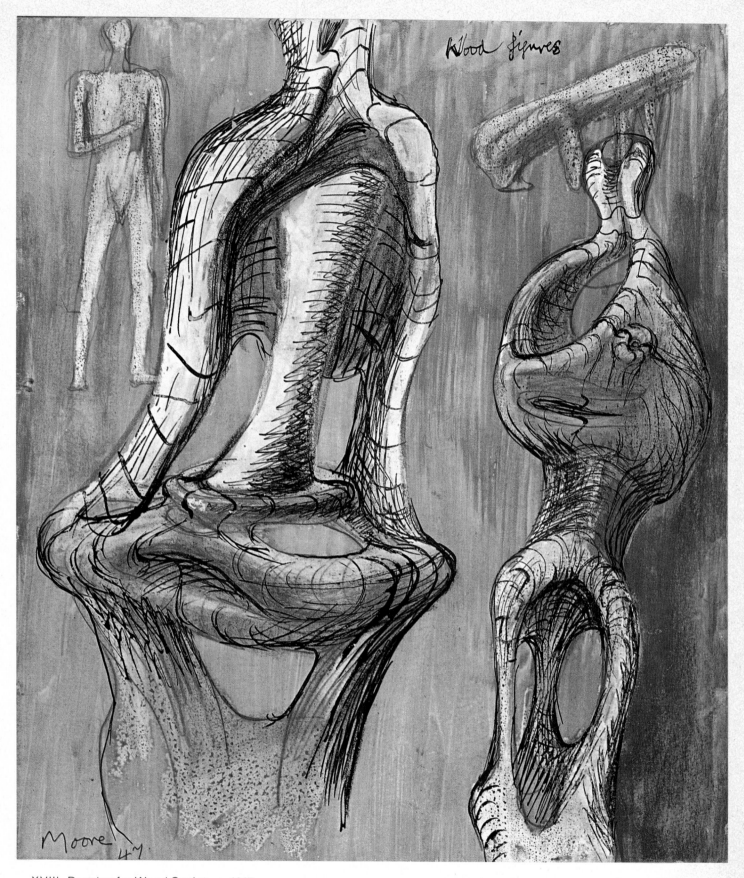

Wood figures

Moore 47

XVIII Drawing for Wood Sculpture, 1947

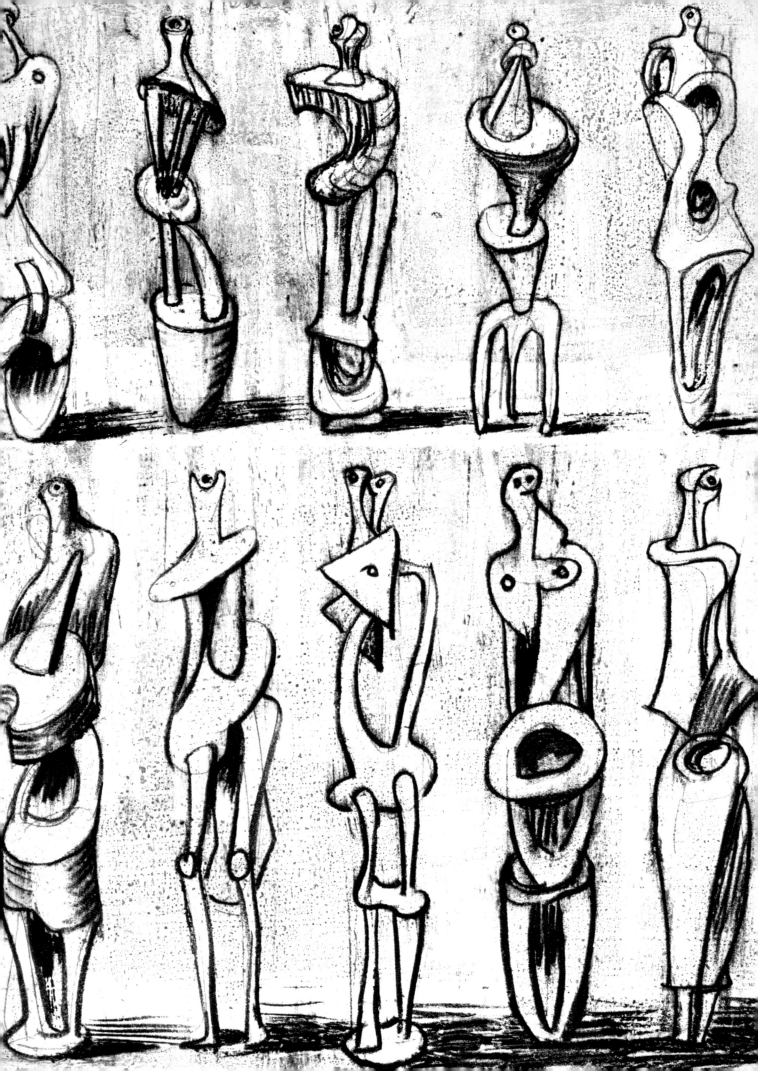

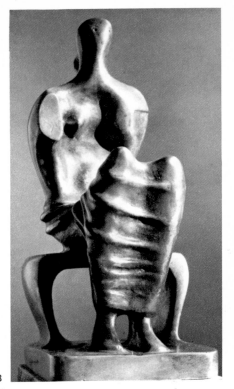

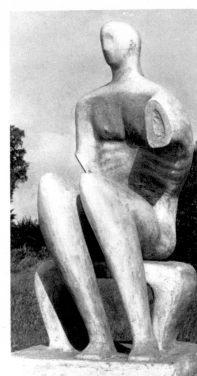

388

389

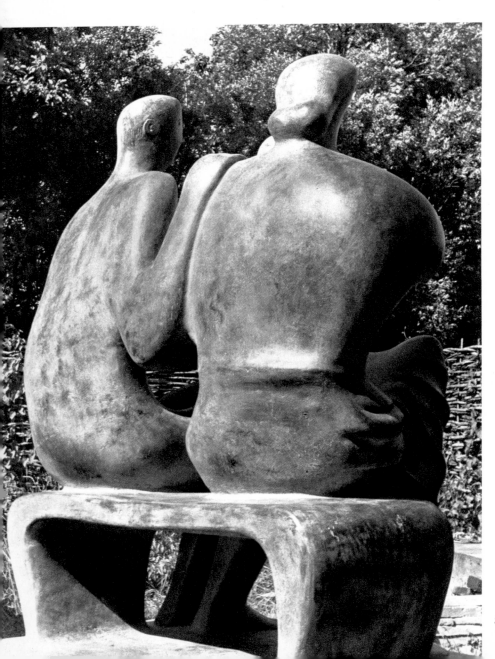

388 Seated Figure · Figure assise
Sitzende Figur · 1949
H. 22.9 cm

389 Seated Man · Homme assis
Sitzender Mann · 1949
H. 1.55 m

390-91 Family Group · Famille
Familiengruppe · 1948–49
H. 1.52 m

390

391

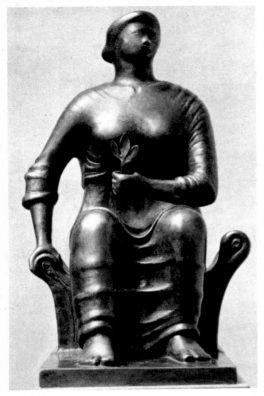

392

394

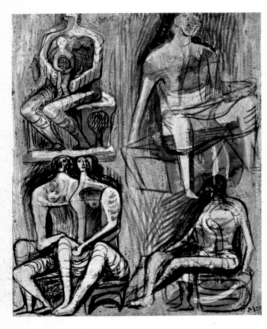

393

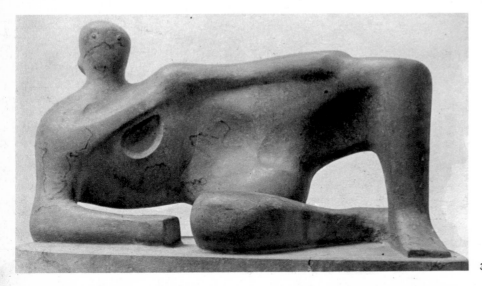

395 396

392 Seated Figure · Figure assise
 Sitzende Figur · 1949 · H. 43.2 cm

393 Seated Figures · Figures assises
 Sitzende Figuren · 1949

394, 396 Claydon Madonna and Child
 Vierge à l'Enfant de Claydon
 Madonna mit Kind in Claydon
 1948–49 · H. 1.22 m

395 Reclining Figure · Figure
 couchée · Liegende Figur · 1949
 L. 76.2 cm

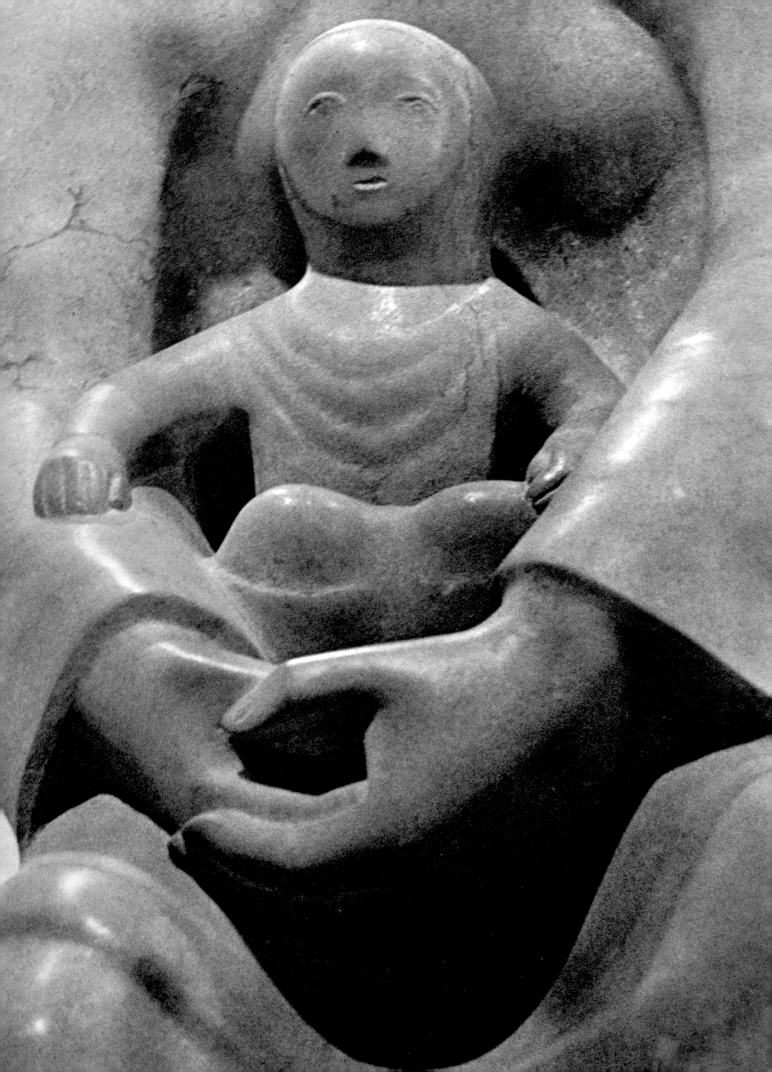

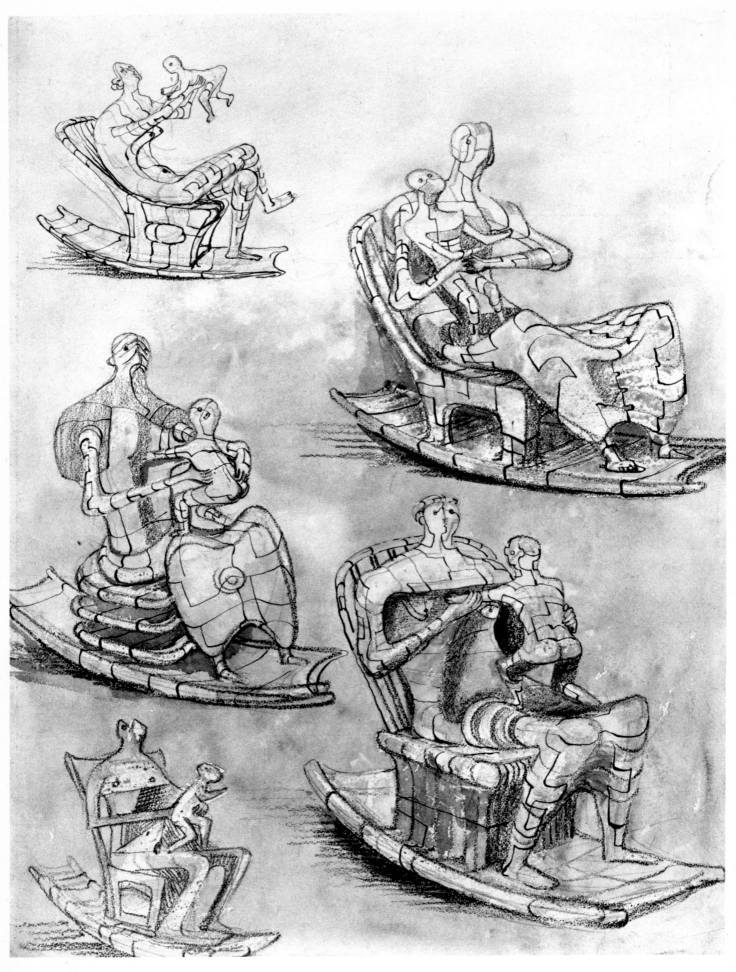

397 Rocking Chairs · Chaises à bascule · Schaukelstühle · 1949

XIX Four Reclining Figures · Quatre figures couchées
Vier liegende Figuren · 1948

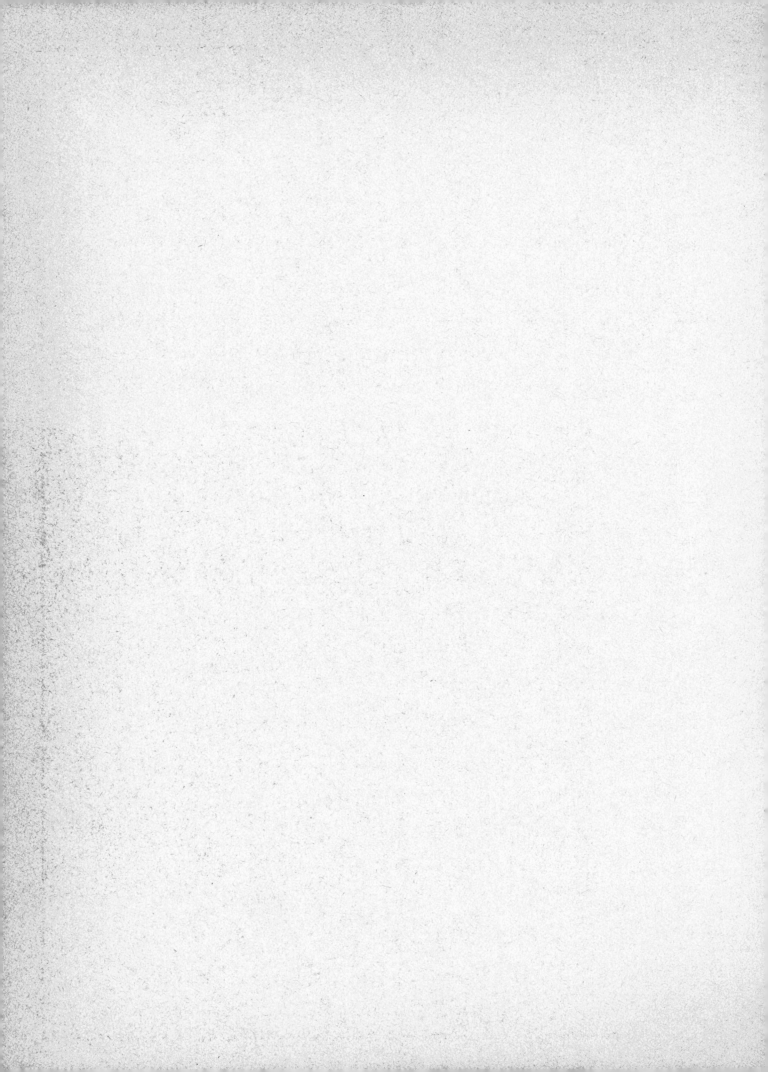

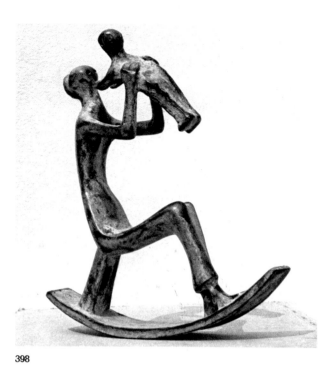

398

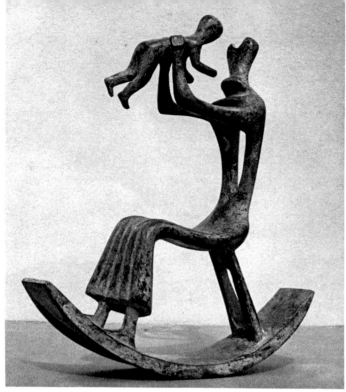

400

398-400 Rocking Chairs · Chaises à bascule · Schaukel-
stühle · 1950 · H. (1) 33.0, (2) 28.0, (3) 31.8 cm

399

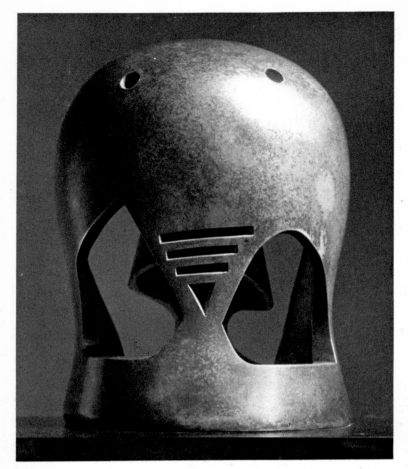

401

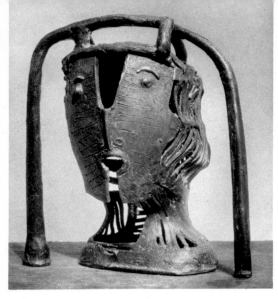

403

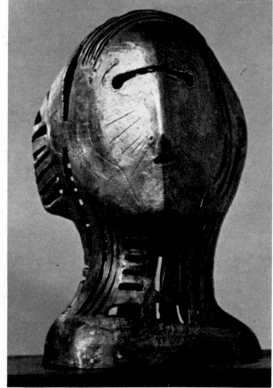

404

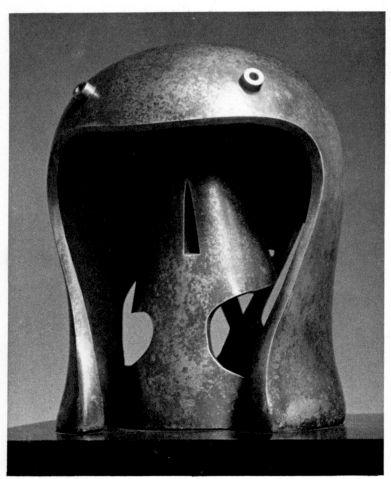

402

403 Maquette for Openwork Head No. 1 · Maquette pour tête ajourée nº 1 · Entwurf für den durchbrochenen Kopf Nr. 1 · 1950 · H. 17.8 cm

404 Openwork Head No. 2 · Tête ajourée nº 2 · Durchbrochener Kopf Nr. 2 · 1950 · H. 39.4 cm

405 Head and Shoulders · Tête et épaules · Kopf und Schultern · 1950 · H. 15.2 cm

401-402 Helmet Head No. 1 · Tête-casque nº 1
Helm-Kopf Nr. 1 · 1950 · H. 34.3 cm

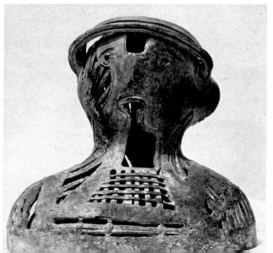

405

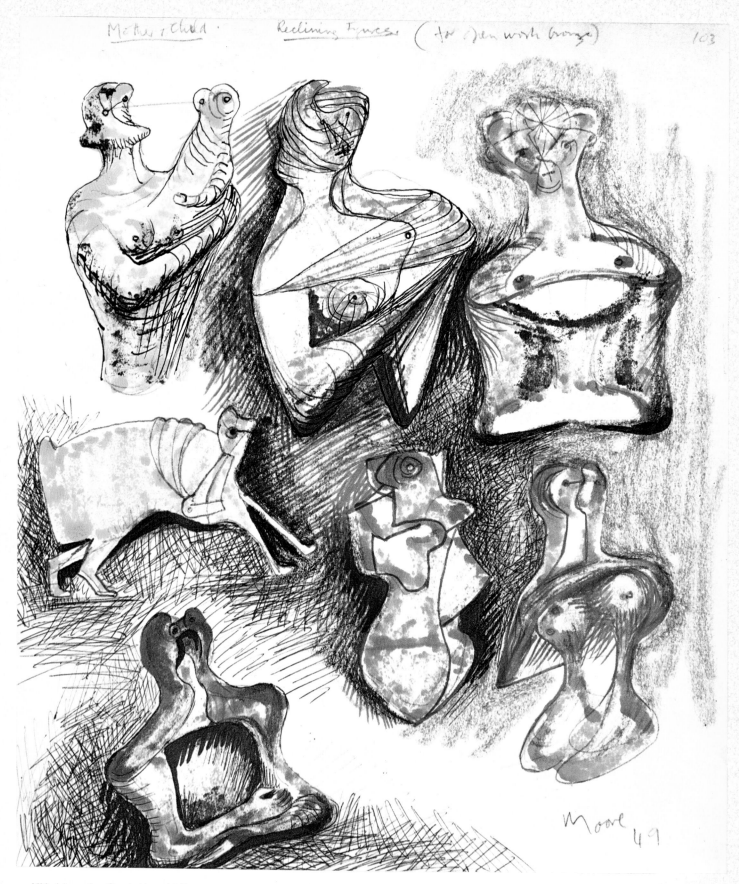

Moore 49

XX Ideas for Sculpture, 1949

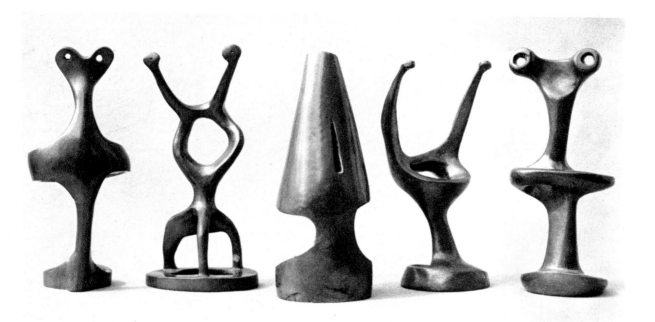

406 Five Figures: interiors
for helmets · Cinq
figures intérieures pour
casques · Fünf Figuren:
Innenformen für Helme
1950 · 12.7 cm

407 Helmet Head No. 2 · Tête-
casque nº 2 · Helm-Kopf
Nr. 2 · 1950 · H. 39.4 cm

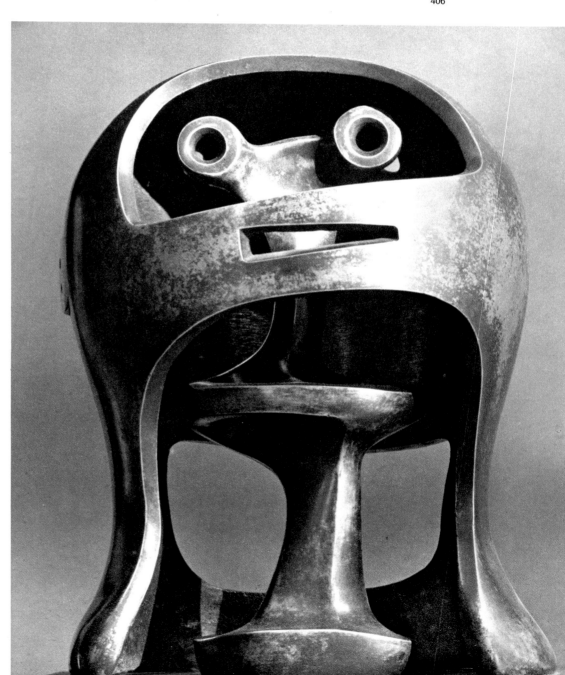

407

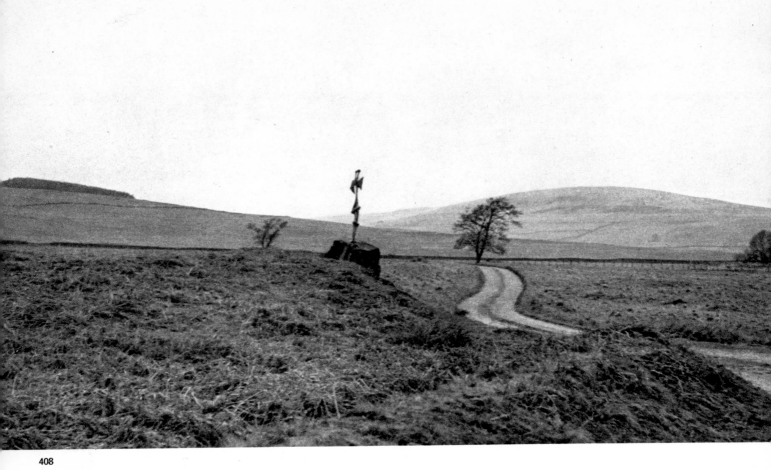

408

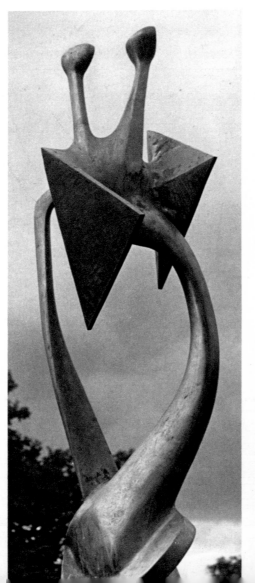

409

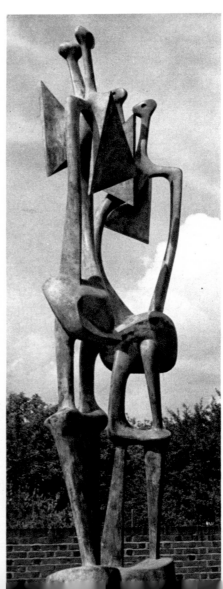

410

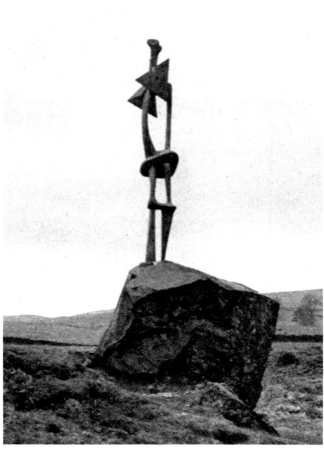

411

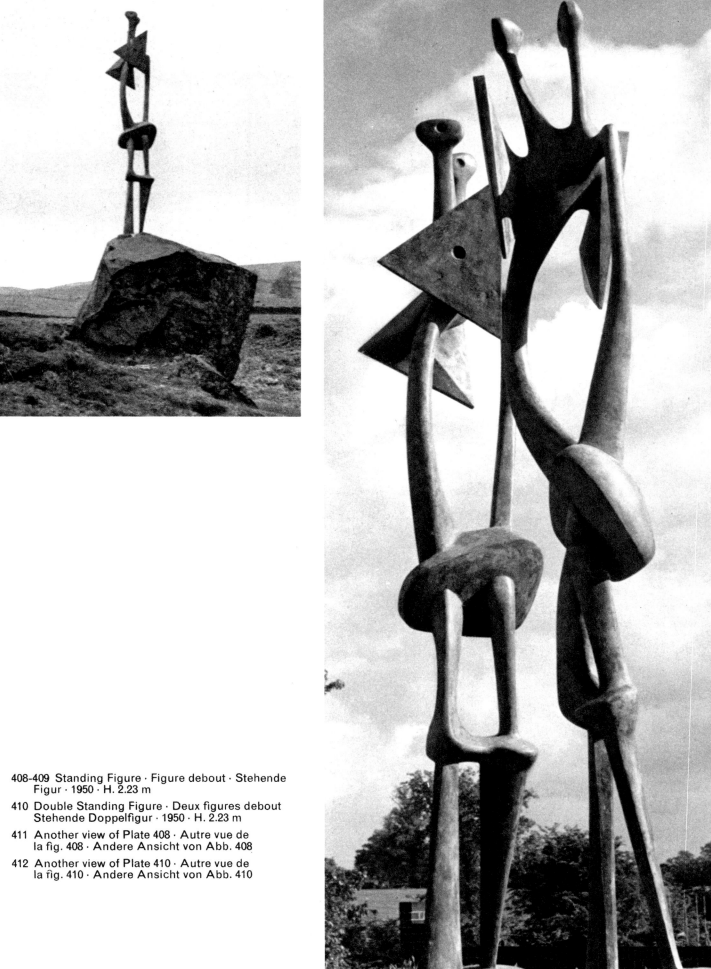

408-409 Standing Figure · Figure debout · Stehende
Figur · 1950 · H. 2.23 m

410 Double Standing Figure · Deux figures debout
Stehende Doppelfigur · 1950 · H. 2.23 m

411 Another view of Plate 408 · Autre vue de
la fig. 408 · Andere Ansicht von Abb. 408

412 Another view of Plate 410 · Autre vue de
la fig. 410 · Andere Ansicht von Abb. 410

412

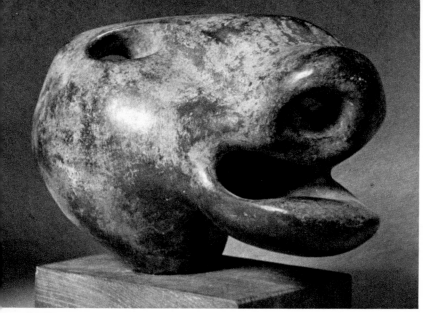

413

413 Animal Head · Tête d'animal · Tierkopf
1951 · L. 30.5 cm

414 Sculpture in Landscape · Sculpture dans un
paysage · Plastik in einer Landschaft · 1950

415-416 Reclining Figure · Figure couchée
Liegende Figur · 1951 · L. 2.31 m

417 Maquette for Reclining Figure · Maquette
pour figure couchée · Entwurf für eine
liegende Figur · 1950 · L. 43.2 cm

418 Maquette No. 1 for Reclining Figure
Maquette nº 1 pour figure couchée
Entwurf Nr. 1 für eine liegende
Figur · 1950 · L. 24.1 cm

419 Detail of Plate 415 · Detail de la fig. 415
Ausschnitt aus Abb. 415

415

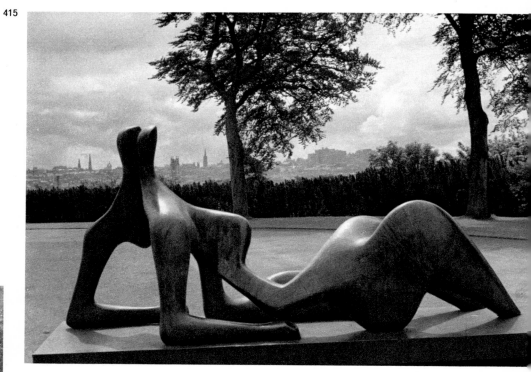

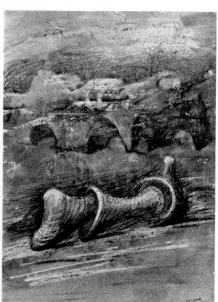

414

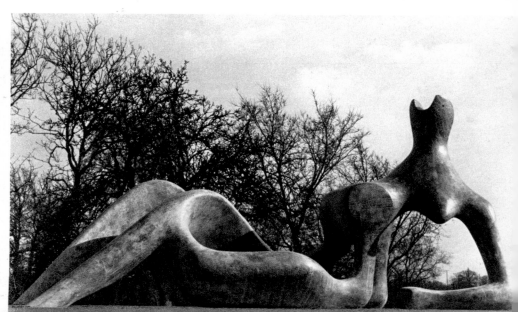

416

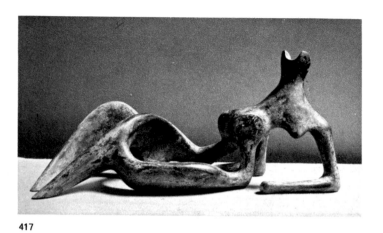

417

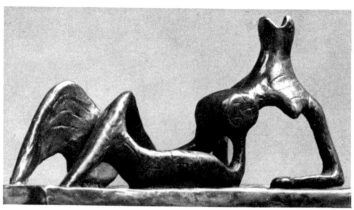

418

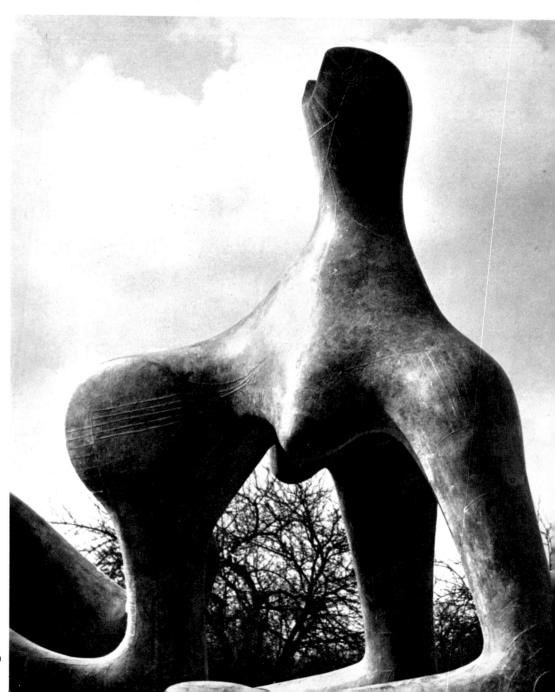

419

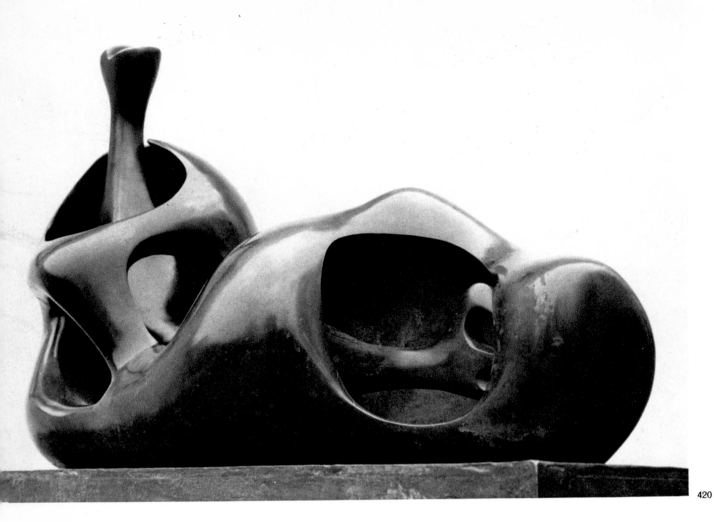

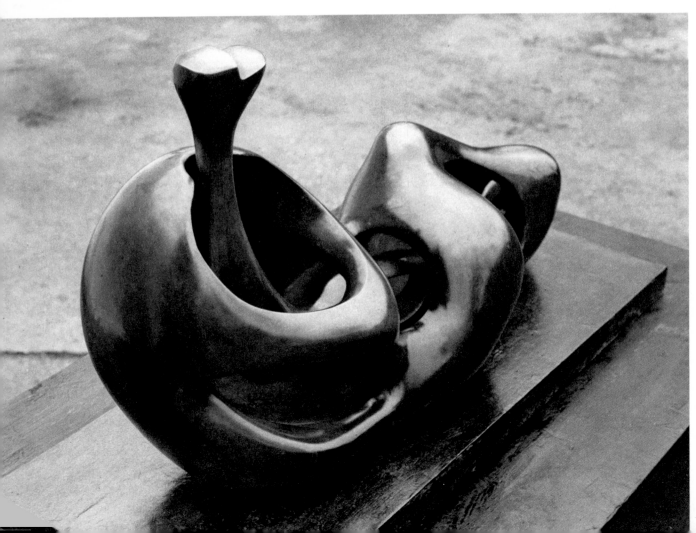

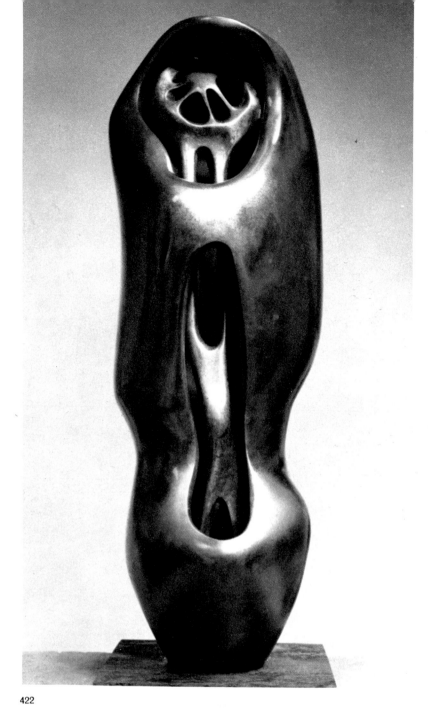

422

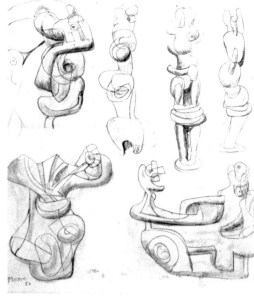

423

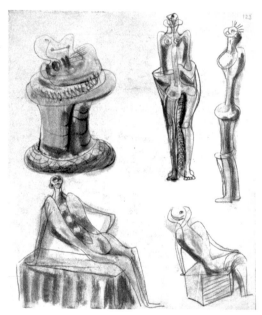

424

420-21 Working Model for Reclining Figure: Internal-External Forms
Maquette de travail pour une figure couchée: formes extérieures
et intérieures · Arbeitsmodell für eine liegende Figur: innere
und äußere Formen · 1951 · L. 53.4 cm

422 Upright Internal Form: Flower · Forme intérieure verticale:
fleur · Aufrechte innere Form: Blume · 1951 · H. 57.2 cm

423 Ideas for Sculpture · Idées pour sculptures · Skizzen zu
Plastiken · 1951

424 Five Figures · Cinq figures · Fünf Figuren · 1951

425 Helmet Heads · Têtes-casques · Helm-Köpfe · 1951

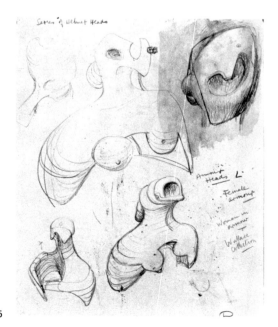

425

426

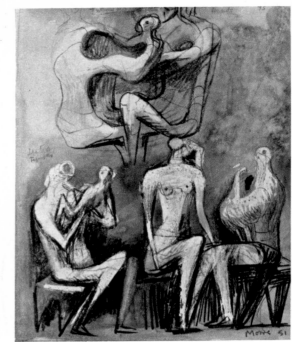

427

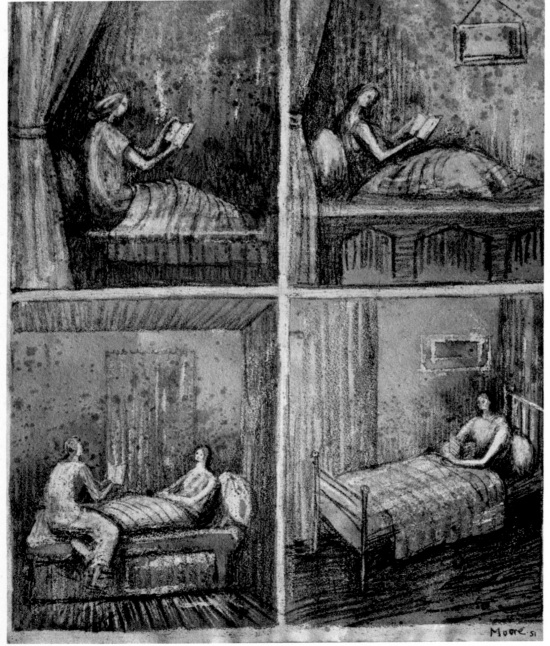

428

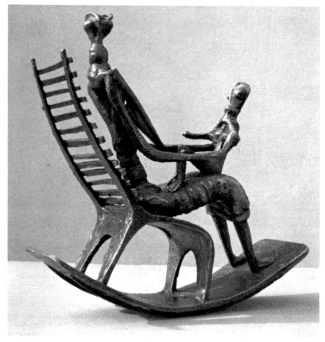

429

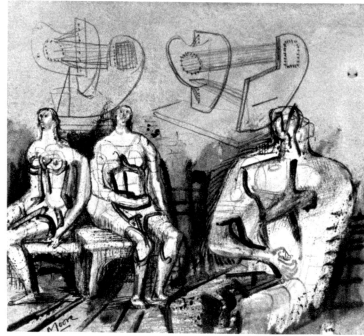

430

426 Reclining Figure in Land-
scape · Figure couchée dans
un paysage · Liegende Figur
in einer Landschaft · 1951

427 Seated Figures · Figures
assises · Sitzende Figuren
1951

428 Woman Reading in Bed
Liseuse au lit
Im Bett lesende Frau
1951

429 Mother and Child on
Ladderback Rocking
Chair · Mère et enfant assis
sur une chaise à bascule
(dossier à barreaux)
Mutter und Kind auf einem
Schaukelstuhl mit Sprossen-
lehne · 1952 · H. 21.0 cm

430 Drawing · Dessin
Zeichnung · 1937–51

431 Mother and Child on Ladder-
back Chair · Mère et enfant
assis sur une chaise avec
dossier à barreaux
Mutter und Kind auf einem
Stuhl mit Sprossenlehne
1952 · H. 40.7 cm

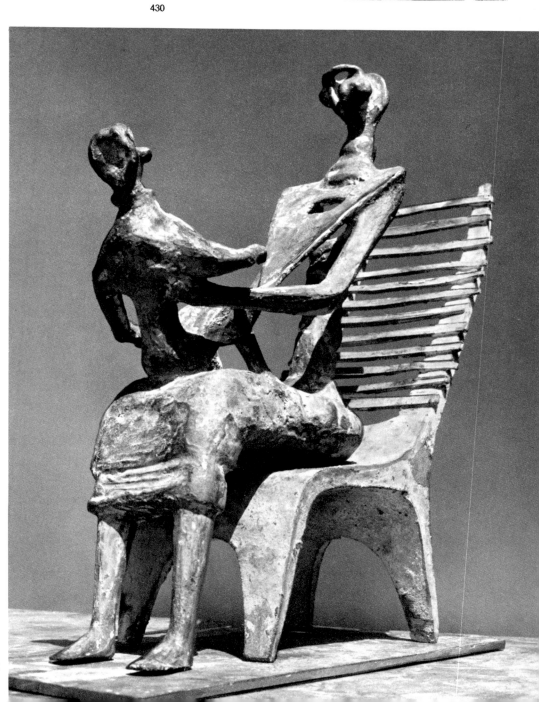

431

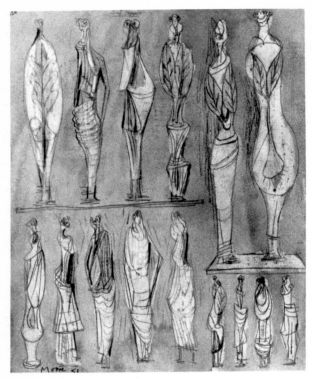

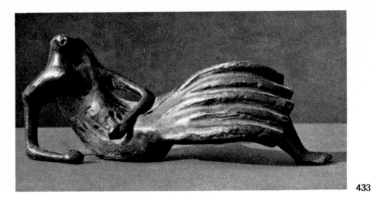

433

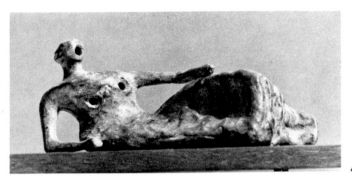

434

432

435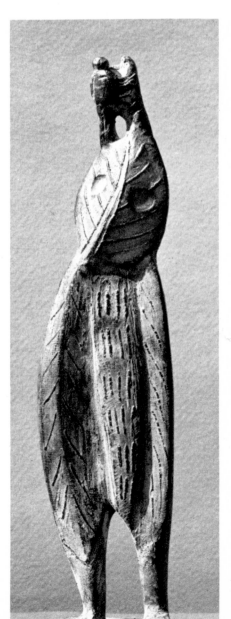

436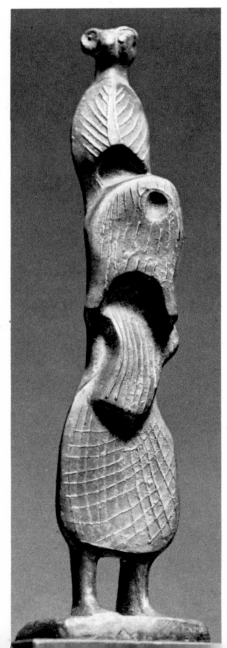

432 Leaf Figures · Figures
feuillues · Blattfiguren
1951

433 Reclining Figure No. 5
Figure couchée n° 5
Liegende Figur Nr. 5
1952 · L. 21.6 cm

434 Reclining Figure No. 3
Figure couchée n° 3
Liegende Figur Nr. 3
1952 · L. 21.0 cm

435 Leaf Figure No. 1
Figure feuillue n° 1
Blattfigur Nr. 1
1952 · H. 25.4 cm

436 Leaf Figure No. 2
Figure feuillue n° 2
Blattfigur Nr. 2
1952 · H. 25.4 cm

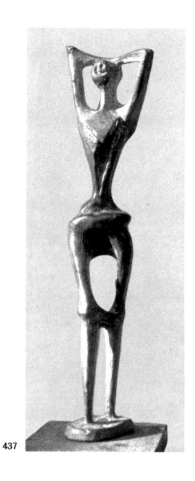

437

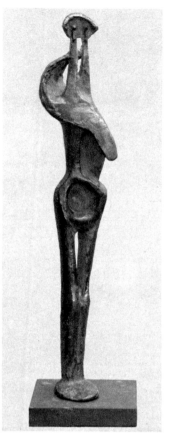

438

437-39 Standing Figures Nos. 1, 2, 4 · Figures debout nᵒˢ 1, 2, 4
Stehende Figuren Nr. 1, 2, 4 · 1952 · H. (1) 24.2, (2) 28.0,
(4) 24.8 cm

440 Half Figure · Demi-figure · Halbfigur · 1952 · H. 17.2 cm

441 Standing Girl · Jeune fille debout · Stehendes Mädchen
1952 · H. 1.52 m

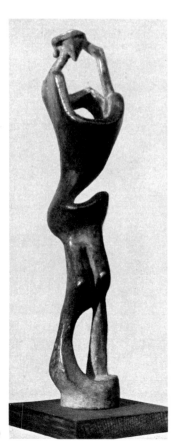

439

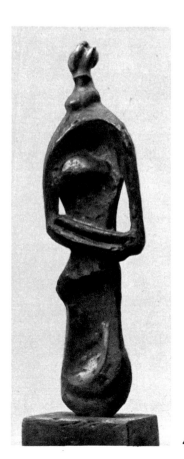

440

441

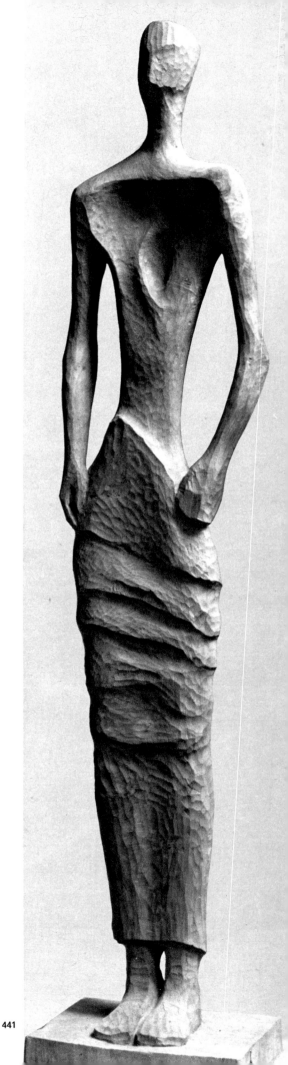

442

442 Relief No. 2 · Relief n° 2 · Relief Nr. 2
1952 · H. 11.4 cm

443 Mother and Child: Corner sculpture No. 2
Mère et enfant: sculpture d'angle n° 2
Mutter und Kind: Eckskulptur Nr. 2
1952 · H. 17.8 cm

444 Goat's Head · Tête de chèvre · Ziegenkopf
1952 · H. 20.4 cm

443

444

XXI Two Women and a Child, 1951

445 Relief No. 1 · Relief n⁰ 1
Relief Nr. 1 · 1952 · H. 12.1 cm

446 Helmet Head and Shoulders
Tête-casque et épaules
Helm-Kopf und Schultern
1952 · H. 16.5 cm

445

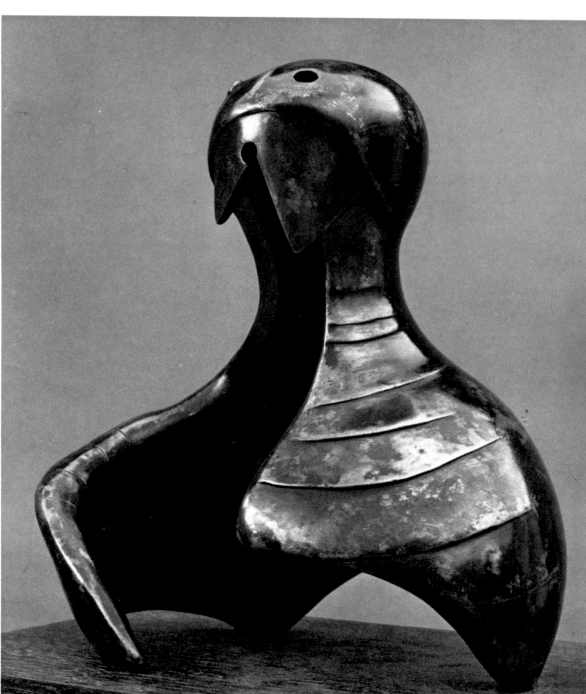

446

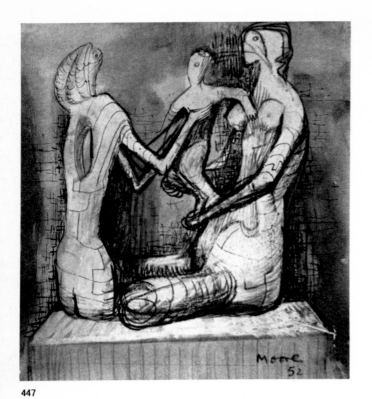

447

447 Two Women and Child · Deux femmes et enfant
Zwei Frauen mit einem Kind · 1952

448 Hands Relief No. 1 · Mains, relief, nº 1
Hände, Relief, Nr. 1 · 1952 · H. 33.0 cm

448

1953-1959

FIVE YEARS AFTER COMPLETING the last of the *Family Group* series, Moore made another seated couple, *King and Queen (450–1)* which has an altogether different significance. Like *Standing Figure* (see *408* and *411*), a cast of this group has a setting on the Scottish heath that belongs to W. J. Keswick. Moore's work always looks well on an outdoor site, but whereas a wild and lonely setting is ideal for *Standing Figure*, where it looks alert and watchful and assumes the meaning of a guardian spirit, the other is perhaps more at home in the formal setting of the sculpture park at Middleheim, where another cast is to be seen. At Shawhead, the royal couple acquire a pathos not intended by the sculptor, as if they have been deserted by their subjects.

The four massive forms carved out of Portland stone for the screen on the Bond Street façade of Time-Life's London office are of more service to the building than the building is to them *(455–7)*. The stone frame in which they are set tends to reduce the sense of their bulk, and, since they are in any case two storeys up, their weighty grandeur can only be glimpsed and surmised by the passer-by.

Draped Reclining Figure (458–63) is one of the noblest of his Nature goddesses, and is closer to the human effigy than most of the figures in which he personifies natural forces. Before making this figure his large bronzes had a smooth, metallic gleam, but here he has found a distinctive use for rough texture. His treatment of the creased drapery brings it into a poetic association with the earth's furrowed surface. *Draped Torso (464–5)* is a cast of the middle section of *Draped Reclining Figure*, fixed in an upright position and open at both ends. This emphatic display of hollowness in no way modifies the solidity of the conception.

Warrior with Shield (474–7) is one of the few male figures which have appeared in his sculpture, and it discloses an overt concern with the miseries of war which brings it unusually close to Expressionism.

Completed in the same year as the vertical *Internal and External Forms (482, 484* and *485)*, the powerful *Reclining Figure, External Form (481)*

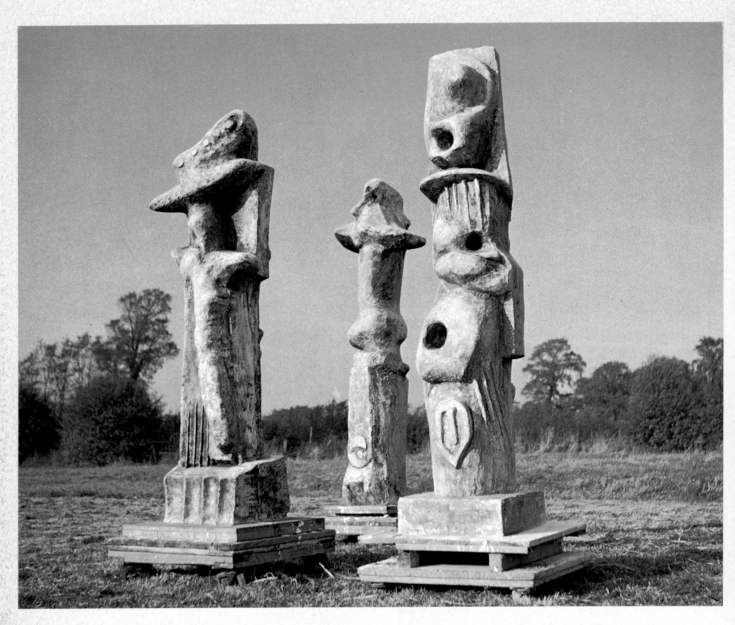

XXII Upright Motives 8, 1 and 5, 1955. H. 2.44 m approx

has a closer formal relationship with the outer shell of the two-part reclining figure in *420–1*. It sharply conveys the sense of a protective pod whose shape has been determined by the form that grew inside it – a living pod partly destroyed by the process of delivery and still almost visibly quivering in the aftermath of the birth-pangs.

The *Upright Motives*, part column and part figure *(503–7)* include 'Glenkiln Cross', which is among Moore's greatest achievements. In connection with three of these Motives acquired by the Kröller–Müller Museum, he has remarked: 'When I came to carry out some of these maquettes in their final full size, three of them grouped themselves together, and in my mind, assumed the aspect of a Crucifixion scene, as though framed against the sky above Golgotha. But I do not especially expect others to find this symbolism in the group. . .' [see p. 28]

212

449 Seated Figure · Figure assise · Sitzende Figur · 1952–53 · H. 1.04 m

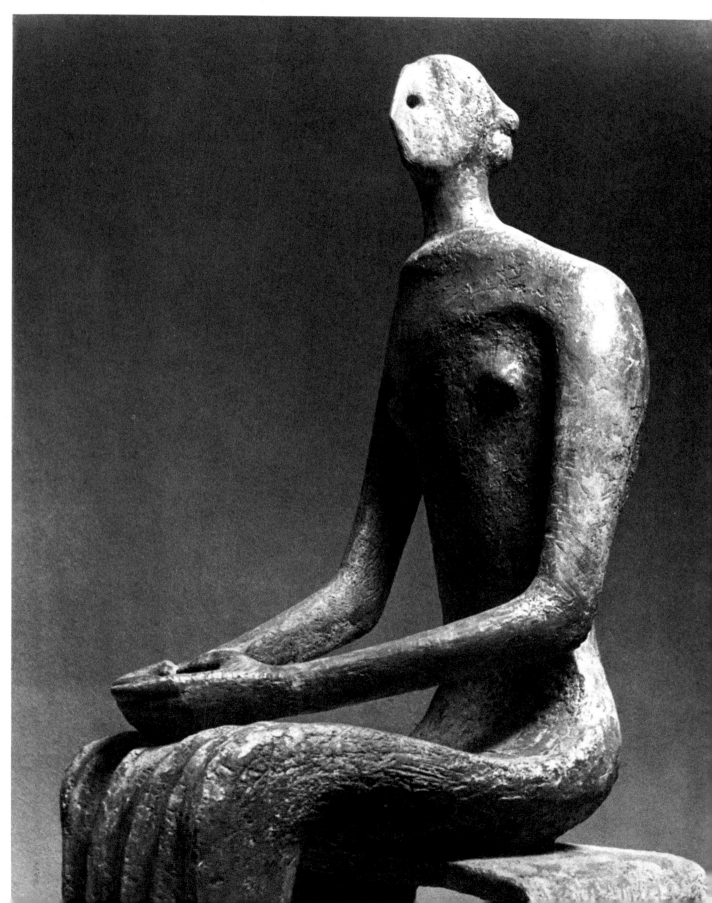

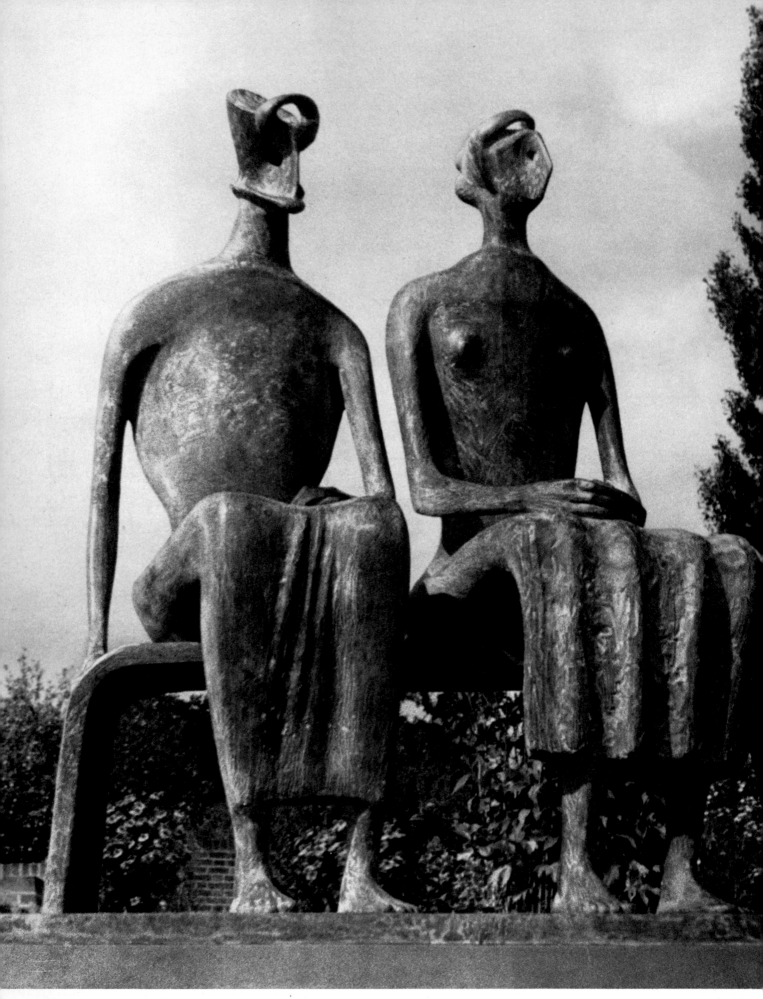

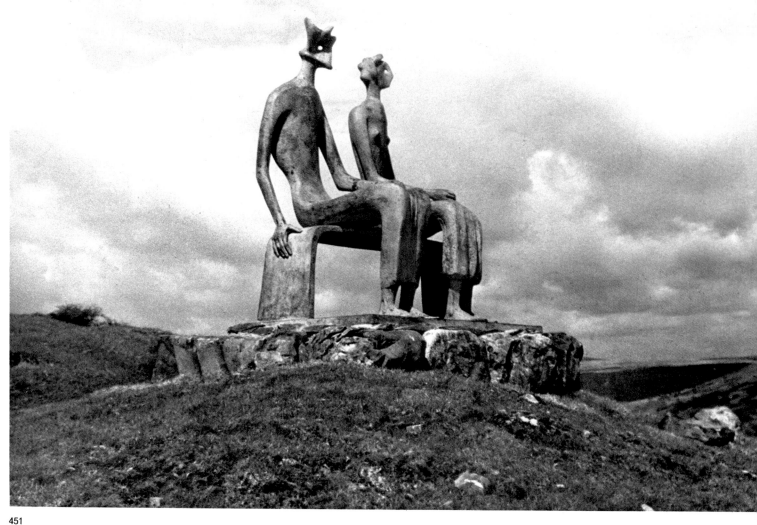

451

450-51, 454 King and Queen
Roi et reine
König und Königin
1952–53 · H. 1.64 m

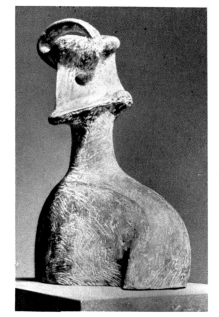

453

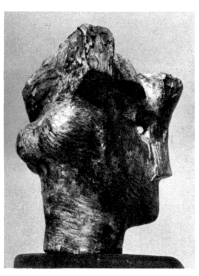

452

452 Study for Head of Queen
Etude pour la tête de la
reine · Studie zum Kopf
der Königin · 1952–53
H. 22.2 cm

453 Head of King · Tête du roi
Kopf des Königs · 1952–53
H. 57.2 cm

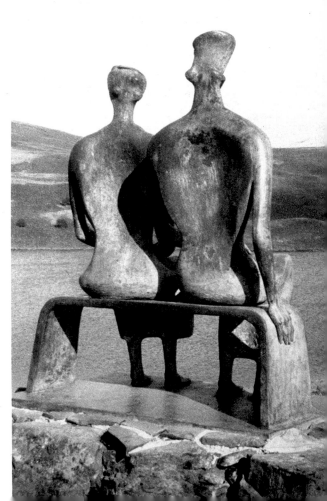

454

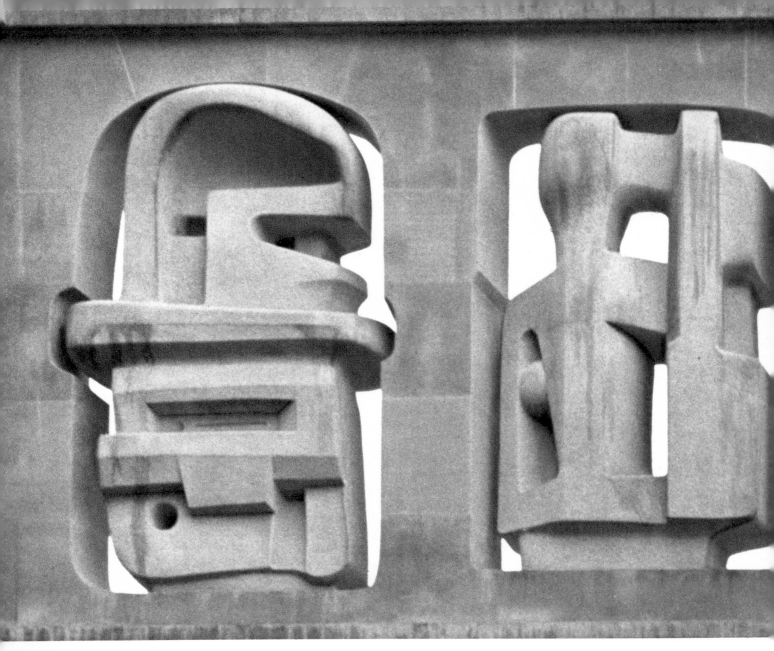

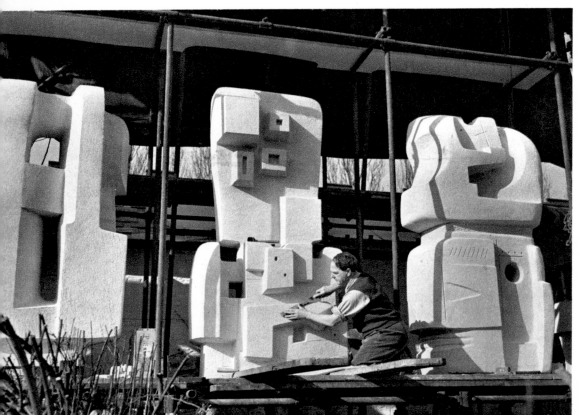

455-57 Time/Life Screen
Panneaux de l'immeuble
Time/Life · Balustrade
am Time/Life-Gebäude
1952–53 · 8.08 m

456

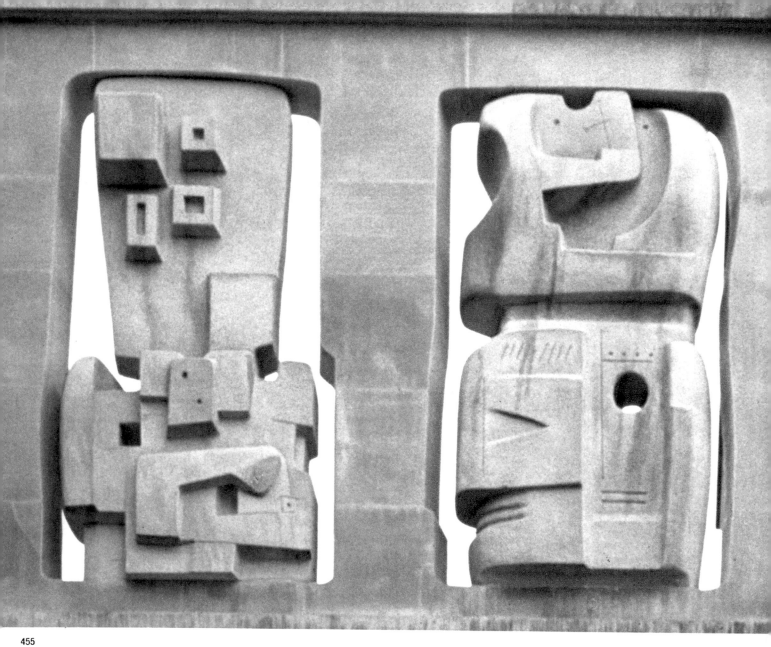

455

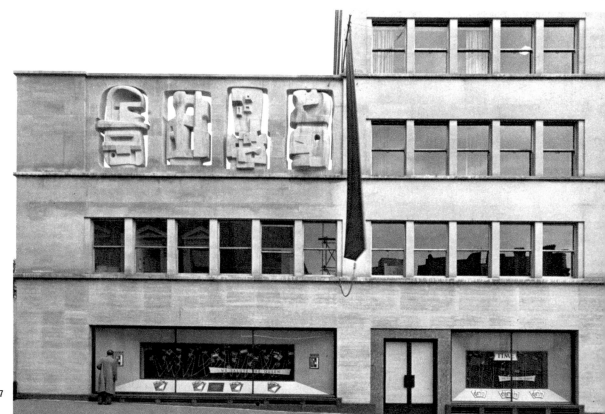

457

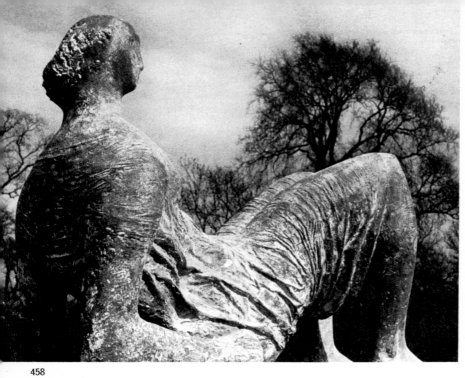

458

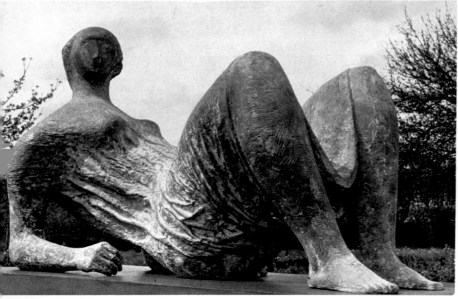

459

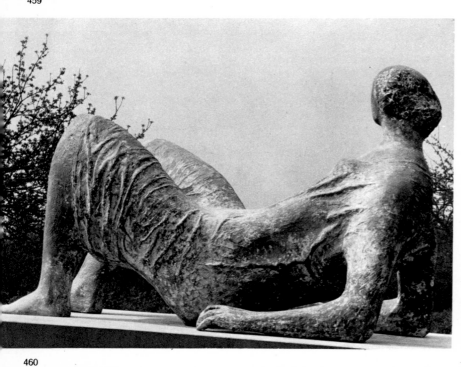

460

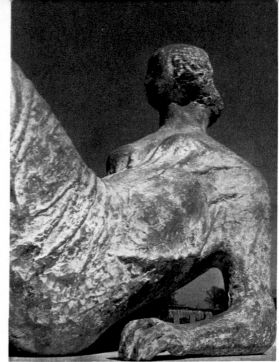

461

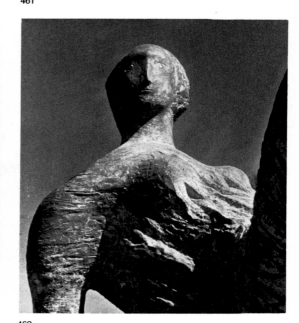

462

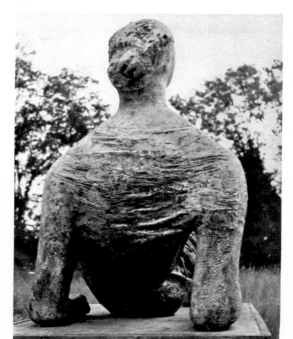

463

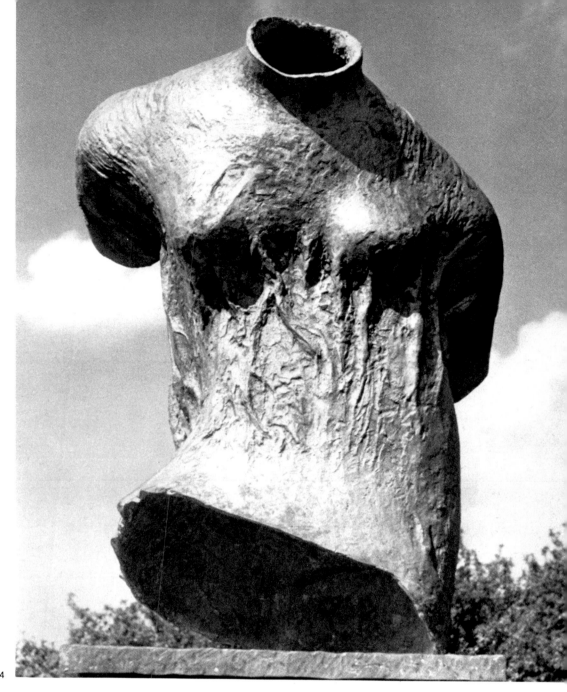

464

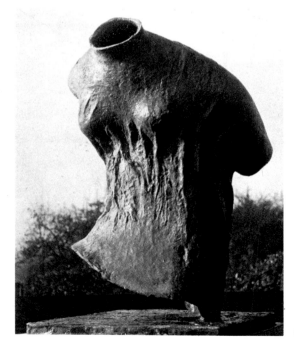

458-63 Draped Reclining Figure · Figure drapée couchée
Bekleidete liegende Figur · 1952–53 · L. 1.57 m

464-65 Draped Torso · Torse drapé · Bekleideter Torso
1953 · H. 88.9 cm

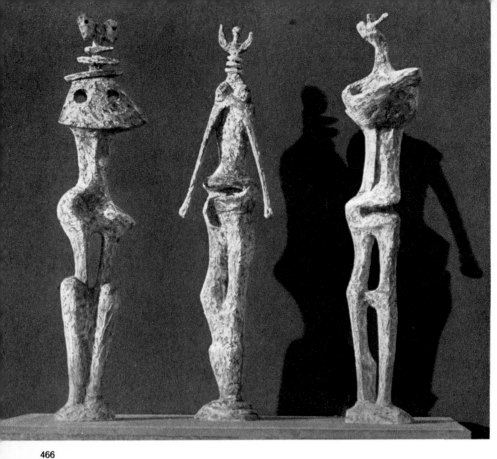

466

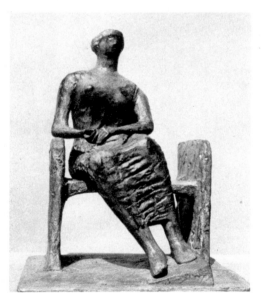

467

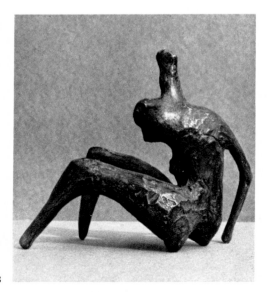

468

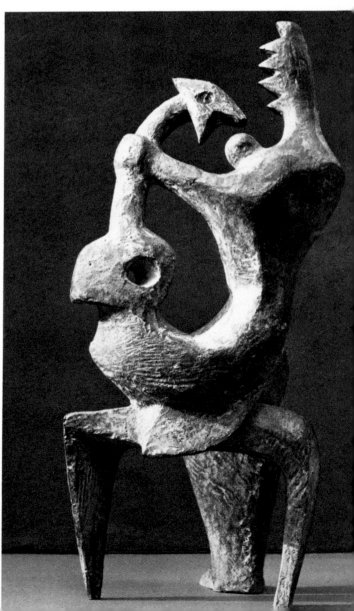

469

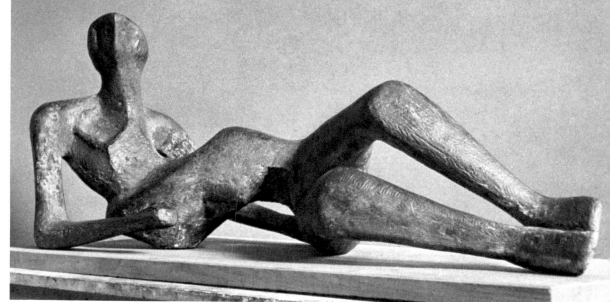

470

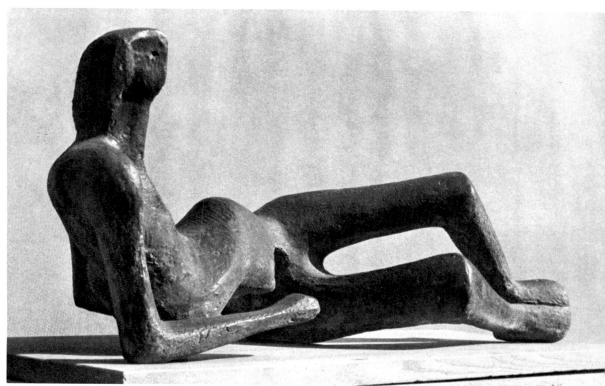

471

472

473

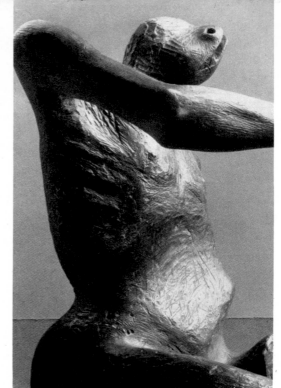

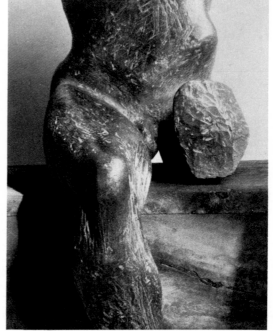

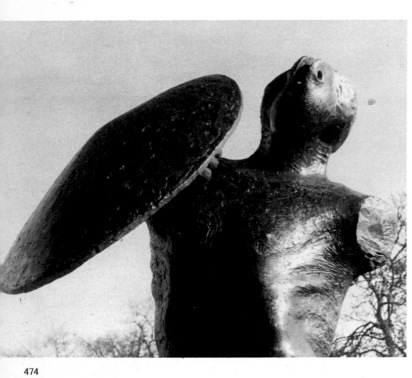

474

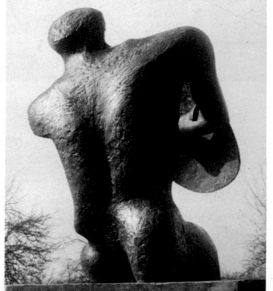

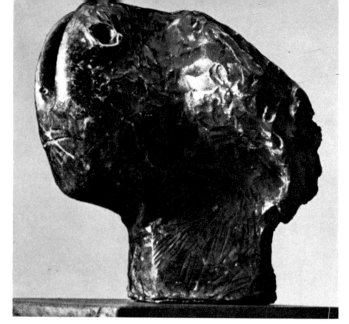

478

473 Maquette for Warrior with Shield
Maquette pour Guerrier au bouclier
Entwurf für Krieger mit Schild
1952–53 · H. 19.7 cm

474-77 Warrior with Shield · Guerrier
au bouclier · Krieger mit Schild
1953–54 · H. 1.52 m

478 Warrior's Head · Tête de guerrier
Kopf eines Kriegers · 1953 · H. 25.4 cm

479 Another view of Plate 474
Autre vue de la fig. 474
Andere Ansicht von Abb. 474

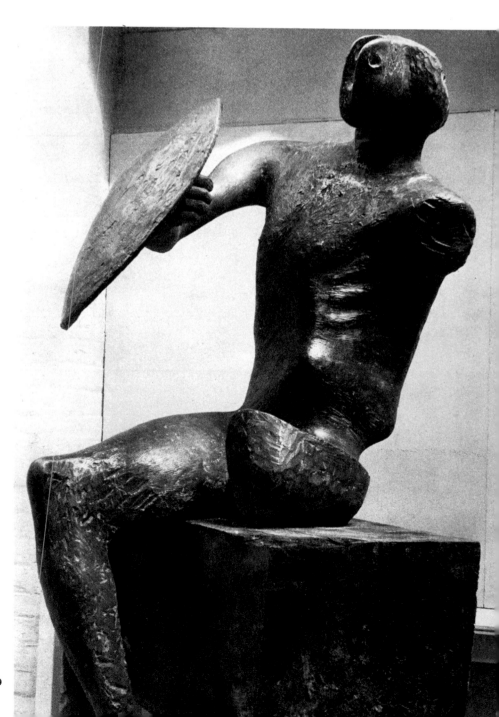

479

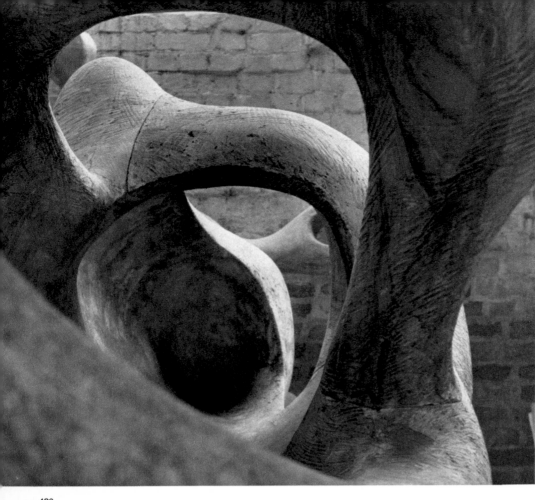

480-81 Reclining Figure,
External Form · Figure
couchée, forme extérieure
Liegende Figur, äußere
Form · 1953–54 · L. 2.15 m

480

481

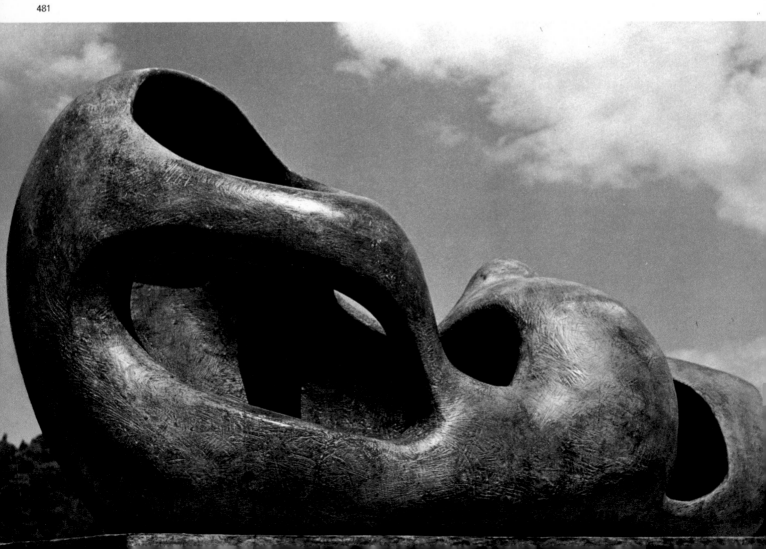

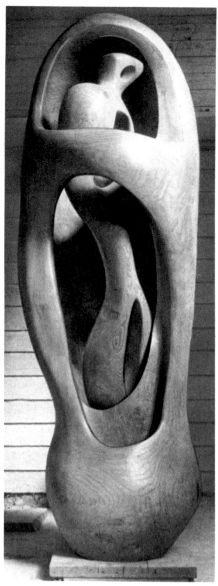

482

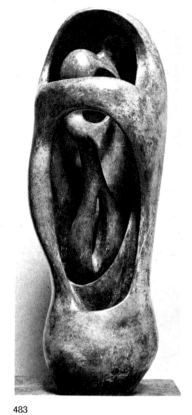

483

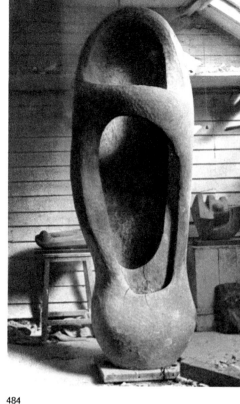

484

482 Internal and External Forms
Formes intérieures et
extérieures · Innere und
äußere Form · 1953–54
H. 2.64 m

483 Working Model for Internal
and External Forms · Maquette
de travail pour Formes
intérieures et extérieures
Arbeitsmodell für innere und
äußere Form · 1951 · H. 61.6 cm

484 Another view of Plate 482 (in
progress) · Autre vue de la fig.
482 (en cours de réalisation)
Andere Ansicht von Abb. 482 (in
unvollendetem Zustand)

485 Detail of Plate 482 · Détail de
la fig. 482 · Ausschnitt aus
Abb. 482

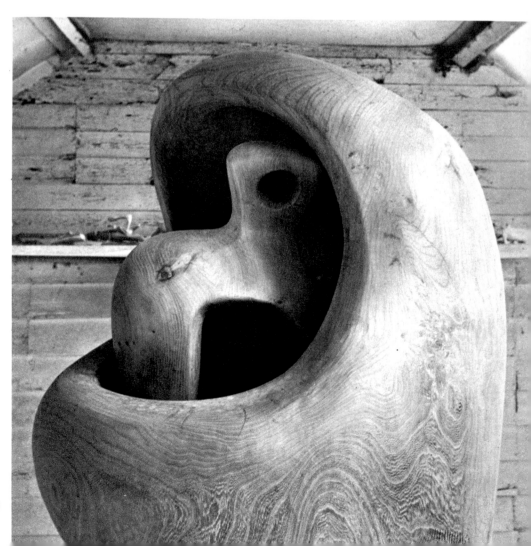

485

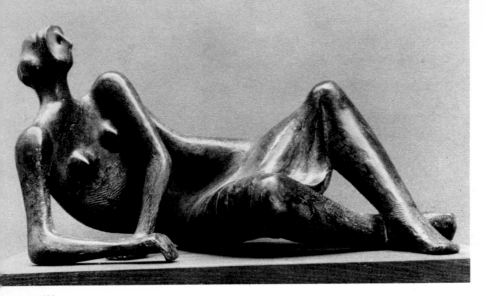

486

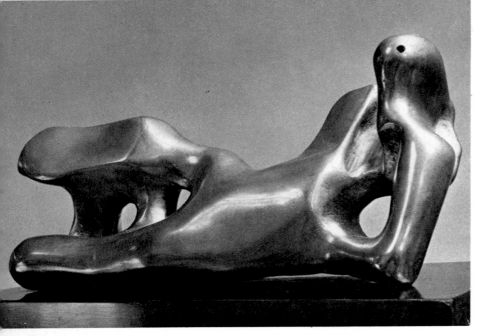

487

488

489

486 Reclining Figure No. 4
Figure couchée n° 4
Liegende Figur Nr. 4
1954 · L. 58.5 cm

487 Reclining Figure No. 6
Figure couchée n° 6
Liegende Figur Nr. 6
1954 · L. 21.6 cm

488 Fabulous Animals · Animaux
fantastiques · Fabeltiere
1954

489 Bird Table · Volière
Vogelhaus · 1954
H. 1.55 m

490

490 Bird · Oiseau · Vogel · 1955
L. 14.0 cm

491 Harlow Family Group
Famille: groupe pour
Harlow · Familiengruppe
von Harlow · 1954–55
H. 1.64 m

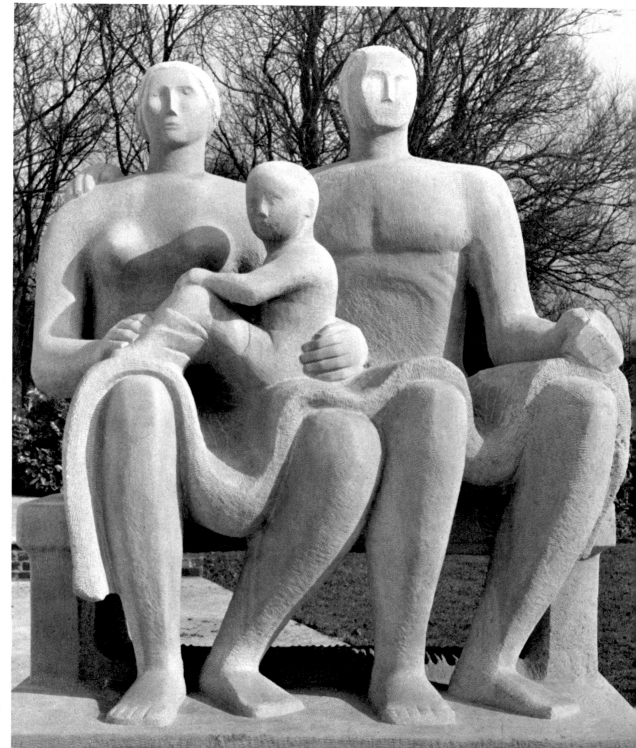

491

492

493

492 Wall Relief : Maquette No. 2 · Relief
mural : maquette nº 2 · Wandrelief:
Entwurf Nr. 2 · 1955 · L. 44.5 cm

493 Wall Relief: Maquette No. 6 · Panneau
mural: maquette nº 6 · Wandrelief:
Entwurf Nr. 6 · 1955 · L. 47.0 cm

494 Wall Relief: Maquette No. 7 · Panneau
mural: maquette nº 7 · Wandrelief:
Entwurf Nr. 7 · 1955 · L. 47.0 cm

495-96 Wall Relief · Relief mural
Wandrelief · 1955 · L. 19.20 m

494

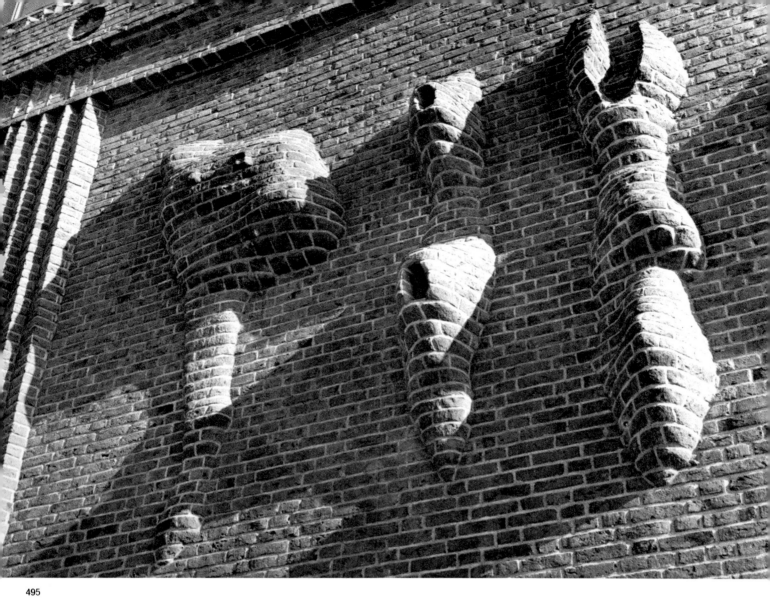

495

496

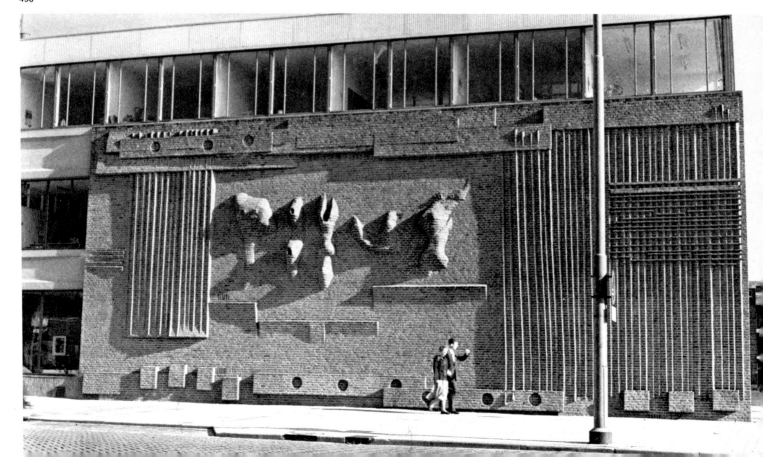

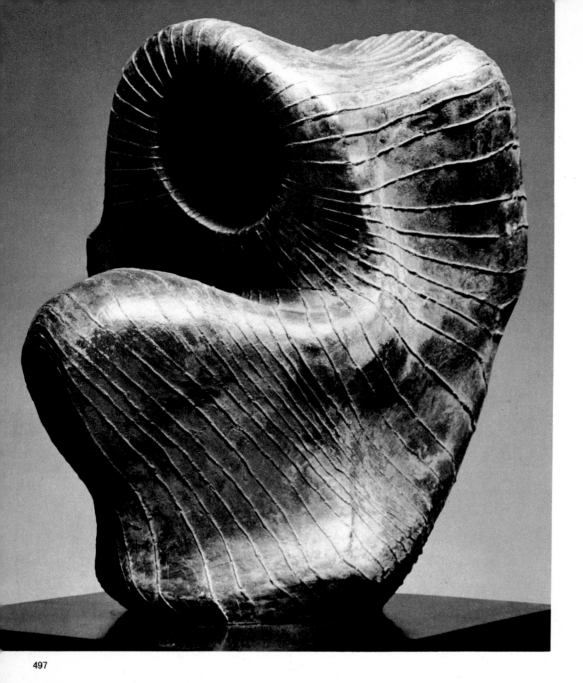

497

497 Head: Lines · Tête: lignes
Kopf mit Linien · 1955
H. 29.9 cm

498 Mother and Child: petal
skirt · Mère et enfant: la
jupe de pétales · Mutter
und Kind im Blumenblatt-
rock · 1955 · H. 16.5 cm

499 Another view of Plate 497
Autre vue de la fig. 497
Andere Ansicht von Abb.
497

500-501 Seated Figure: Arm-
less · Figure assise,
sans bras · Sitzende
armlose Figur · 1955
H. 44.5 cm

502 Three Forms, Relief
Trois formes, relief
Drei Formen, Relief
1955 · H. 19.1 cm

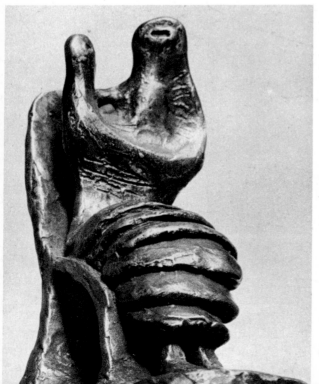

498

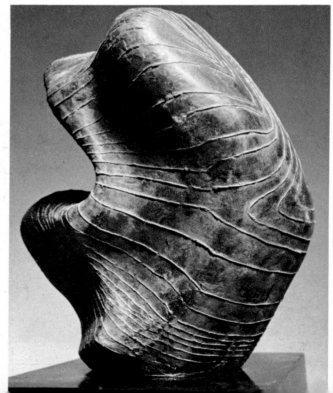

499

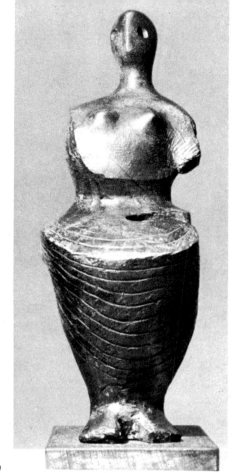

500

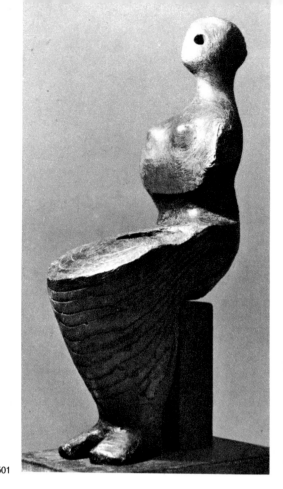

501

502

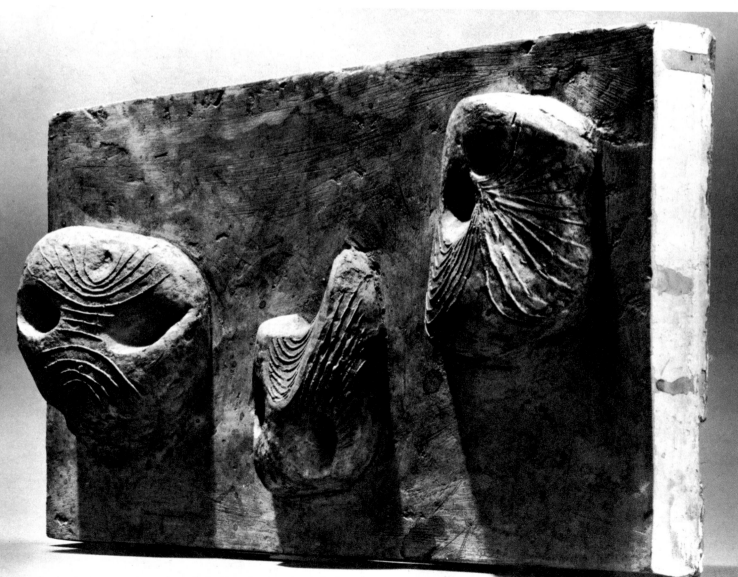

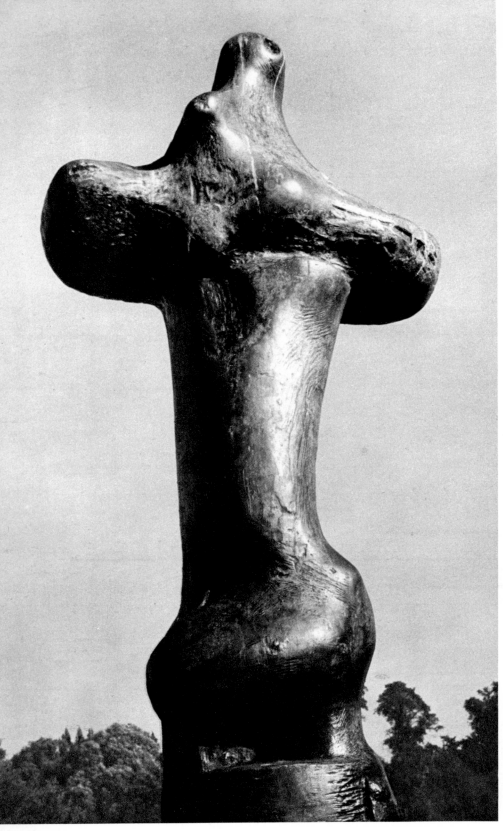

503

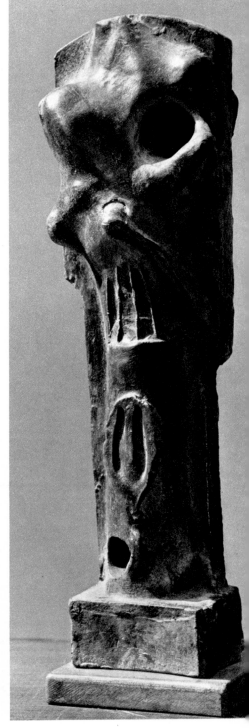

504

503 Upright Motive No. 1: Glenkiln Cross (detail)
Motif vertical nº 1: Croix de Glenkiln (détail)
Aufrechtes Motiv Nr. 1: Glenkiln-Kreuz (Ausschnitt)
1955–56 · H. 3.35 m

504 Upright Motive: Maquette No. 3 · Motif vertical:
maquette nº 3 · Aufrechtes Motiv: Entwurf
Nr. 3 · 1955 · H. 25.4 cm

505 Upright Motive No. 5 · Motif vertical nº 5
Aufrechtes Motiv Nr. 5 · 1955–56 · H. 2.13 m

506 Upright Motive No. 8 · Motif vertical nº 8
Aufrechtes Motiv Nr. 8 · 1955–56 · H. 1.98 m

507 Upright Motive No. 7 · Motif vertical nº 7
Aufrechtes Motiv Nr. 7 · 1955–56 · H. 3.20 m

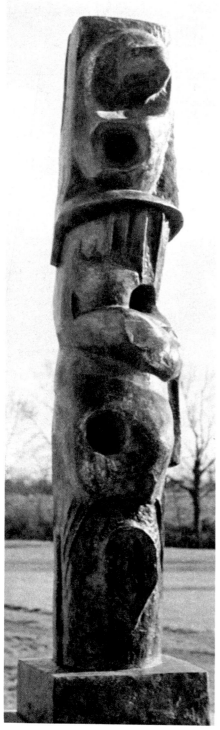

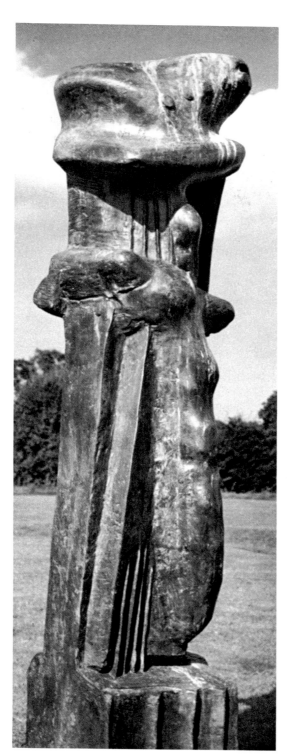

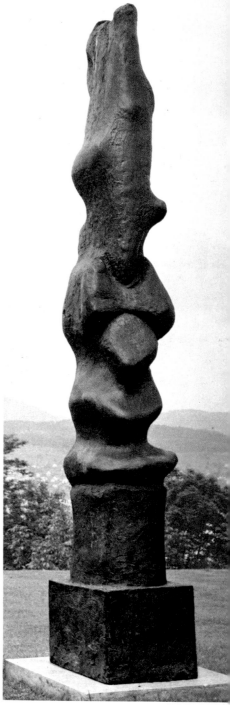

505

506

507

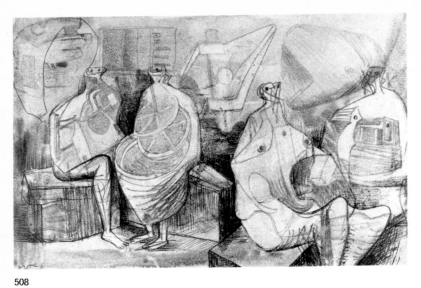

508

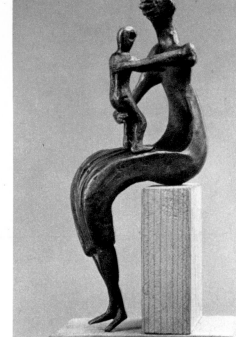

510

508 Seated Figures · Figures assises · Sitzende
 Figuren · 1956
509 Ideas for Sculpture · Idées pour sculptures
 Skizzen zu Plastiken · 1956

509

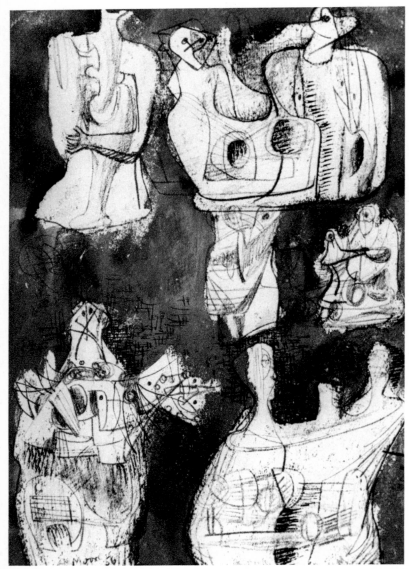

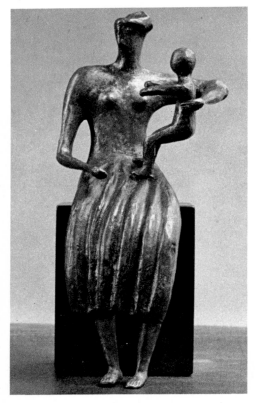

511

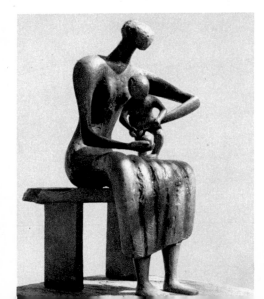

512

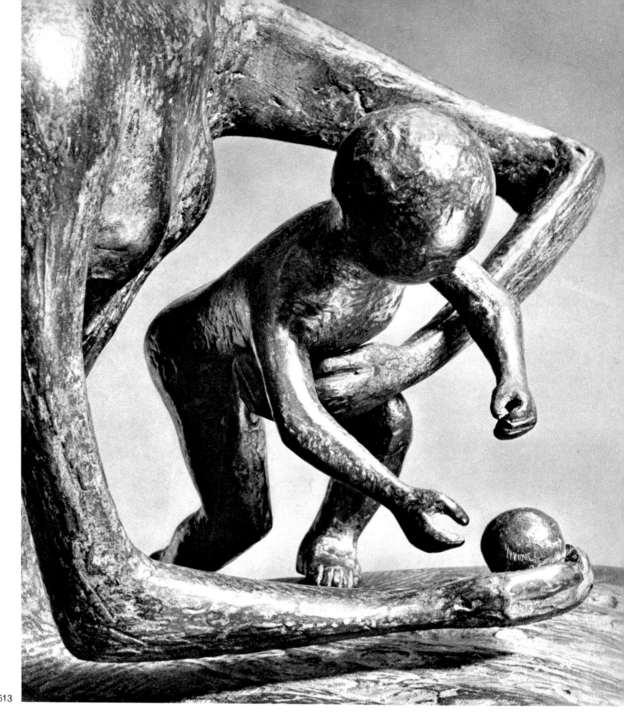

513

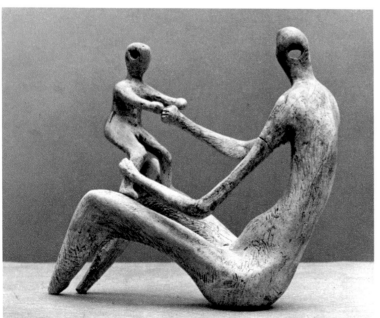

510 Mother and Child No. 2 · Mère et enfant nº 2
Mutter und Kind Nr. 2 · 1956 · H. 22.9 cm

511 Mother and Child No. 3 · Mère et enfant nº 3
Mutter und Kind Nr. 3 · 1956 · H. 19.1 cm

512-13 Mother and Child No. 1 · Mère et enfant nº 1
Mutter und Kind Nr. 1 · 1956 · H. 55.9 cm

514 Mother and Child No. 4 · Mère et enfant nº 4
Mutter und Kind Nr. 4 · 1956 · H. 19.1 cm

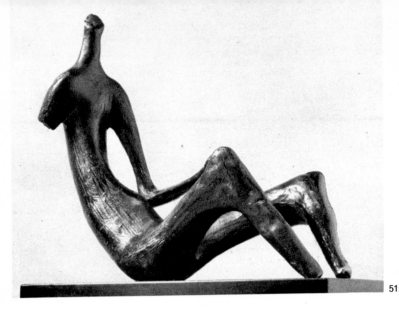

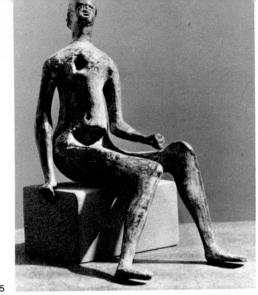

515

518

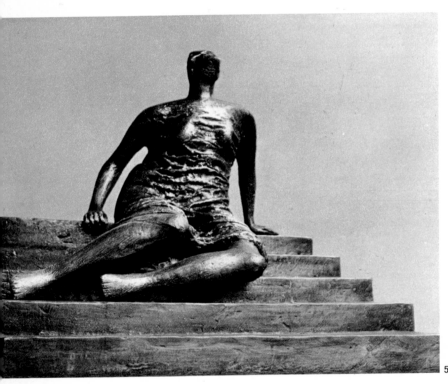

516

515 Seated Woman: One Arm · Femme
assise: un bras · Sitzende Frau
mit einem Arm · 1956 · H. 20.3 cm

516-17 Figure on Steps · Figure sur
marches · Figur auf Stufen
1956 · H. 64.8 cm

518 Seated Girl · Jeune fille assise
Sitzendes Mädchen · 1956 · H. 21.0 cm

519 Mother and Child · Mère et enfant
Mutter und Kind · 1956 · H. 24.8 cm

520-22 Reclining Figure · Figure couchée
Liegende Figur · 1956 · L. 2.44 m

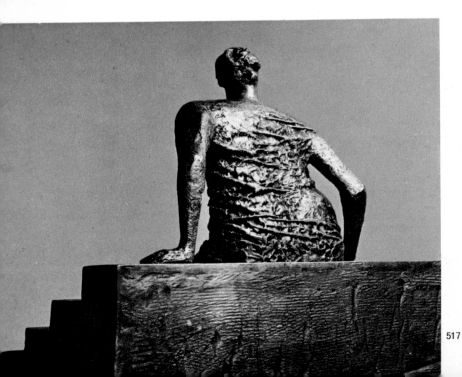

517

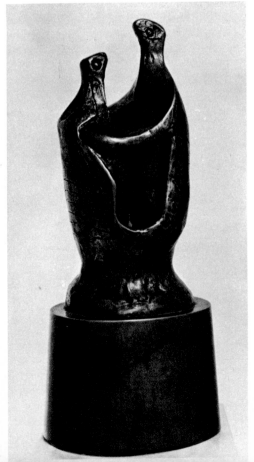

519

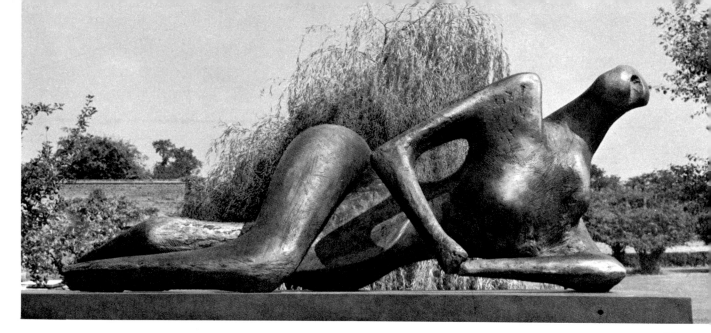

520

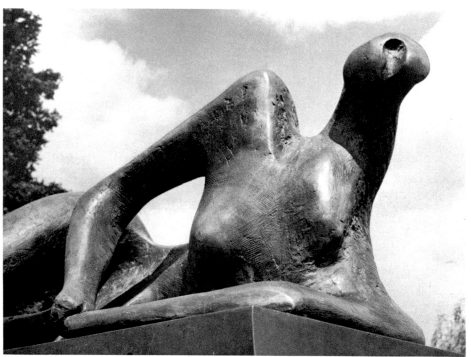

521

522

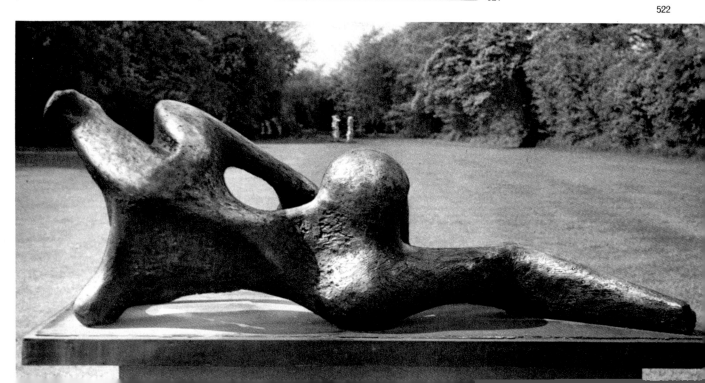

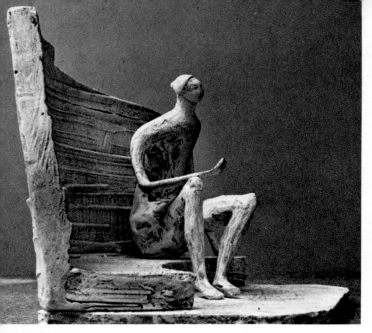

523

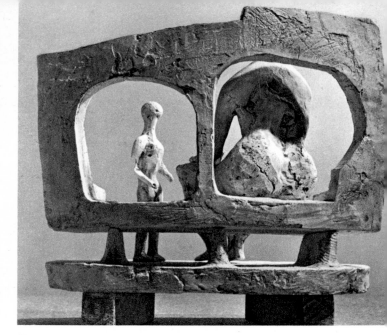

526

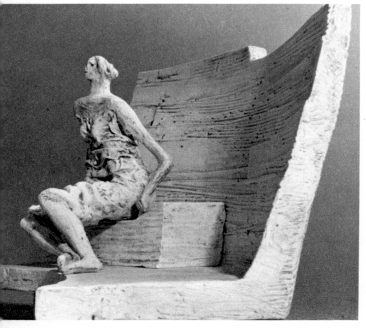

524

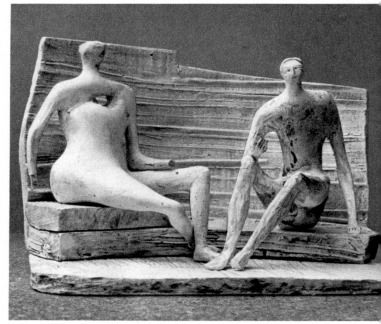

527

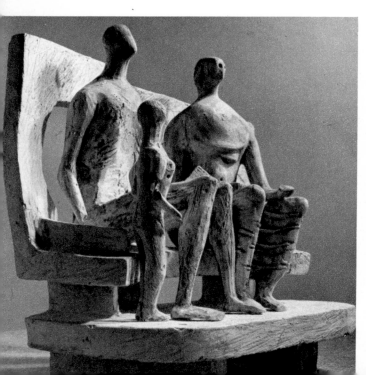

525

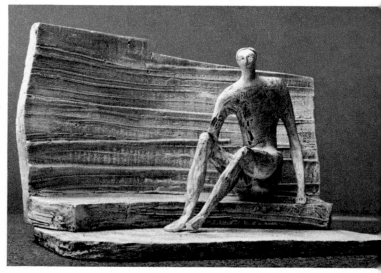

528

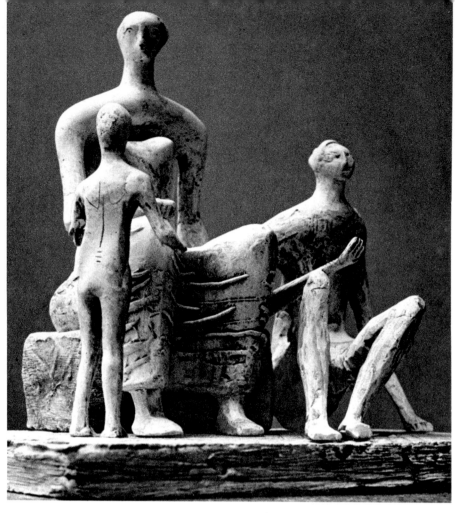

523, 528 Maquette for Seated
Figure against Curved Wall
Maquette pour figure assise
devant un mur incurvé
Entwurf für sitzende Figur
vor einer geschwungenen Wand
1956 · H. 28.0 cm

524 Draped Seated Figure against
Curved Wall · Figure drapée
assise devant un mur incurvé
Bekleidete sitzende Figur
vor einer geschwungenen Wand
1956–57 · H. 22.9 cm

525 Family Group · Famille
Familiengruppe · 1956–57

526 Mother and Child against Open
Wall · Mère et enfant devant
un mur ouvert · Mutter und
Kind vor einer durchbrochenen
Wand · 1956 · H. 20.3 cm

527 Two Seated Figures against
Curved Wall · Deux figures
assises devant un mur incurvé
Zwei sitzende Figuren vor einer
geschwungenen Wand · 1956–57

529 Family Group · Famille
Familiengruppe · 1956–57

530 Maquette for Unesco Reclining
Figure · Maquette pour la
figure couchée de l'Unesco
Entwurf für die liegende Unesco-
Figur · 1956 · L. 21.6 cm

529

530

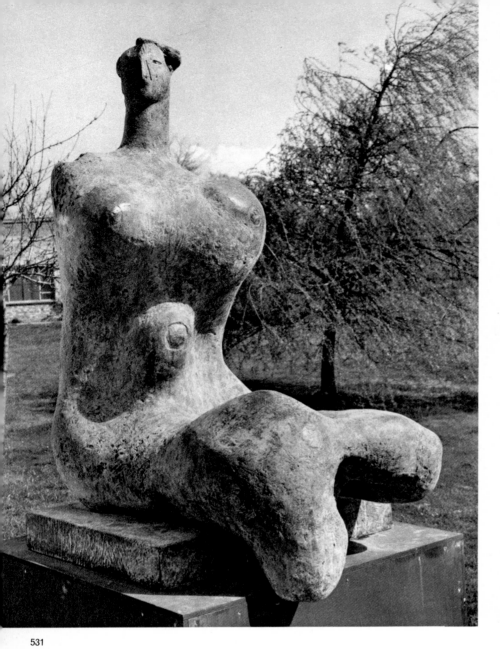

531

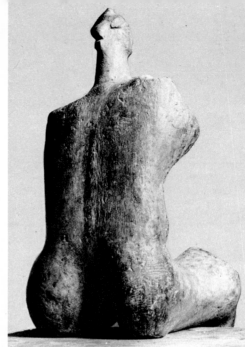

532

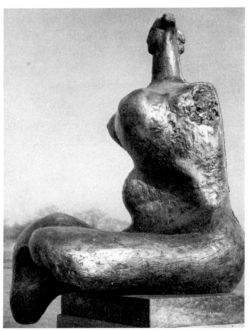

533

531-34 Woman · Femme · Frau · 1957–58 · H. 1.52 m
535-37 Seated Woman · Femme assise · Sitzende Frau · 1957 · H. 1.45 m

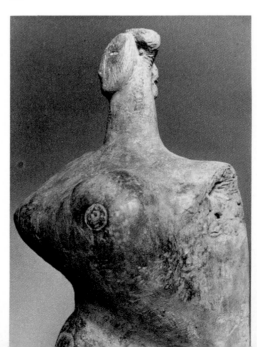

534

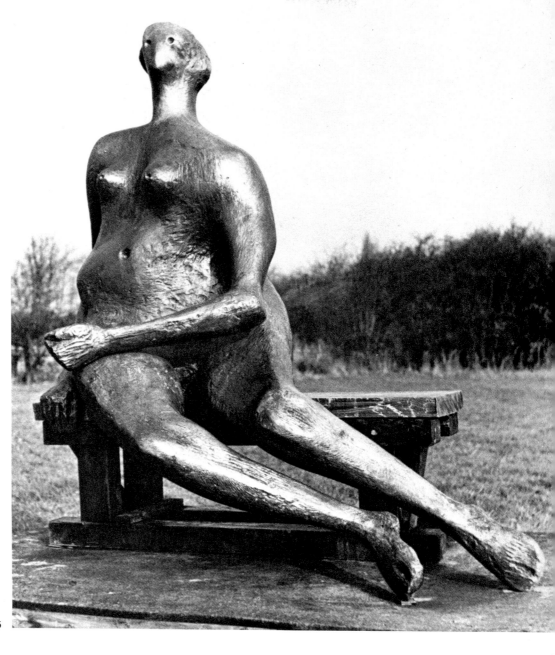

535

536

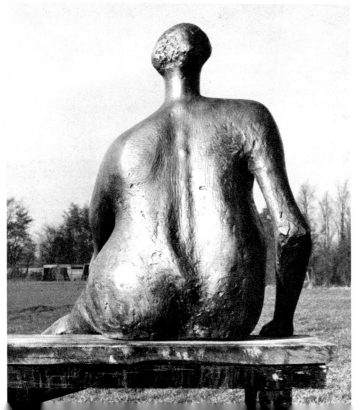

537

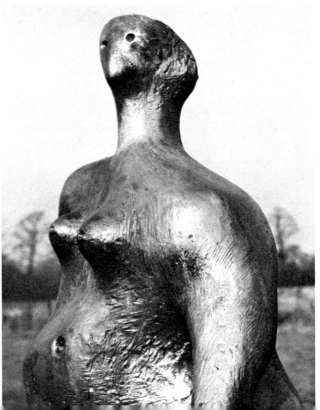

538-40 Falling Warrior · Guerrier tombant
Fallender Krieger · 1956–57 · L. 1.47 m

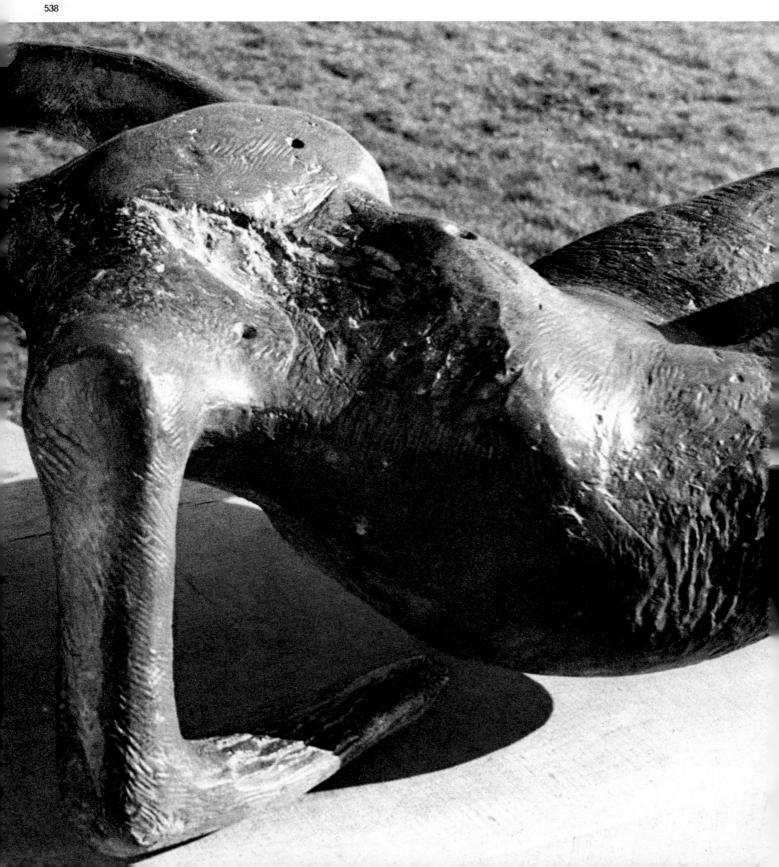

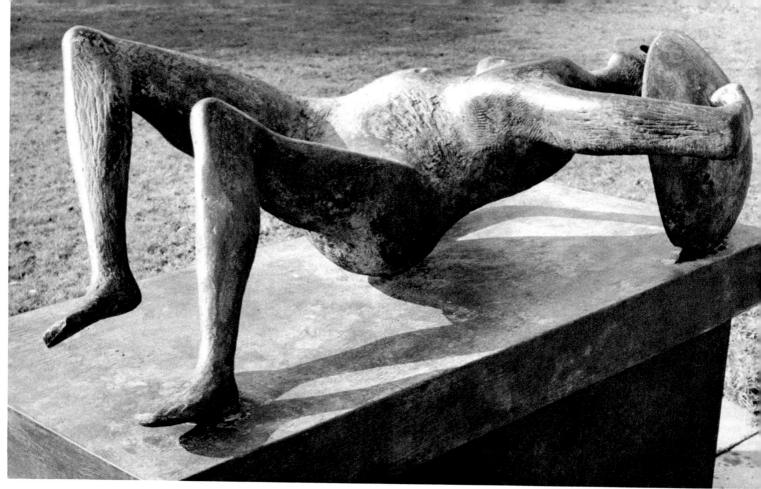

539

540

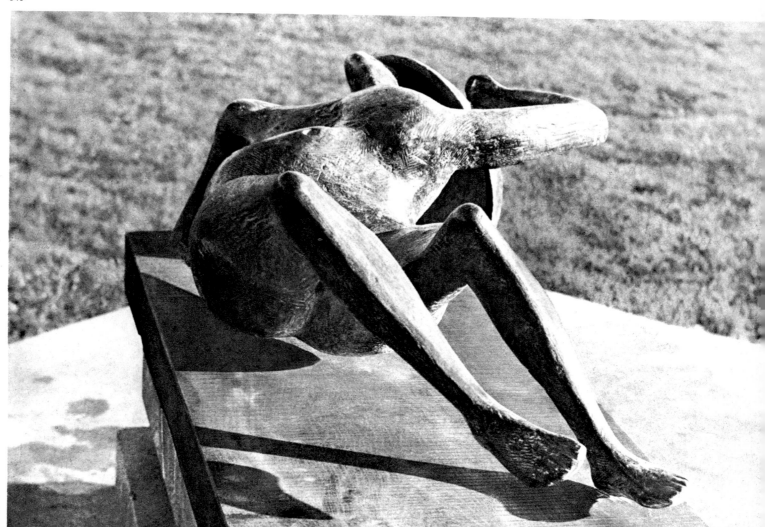

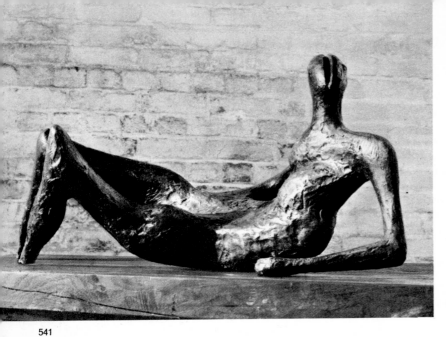

541

542

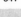

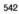

543

541, 544 Reclining Figure · Figure couchée
Liegende Figur · 1957 · L. 69.9 cm

542 Draped Reclining Figure · Figure drapée
couchée · Bekleidete liegende Figur
1957 · L. 73.7 cm

543 Drawings for Unesco Figure · Dessins pour
la sculpture de l'Unesco · Zeichnungen
für die Unesco-Figur · 1957

544

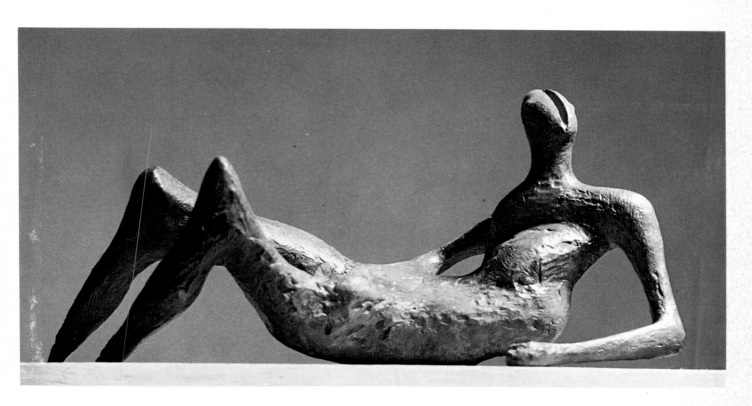

XXIII Reclining Figure, 1957. L. 69.9 cm

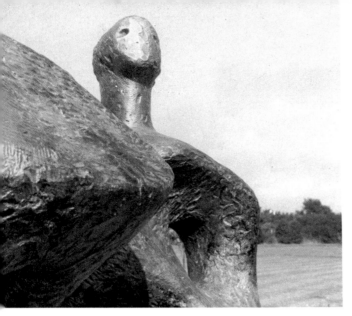

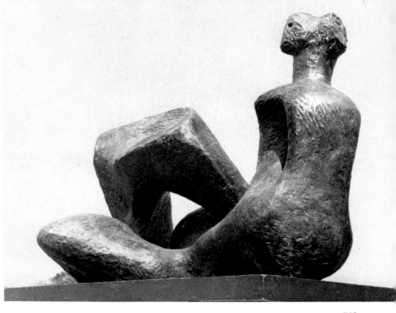

545

546

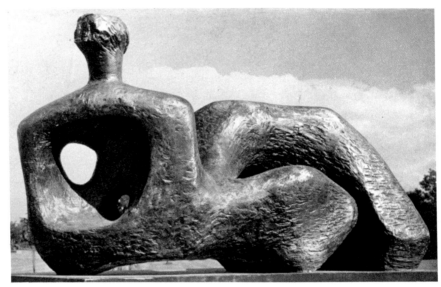

545-48 Reclining Figure · Figure couchée
Liegende Figur · L. 2.39 m

547

548

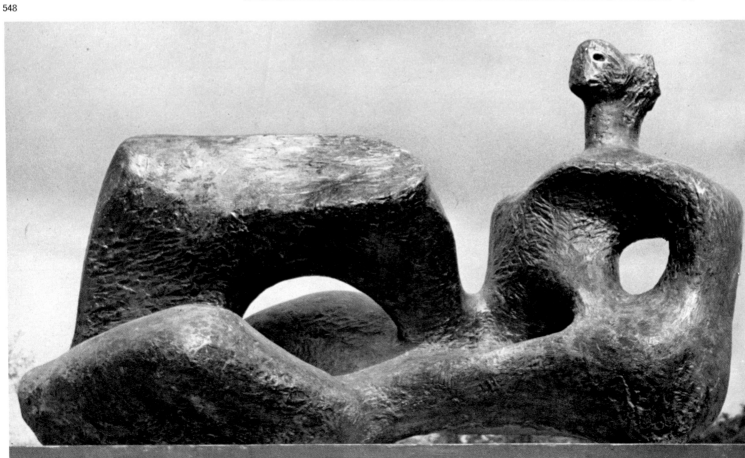

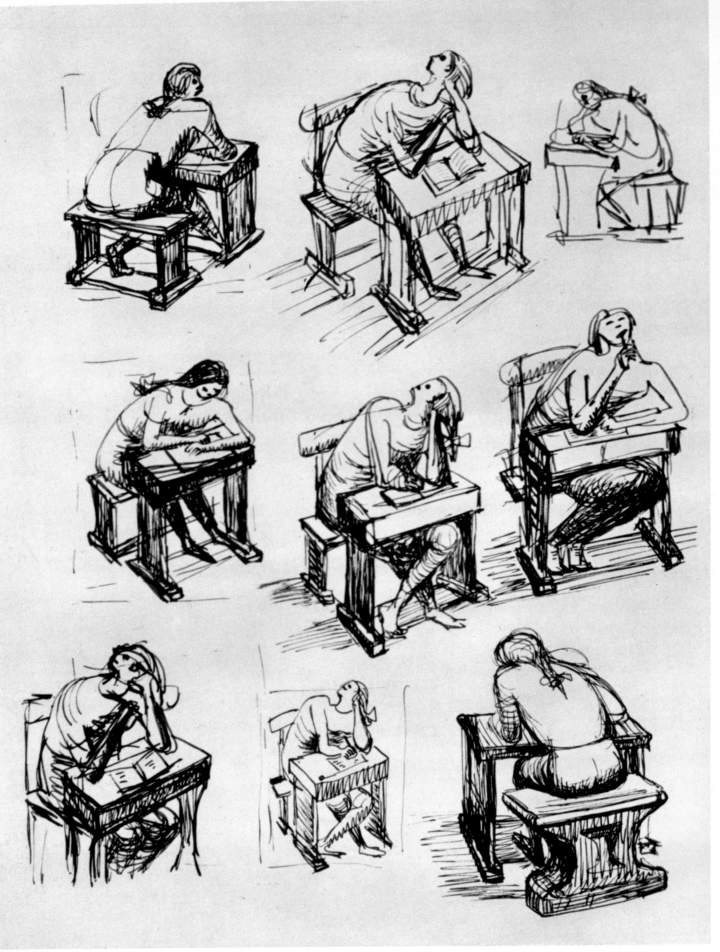

549 Girl Doing Homework · Jeune fille faisant ses devoirs · Schulaufgaben machendes Mädchen · 1956

550 Woman with Cat · Femme au chat · Frau mit Katze · 1957 · H. 21.6 cm

551 Armless Seated Figure against Round Wall · Figure sans bras assise devant un mur arrondi · Armlose sitzende Figur vor einer abgerundeten Wand · 1957 · H. 28.0 cm

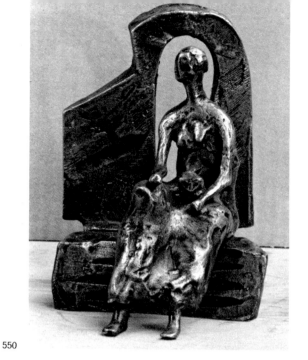

550

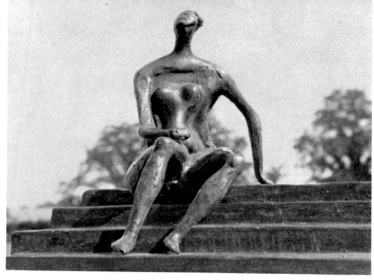

553

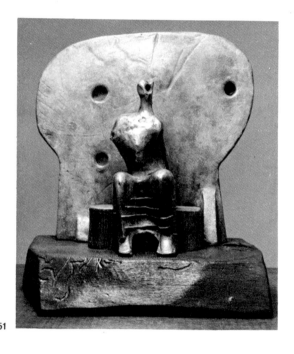

551

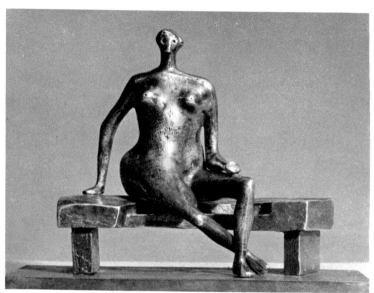

554

552 Seated Woman on Curved Block · Femme assise sur un bloc curviligne
Auf einem geschwungenen Klotz sitzende Frau · 1957 · H. 20.3 cm

553 Seated Figure on Square Steps · Figure assise sur marches carrées
Sitzende Figure auf rechteckigen Stufen · 1957 · L. 23.5 cm

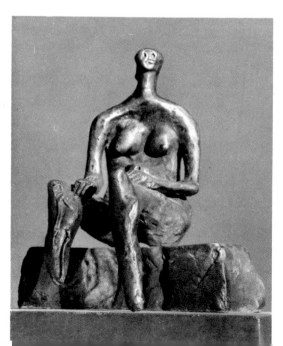

552

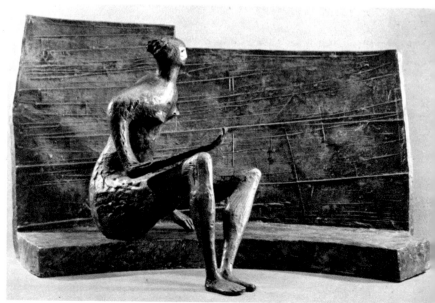

555

554 Seated Woman with Crossed Feet · Femme assise aux pieds
croisés · Sitzende Frau mit gekreuzten Füßen · 1957 · H. 19.0 cm

555 Seated Figure against Curved Wall · Figure assise devant
un mur incurvé · Sitzende Figure vor einer geschwungenen
Wand · 1956–57 · L. 81.3 cm

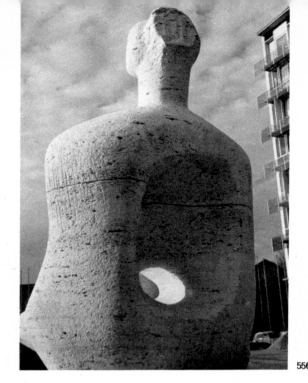

556

559

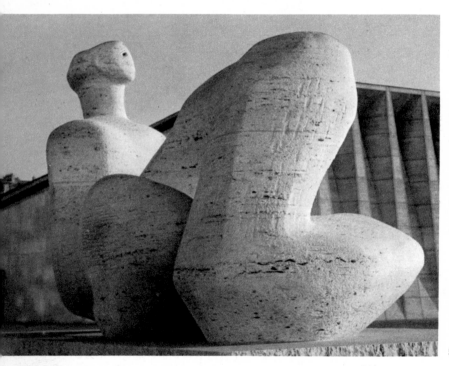

557

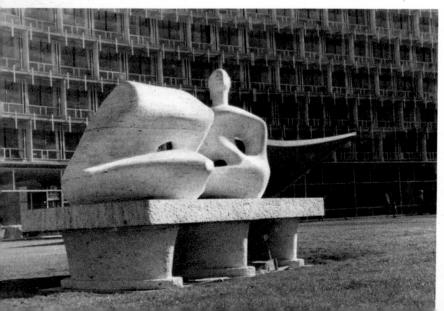

558

556-59 Unesco Reclining Figure · Figure couchée,
pour le siège de l'Unesco · Liegende Figur für
das Unesco-Gebäude · 1957-58 · L. 5.08 m

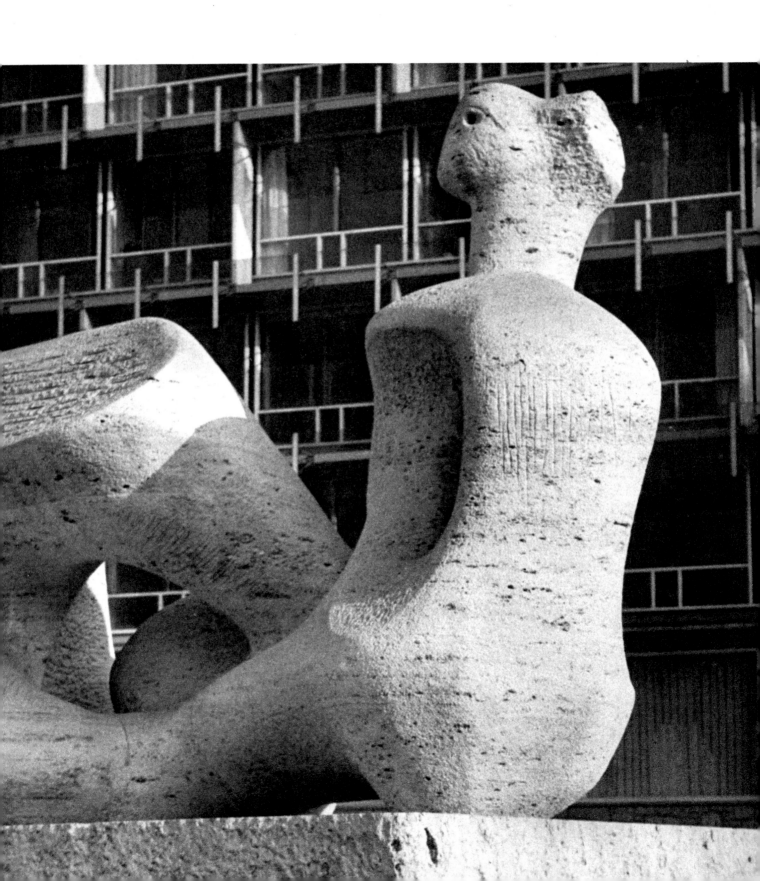

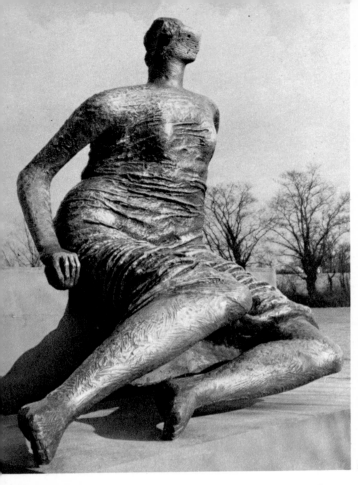

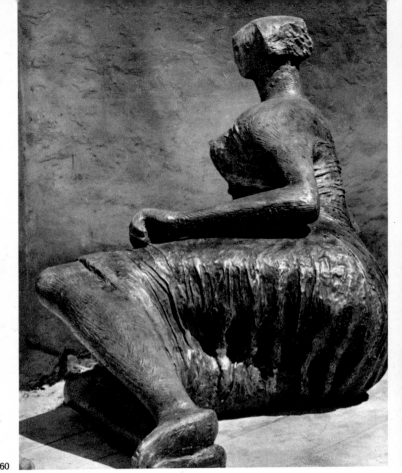

560

563

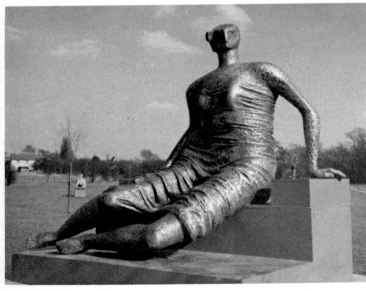

561

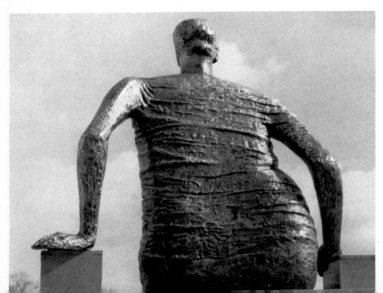

562

564

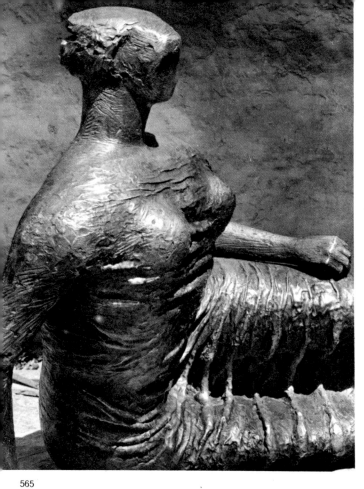

565

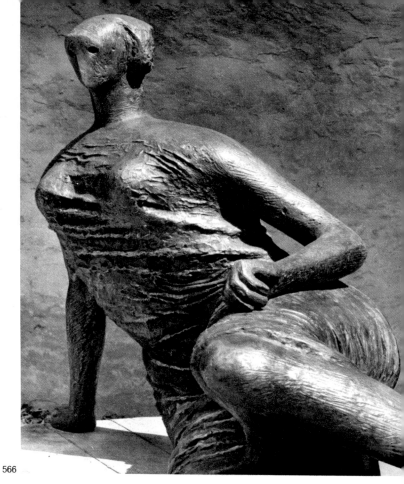

566

560-62 Draped Seated Woman · Femme assise
 drapée · Bekleidete Sitzende · 1957-58
 H. 1.86 m

563 Draped Reclining Woman · Femme couchée
 drapée · Bekleidete Liegende · 1957-58
 L. 2.08 m

564 Fragment Figure · Figure-fragment
 Fragmentfigur · 1957 · L. 19.0 cm

565-68 Other views of Plate 563 · Autres vues
 de la fig. 563 · Andere Ansichten von Abb. 563

569 Maquette for a Draped Reclining Woman
 Maquette pour une femme drapée couchée
 Entwurf für eine bekleidete liegende Frau
 1956 · L. 19.0 cm

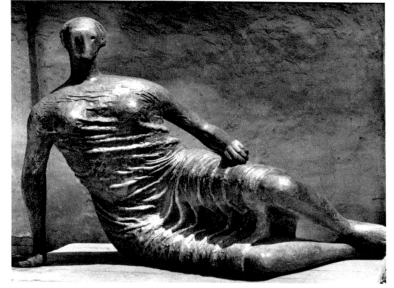

567

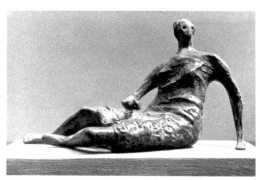

569

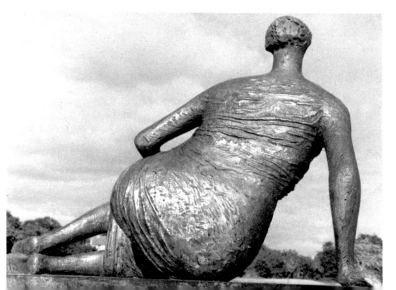

568

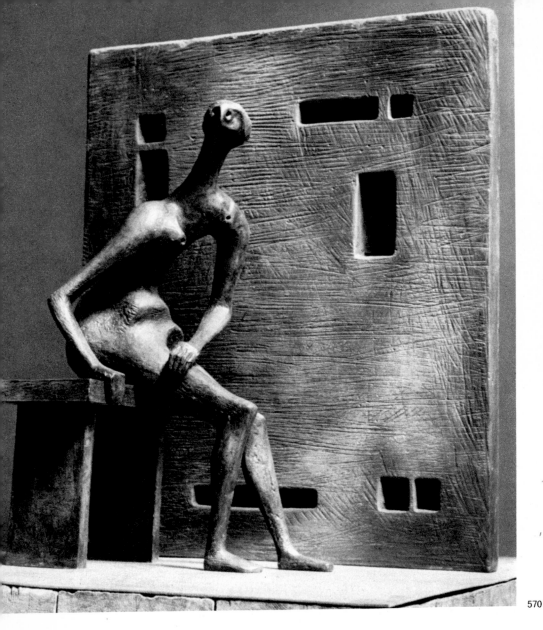

571

570

572

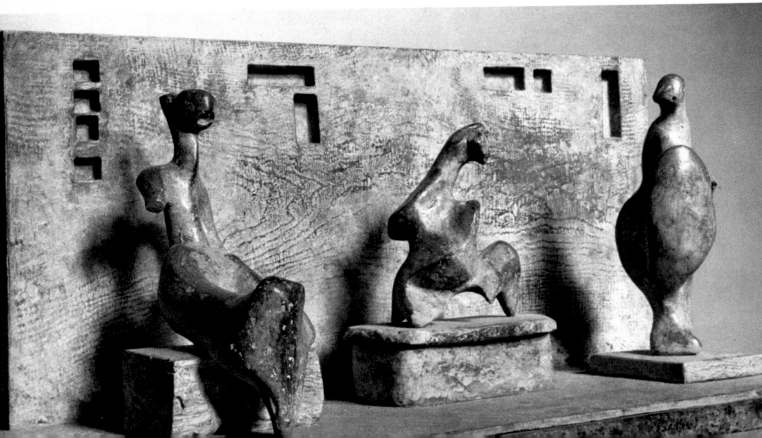

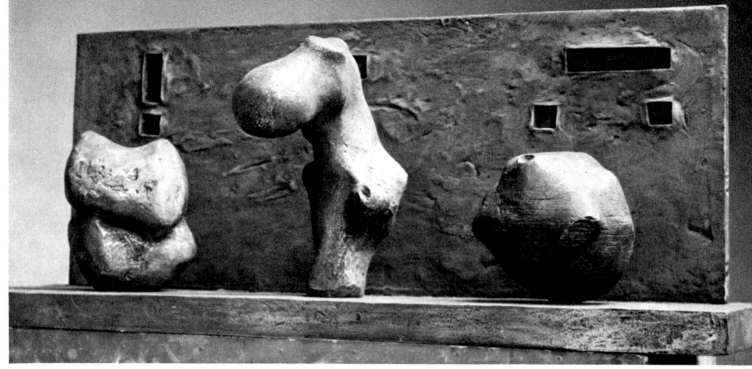

573

570 Girl Seated against Square Wall · Jeune
 fille assise devant un mur carré
 Sitzendes Mädchen vor einer rechteckigen
 Wand · 1957–58 · H. 1.02 m

571 Round Sculptural Object · Objet rond
 sculptural · Rundskulptur · 1959 · H. 11.5 cm

572 Three Motives against Wall No. 1 · Trois
 motifs devant un mur n° 1 · Drei Motive
 vor einer Wand Nr. 1 · 1958 · L. 1·07 m

573 Three Motives against Wall No. 2 · Trois
 motifs devant un mur n° 2 · Drei Motive
 vor einer Wand Nr. 2 · 1959 · L. 1.07 m

574 Animal Form · Forme animale · Tierform
 1958 · H. 34.3 cm

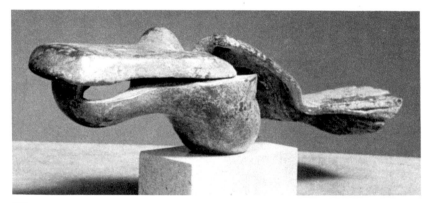

575

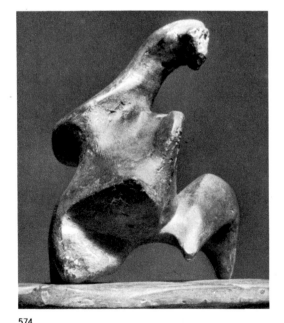

574

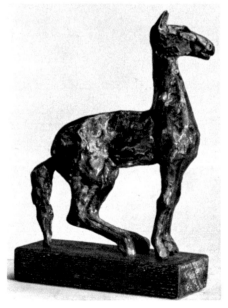

576

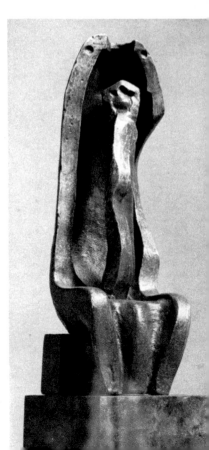

577

575 Bird · Oiseau · Vogel · 1959 · L. 38.1 cm

576 Horse · Cheval · Pferd · 1959 · H. 19.1 cm

577 Mother and Child · Mère et enfant · Mutter
 und Kind · 1959 · H. 31.8 cm

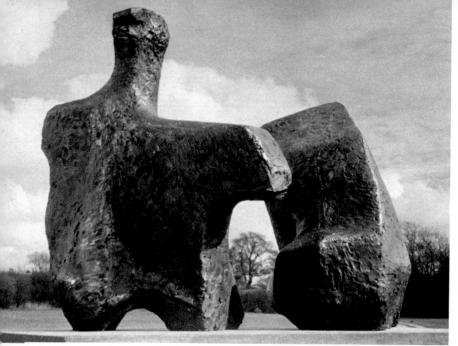

578

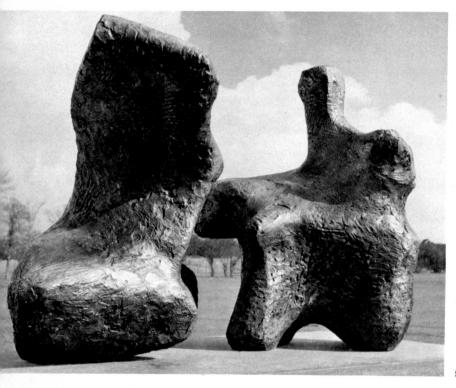

579

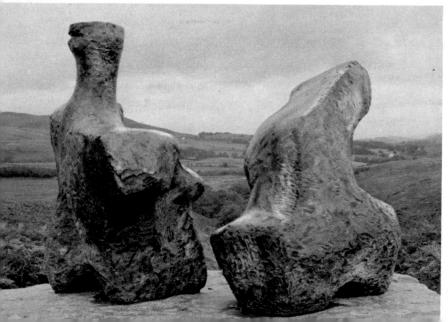

580

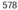

581

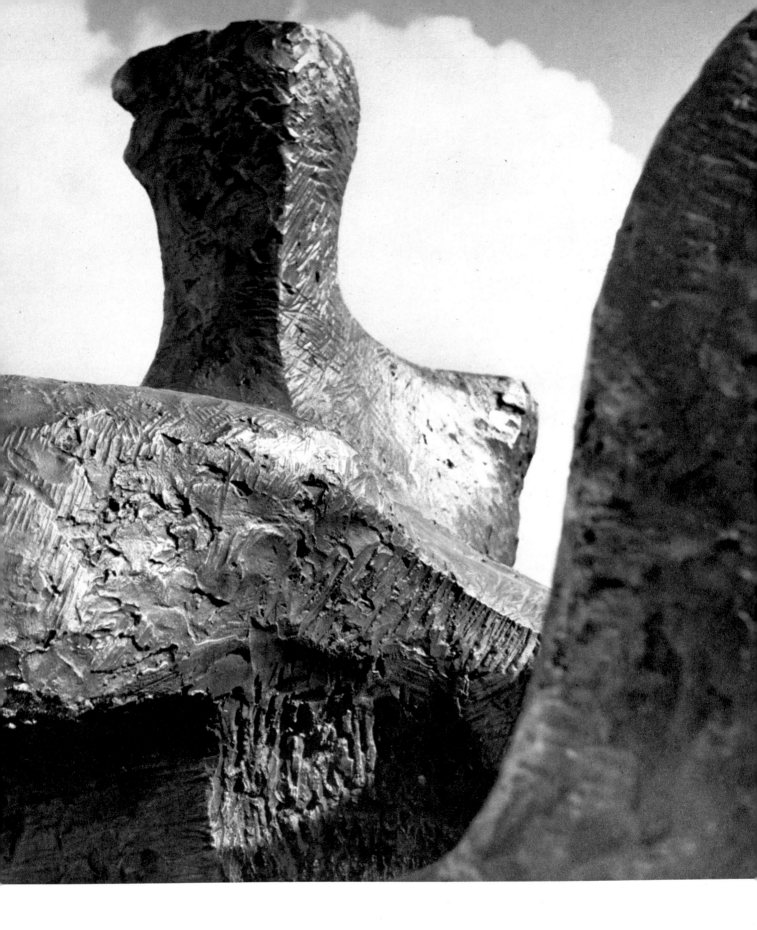

578-81 Two-Piece Reclining Figure No. 1 · Figure couchée en deux pièces
nº 1 · Zweiteilige liegende Figur Nr. 1 · 1959 · L. 1.93 m

582 Relief No. 1 · Relief nº 1 · Relief Nr. 1 · 1959 · H. 2.24 m

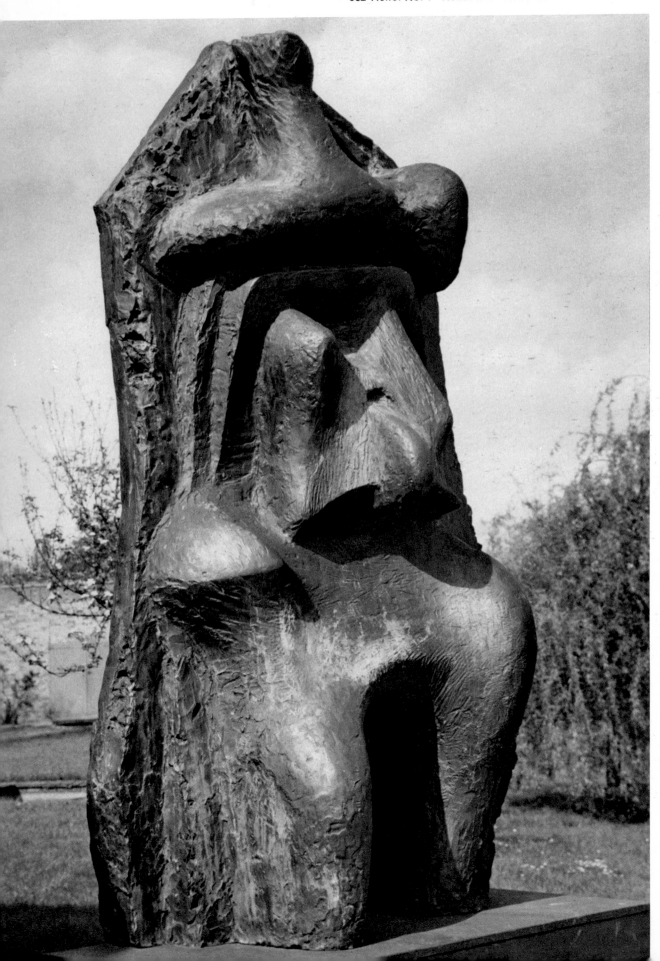

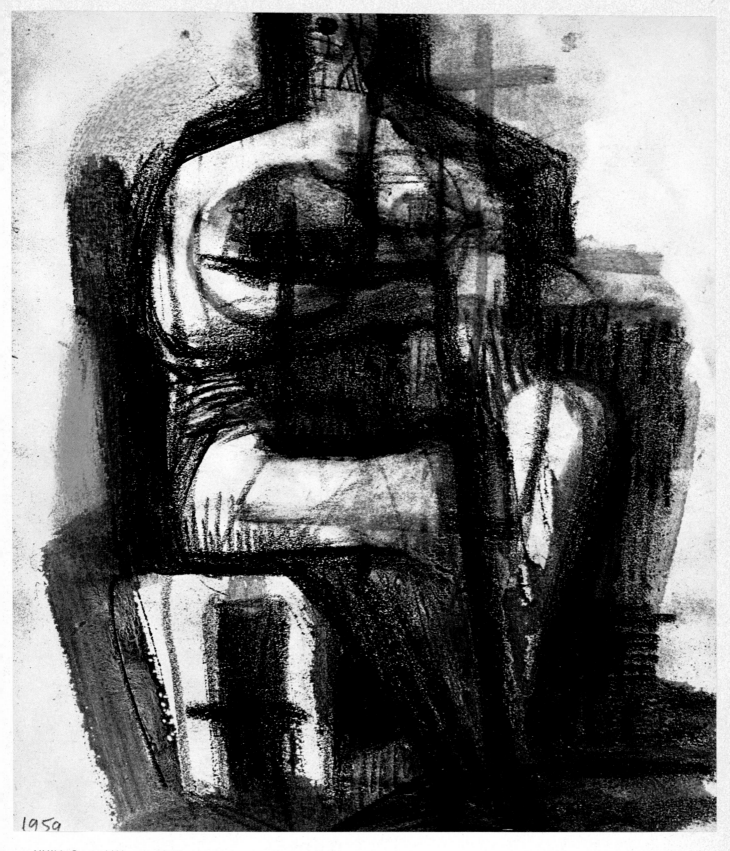

1959

XXIV Seated Woman, 1959

1960-1964

THIS IS THE PERIOD of the monumental two-piece and three-piece versions of the *Reclining Figure*, which, like the ancient Mexican sculpture he has so warmly praised, 'give out something of the energy and power of great mountains'. Curiously enough, his writings make very few direct comments on his reclining figures. He once said that there are three fundamental poses of the human figure, standing, seated and lying down; that the reclining pose gives the most freedom, compositionally and spatially; that it is free and stable at the same time; that it has repose. Referring specifically to the two-piece Reclining Figures *(578–81, 583, 585–8)* he has spoken of the advantage a sectionalized composition has in relating figures to landscape: 'Knees and breasts are mountains. Once these two parts become separated you do not expect it to be a naturalistic figure; therefore, you can justifiably make it like a landscape or a rock. . . . As you move round it, the two parts overlap or they open up and there is space between. Sculpture is like a journey. You have a different view as you return. The three-dimensional world is full of surprises in a way that a two-dimensional world could never be.'

The bones of farm animals which were dug up in his garden have influenced some of the forms in his two-piece and three-piece figures – the headpiece, for instance, of *Three-piece Reclining Figure No. 2: Bridge Prop (651–3)*. *Locking Piece (681–2)* is a complex result of his study of bone structures; its forms are freely invented, but it has its own closed system of jointing which is a superb example of what T. S. Eliot called 'the logic of the imagination'.

Of the Knife-edge forms that appear in his work towards the end of this period, Moore has this to say: 'There are many structural and sculptural principles to be learnt from bones, e.g. that in spite of their lightness they have great strength. Some bones, such as the breast bones of birds, have the lightweight fineness of a knife-edge. Finding such a bone led to my using this knife-edge thinness in 1961 in a sculpture

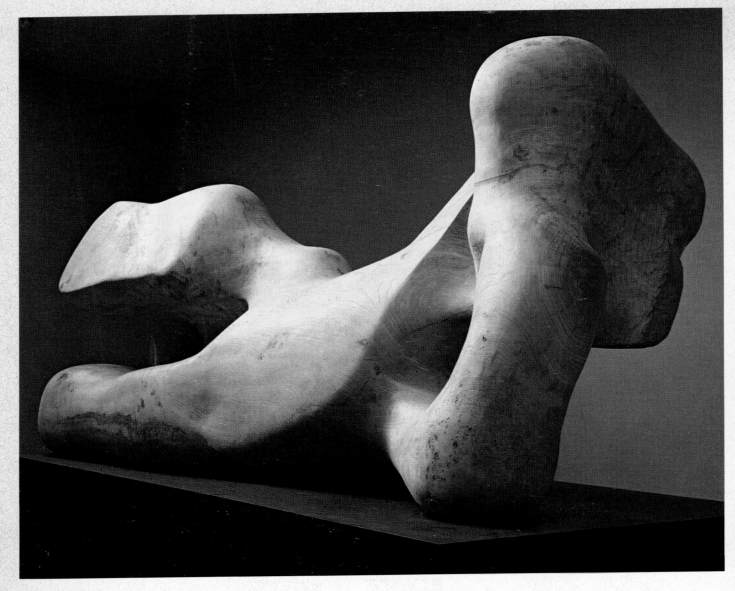

XXV Reclining Figure, 1959–64. L. 2.29 m

Seated Woman: Thin Neck (631–2). In this figure the thin neck and head, by contrast with the width and bulk of the body, gives more monumentality to the work. Later in 1961 I used this knife-edge thinness throughout a whole figure . . . *Standing Figure: Knife-edge (633)*. In walking round this sculpture the width and flatness from the front gradually change through the three-quarter views into the thin sharp edges of the side views, and then back again to the width seen from the back. And the back half of the figure bends backwards, is angled towards the sky, opens itself to the light in a rising upward movement – and this may be why, at one time, I called it *Winged Victory*. In a sculptor's work all sorts of past experiences and influences are fused and used – and somewhere in this work there is a connection with the so-called *Victory of Samothrace* in the Louvre – and I would like to think that others see something Greek in this Standing Figure.'

262

583 Two-Piece Reclining Figure No. 2 · Figure couchée en deux pièces nº 2 · Zweiteilige liegende Figur Nr. 2 · 1960 · L. 2.59 m

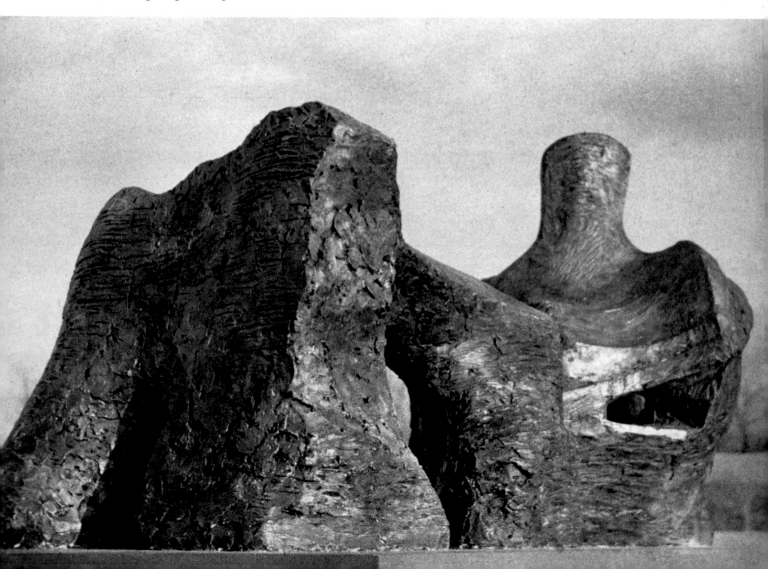

584 Two-piece Reclining
Figure: Maquette No. 1
Figure couchée en deux
pièces: maquette n° 1
Zweiteilige liegende
Figur: Entwurf Nr. 1
1960 · L. 24.1 cm

584

585

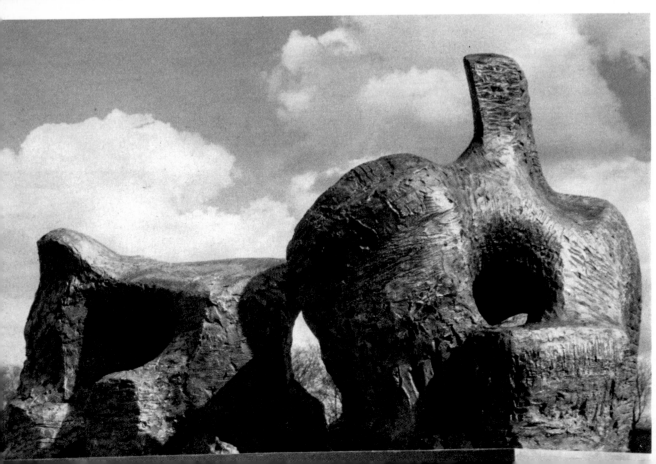

586

585-88 Other views of Plate 583 · Autres vues de la fig. 583
Andere Ansichten von Abb. 583

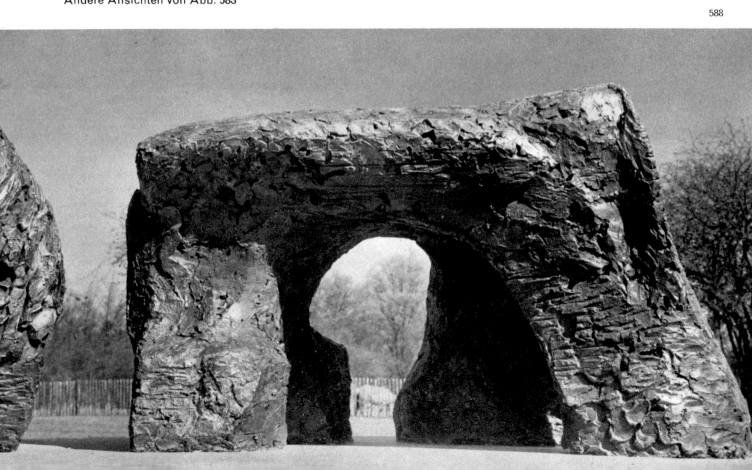

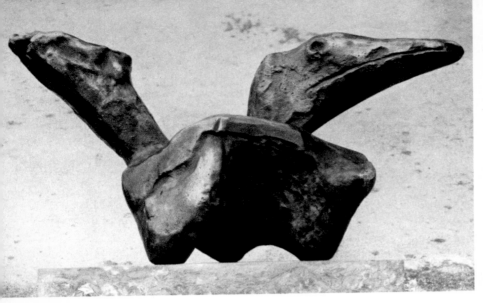

589

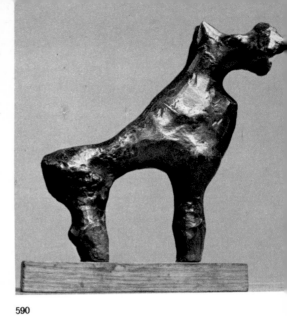

590

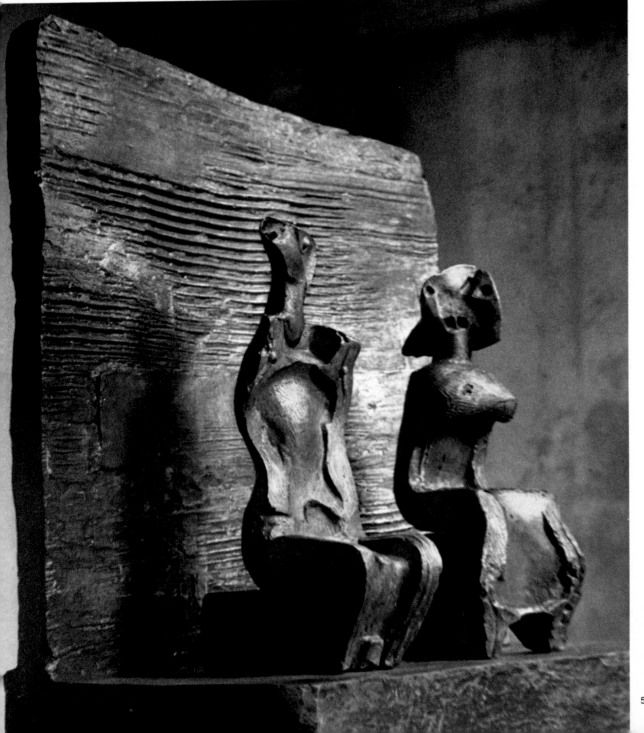

591

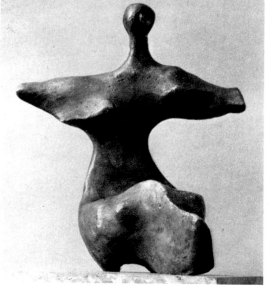

592

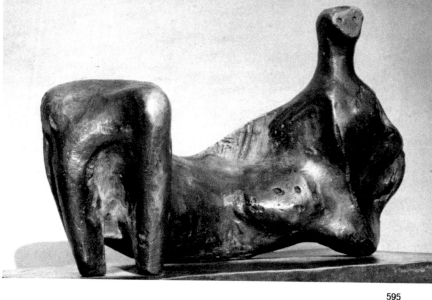

595

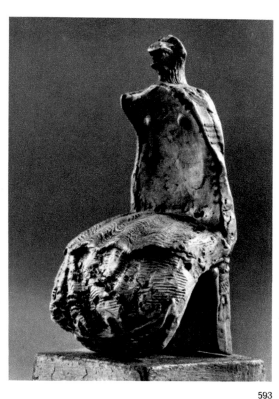

593

589 Fledgling · Oisillon · Junger Vogel · 1960 · H. 8.3 cm

590 Animal: Horse · Animal: cheval · Tier: Pferd · 1960 · H. 17.8 cm

591 Two Seated Figures against Wall · Deux figures assises
devant un mur · Zwei sitzende Figuren vor einer Wand
1960 · H. 48.3 cm

592 Seated Figure: Arms Outstretched · Figure assise : bras
étendus · Sitzende Figur mit ausgebreiteten Armen · 1960
H. 16.5 cm

593 Seated Figure: Shell Skirt · Figure assise: jupe en
coquillage · Sitzende Figur mit Muschelrock · 1960
H. 22.2 cm

594 Maquette for Seated Woman: Thin Neck · Maquette pour
femme assise: cou mince · Entwurf für sitzende Frau
mit dünnem Hals · 1960 · H. 25.4 cm

595 Maquette for Reclining Figure · Maquette pour figure
couchée · Entwurf für liegende Figur · 1960 · L. 21.0 cm

596 Reclining Figure: Bowl · Figure couchée: coupe
Liegende Figur: Schale · 1960 · L. 28.0 cm

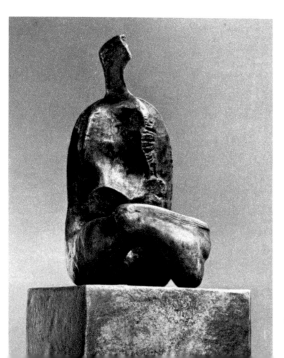

594

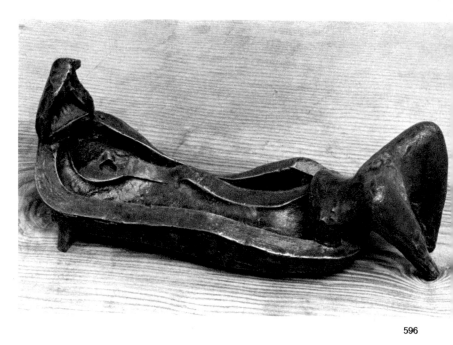

596

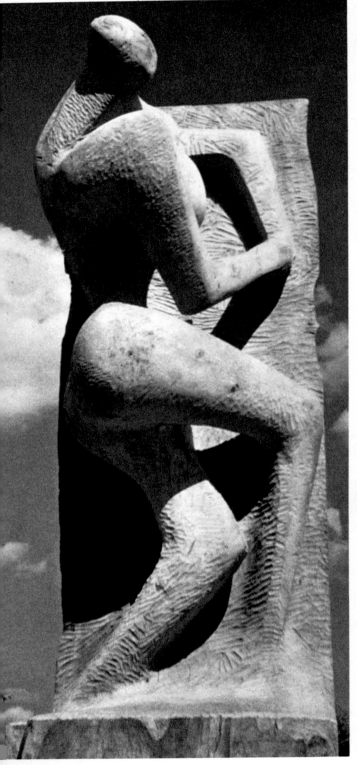

597

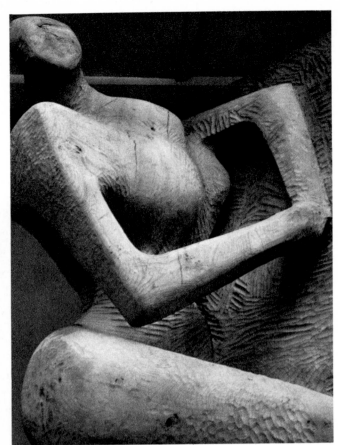

598

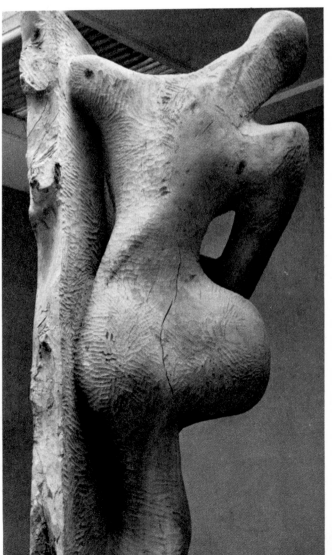

599

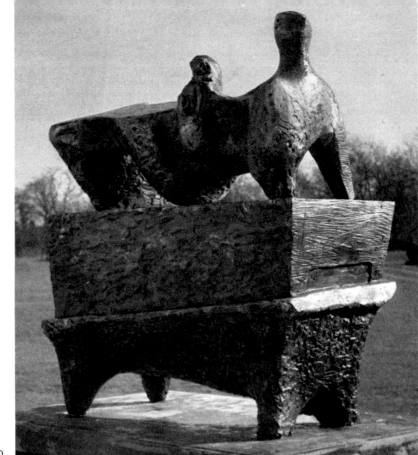

597-99 Upright Figure · Figure
verticale · Aufrechte Figur
1956–60 · H. 2.74 m

600-601 Reclining Figure on Pedestal
Figure couchée sur un socle
Liegende Figur auf einem
Sockel · 1959–60 · H. 1.30 m

600

601

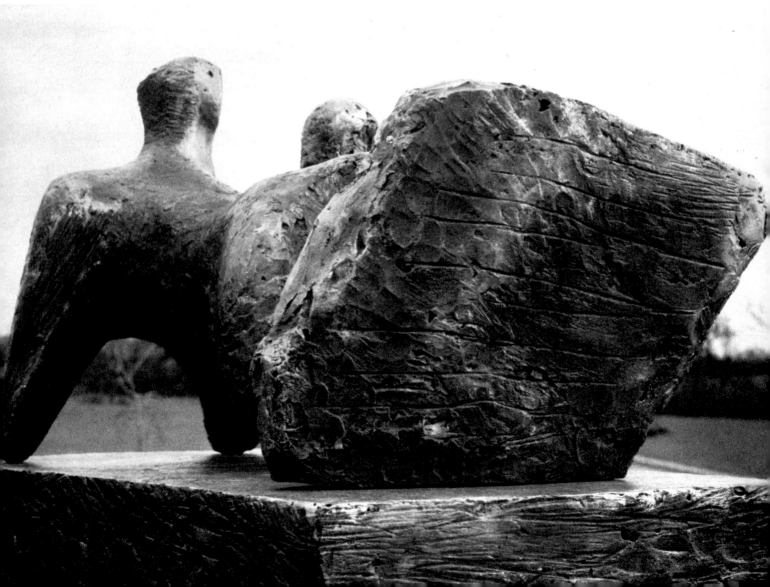

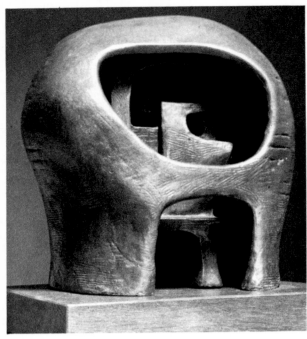

602

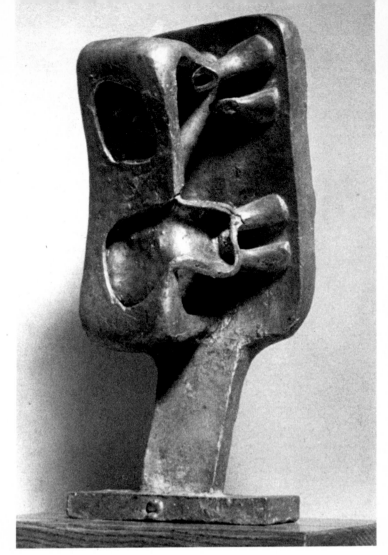

602 Helmet Head No. 3 · Tête-casque n° 3
Helm-Kopf Nr. 3 · 1960 · H. 29.2 cm

603 Three Part Object · Objet en trois pièces
Dreiteiliger Gegenstand · 1960 · H. 1.23 m

604 Square Head · Tête carrée · Rechteckiger Kopf
1960 · H. 28.0 cm

605 Sculptural Object · Objet sculptural · Skulptur
1960 · H. 46.3 cm

603

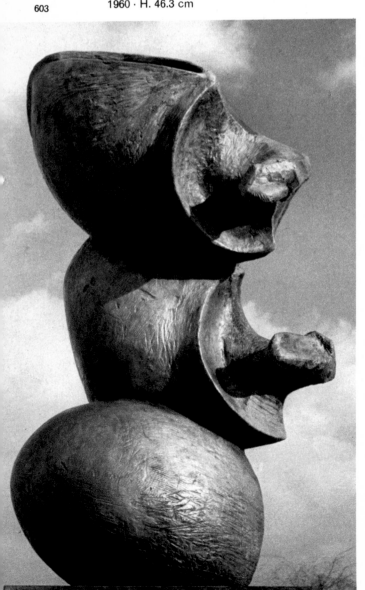

604

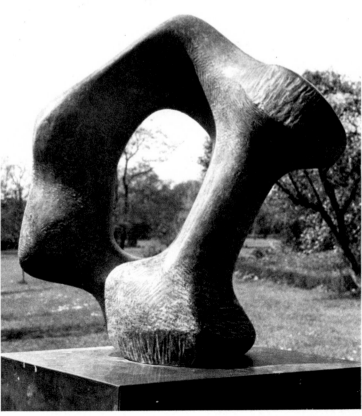

605

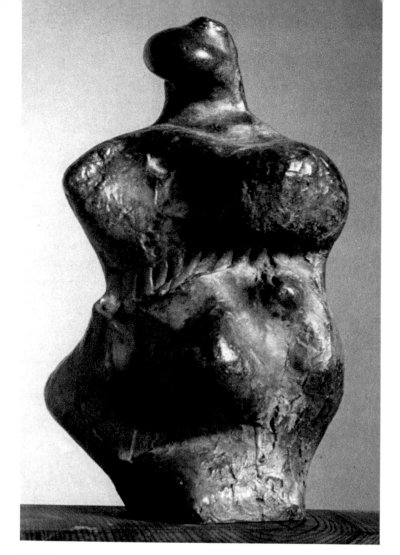

608

606 Three-quarter Figure · Figure en trois-quarts
Dreiviertelfigur · 1961 · H. 38.1 cm

609

607 Seated Figure: Cross Hatch · Figure assise: hachures
Sitzende Figur mit Schraffierungen · 1961 · H. 13.3 cm

608 Small Head: Strata · Petite tête: strates · Kleiner
Kopf mit Schichten · 1960 · H. 12·1 cm

609 Head: Cross Hatch · Tête: hachures · Kopf mit
Schraffierungen · 1961 · H. 13.3 cm

610 Emperor's Heads · Têtes d'empereur · Kaiserköpfe
1961 · L. 20.9 cm

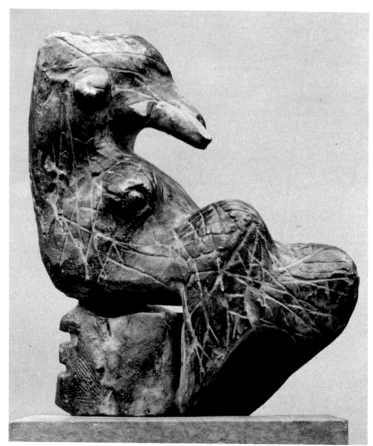

607

610

611

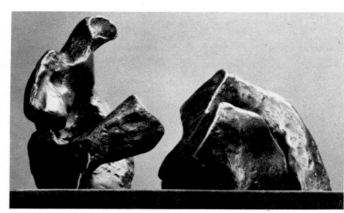

613

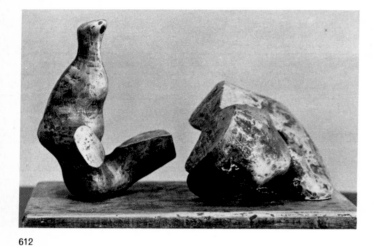

612

611 Two-piece Reclining Figure: Maquette No. 2 · Figure
couchée en deux pièces: maquette nº 2 · Zweiteilige
liegende Figur: Entwurf Nr. 2 · 1961 · L. 25.4 cm

612 Two-piece Reclining Figure: Maquette No. 3 · Figure
couchée en deux pièces: maquette nº 3 · Zweiteilige
liegende Figur: Entwurf Nr. 3 · 1961 · L. 20.3 cm

613 Two-piece Reclining Figure: Maquette No. 4 · Figure
couchée en deux pièces: maquette nº 4 · Zweiteilige
liegende Figur: Entwurf Nr. 4 · 1961 · L. 21.0 cm

614-16 Two-piece Reclining Figure No. 3 · Figure couchée
en deux pièces nº 3 · Zweiteilige liegende Figur
Nr. 3 · 1961 · L. 2.39 m

614

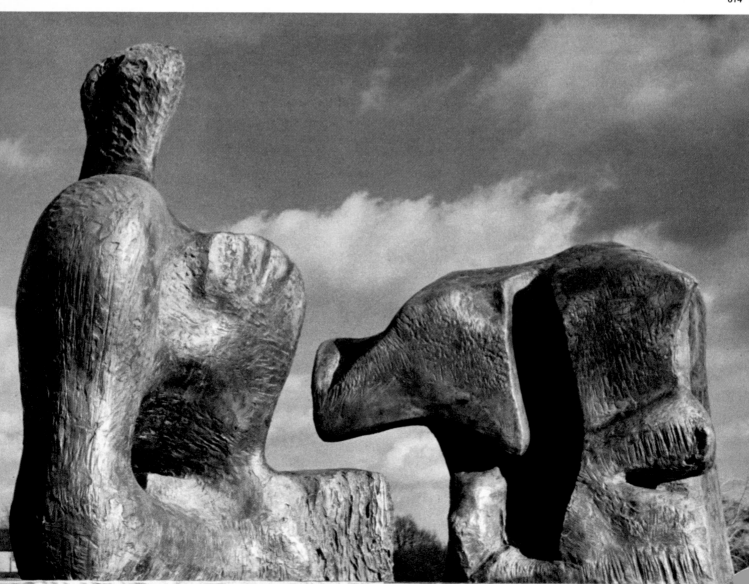

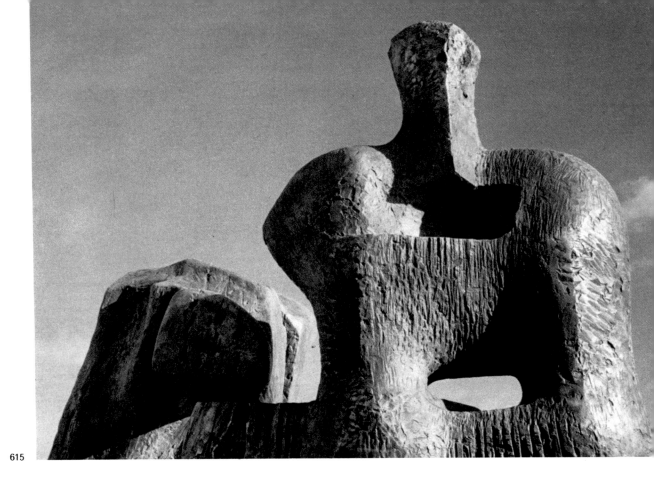

615

616

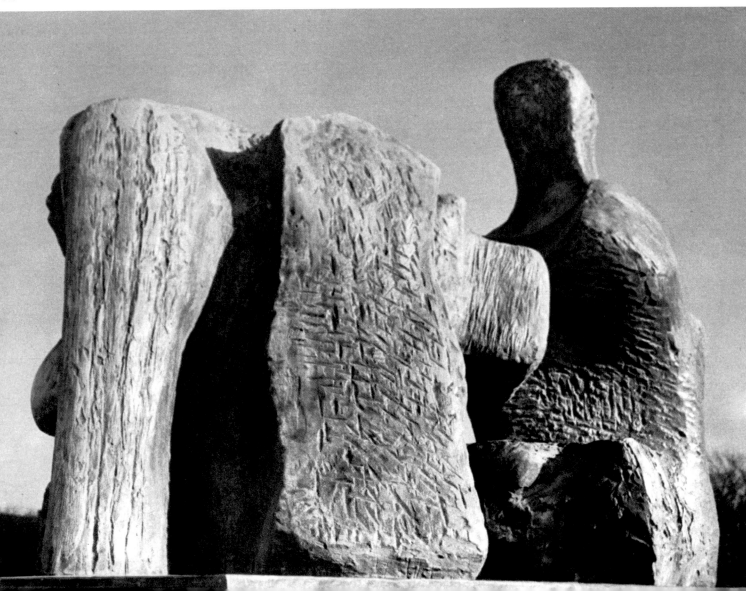

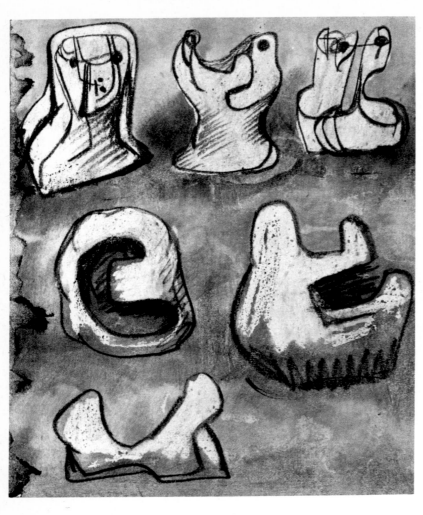

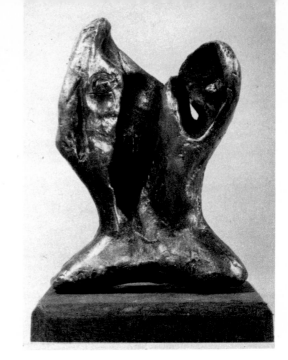

618

617 Heads: Ideas for Sculpture · Têtes:
idées pour sculptures · Köpfe: Skizzen
zu Plastiken · 1961

618 Split Head · Tête fendue · Gespaltener
Kopf · 1961 · H. 10.2 cm

619 Reclining Mother and Child · Mère
couchée avec enfant · Liegende Mutter
mit Kind · 1960-61 · L. 2.20 m

617

619

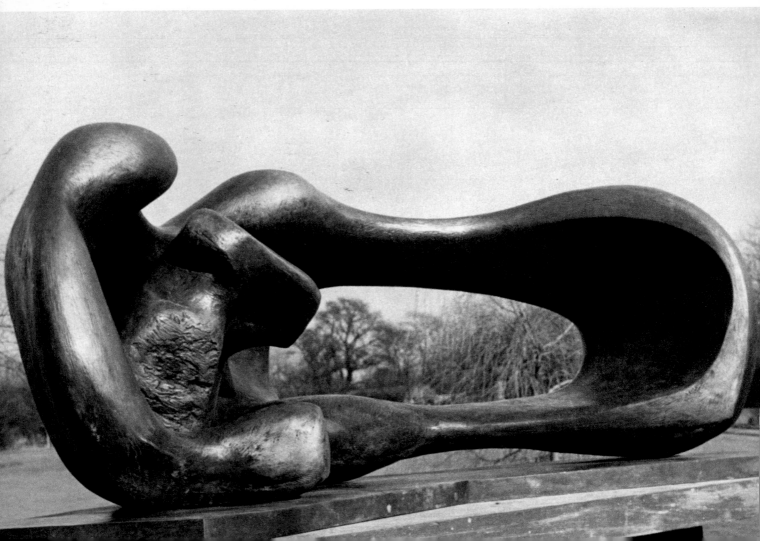

620

622

621

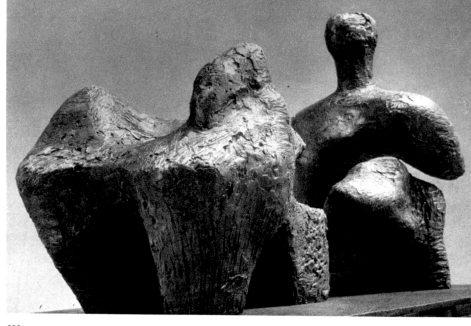

623

620 Maquette for Stone Memorial No. 1
Maquette pour un monument en pierre
n° 1 · Entwurf für ein steinernes
Denkmal Nr. 1 · 1961 · H. 13.3 cm

621 Maquette for Stone Memorial No. 2
Maquette pour un monument en pierre
n° 2 · Entwurf für ein steinernes
Denkmal Nr. 2 · 1961 · H. 9.5 cm

622–24 Two-piece Reclining Figure No. 4
Figure couchée en deux pièces n° 4
Zweiteilige liegende Figur Nr. 4
1961 · L. 1.09 m

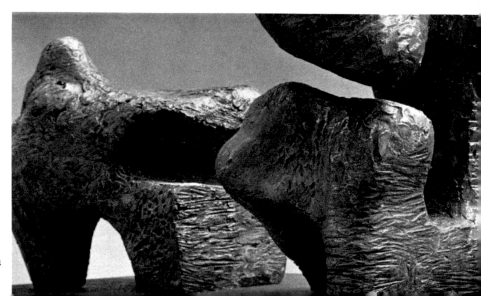

624

625

625 Reclining Figure · Figure couchée
Liegende Figur · 1961

626 Seated Figure: Armless · Figure
assise sans bras · Sitzende
armlose Figur · 1961 · H. 12.7 cm

627 Two Reclining Figures · Deux
figures couchées · Zwei liegende
Figuren · 1961

626

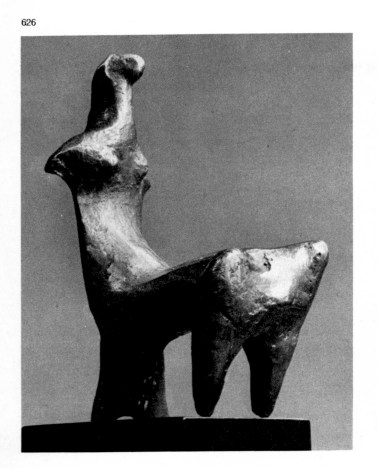

627

628 Stone Reclining Figure · Figure
couchée en pierre · Liegende
Steinfigur · 1961

629 Two Draped Reclining Figures · Deux
figures couchées drapées · Zwei
bekleidete liegende Figuren · 1961

630 Draped Seated Figure: Headless
Figure assise drapée: sans tête
Bekleidete sitzende Figur ohne
Kopf · 1961 · H. 20·3 cm

628

629

630

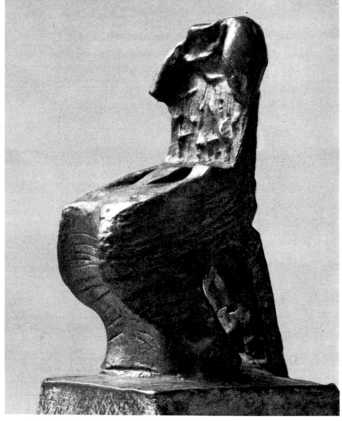

631-32 Seated Woman: Thin Neck · Femme
assise: cou mince · Sitzende Frau
mit dünnem Hals · 1961 · H. 1.62 m

633 Standing Figure: Knife-edge
Figure debout: lame de couteau
Stehende Figur: Messerschneide
1961 · H. 2.84 m

631

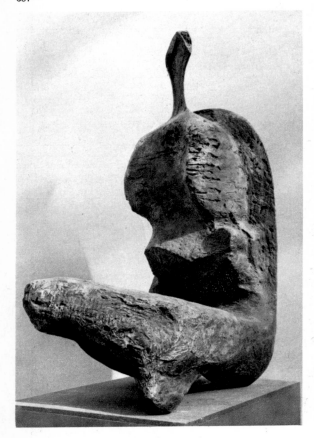

632

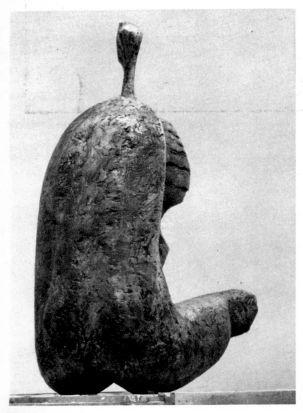

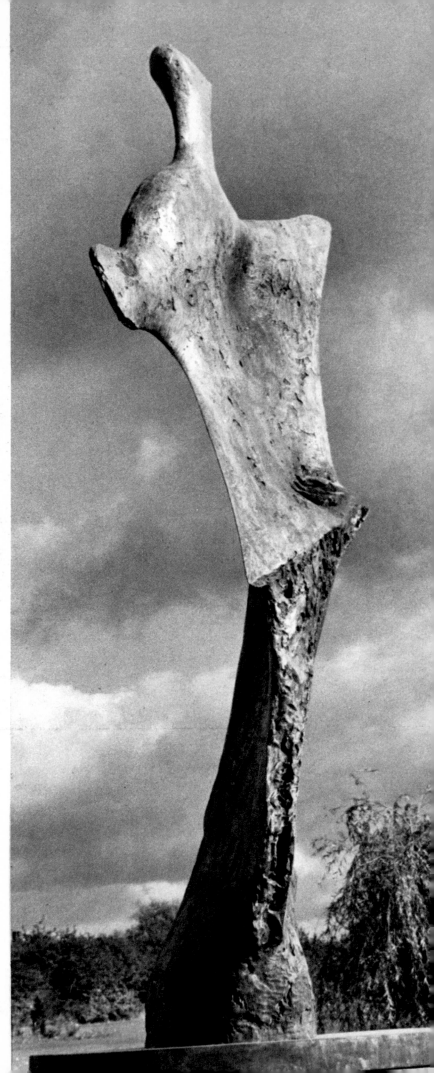

633

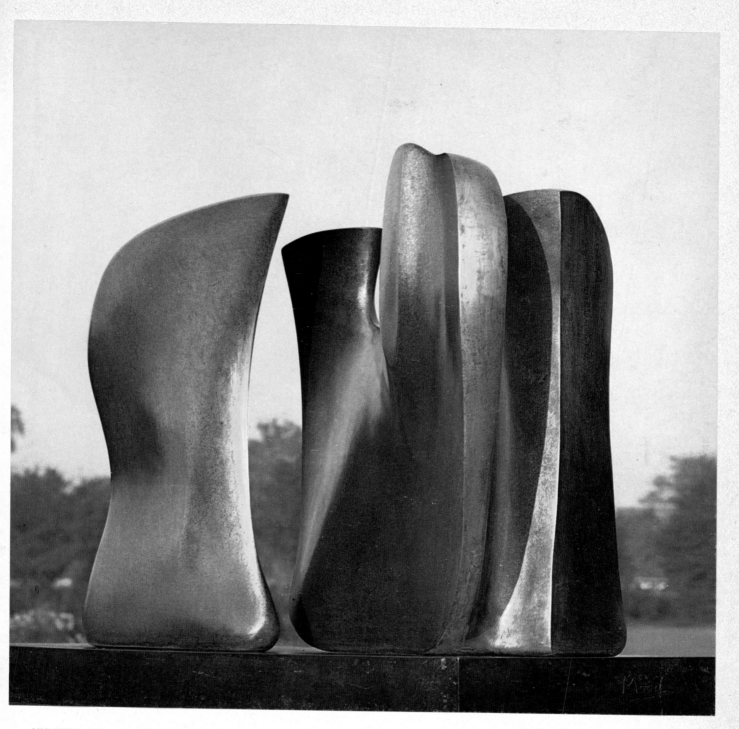

XXVI Working model for Knife-edge Two-piece, 1962. L. 71.1 cm

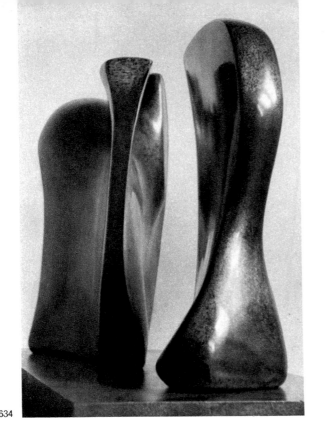

634

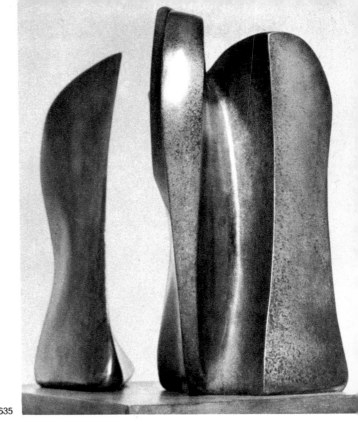

635

634-36 Working Model for Knife-edge Two-piece · Maquette de travail pour deux-pièces en lame de couteau · Arbeitsmodell für zweiteilige Messerschneide 1962 · L. 71.1 cm

636

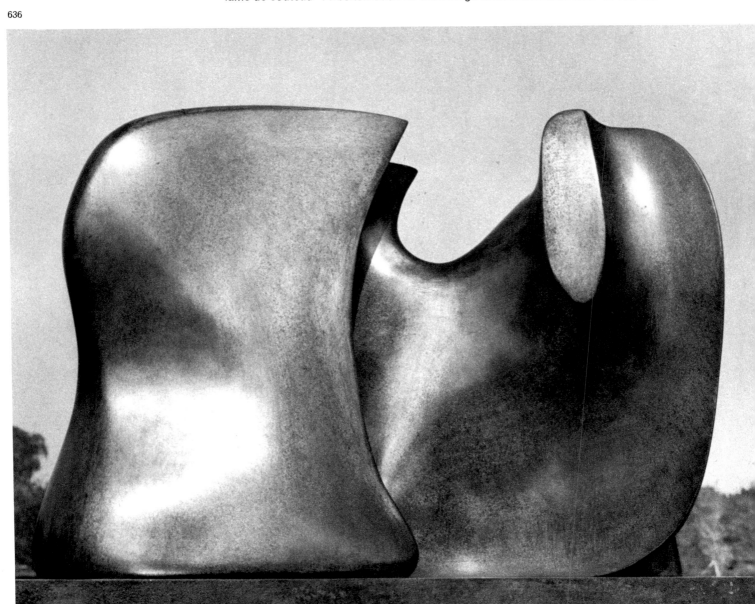

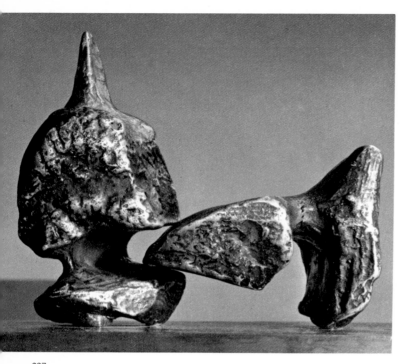

637

640

637 Two-piece Reclining Figure: Maquette No. 5
Figure couchée en deux pièces: maquette n° 5
Zweiteilige liegende Figur: Entwurf Nr. 5
1962 · L. 15.2 cm

638 Three-piece Reclining Figure: Maquette No. 1
Figure couchée en trois pièces: maquette n° 1
Dreiteilige liegende Figur: Entwurf Nr. 1
1961 · L. 19.7 cm

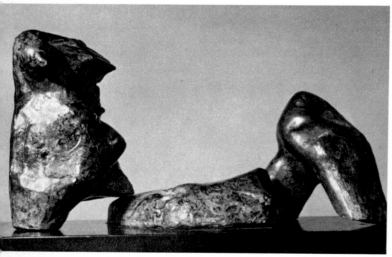

638

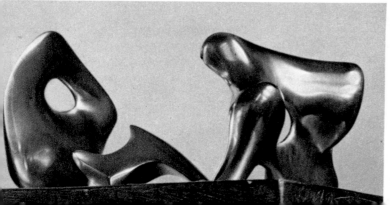

639

641

639 Three-piece Reclining Figure: Maquette No. 2
Figure couchée en trois pièces: maquette n° 2
Dreiteilige liegende Figur: Entwurf Nr. 2
1962 · L. 21.6 cm

640 Two Reclining Figures · Deux figures couchées
Zwei liegende Figuren · 1962

641 Maquette for Slow Form: Tortoise · Maquette pour
forme lente: tortue · Entwurf für langsame Form:
Schildkröte · 1962 · L. 21.6 cm

642

643

642 Three Reclining Figures · Trois figures couchées · Drei
liegende Figuren · 1961

643 Reclining Figure · Figure couchée · Liegende Figur · 1962

644 Two Torsos · Deux torses · Zwei Torsi · 1960 · L. 20.3 cm

645 Mother and Child: Wheels · Mère et enfant: roues · Mutter und
Kind: Räder · 1962 · H. 27.9 cm

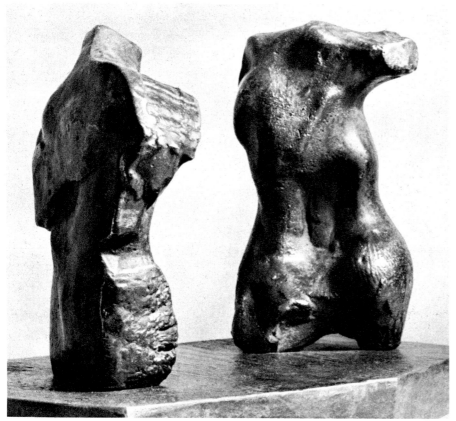

644

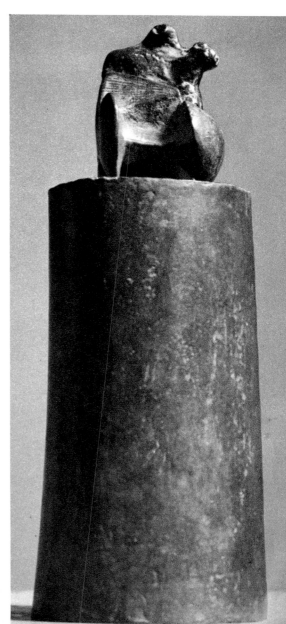

645

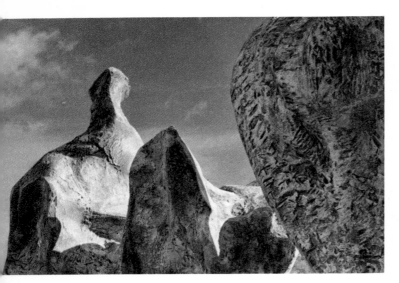

646

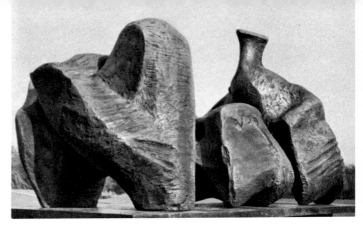

647

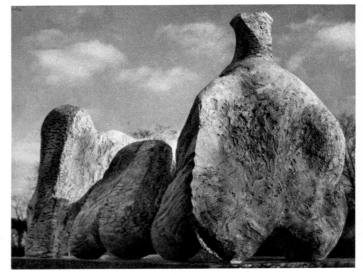

648

646-49 Three-piece Reclining Figure No. 1 · Figure couchée en trois pièces n° 1 · Dreiteilige liegende Figur Nr. 1 · 1961–62 · L. 2.87 m

650 The Wall: Background for Sculpture · Le mur: fond pour sculpture · Die Wand: Hintergrund für eine Skulptur · 1962 · L. 2.13 m

649

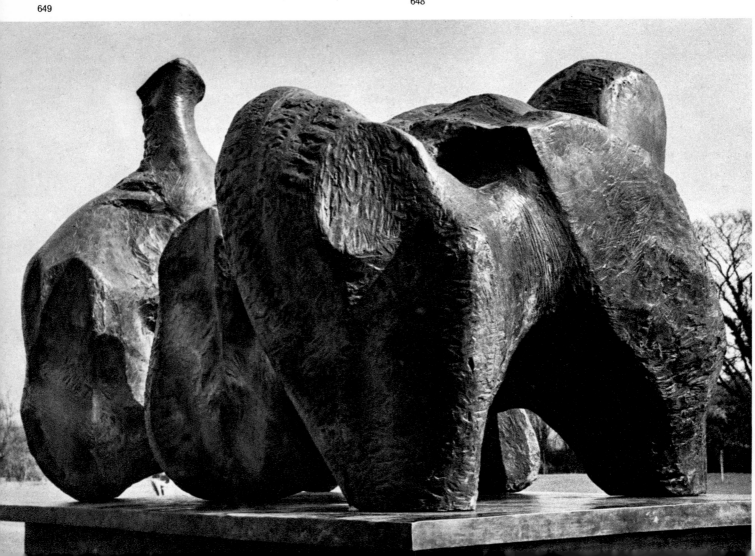

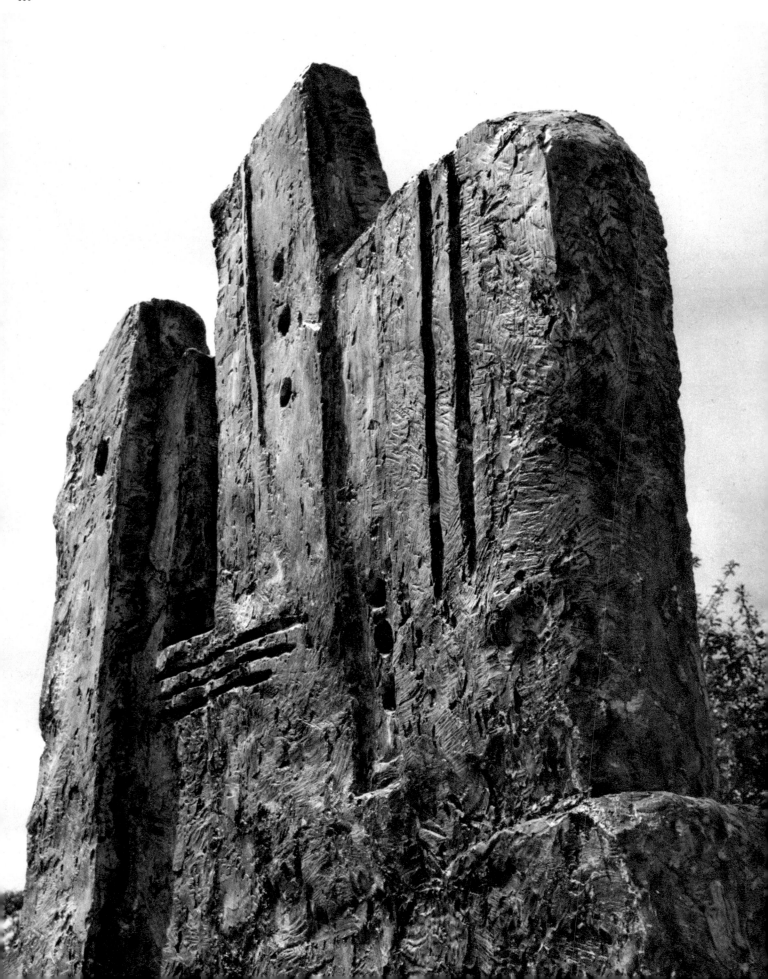

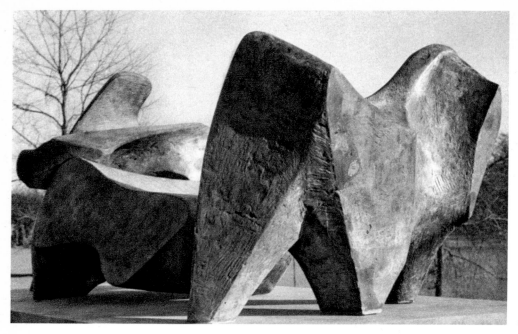

651

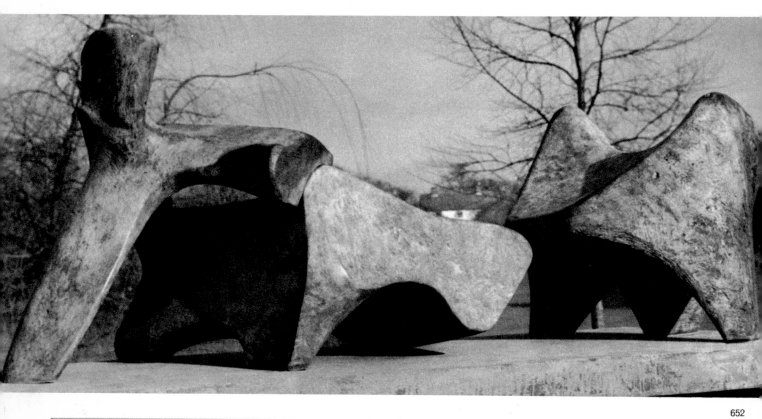

652

651-53 Three-piece Reclining
Figure No. 2: Bridge Prop
Figure couchée en trois
pièces nº 2: pile de pont
Dreiteilige liegende Figur
Nr. 2: Brückenpfeiler · 1963
L. 2.51 m

653

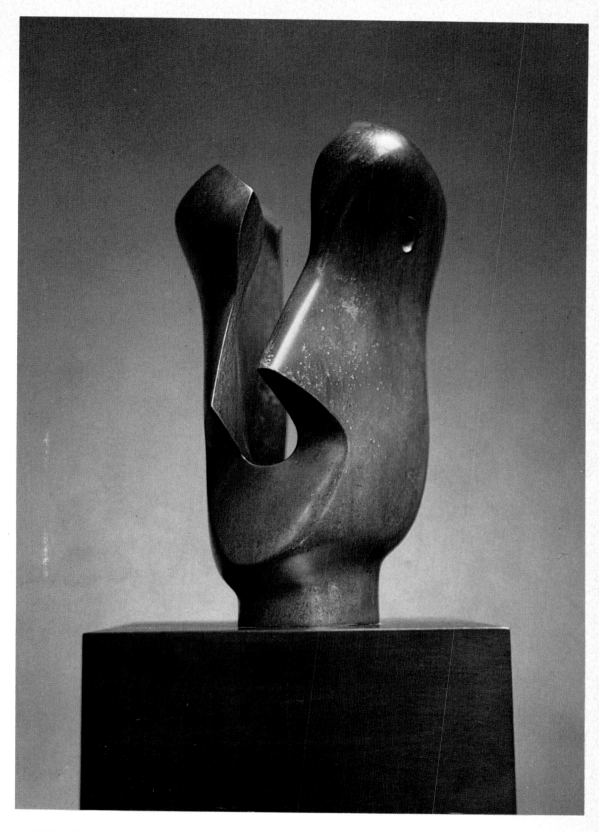

XXVII Divided Head, 1963. H. 34.9 cm

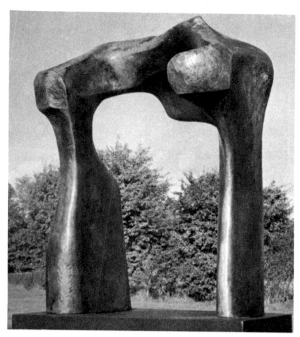

654

654-55 Large Torso: Arch · Grand torse: arc
Großer Torso: Bogen · 1962–63 · H. 1.98 m

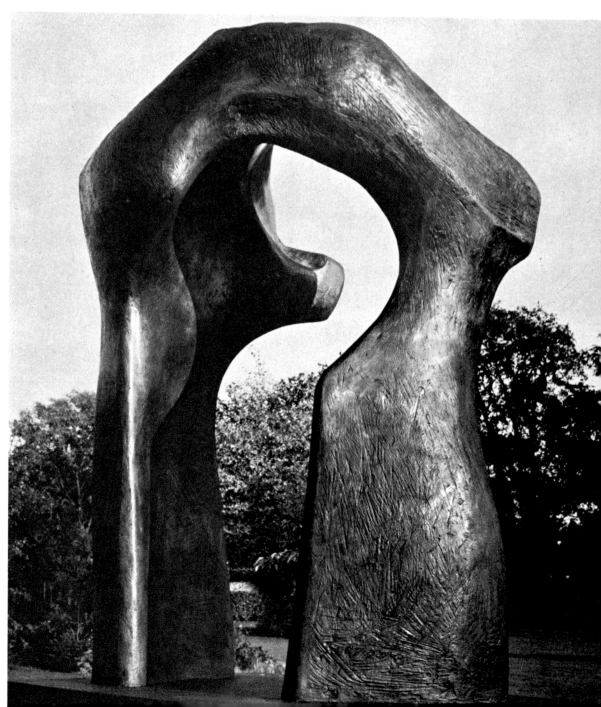

655

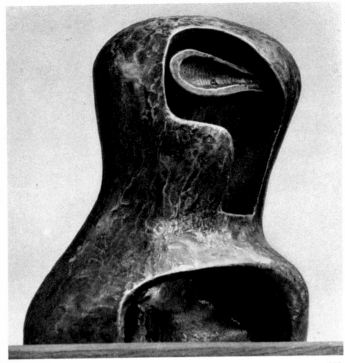

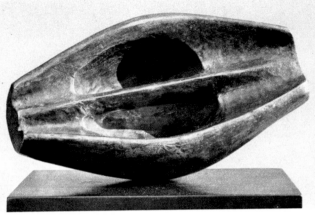

656

657

658

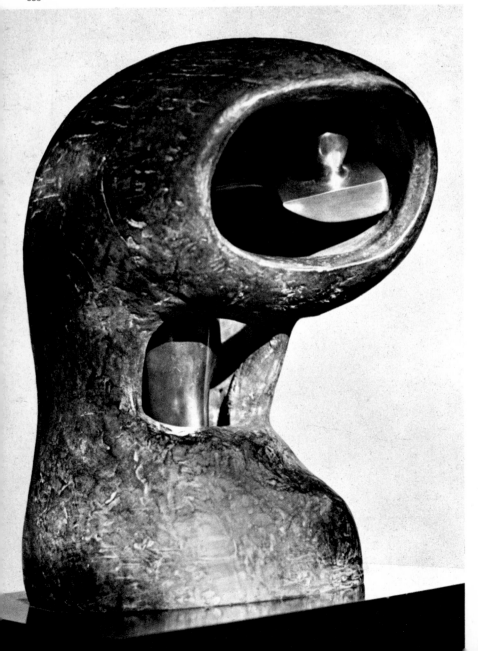

656 Head: Cyclops · Tête: cyclope
Zyklopenkopf · 1963 · H. 20.3 cm

657 Head: Boat Form · Tête: forme de
bateau · Kopf: Bootform · 1963
L. 15.2 cm

658 Helmet Head No. 4 · Tête-casque
n° 4 · Helm-Kopf Nr. 4 · 1963
H. 47.6 cm

659

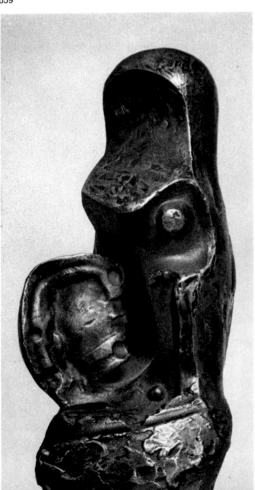

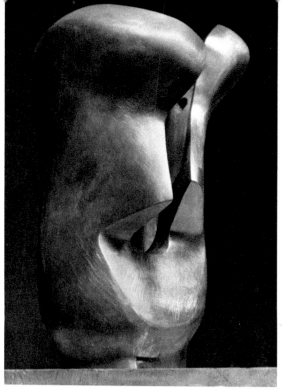

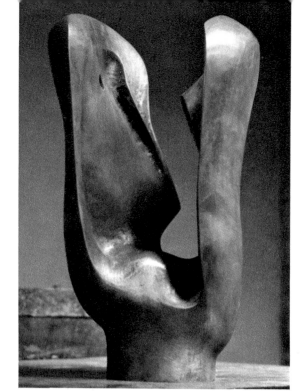

660

661

662

659 Mother and Child: Round Head · Mère et
 enfant: tête ronde · Mutter und Kind
 mit rundem Kopf · 1963 · H. 28.6 cm

660-62 Divided Head · Tête fendue
 Gespaltener Kopf · 1963 · H. 34·9 cm

663 Mother and Child: Bone · Mère et enfant:
 os · Mutter und Kind: Knochen · 1963
 H. 19.0 cm

663

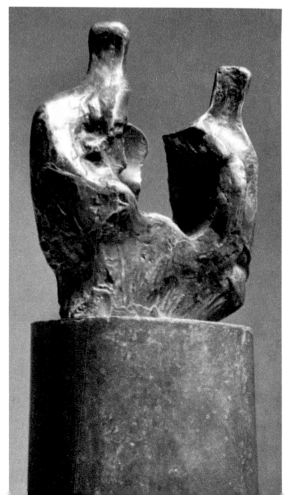

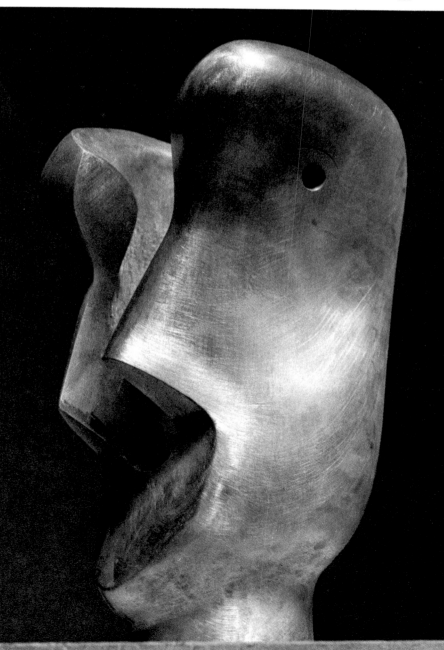

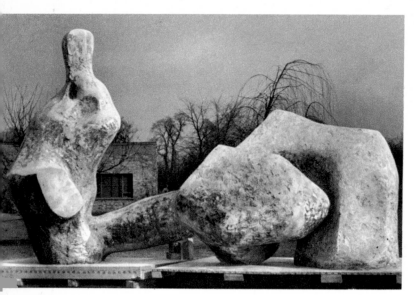

664

664-65 Two-piece Reclining Figure No. 5 · Figure couchée en deux pièces n° 5 · Zweiteilige liegende Figur Nr. 5 · 1963–64 · L. 3.73 m

666 Two Reclining Figures · Deux figures couchées Zwei liegende Figuren · 1964

665

666

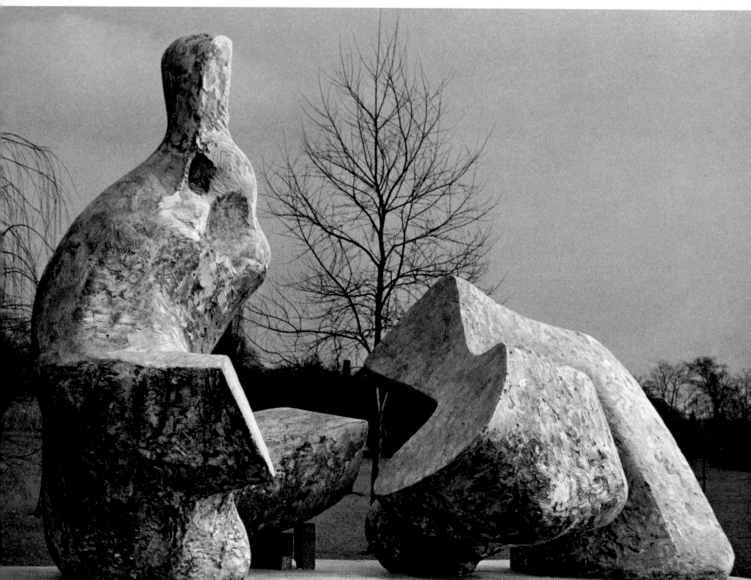

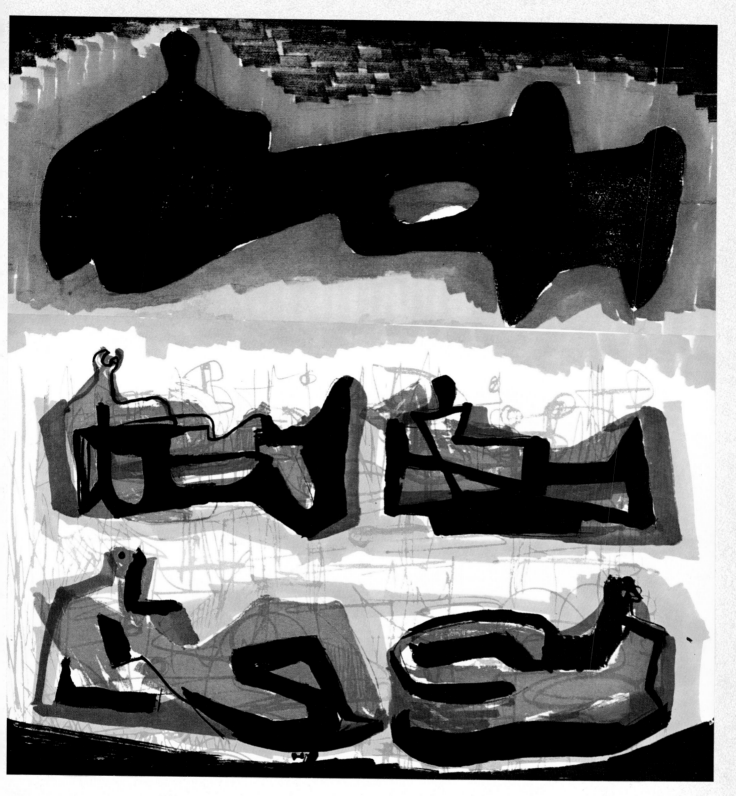

XXVIII Five Reclining Figures, 1964

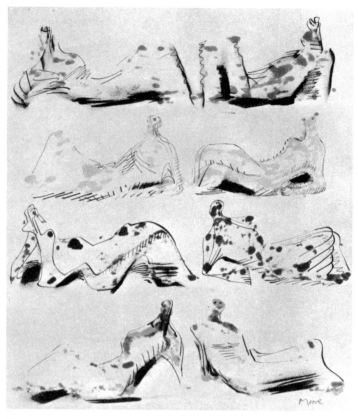

667

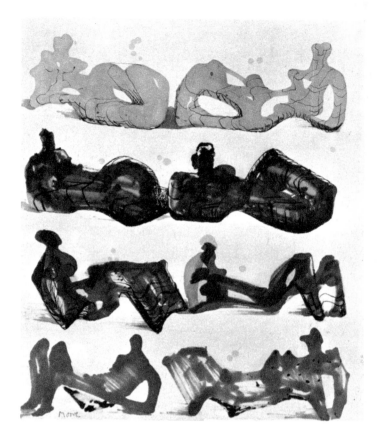

668

667 Eight Reclining Figures · Huit figures couchées
 Acht liegende Figuren · 1964

668 Eight Reclining Figures · Huit figures couchées
 Acht liegende Figuren · 1964

669 Five Reclining Figures · Cinq figures couchées
 Fünf liegende Figuren · 1964

670 Five Reclining Figures · Cinq figures couchées
 Fünf liegende Figuren · 1964

669

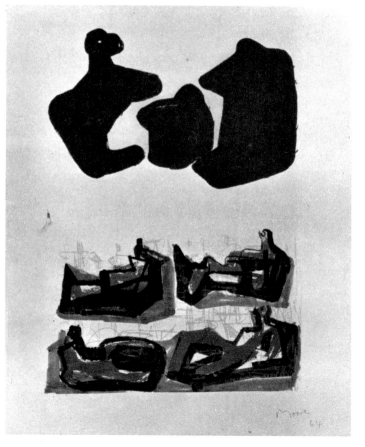

670

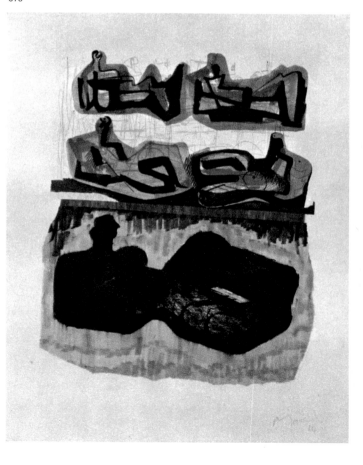

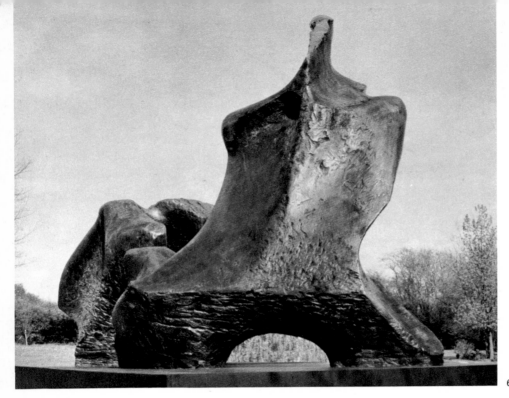

671

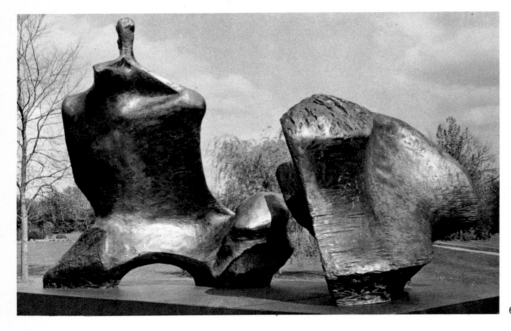

672

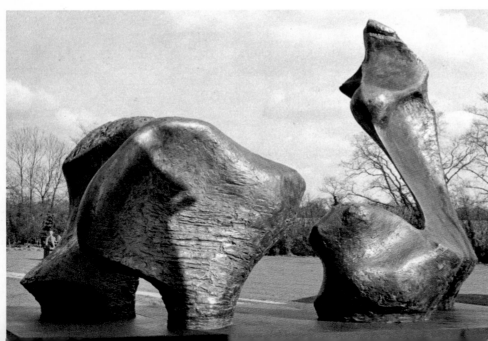

673

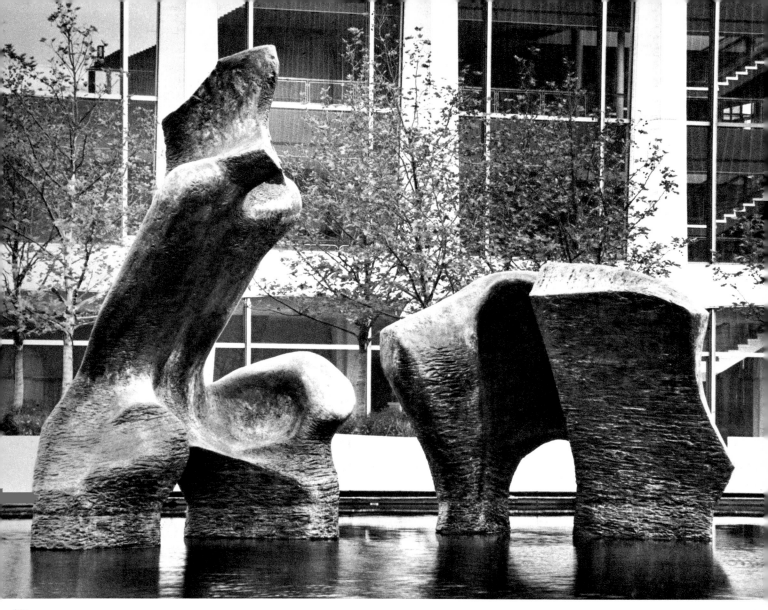

674

671-73 Reclining Figure (working model for Lincoln
Center sculpture) · Figure couchée (maquette de
travail pour la sculpture du Lincoln Center)
Liegende Figur (Arbeitsmodell für die Plastik
im Lincoln Center) · 1963 · L. 4.27 m

674-75 Reclining Figure (Lincoln Center sculpture)
Figure couchée (la sculpture du Lincoln Center)
Liegende Figur (die Plastik im Lincoln Center)
1963–65 · L. 9.14 m

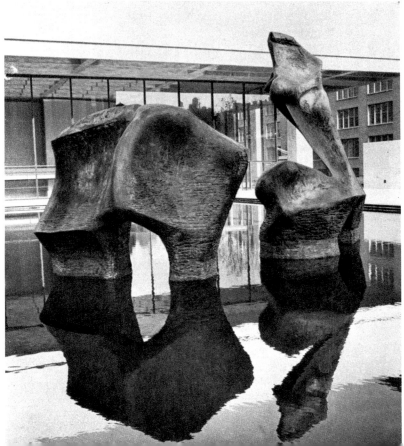

675

676

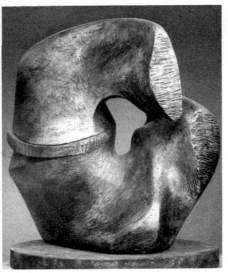

677

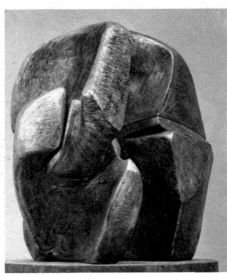

678

679

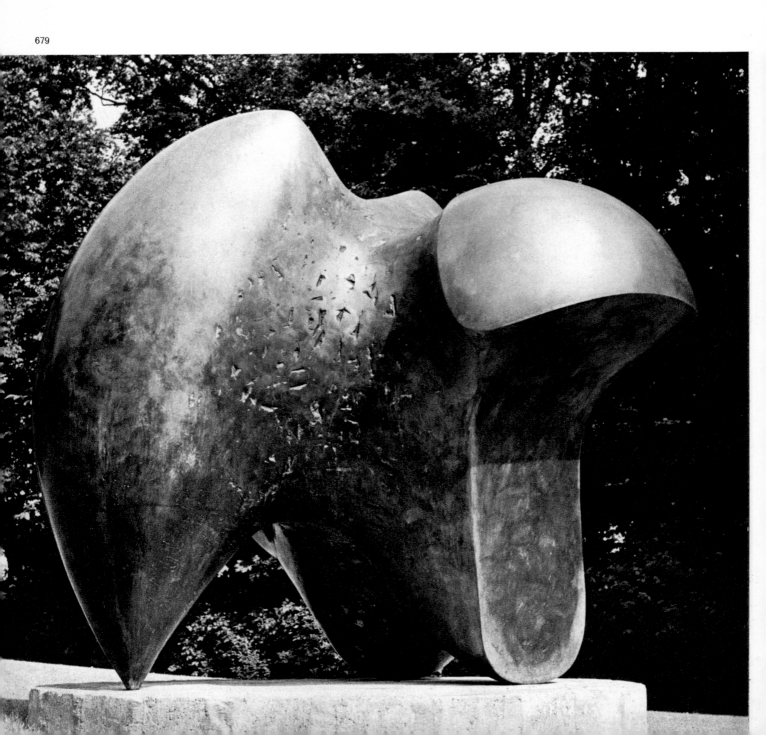

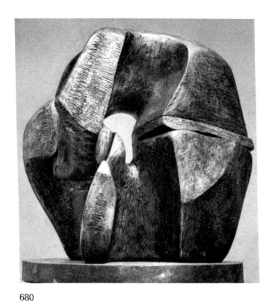

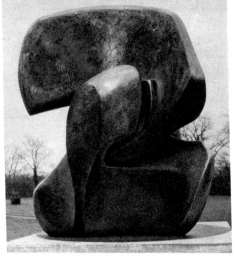

680

681

676-78 Working model for Locking
 Piece · Maquette de travail
 pour pièce d'enclenchement
 Arbeitsmodell für geschlossene
 Form · 1962 · H. 1.07 m

679 Three-way Piece No. 1: Points
 Pièce à trois voies n° 1: Pointes
 Dreiwegestück Nr. 1: Spitzen
 1964 · H. 1.93 m

680 Another view of Plate 676
 Autre vue de la fig. 676
 Andere Ansicht von Abb. 676

681-82 Locking Piece · Pièce
 d'enclenchement · Geschlossene
 Form · 1963–64 · H. 2.93 m

682

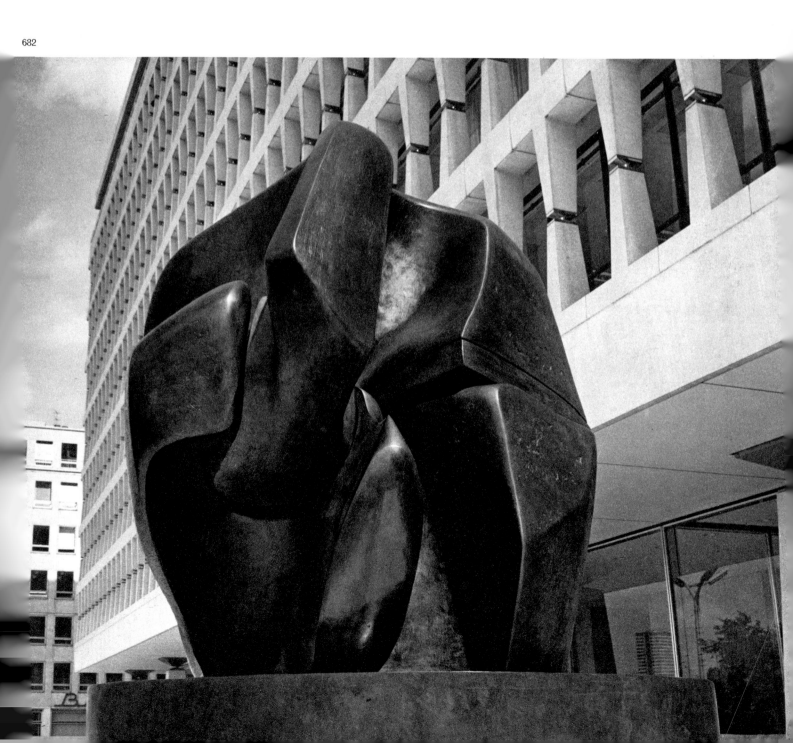

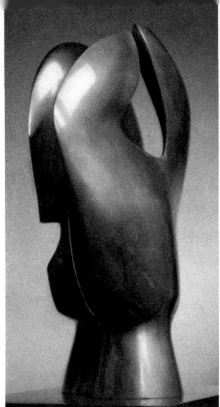

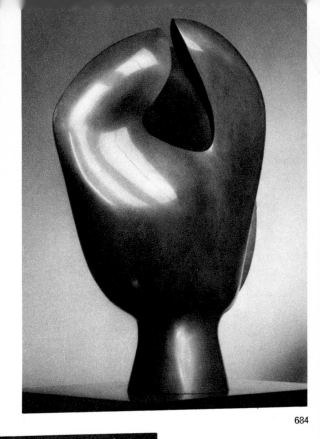

683-85 Moon Head · Tête lunaire · Mondkopf 1964 · H. 57.2 cm

683

684

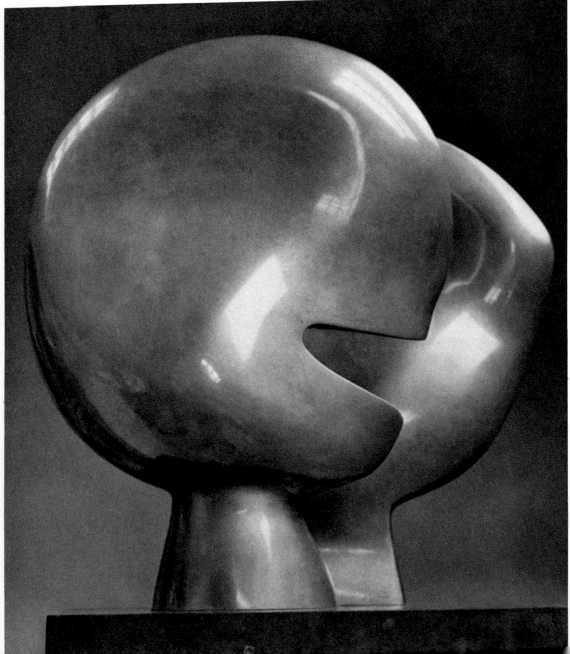

685

1965–1969

THIS PERIOD IS AS RICH and varied as any in Moore's career. In 1965, he bought a summer residence at Forte dei Marmi, not far from the Carrara quarries, and now spends three or four months of the year working on marble sculptures in a stoneyard near his summer home. They include two large organic abstracts in Red Soraya marble, *Three Rings (709)* and *Two Forms (726)* which are remote from the appearance of the human figure yet seem as magically female as the greatest of his reclining figures.

In *Two-piece No. 7: Pipe (700)*, the sculptor takes up the Classical theme of Rape. It is connected with the two-piece reclining figures, but the two forms do not signify a divided figure: they are separate organisms, and one of them emblemizes the importunate male. The same theme is treated more violently in *Two-piece No. 10: Interlocking (744–5)*. There is not an obvious protagonist in the white marble *Two-piece Carving: Interlocking (730–1)* and although the interlocking of the forms is sexual it seems to signify the intimacy of lovers. The *Mother and Child* theme is also treated in the terms of organic abstraction *(732)*. The mother is conceived as a food-providing vessel, and the smaller biomorphic form suggests an embryo uncurling to reach up to the open mouth of the vessel.

The working models for three new variations on the *Upright Motive* theme *(739)* are carved out of polystyrene, and Moore finds that for sculpture of a certain bulk this light and easily handled material provides much quicker results than plaster.

At the close of this period, he is engaged on three works *(747–54)* which, along with the Lincoln Center Bronze *(674–5)* are the largest he has ever undertaken. When, in 1939, he made the fantastic drawing called *Sculptural Object in Landscape (225)* it became an open secret that he planned at some time to create collosal sculptures that would be at once organic and environmental, and in these four works the grand design has been accomplished.

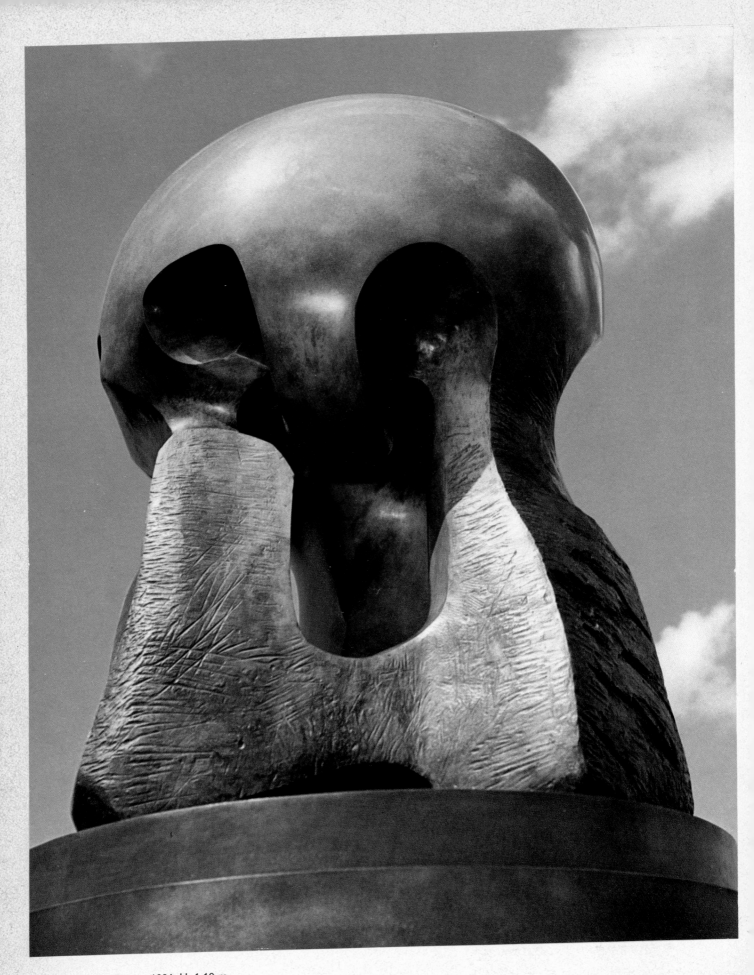

XXIX Atom Piece, 1964. H. 1.19 m

1965-1969

THIS PERIOD IS AS RICH and varied as any in Moore's career. In 1965, he bought a summer residence at Forte dei Marmi, not far from the Carrara quarries, and now spends three or four months of the year working on marble sculptures in a stoneyard near his summer home. They include two large organic abstracts in Red Soraya marble, *Three Rings (709)* and *Two Forms (726)* which are remote from the appearance of the human figure yet seem as magically female as the greatest of his reclining figures.

In *Two-piece No. 7: Pipe (700)*, the sculptor takes up the Classical theme of Rape. It is connected with the two-piece reclining figures, but the two forms do not signify a divided figure: they are separate organisms, and one of them emblemizes the importunate male. The same theme is treated more violently in *Two-piece No. 10: Interlocking (744–5)*. There is not an obvious protagonist in the white marble *Two-piece Carving: Interlocking (730–1)* and although the interlocking of the forms is sexual it seems to signify the intimacy of lovers. The *Mother and Child* theme is also treated in the terms of organic abstraction *(732)*. The mother is conceived as a food-providing vessel, and the smaller biomorphic form suggests an embryo uncurling to reach up to the open mouth of the vessel.

The working models for three new variations on the *Upright Motive* theme *(739)* are carved out of polystyrene, and Moore finds that for sculpture of a certain bulk this light and easily handled material provides much quicker results than plaster.

At the close of this period, he is engaged on three works *(747–54)* which, along with the Lincoln Center Bronze *(674–5)* are the largest he has ever undertaken. When, in 1939, he made the fantastic drawing called *Sculptural Object in Landscape (225)* it became an open secret that he planned at some time to create collosal sculptures that would be at once organic and environmental, and in these four works the grand design has been accomplished.

XXIX Atom Piece, 1964. H. 1.19 m

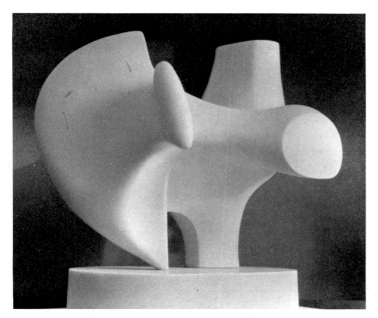

686

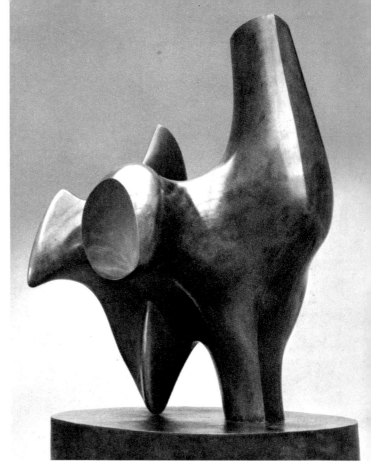

686 Archer · Archer · Bogenschütze · 1965 · H. 91.4 cm

687 Working model for Three-way Piece No. 2: Archer
Maquette de travail pour pièce à trois voies nº 2:
archer · Arbeitsmodell für Dreiwegestück Nr. 2:
Bogenschütze · 1964 · H. 77.5 cm

688 The Archer · L'archer · Der Bogenschütze · 1964–65
L. 3.25 m

687

688

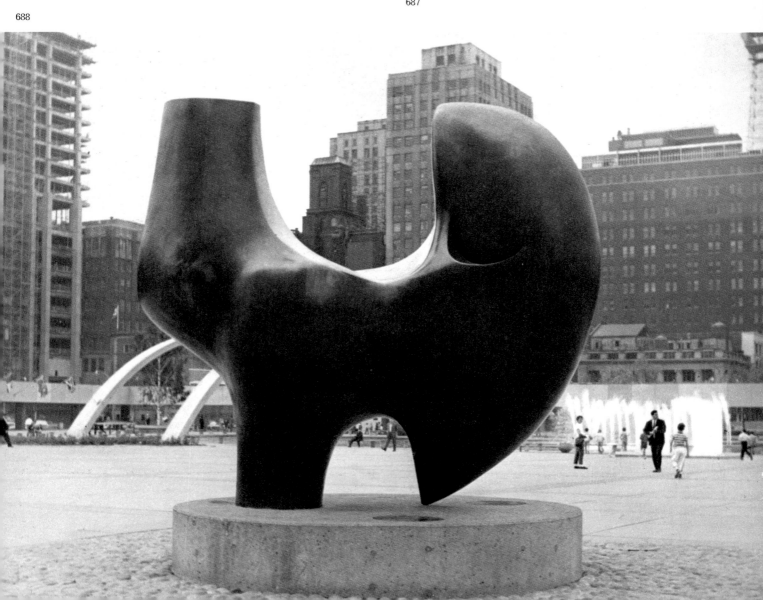

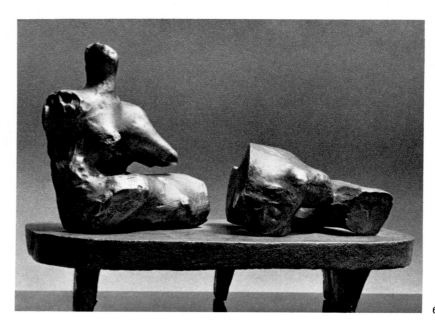

691

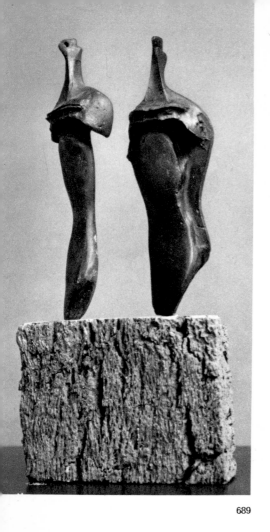

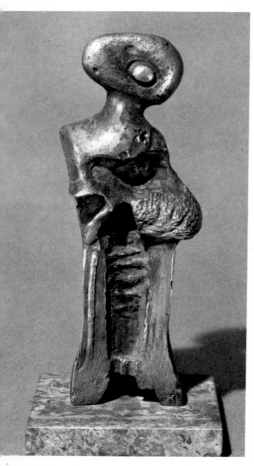

689

689 Two Three-quarter Figures · Deux figures en trois-quarts
Zwei Dreiviertelfiguren · 1965 · H. 19.4 cm

690 Standing Girl: Bonnet and Muff · Jeune fille debout: capote et
manchon · Stehendes Mädchen mit Mütze und Muff · 1966 · H. 24.1 cm

691 Two-piece Reclining Figure, Maquette No. 8 · Figure couchée en
deux pièces, maquette n° 8 · Zweiteilige liegende Figur, Entwurf Nr. 8
1966 · L. 24.1 cm

692 Helmet Head No. 5 · Tête-casque n° 5 · Helm-Kopf Nr. 5 · 1966
H. 41.9 cm

692

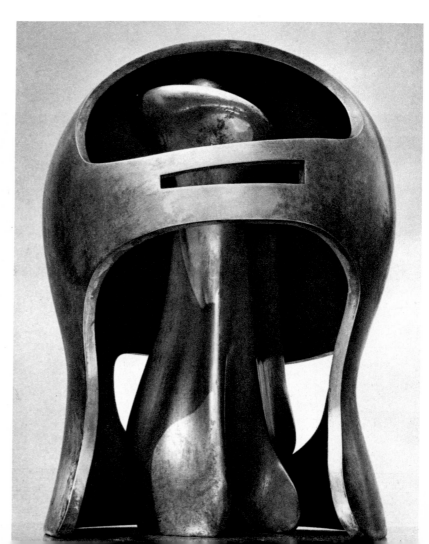

690

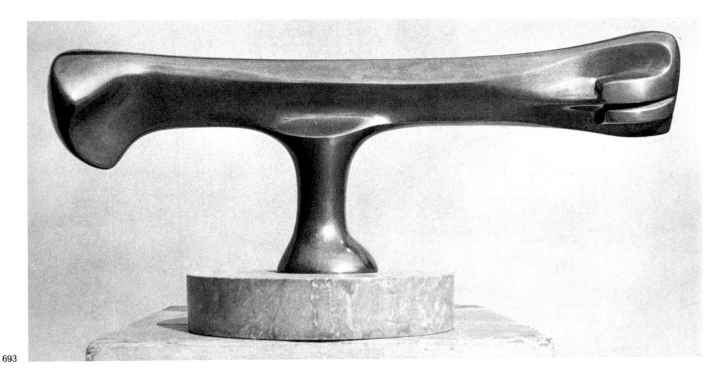

693

693 Anvil · Enclume · Amboß · 1966 · L. 57.1 cm

694 Interior Form · Forme intérieure · Innere
Form · 1966 · H. 33.0 cm

695 Globe and Anvil · Globe et enclume · Kugel
und Amboß · 1966 · H. 20.3 cm

696 Owl · Hibou · Eule · 1966 · H. 21.6 cm

694

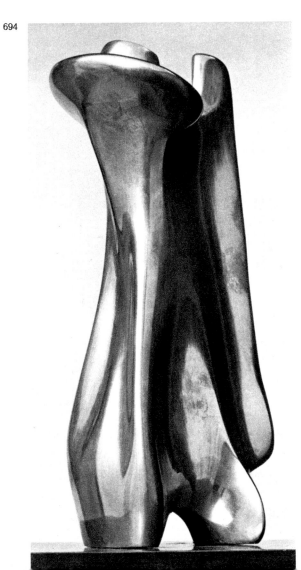

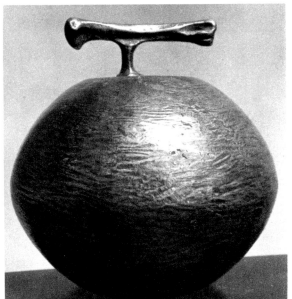

695

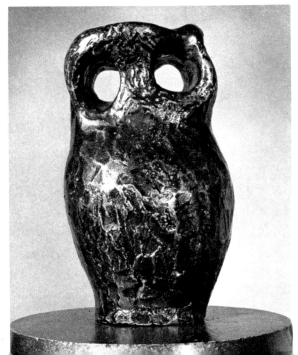

696

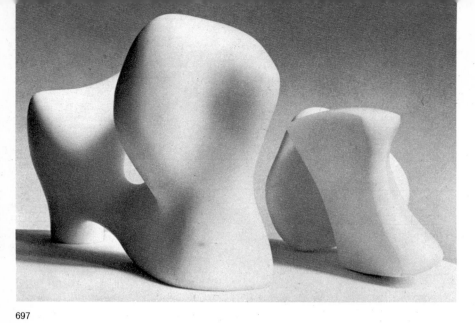

697

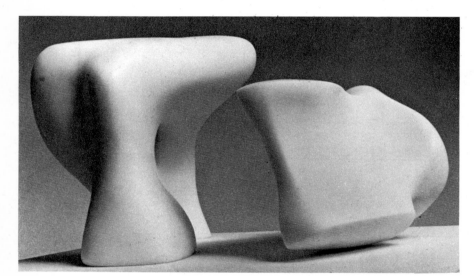

698

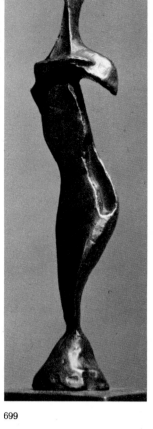

699

700

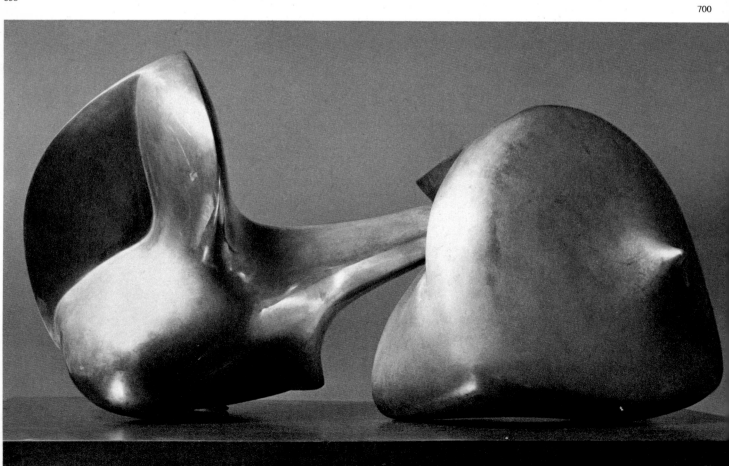

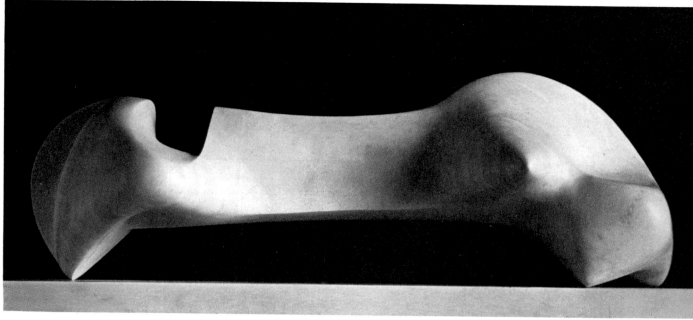

701

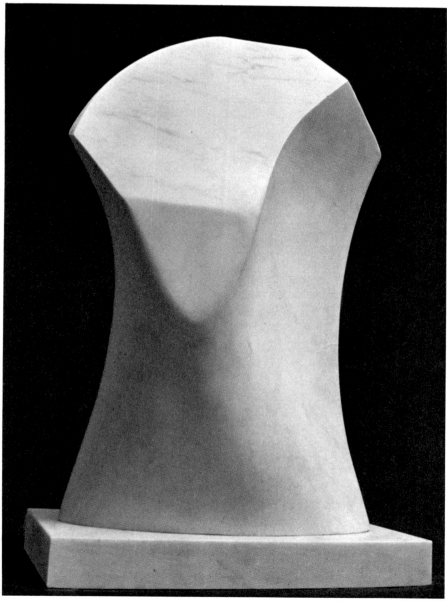

697-98 Two Forms · Deux formes
Zwei Formen · 1963–66
L. 45.7 cm

699 Thin Standing Figure · Figure
mince debout · Stehende
schlanke Figur · 1965
H. 19.0 cm

700 Two-piece No. 7: Pipe
Sculpture en deux pièces
n° 7: pipe · Zweiteilige
Skulptur Nr. 7: Pfeife
1966 · L. 94.0 cm

701 Reclining Form · Forme
couchée · Liegende Gestalt
1966 · L. 1.14 m

702 Torso · Torse · Torso
1966 · H. 78.7 cm

702

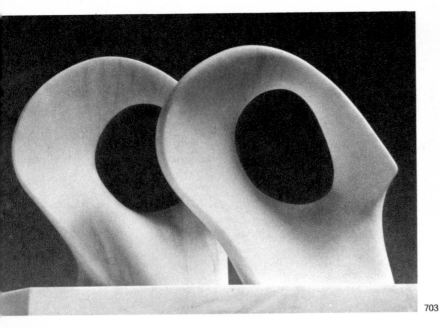

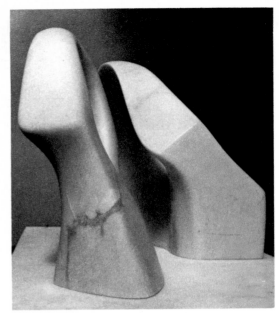

703

704

705

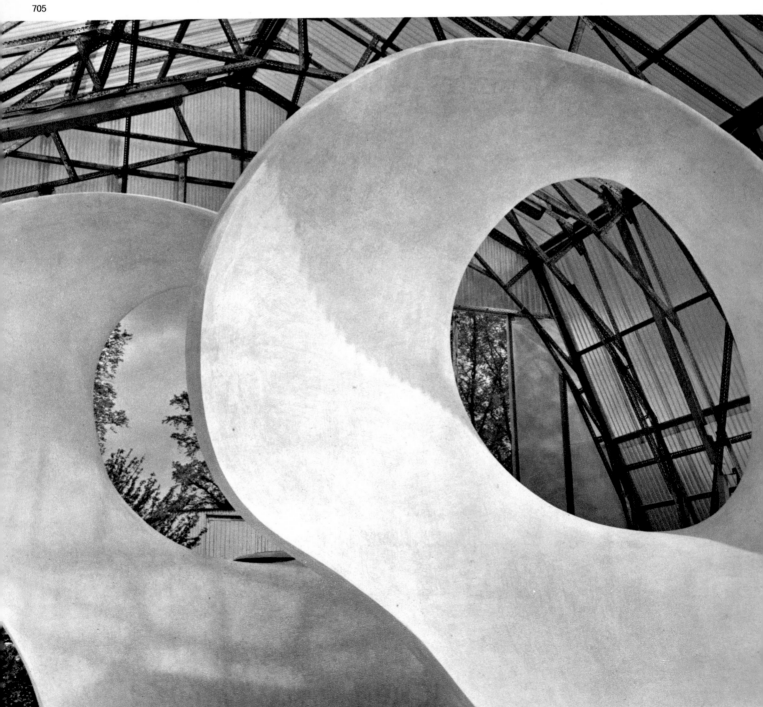

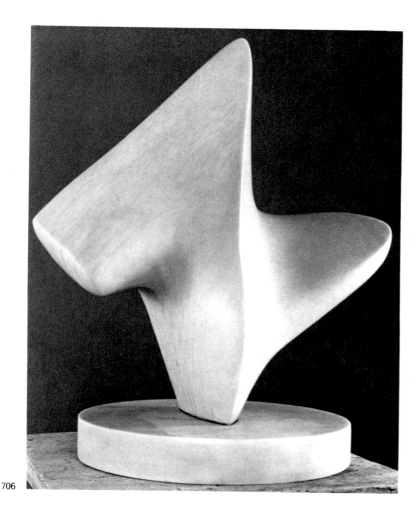

706

703-704 Double Oval · Double ovale
Doppel-Oval · 1966 · H. 61.0 cm

705 Double Oval (detail) · Double
ovale (détail) · Doppel-Oval
(Ausschnitt) · 1967 · H. 3.96 m

706 Upright Form, Knife-edge · Forme
verticale, lame de couteau
Aufrechte Form, Messerschneide
1966 · H. 60.3 cm

707-708 Sundial · Cadran solaire
Sonnenuhr · 1965–66 · H. 3.66 m

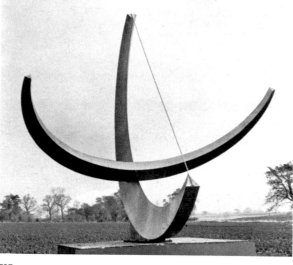

707

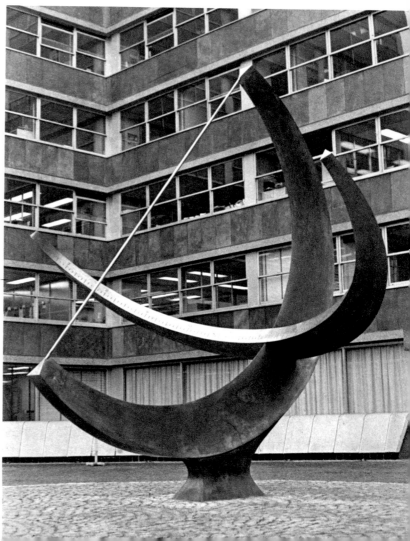

708

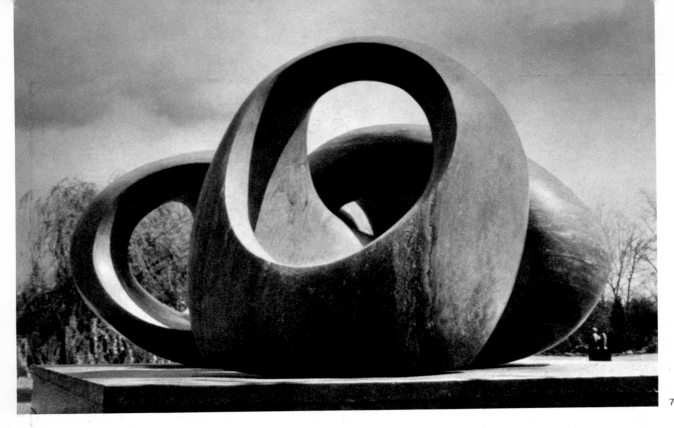

709

709 Three Rings · Trois anneaux · Drei Ringe · 1966 · L. 2.69 m
710-11 Three Rings · Trois anneaux · Drei Ringe · 1966 · L. 99.1 cm

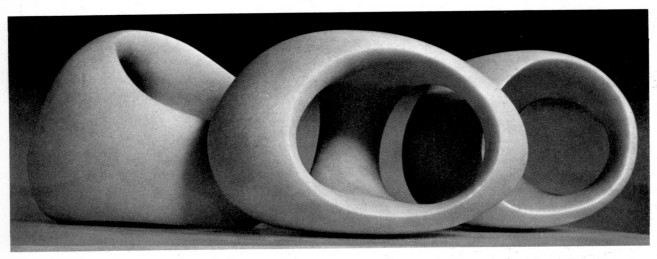

710

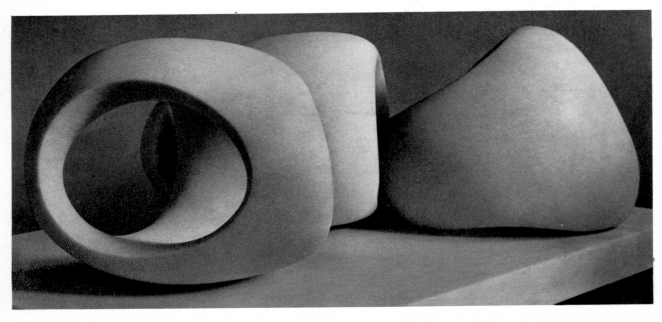

711

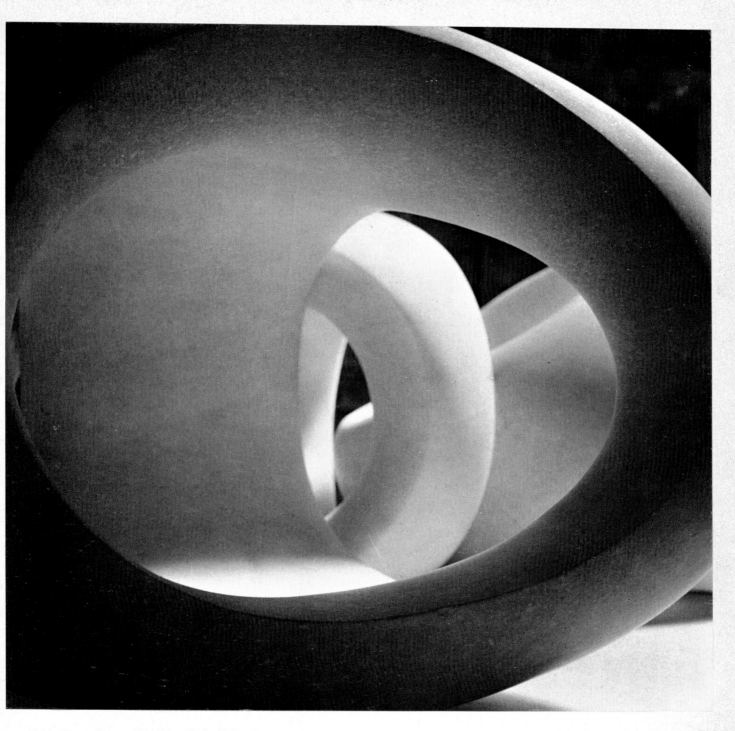

XXX Three Rings, 1966 (detail). L. 99.7 cm

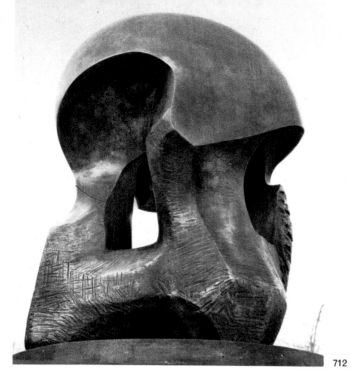
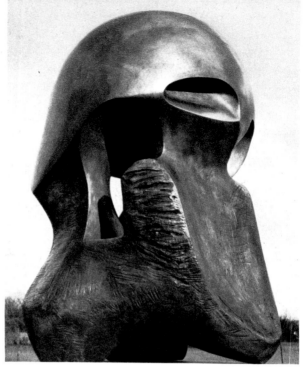

712

713

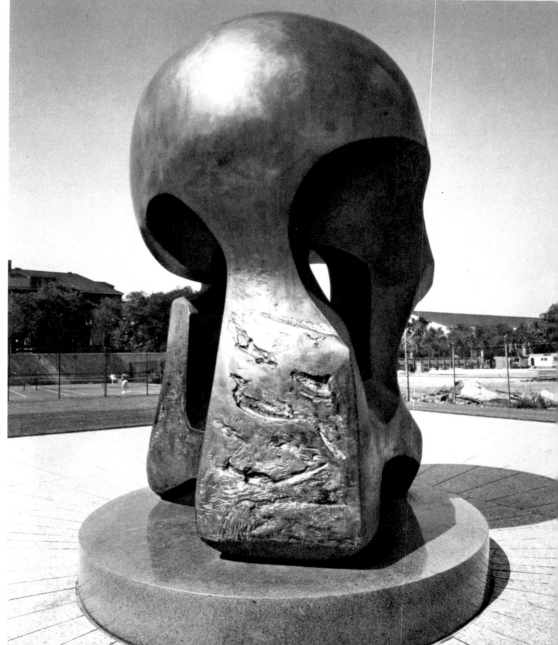

712-13 Atom Piece · Pièce-atome
Atomstück · 1964 · H. 1.19 m

714 Nuclear Energy · Energie
nucléaire · Kernenergie
1965–66 · H. 3.66 m

714

715

716

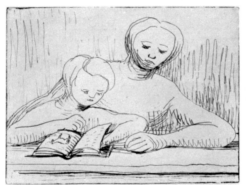

717

715 Black Seated Figure on Orange Background · Figure assise noire sur fond orangé · Schwarze sitzende Figur vor orangegelbem Hintergrund · 1966–67

716 Two Reclining Figures in Yellow and Red · Deux figures couchées en jaune et rouge · Zwei liegende Figuren in gelb und rot · 1967

717 Picture Book · Livre d'images · Bilderbuch · 1967

718 Eight Reclining Figures · Huit figures couchées · Acht liegende Figuren · 1966-67

719 Reclining Figures with Blue Central Composition · Figures couchées au motif central bleu · Liegende Figuren mit blauem Hauptmotiv · 1966–67

718

719

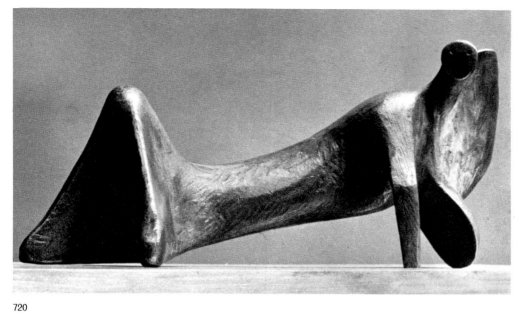

720

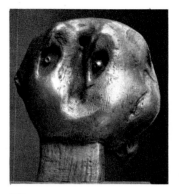

721

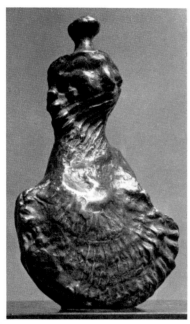

722

720 Reclining Figure: Cloak
 Figure couchée: manteau
 Liegende Figur mit Mantel
 1967 · L. 36.8 cm

721 Doll Head · Tête de poupée
 Puppenkopf · 1967 · H. 10.5 cm

722 Standing Figure: Shell Skirt
 Figure debout: jupe en
 coquillage · Stehende Figur
 mit Muschelrock · 1967
 H. 17.8 cm

723 Torso · Torse · Torso
 1967 · H. 1.07 m

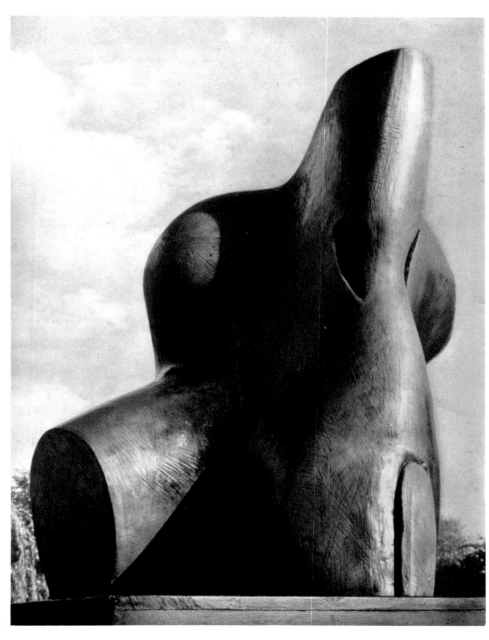

723

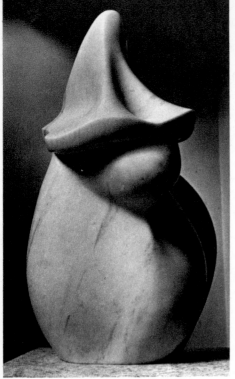

724

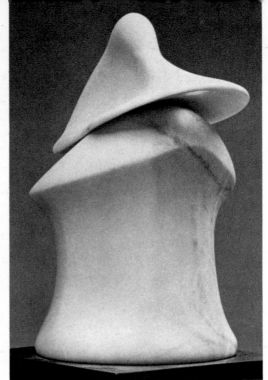

725

724 Girl: Half Figure · Jeune fille: demi-figure
Mädchen: Halbfigur · 1967 · H. 88.9 cm

725 Bust of a Girl: Two-piece · Buste de jeune fille:
deux-pièces · Mädchenbüste in zwei Teilen
1968 · H. 78·1 cm

726

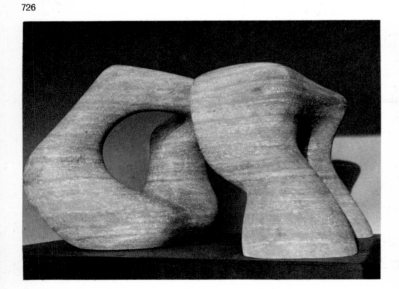

727

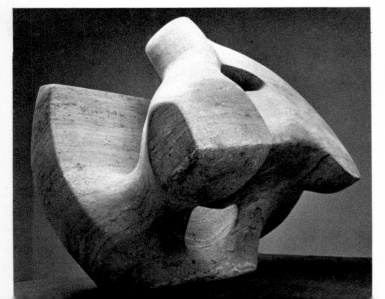

728

726 Two Forms · Deux formes · Zwei Formen · 1966
L. 1.50 m

727 Sculpture with Light and Hole · Sculpture ajourée
Plastik mit Lichtöffnung · 1967 · L. 1.22 m

728 Two Nuns · Deux nonnes · Zwei Nonnen · 1966–68
H. 1.51 m

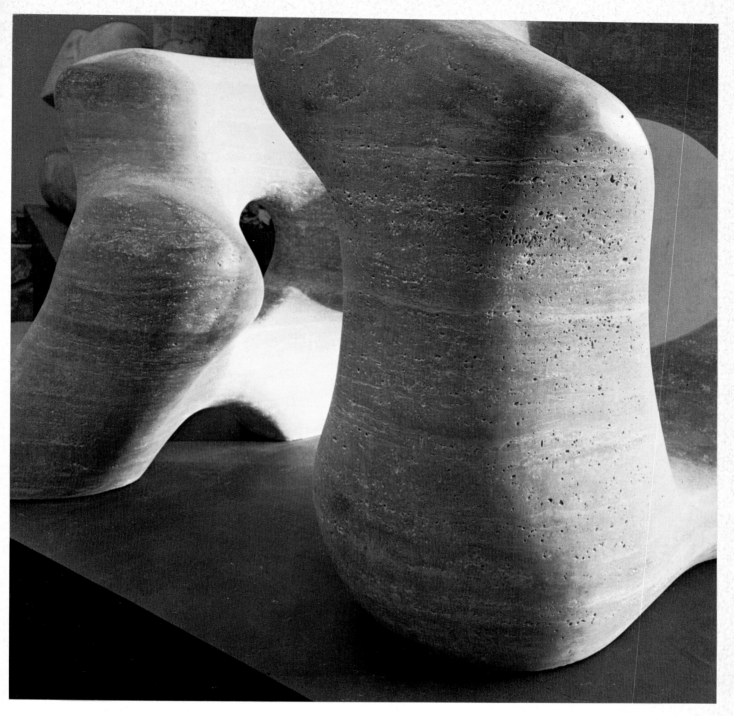

XXXI Two Forms, 1966 (detail). L. 1.52 m

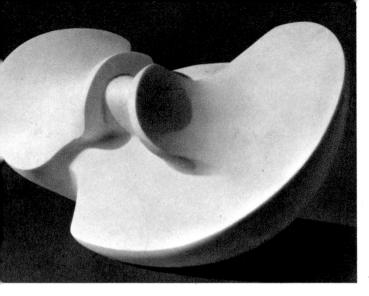

729 Divided Oval (Butterfly) · Ovale fendu (papillon)
Geteiltes Oval (Schmetterling) · 1967 · L. 91.4 cm

730-31 Two-piece Carving: Interlocking · Sculpture en
deux pièces: enclenchement · Zweiteilige ineinander-
greifende Skulptur · 1968 · L. 71.1 cm

732 Mother and Child · Mère et enfant · Mutter und Kind
1967 · H. 1.30 m

729

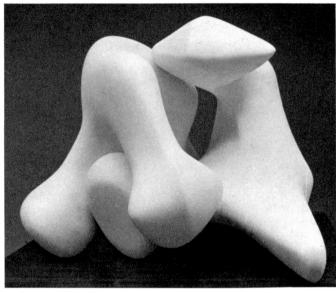

730

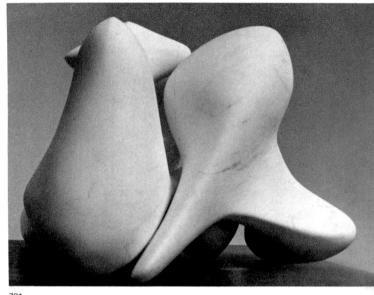

731

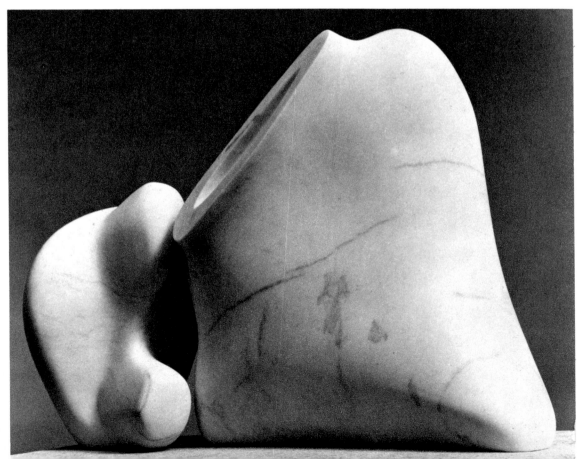

732

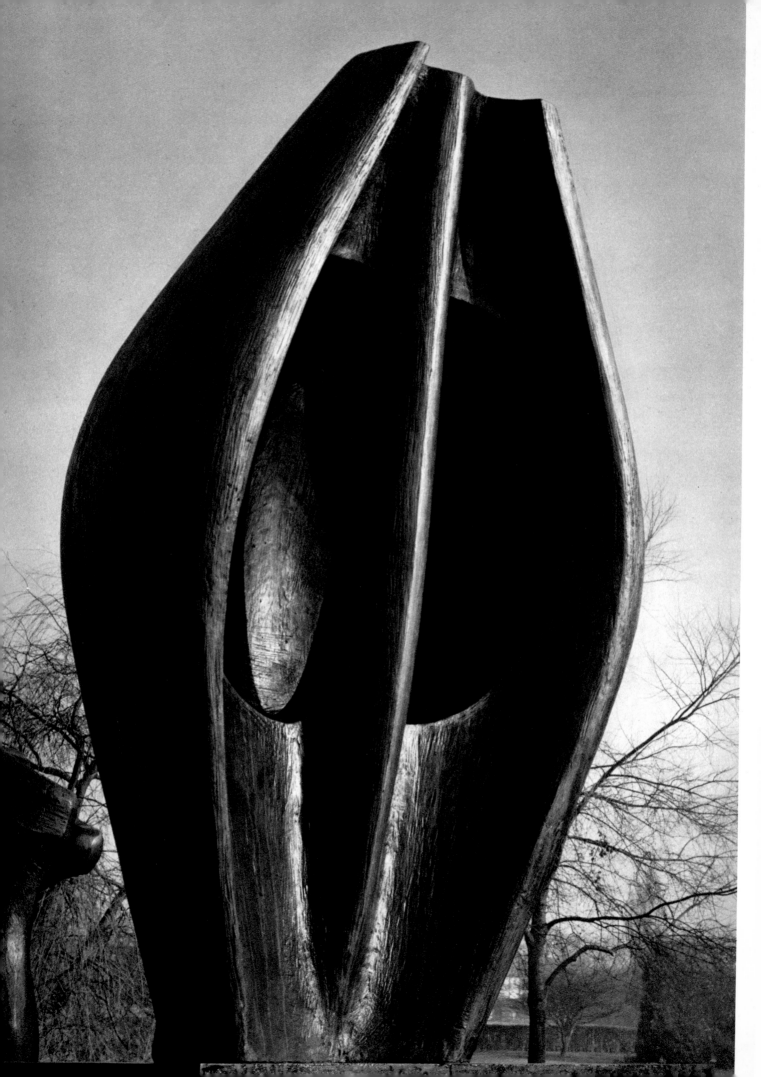

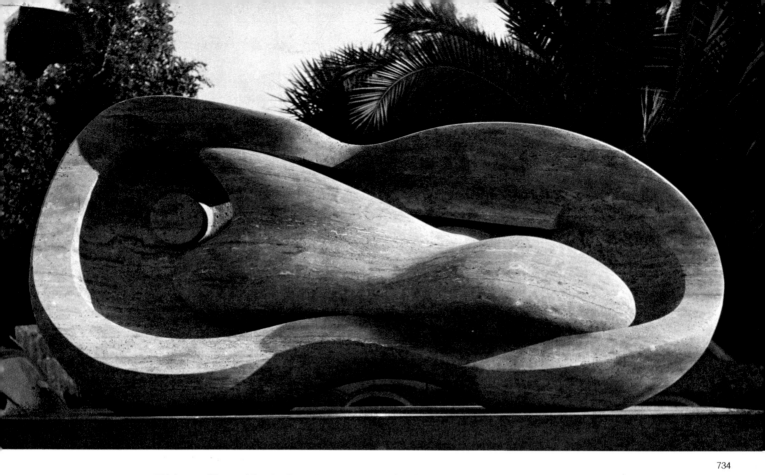

734

733 Large Totem Head · Grande tête-totem · Großer Totemkopf · 1968 · H. 2.44 m

734 Reclining Interior: Oval · Forme couchée intérieure: ovale · Liegende Innenform, oval · 1965–68 · L. 2.16 m

735 Stone Memorial · Monument de pierre · Steinernes Denkmal · 1961–68 · L. 1.80 m

735

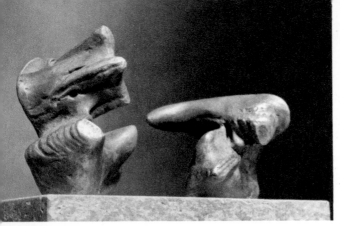

736

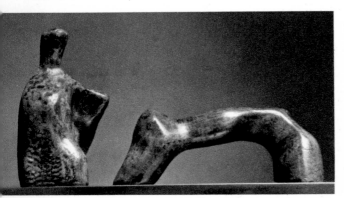

737

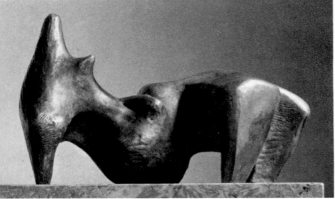

738

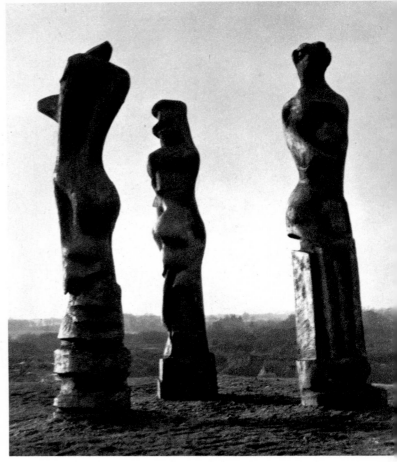

739

736 Maquette for Two-piece Reclining Figure: Points
Maquette pour figure couchée en deux pièces: pointes
Entwurf für zweiteilige liegende Figur: Spitzen · 1968 · L. 14.0 cm

737 Reclining Figure: Arch Leg · Figure couchée: jambe en arc
Liegende Figur mit bogenförmigen Beinen · 1969 · L. 18.4 cm

738 Maquette for Reclining Figure · Maquette pour figure
couchée · Entwurf für liegende Figur · 1969 · L. 15.2 cm

739 Three Upright Motives · Trois motifs verticaux
Drei aufrechte Motive · 1968 · H. 3.66 m

740 Two-piece Reclining Figure
No. 9 · Figure couchée en
deux pièces nº 9
Zweiteilige liegende Figur
Nr. 9 · 1968 · L. 2.49 m

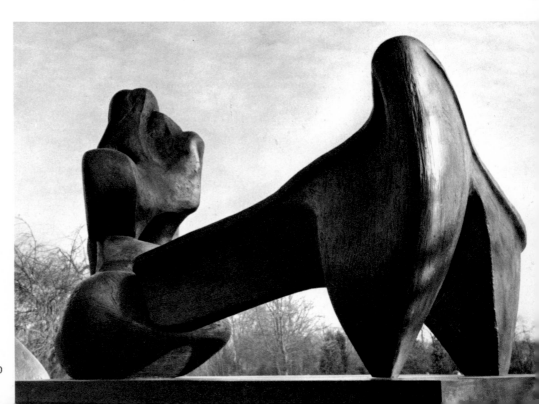

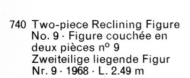

740

XXXII Eight Reclining Figures on White Background, 1966

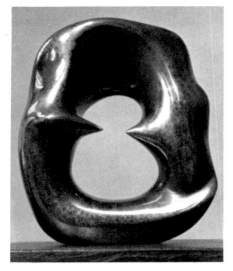

741

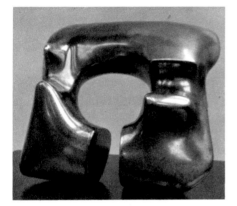

742

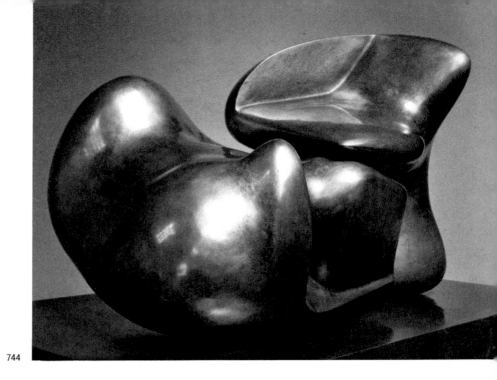

744

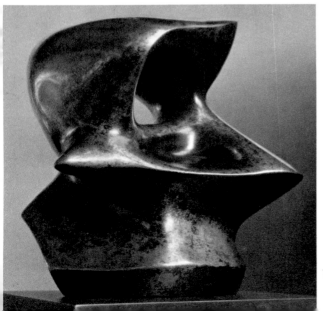

743

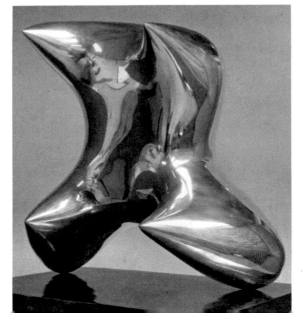

745

746

747

748

749

750

747-52 Progressive stages in the modelling of Three-piece No. 3:
Vertebrae · Etapes successives au cours du modelage de trois-
pièces n° 3: vertèbres · Enstehungsstadien der dreiteiligen
Skulptur Nr. 3: Rückenwirbeln · 1968–69 · L. 6.10 m

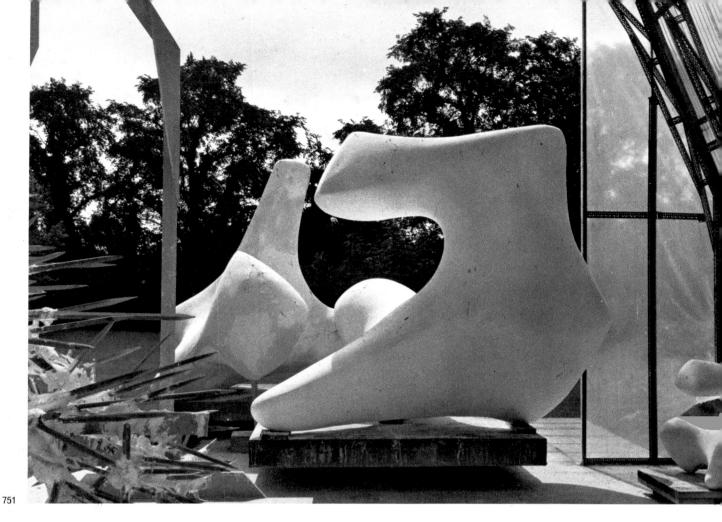

751

752

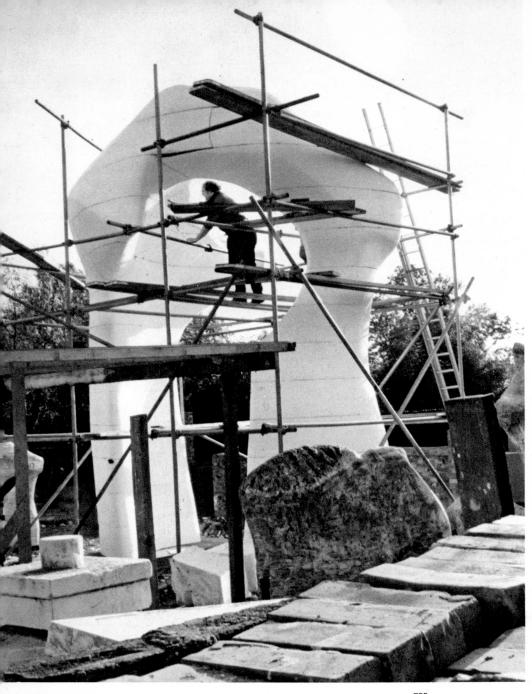

753 Large Arch · Grand arc
Großer Bogen · 1963–69
H. 6.10 m

754-55 Large Two Forms · Deux
grandes formes · Zwei große
Formen · 1966–69 · L. 4.72 m

753

754

755

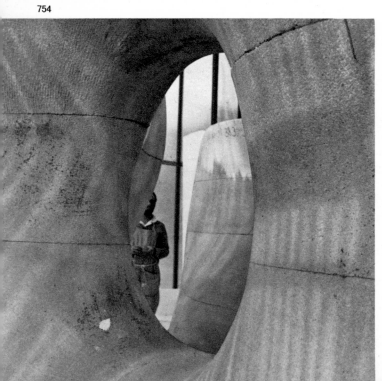

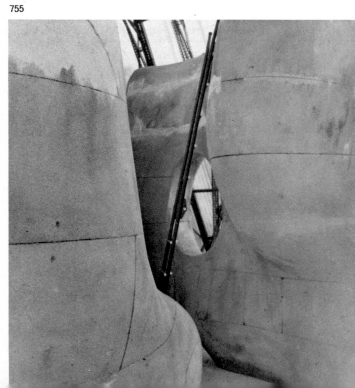

SELECT BIBLIOGRAPHY
CHRONOLOGY
LIST OF ILLUSTRATIONS
PHOTOGRAPH ACKNOWLEDGEMENTS

SELECT BIBLIOGRAPHY

Statements made by the sculptor himself in articles, broadcasts and interviews have been collected in *Henry Moore on Sculpture*, edited by Philip James. London, Macdonald & Co. Ltd., 1966.

GROHMANN, WILL: *The Art of Henry Moore*, London, Thames & Hudson Ltd., 1960.

HEDGECOE, JOHN: *Henry Moore*. Photographs of Moore at work and on holiday, accompanied by photographs of landscapes and natural objects connected with some of the sources of his inspiration. With a running commentary by the sculptor. London, Thomas Nelson & Sons Ltd., 1968.

MARLBOROUGH FINE ART: Catalogue of an exhibition, *Henry Moore: Carvings 1923–1966*, with an introduction, *On Henry Moore's doctrine of truth to material*, by Robert Melville. London, Marlborough Fine Art Ltd., 1967.

READ, HERBERT: *Henry Moore, Sculpture and Drawings*. Vol. I (1921–48), edited by David Sylvester. Vol. II (1949–54), catalogue of sculpture by Alan Bowness. Vol. III (1955–64), edited by Alan Bowness. (Sculpture only.) London, Lund, Humphries & Co.

READ, HERBERT: *Henry Moore: A study of his life and work*, London, Thames & Hudson Ltd., 1965.

RIJKSMUSEUM KRÖLLER-MÜLLER and MUSEUM BOYMANS-VAN BEUNINGEN: *70 Years of Henry Moore*. A pictorial biography published to accompany an exhibition held to celebrate Moore's 70th birthday. Documentation collected and edited by David Mitchinson. Netherlands, 1968.

RUSSELL, JOHN: *Henry Moore: Stone and Wood Carvings*. London, Marlborough Fine Art Ltd., in conjunction with Anthony Blond Ltd., 1961.

RUSSELL, JOHN: *Henry Moore*. An examination of his life and art. London, Allen Lane, The Penguin Press, 1968.

SYLVESTER, DAVID: *Sculpture and Drawings by Henry Moore*. Catalogue of an exhibition at the Tate Gallery selected by David Sylvester for the Arts Council of Great Britain. Catalogue prepared by David Sylvester, with an analytical text. London, Arts Council of Great Britain, 1951.

SYLVESTER, DAVID: *Henry Moore*. Catalogue of an exhibition at the Tate Gallery selected by David Sylvester for the Arts Council of Great Britain. The text is a substantial study of Moore's imagery. London, Arts Council of Great Britain, 1968.

330

30 July, birth of Henry Moore at his parents' home, 30 Roundhill Road, Castleford, **1898**
Yorkshire. Seventh of eight children of Raymond Spencer Moore (1849–1921) and
Mary Baker (1860–1944). His father, who was of Irish descent, began work at the
age of nine on a farm, but spent most of his life as a miner. He was an active Socialist
and Trade Unionist. His mother came from Staffordshire.

Elementary school at Castleford. **1902**

Attends Temple Street School and in 1908 wins a scholarship to Castleford Grammar **1904–1908**
School.

Encouraged by his art teacher, Miss Alice Gostick, to develop his talent for drawing **1909–1914**
and painting. His headmaster introduces him to Gothic carvings in Yorkshire churches.
In 1914 passes his Cambridge Senior Certificate which qualifies him to enter a Teachers
Training College.

Despite his wish to become an artist, he follows his father's advice and goes to the **1915**
Training College.

Appointed to a teaching post at Temple Street Elementary School. First visit to **1916**
London, where he visits the British Museum and the National Gallery. Enlists in the
Fifteenth London Regiment (Civil Service Rifles). Military training at Wimbledon
and Hazeley Downs, near Winchester.

Leaves for the front in France. His division goes into action towards the end of the **1917**
year. Gassed at Cambrai and sent back to hospital in England.

After two months convalescence becomes a bayonet instructor at Aldershot with the **1918**
rank of lance-corporal. Volunteers to return to the front and reaches France just
before the Armistice.

Demobilized in England in February and returns to his teaching post in Castleford **1919**
for a few months. Enters Leeds School of Art in September.

First encounter with modern art (Cézanne, Gauguin, Rouault, Matisse, Kandinsky) **1920**
and African sculpture on a visit to the collection of Sir Michael Sadler, Vice-Chancellor
of Leeds University. His play *Narayana and Bhataryan* (dedicated to the memory of
Rupert Brooke) produced by Castleford Grammar School amateur drama group,
with the author as Bhataryan and his sister Mary as Narayana.

1921 Awarded a scholarship to the Royal College of Art. Studies ancient Mexican sculpture and primitive art at the British Museum. Approach to art influenced by Ezra Pound's book on Gaudier-Brzeska (more particularly, by Gaudier's own statements about sculpture quoted by Pound) and by Roger Fry's *Vision and Design*.

1922 Begins carving in stone and wood with Barry Hart, Professor Derwent Wood's assistant at the RCA. Begins the *Mother and Child* series under the influence of pre-Columbian sculpture.

1923 First visit to Paris. Impressed by the Cézanne paintings in the Pellerin collection.

1924 Awarded Royal College of Art Travelling Scholarship. Appointed instructor in the sculpture school for a term of seven years. Temporarily replaces Derwent Wood in the sculpture school pending appointment of a new professor. Carvings include *Mother and Child*, now in the collection of the City Art Gallery, Manchester; *Woman with Upraised Arms*; first *Reclining Figure*.

1925 Travels for six months in France and Italy, visiting Paris, Rome, Florence, Pisa, Sienna, Assisi, Ravenna and Venice. Particularly impressed by Giotto, Masaccio and late Michelangelo. On his return to London, appointed assistant to Professor Ernest Cole at the RCA.

1926 Takes part for the first time in a group exhibition, held at St George's Gallery, London. Sets up studio at 3 Grove Studios, Hammersmith. *Reclining Figures*.

1927 Helps a group of young painters and sculptors to organize an exhibition at the Beaux Arts Gallery. Direct carvings in stone and wood; terra-cottas and bronzes.

1928 First one-man exhibition at Warren Gallery, London: forty-two sculptures and fifty-one drawings. Art critic of *The Morning Post* describes Moore's sculpture as 'immoral' and demands his dismissal from the RCA. The Old Students Association backs the demand, but Sir William Rothenstein resists the pressure. Commissioned to produce a relief *North Wind* for the St James's Park Underground station.

1929 Marries Irina Radetzky, a painting student at the RCA. They rent a studio-flat at 11a Parkhill Road, Hampstead. Carves *Reclining Figure* in brown Hornton stone, under the influence of the Mexican Chac Mool carving. First use of a hole in his sculpture.

1930 Elected to the Seven and Five Society, a group of avant-garde artists (seven painters and five sculptors). *Apollo* publishes first article to appear on his work, written by R. H. Wilenski: 'His intention is nothing less than to make a new mould for the word *beautiful*.' Makes five versions of *Mother and Child* and four of *Reclining Figure*.

1931 One-man exhibition of thirty-four sculptures and forty-one drawings at Leicester Galleries, with a foreword in the catalogue by Jacob Epstein: 'Bound by the severest aesthetic considerations, this sculpture is a liberation of the spirit.' Hamburg Art Museum buys a sculpture and several drawings, his first foreign sale. Buys a cottage at Barfreston in Kent. Several versions of *Mother and Child* and *Reclining Figure*. First biomorphic abstracts.

1932 Leaves RCA when his appointment expires, and moves to Chelsea School of Art where he establishes a department of sculpture.

1933 Exhibition at Leicester Galleries. Member of *Unit One*, founded by Paul Nash. Contributes to the Group's magazine, edited by Herbert Read.

332

Takes a cottage at Kingston, near Canterbury, with a large garden, where he can work in the open air. Herbert Read's first book on Henry Moore published by Zwemmer. Sculptures in several parts initiate a new conception of space.

1934

Exhibition at Zwemmer Gallery. Special issue of the magazine *Konkretion* on contemporary English art reproduces a Henry Moore sculpture on cover. Moore contributes an article on Mesopotamian art to *The Listener*. Sculptures approach geometrical abstraction without abandoning the human reference.

1935

Exhibition at Leicester Galleries. Contributes to the International Surrealist Exhibition in London. Visits Madrid, Toledo and Barcelona, and the caves at Altamira. Signs the manifesto of the Surrealist Group in England, to protest against the policy of so-called 'non-intervention' in the Spanish Civil War. Completes first opened-out *Reclining Figure* in Elm wood started previous year (Collection Albright Art Gallery, Buffalo). Executes *Reclining Figure* in Elm wood now in Wakefield City Art Gallery.

1936

Contributes Notes on Sculpture to *The Listener*. Contributes to *Circle*, the magazine edited by J. L. Martin, Ben Nicholson and Naum Gabo. Leaning towards abstract art more pronounced, using metal struts in stringed figures.

1937

Takes part in Abstract Art Exhibition at Stedelijk Museum, Amsterdam. Carves the famous *Recumbent Figure* in green Hornton stone at present in the Tate Gallery, and *Reclining Figure* in lead in Museum of Modern Art, New York, using holes in a new conception of open form.

1938

Exhibition of drawings at Mayor Gallery. Gives up teaching at Chelsea School of Art, and devotes himself entirely to sculpture at his home in Kingston. Takes on Bernard Meadows as an assistant. Executes the *Reclining Figure* in Elm wood now in the Detroit Institute of Art.

1939

Becomes an official war artist. Drawings of life in London air-raid shelters. Buys farmhouse at Much Hadham in Hertfordshire, where he still lives.

1940

First retrospective exhibition, held at Temple Newsam, Leeds. Appointed Trustee of the Tate Gallery for a term of seven years. Continues to work on shelter drawings.

1941

Drawings of miners at the coal face in Castleford complete his work as a war artist.

1942

Commissioned to provide a sculpture of *Madonna and Child* for the church of St Matthew in Northampton. First one-man exhibition in the United States: forty watercolours and drawings at the Buchholz Gallery (Curt Valentin), New York. Geoffrey Grigson's study of Henry Moore published in the Penguin series on modern artists.

1943

Numerous sketches for the St Matthew's Church *Madonna and Child* and for a *Family Group* executed 1954–55 for Harlow New Town. Abandons the idea of reliefs for the University of London after making several sketches. Illustrations for Edward Sackville-West's *The Rescue*. First volume of Lund Humphries' *Henry Moore: Sculpture and Drawings*.

1944

One-man exhibition at Berkeley Galleries. Appointed member of the art panel of The British Council. Honorary doctorate, Leeds University. *Madonna and Child* unveiled at St Matthew's, Northampton. Contributes to exhibition in Paris, *Some English Contemporaries*. Meets Brancusi. Executes *Memorial to Christopher Martin*, at Dartington, Devon. Several versions of *Reclining Figure* and *Family Group*. Studies for *Three Standing Figures*.

1945

333

1946 Retrospective exhibition at Museum of Modern Art, New York. One-man exhibitions at Leicester Galleries and the Phillips Memorial Gallery, Washington. J. J. Sweeney's exhibition monograph on Henry Moore. Visits United States. Daughter Mary born.

1947 The New York retrospective exhibition goes to Chicago and San Francisco. Travelling exhibition introduces Moore's work to Australia (Sydney, Melbourne, Adelaide, Hobart, Perth). *Madonna and Child* commissioned for Claydon Church, Suffolk. Executes *Three Standing Figures*, erected in Battersea Park.

1948 Exhibition in the English Pavilion, xxivth Biennale of Venice and awarded the International Prize for Sculpture. One-man exhibition at Galleria d'Arte, Milan. Appointed to Royal Fine Art Commission. Elected Honorary Associate of the Royal Institute of British Architects, and Foreign Corresponding Member of the Académie Royale Flamande des Sciences, Lettres et Beaux-Arts de Belgique. Giulio-Carlo Argan's book on Henry Moore published in Turin. Travels in Italy.

1949 Retrospective exhibitions at Musée National d'Art Moderne, Paris; Palais des Beaux-Arts, Brussels; City Art Gallery, Wakefield. Further seven-year term as a Trustee of the Tate Gallery. *Family Group* unveiled at Stevenage.

1950 Travelling exhibition, Stedelijk Museum, Amsterdam, Berne Kunsthalle, and at Hamburg and Dusseldorf in Germany. Exhibition in Mexico. Elected foreign member of Swedish Royal Academy of Fine Arts. *Reclining Figure* commissioned for the 1951 Festival of Britain. *Standing Figure* installed at Shawhead, Dumfries, Scotland.

1951 First London retrospective exhibition at Tate Gallery. One-man exhibitions at Leicester Galleries; Buchholz Gallery, New York; the Albertina, Vienna; and in Athens. Travels in Greece. Contributes to the second International Exhibition of Sculpture in the Open Air, London, and first International Exhibition of Sculpture in the Open Air, Middelheim Park, Antwerp.

1952 Travelling Exhibition in Sweden. Exhibitions in Cape Town, Stockholm and Linz. Contributes to International Sculpture Exhibition, Sonsbeek Park, Arnhem. Commissioned to make the Stone Screen and the *Draped Reclining Figure* for the Time-Life Building in London. Attends International Conference of Artists in Venice, organized by UNESCO. Travels in Italy. *Leaf Figures* in bronze.

1953 Exhibition at the second Biennale of São Paulo, Brazil and awarded the International Sculpture Prize. Travels in Brazil and Mexico. Travelling exhibition, Germany, Norway and Denmark. Exhibitions at Antwerp, Rotterdam and London. Reappointed to Royal Fine Art Commission. Honorary Doctorate of London University. Alfonso Sato Soria executes mural painting at El Eco Museum, Mexico City, from designs by Henry Moore. Produces *Draped Torso*. Sketches for *Warrior with Shield* and *King and Queen*.

1954 One-man exhibitions, Leicester Galleries and Buchholz Gallery. Contributes to third International Exhibition of Sculpture in the Open Air, London. Commissioned to design a relief in brick for the Rotterdam Bouwcentrum. Travels in Italy, Germany and the Netherlands.

1955 Companion of Honour. Appointed Trustee of the National Gallery. Elected foreign Honorary Member of the American Academy of Arts and Sciences. Re-appointed a member of the Art Panel of the Arts Council. Exhibitions in United States, Canada, Yugoslavia, and at Leicester Galleries and the Kunsthalle, Basle. Lund Humphries publish second volume of *Henry Moore: Sculpture and Drawings*, covering the period 1949–54. A book on Henry Moore by Siegfried Walter published in Germany.

Reclining Figure commissioned for the UNESCO Building in Paris. Visits the Netherlands to take part in the celebrations for the 350th anniversary of the birth of Rembrandt. H. T. Flemming's book *Henry Moore: Katakomben* published in Germany. Executes *Glenkiln Cross*. **1956**

Exhibitions at Galerie Berggruen, Paris, and Roland, Browse and Delbanco, London. Contributes to 4th International Exhibition of Sculpture in the Open Air in London. UNESCO *Reclining Figure* unveiled in Paris, where the carving was completed. Contributes to various group exhibitions in Europe and America. A book by J. P. Hodin on Henry Moore published in Amsterdam and London. The New York Graphic Society publishes album *Heads, Figures and Ideas* by Henry Moore, with an introduction by Geoffrey Grigson. Prize at Carnegie International, Pittsburgh. Large bronzes of Draped Female Figures. **1957**

Participates in Tokyo Biennale and awarded the International Prize for Sculpture. Travelling exhibitions, Japan, Portugal and Spain. Doctor honoris causa, Cambridge University and Reading University. Corresponding Academician of Academia Nacional de Bellas Artes, Buenos Aires. Awarded Gold Medal by Society of the Friends of Art, Krakow, Poland. *Two-Piece Reclining Figure No. 1* is executed. (First cast of this, with a cast of *Two-Piece Reclining Figure No. 2*, are now installed at Lambert Airport, St Louis, U.S.A.) Werner Hofmann's book on Henry Moore published in Germany. **1959**

Retrospective Exhibition at Whitechapel Art Gallery. Re-appointed to the Royal Fine Art Commission. Will Grohmann's book on Henry Moore, published in Germany. **1960**

Honorary doctorate of Oxford University. Elected member of American Academy of Art and Letters and Berlin Akademie der Künste. Exhibitions at Marlborough Fine Art and Scottish National Gallery of Modern Art. Executes *Three-Piece Reclining Figure No. 1* and *Standing Figure: Knife Edge*. **1961**

Honorary doctorates of Hull University and the Technische Hochschule, Berlin. Freeman of the borough of Castleford. Honorary Fellow of Lincoln College, Oxford. Appointed member of the National Theatre Board. Exhibitions at Marlborough Fine Art; Knoedler Gallery, New York; Ashmolean Museum, Oxford; Gerald Cramer Gallery, Geneva. Commissioned to make a sculpture for the Reflecting Pool of Lincoln Arts Center, New York. **1962**

Order of Merit. Awarded Feltrinelli Prize in Italy. Exhibitions at Marlborough Fine Art; Wakefield City Art Gallery; Ferens Art Gallery, Hull. Honorary Member of the Society of Finnish Artists. **1963**

Appointed member of Arts Council of Great Britain. Re-appointed Trustee of National Gallery. Exhibitions at Marlborough Fine Art, London, and Knoedler Gallery, New York. Travelling exhibitions in Argentina, Brazil, Mexico and Venezuela. Completes *Locking Piece*. **1964**

Honorary Fellow of Churchill College, Cambridge. Doctor honoris causa, University of Sussex. Exhibitions at Marlborough Fine Art and at Rio de Janeiro and New Orleans. Lund Humphries publish third volume of *Henry Moore: Sculpture* (no drawings) covering period 1955–64. *Henry Moore: A Study of His Life and Work*, by Herbert Read, published by Thames and Hudson. Three *Upright Motives* erected on a hill at the Kröller-Müller Museum, Otterlo. Buys a small summer residence at Forte dei Marmi, near the Carrara quarries. **1965**

1966 Honorary doctorates of Universities of York and Sheffield, Yale University, U.S.A. Fellow of the British Academy. Exhibitions at Marlborough Fine Art and Philadelphia College of Art. Travelling exhibitions in Eastern Europe. Visits Canada for unveiling of *The Archer* in Nathan Phillips Square, Toronto. Donald Hall's *The Life and Work of a Great Sculptor: Henry Moore*, and Philip James's *Henry Moore on Sculpture*, published in London. Carves *Two Forms* in Red Soraya marble, *Three Rings* in Rosa Aurora marble, and large version of *Three Rings* in Red Soraya marble.

1967 Elected Professor Ad Honorem of Accademia di Belle Arti, Carrara. Doctor honoris causa of Royal College of Art, St Andrew's University, Scotland, and University of Toronto. Exhibitions at Marlborough New London Gallery, London, and the Museum of Lincoln, Massachusetts. Represented in Montreal World Fair and Guggenheim International Exhibition, New York. Participates in exhibition Hommage à Rodin at the Galerie Lucie Weil in Paris. Album of Henry Moore's shelter drawings published in Berlin. Executes *Sundial* for *The Times* Building, London.

1968 Erasmus Prize for 1968. Albert Einstein Commemorative Award for the Arts by Yeshiva University, New York. Large retrospective exhibitions at Tate Gallery, Kröller-Müller Museum, Boymans-Van Beuningen Museum, Stadtische Kunsthalle of Düsseldorf and Stadtische Kunsthalle of Baden-Baden, in celebration of Henry Moore's seventieth birthday. New publications on Henry Moore include John Russell's account of his life and work, and John Hedgecoe's collection of photographs with an accompanying text by Henry Moore.

1969 Executes *Three-Piece No. 3: Vertebrae*. Work in progress on *Large Arch*, in polystyrene for bronze, and *Large Two Forms*.

1970 Important exhibitions of recent works at Knoedler Galleries and Marlborough-Gerson, New York.

LIST OF ILLUSTRATIONS

COLOUR PLATES

1 Head of a Girl, 1922
Wood, H. 24.1 cm (9½ in)
Collection: City Art Gallery, Manchester

2 Mother and Child, 1922
Portland stone, H. 27.9 cm (11 in)
Private collection

3 Standing Woman, 1923
Walnut wood, H. 30.5 cm (12 in)
Collection: City Art Gallery, Manchester

4 Mask, 1924
Verde di prato, H. 17.8 cm (7 in)
Collection: Alistair McAlpine, London

5 Snake, 1924
Marble, H. 15.3 cm (6 in)
Collection the artist

6 Mother and Child, 1924–5
Hornton stone, H. 57.2 cm (22½ in)
Collection: City Art Gallery, Manchester

7 Maternity, 1924
Hopton-wood stone, H. 22.9 cm (9 in)
Collection: Miss Ann F. Brown, London

8 Figure, 1923
Verde di prato, H. 39.4 cm (15½ in)
Collection: The late Mrs Dorothy Elmhirst,
Totnes

9 Woman with Upraised Arms, 1924–5
Hopton-wood stone, H. 43.2 cm (17 in)
Collection the artist

10 Head of a Woman, 1926
Cast concrete, H. 22.9 cm (9 in)
Collection: Wakefield City Art Gallery and
Museum

11 Head and Shoulders, 1927
Verde di prato, H. 45.7 cm (18 in)
Collection: Dr Henry M. Roland, London

12 Duck, 1927
Cast concrete, H. 15.3 cm (6 in)
Bronze, collection: Mr and Mrs Newbury,
Chicago

13–4 Suckling Child, 1927
Cast concrete, L. 43.2 cm (17 in)
Probably destroyed

15 Spring, 1921
Oil, 55.9 × 40.6 cm (22 × 16 in)
Collection: Mrs Irina Moore

16 The Wrestlers, 1924
Charcoal, 26.0 × 31.4 cm (10¼ × 12⅜ in)
Private collection

17 Woman Reading, 1926
Chalk, pen and watercolour,
44.5 × 33.0 cm (17½ × 13 in)
Collection: British Council, London

18 Portrait of the Artist's Mother, 1927
Line and wash, 27.3 × 17.8 cm (10¾ × 7 in)
Collection the artist

19 Seated Figure with Necklace, 1928
Chalk, pen and wash,
50.8 × 31.8 cm (20 × 12½ in)
Collection: Alan Wilkinson, London

20 Standing Figure, 1928
Chalk and wash, 55.9 × 29.8 cm (22 × 11¾ in)
Collection: Mrs Irina Moore

21 Section Line Drawing, 1928
Chalk, pen and wash,
43.2 × 34.3 cm (17 × 13½ in)
Private collection

22 Girl, 1928
Pen and wash, 38.7 × 49.5 cm (15¼ × 19½ in)
Collection: Roger Senhouse, London

23 North Wind, 1928–9
Portland stone, L. 2.46 m (96 in)
Underground Building, St James's, London

24 Ideas for Relief on St James's Underground
Station, 1927
Pen and wash, 38.1 × 25.4 cm (15 × 10 in)
Collection: Arts Council of Great Britain,
London

25 Mother and Child, 1929
Stone, H. 12.7 cm (5 in)
Cast in bronze 1967, edition of 6
Private collections

26 Figure with Clasped Hands, 1929
Travertine marble, H. 45.7 cm (18 in)
Collection: Tel Aviv Museum

27 Reclining Woman, 1927
Cast concrete, L. 63.5 cm (25 in)
Collection: Mrs Irina Moore

28 Reclining Figure, 1929
Brown Hornton stone, L. 83.8 cm (33 in)
Collection: City Art Gallery, Leeds

29 Mask, 1929
Cast concrete, H. 21.6 cm (8½ in)
Collection: Sir Philip Hendy, London

30 Torso, 1927
Cast concrete, H. 21.6 cm (8½ in)
Collection: Lady Norton, London

31 Mask, 1929 (detail)
Stone, L. 12.7 cm (5 in)
Collection: Miss Mary Moore

32 Reclining Figure, 1929
Alabaster, L. 46.7 cm (18⅜ in)
Collection: Sophia Loren and Carlo Ponti

33 Life Drawing, 1929
Pen and wash, 55.9 × 38.1 cm (22 × 15 in)
Collection the artist

34 Female Nude, 1929
Pencil, ink and wash,
41.3 × 31.1 cm (16¼ × 12¼ in)
Private collection

35 Life Drawing, 1929
Pen and wash, 40.7 × 30.5 cm (16 × 12 in)
Collection: Sir Robert and Lady Sainsbury,
London

36 Study of a Female Nude, 1928–9
Chalk and pen, 37.5 × 23.5 cm (14¾ × 9¼ in)
Collection: Mrs Irina Moore

37 Seated Figure, 1929
Cast concrete, H. 45.1 cm (17¾ in)
Collection: Mrs Irina Moore

38 Drawing from Life, 1929
Indian ink and brush,
55.9 × 38.1 cm (22 × 15 in)
Private collection

39 Seated Figure, 1929
Chalk and wash, 50.8 × 29.2 cm (20 × 11½ in)
Private collection

40 Drawing for Figure in Concrete, 1929
Chalk, 30.5 × 22.9 cm (12 × 9 in)
Collection: Arts Council of Great Britain,
London

41 Half Figure, 1929
Cast concrete, H. 36.9 cm (14½ in)
Collection: British Council, London, and
Sir Philip Hendy

42 Mother and Child, 1929
Verde di prato, H. 12.1 cm (4¾ in)
Collection: Lord Clark of Saltwood

43 Mother and Child, 1930
Ancaster stone, H. 25.4 cm (10 in)
Private collection

44 Seated Figure, 1930
Albaster, H. 38.1 cm (15 in)
Collection: A. McNeill Reid, Scotland

45 Mask, 1930
Green stone, H. 16.5 cm (6½ in)
Private collection

46 Mother and Child, 1930
Ham Hill stone, H. 78.8 cm (31 in)
Collection: David Lloyd Kreeger, USA

47 Mother and Child, 1930
Alabaster, H. 25.5 cm (10 in)
Collection: Herbert Marks, London

48 Girl with Clasped Hands, 1930
Cumberland alabaster, H. 38.1 cm (15 in)
Collection: British Council, London

49 Mother and Child, 1930–1
Cumberland alabaster, H. 40.7 cm (16 in)
Collection: Sir Colin Anderson, London

50 Reclining Figure, 1930
Ironstone, L. 17.8 cm (7 in)
Collection: Sir Robert Sainsbury, London

51 Reclining Figure, 1930
Corsehill stone, L. 49.6 cm (19½ in)
Lost, probably destroyed

52 Reclining Figure, 1930
Ancaster stone, L. 53.4 cm (21 in)
Collection: Detroit Institute of Art

53 Reclining Woman, 1930
Green Hornton stone, L. 94.0 cm (37 in)
Collection: National Gallery of Canada,
Ottawa

54 Figure, 1930
Ebony, H. 25.5 cm (10 in)
Collection: Mrs Michael Ventris, London

55 Mother and Child, 1931
Burgundy stone, H. 35.6 cm (14 in)
Collection: Miss McCaw, London

56 Half Figure, 1930
Ancaster stone, H. 50.8 cm (20 in)
Collection: National Gallery of Victoria,
Melbourne

57 Suckling Child, 1930
Albaster, H. 19.7 cm (7¾ in)
Collection: The Dean of Chichester

58 Composition, 1931
Green Hornton stone, H. 48.3 cm (19 in)
Collection: Mrs Irina Moore

59 Head, 1930
Ironstone, H. 20.4 cm (8 in)
Collection: Lord Clark of Saltwood

60 Head, 1930
Slate, H. 25.5 cm (10 in)
Private collection

61 Reclining Figure, 1931
Lead, L. 43.2 cm (17 in)
Collection: Mr and Mrs Frederick Zimmer-
man, New York
Cast in bronze 1963, edition of 5
Private collections

62 Figure, 1932
Box wood, H. 43.2 cm (17 in)
Private collection

63 Mother and Child, 1932
Carved reinforced concrete,
H. 17.8 cm (7 in)
Collection: Ian Phillips, London

64 Figure, 1932
Beech wood, H. 33.0 cm (13 in)
Collection: Michael A. Tachmindji,
London

65 Figure, 1931
Beech wood, H. 24.2 cm (9½ in)
Collection: Tate Gallery, London

66 Mother and Child, 1931
Sycamore wood, H. 76.2 cm (30 in)
Collection: Mrs John Lister, Bridport,
Devon

67 Mother and Child, 1931
Verde di prato, H. 20.3 cm (8 in)
Collection: Michael Maclagan, Oxford

68 Drawing for Figure in Metal or Reinforced
Concrete, 1931
Pen and wash, 27.0 × 39.0 cm (10⅝ × 15⅜ in)
Collection: H. J. Patterson

69 Composition, 1932
African wonderstone, H. 44.5 cm (17½ in)
Collection: Tate Gallery, London

70 Composition, 1932
Dark African wood, H. 38.8 cm (15¼ in)
Collection: Lord Clark of Saltwood

71 Half Figure, 1932
Armenian marble, H. 83.9 cm (33 in)
Collection: Tate Gallery, London

72 Girl, 1932
Box wood, H. 31.8 cm (12½ in)
Collection: Mrs Barbara von Bethmann-
Hollweg, London

73 Reclining Figure, 1932
Carved reinforced concrete,
L. 1.09 m (43 in)
Collection: City Art Museum, St Louis

74 Mother and Child, 1932
Green Hornton stone, H. 88.9 cm (35 in)
Collection: Sir Robert Sainsbury, London

75 Drawing, 1931
Pen and wash, 27.9 × 23.5 cm (11 × 9¼ in)
Private collection

76 Standing Figures, Ideas for Wood Sculpture,
1932
Pen and wash, 25.4 × 53.3 cm (10 × 21 in)
Collection: Mrs Irina Moore

77 Study of Seated Nude, 1932
Wash, 56.5 × 38.7 cm (22¼ × 15¼ in)
Private collection

78 Standing Figure and Head, 1932
Wash, 43.2 × 34.9 cm (17 × 13¾ in)
Private collection

79 Mother and Child, 1932
Pen and wash, 55.9 × 38.1 cm (22 × 15 in)
Private collection

80 Life Drawing, Seated Woman, 1928
Crayon and wash,
46.4 × 27.9 cm (18¼ × 11 in)
Collection the artist

341

81 Drawings of Shells, 1932
Pencil, 23.5 × 17.1 cm (9¼ × 6¾ in)
Collection: Arts Council of Great Britain,
London

82 Drawing for Sculpture, 1932
Pen and chalk, 38.1 × 27.9 cm (15 × 11 in)
Private collection

83 Seated Figures: Studies for Sculpture, 1932
Chalk, pen and wash,
37.5 × 27.3 cm (14¾ × 10¾ in)
Collection: J. A. Paton Walker, London

84 Reclining Figure, 1933
Carved reinforced concrete,
L. 77.5 cm (30½ in)
Collection: Washington University, St
Louis

85 Head and Ball, 1934
Cumberland alabaster, L. 50.8 cm (20 in)
Private collection

86 Composition, 1933
Walnut wood, H. 34.6 cm (14 in)
Collection: Douglas Glass, London

87 Composition, 1933
Lignum vitae, H. 45.8 cm (18 in)
Collection: Mrs M. Hill, Ditchling

88 Family, 1935
Elm wood, H. 1.02 m (40 in)
Collection the artist

89 Hole and Lump, 1934
Elm wood, H. 55.9 cm (22 in)
Collection the artist

90 Figure, 1933–4
Travertine marble, H. 40.7 cm (16 in)
Collection: H. Cady Wells, Santa Fe

91 Figure, 1933–4
Corsehill stone, H. 76.2 cm (30 in)
Collection: Carlo Ponti, Rome

92 Seated Figure (drawing from life), 1933
Pencil and wash, 38.1 × 55.9 cm (15 × 22 in)
Collection: Sir Philip Hendy, London

93 Mother and Child, 1933
Pen and watercolour,
55.9 × 38.1 cm (22 × 15 in)
Collection: Ralph Keene

94 Reclining Forms, 1933
Wash, 43.2 × 36.8 cm (17 × 14½ in)
Private collection

95 Ideas for Bronze Standing Figure, 1933
(detail)
Indian ink and wash,
38.7 × 29.8 cm (15¼ × 11¾ in)
Private collection

96 Montage, 1933
Pen and wash, 38.1 × 55.9 cm (15 × 22 in)
Collection: National Gallery of Victoria,
Melbourne

97 Reclining Figure, 1933
Chalk, pen, wash and watercolour,
27.3 × 37.5 cm (10¾ × 14¾ in)
Collection: Miss Mary Moore

98 Reclining Figure, 1933
Pen and wash, 38.1 × 55.9 cm (15 × 22 in)
Private collection

99 Reclining Figure, 1934
African wonderstone, L. 15.3 cm (6 in)
Private collection

100 Carving, 1934
African wonderstone, H. 10.2 cm (4 in)
Collection: Mrs Irina Moore

101 Carving, 1934
Blue ancaster stone, L. 40.7 cm (16 in)
Collection: Martha Jackson Gallery, New
York

102 Two Forms, 1934
Ironstone, H. 18.4 cm (7¼ in)
Cast in bronze, 1967, edition of 6
Private collections

103 Carving, 1934
Ironstone, H. 12.7 cm (5 in)
Private collection

104 Two Forms, 1934
Pynkado wood, L. 53.4 cm (21 in)
Collection: Museum of Modern Art, New
York

105 Four-piece Composition: Reclining Figure,
1934
Cumberland alabaster, L. 50.8 cm (20 in)
Collection: Martha Jackson Gallery, New
York

106 Composition, 1934
Cast in bronze, 1961, L. 44.5 cm (16¾ in)
Edition of 9
Private collections

107 Bird and Egg, 1934
Cumberland alabaster, L. 55.9 cm (22 in)
Private collection

108 Three Forms, 1934
Stone, H. 40.7 cm (16 in)
Destroyed

109 Study for Sculpture I, 1934
Charcoal, 57.5 × 37.5 cm (22⅝ × 14¾ in)
Private collection

110 Stone Forms, 1934
Chalk, 55.9 × 38.1 cm (22 × 15 in)
Collection: Arts Council of Great Britain,
London

111 Study for a Reclining Figure as a Four-piece
Composition, 1934
Pen and watercolour,
55.9 × 38.1 cm (22 × 15 in)
Collection: Lord Clark of Saltwood

112 Ideas for Metal Sculpture, 1934
Pen and wash, 38.1 × 27.9 cm (15 × 11 in)
Private collection

113 Ideas for Metal Sculpture, 1934
Pen and wash, 27.9 × 76.2 cm (11 × 30 in)
Collection the artist

114 Drawing for Sculpture: Bird Head, 1934
Charcoal and pen,
27.9 × 38.1 cm (11 × 15 in)
Collection: Miss Mary Moore

115 Seated Figure, 1934
Charcoal and pen,
55.9 × 38.1 cm (22 × 15 in)
Collection: Oswald T. Falk

116 Recumbent Figures, 1934
Pen and watercolour,
27.3 × 37.5 cm (10¾ × 14¾ in)
Private collection

117 Ideas for Sculpture, 1934
Pen, chalk and watercolour,
38.1 × 55.9 cm (15 × 22 in)
Private collection

118 Study for Recumbent Figure, 1934
Pencil and wash on paper,
27.6 × 38.7 cm (10⅞ × 15¼ in)
Collection: The Art Gallery of Toronto

119 Drawing for Sculpture, 1934
Pencil, 26.7 × 17.8 cm (10½ × 7 in)
Collection: Mrs Irina Moore

120 Ideas for Stone Seated Figures, 1934
Charcoal and pen,
55.9 × 38.1 cm (22 × 15 in)
Collection: Stephen Spender

121 Ideas for Sculpture, 1934
Pencil, pen and wash,
27.9 × 19.1 cm (11 × 7½ in)
Collection: Miss Mary Moore

122 Sculpture, 1935
White marble, L. 55.9 cm (22 in)
Collection: Art Institute of Chicago

123 Carving, 1935
African wood, L. 40.7 cm (16 in)
Private collection

124 Carving, 1935
African wood, L. 40.7 cm (16 in)
Private collection

125 Drawing, 1934–5
Pen and wash, 38.1 × 55.9 cm (15 × 22 in)
Private collection

126 Carving, 1935
Cumberland alabaster, H. 34.3 cm (13½ in)
Collection: Joseph H. Hirshhorn, New
York

127 Ideas for Stone Carving, 1934
Chalk and pen, 55.9 × 38.1 cm (22 × 15 in)
Collection: Tate Gallery, London

128 Drawing, 1935
Pen and watercolour,
38.1 × 27.9 cm (15 × 11 in)
Collection: R. H. M. Ody

129 Drawing for Sculpture, 1935
Pencil and wash,
26.7 × 17.8 cm (10½ × 7 in)
Collection: Mrs Irina Moore

130 Drawing, 1935
Chalk, pen and watercolour,
27.9 × 39.4 cm (11 × 15½ in)
Collection: Rex de C. Nan Kivell, London

131 Drawing, 1935
Chalk and watercolour,
45.7 × 55.9 cm (18 × 22 in)
Private collection

132 Drawing for Metal Sculpture, 1935
Watercolour, 55.9 × 38.1 cm (22 × 15 in)
Private collection

133 Ideas for Stone Carving, 1935
Black chalk and pen,
55.9 × 38.1 cm (22 × 15 in)
Private collection

134 Drawing for Metal Sculpture, 1935
Watercolour, 55.9 × 38.1 cm (22 × 15 in)
Collection: Mark Gertler

135 Carving, 1935
Walnut wood, H. 96.5 cm (38 in)
Collection: Mrs Irina Moore

136 Reclining Figure, 1935
Pen and wash, 38.1 × 55.9 cm (15 × 22 in)
Private collection

137 Reclining Figure, 1934–5
Corsehill stone, L. 62.2 cm (24½ in)
Collection: Mrs Irina Moore

138 Mother and Child, 1936
Green Hornton stone, H. 1.14 m (45 in)
Collection: Sir Roland Penrose, London

139 Head, 1936
Hopton-wood stone, H. 26.7 cm (10½ in)
Private collection

140 Reclining Figure, 1936
Elm wood, L. 1.07 m (42 in)
Collection: Wakefield City Art Gallery and
Museum

141 Reclining Figure, 1935–6
Elm wood, L. 88.9 cm (35 in)
Collection: Albright-Knox Art Gallery,
Buffalo, New York

142 Four Forms, 1936
African wonderstone, L. 55.9 cm (22 in)
Collection: Henry R. Hope, Bloomington,
Indiana

143 Another view of Plate 141

144 Two Forms, 1936
Hornton stone, H. 1.07 m (42 in)
Collection: Mrs H. Gates Lloyd, Haverford,
Pennsylvania

145 Mother and Child, 1936
Ancaster stone, H. 50.8 cm (20 in)
Collection: British Council, London

146 Square Form, 1936
Brown Hornton stone, L. 53.4 cm (21 in)
Collection: Dr van der Wal, Amsterdam

147 Carving, 1936
Travertine marble, H. 45.7 cm (18 in)
Collection: Mrs Irina Moore

148 Stones in Landscape, 1936
Pen and wash, 55.9 × 38.1 cm (22 × 15 in)
Collection: Mrs W. F. C. Ohly

149 Carving, 1936
Brown Hornton stone, L. 50.8 cm (20 in)
Collection: Martha Jackson Gallery, New
York

150 Carving, 1936
Elm wood, H. 50.8 cm (20 in)
Private collection

151 Drawing, 1936
Pen and wash, 40.6 × 50.8 cm (16 × 20 in)
Collection: Lord Clark of Saltwood

152 Projects for a Sarcophagus, 1936
Black chalk and wash,
52.1 × 39.4 cm (20½ × 15½ in)
Collection: Mrs Irina Moore

153 Drawing for Sculpture, 1936
Pen and watercolour,
38.1 × 55.9 cm (15 × 22 in)
Collection: Ruthven Todd, New York

154 Two Stone Forms, 1936
Pen and wash, 55.9 × 38.1 cm (22 × 15 in)
Collection: Lord Clark of Saltwood

155 Drawing for Sculpture, 1936
Pencil, chalk and wash,
55.9 × 36.8 cm (22 × 14½ in)
Private collection

156 Reclining Figure, 1936
Watercolour, 38.1 × 55.9 cm (15 × 22 in)
Collection: Mrs Irina Moore

157 Ideas for Sculpture, 1936
Chalk and wash, 36.8 × 57.2 cm (14½ × 22½ in)
Collection: Mrs Irina Moore

158 Drawing, 1936
Chalk and wash, 36.8 × 43.2 cm (14½ × 17 in)
Collection: City Art Museum, Zagreb

159 Head, 1937
Hopton-wood stone, H. 53.4 cm (21 in)
Collection: Martha Jackson Gallery, New
York

160 Sculpture, 1937
Hopton-wood stone, L. 50.8 cm (20 in)
Private collection

161 Figure, 1937
Bird's eye marble, H. 50.8 cm (20 in)
Collection: City Art Museum, St Louis

162 Reclining Figure, 1937
Hopton-wood stone, L. 83.8 cm (33 in)
Collection: Miss Lois Orswell, Pomfret,
Conn.

163 Figure, 1937
Bird's eye marble, H. 50.8 cm (20 in)
Collection: Art Institute of Chicago

164 Stringed Figure No. 1, 1937
Cherry wood and string, H. 50.8 cm (20 in)
Collection: Mrs Irina Moore

165 Reclining Figure and Ideas for Sculpture,
1937
Pen and wash, 38.1 × 55.9 cm (15 × 22 in)
Private collection

166 Ideas for Sculpture, 1937
Pencil, pen and chalk,
50.8 × 38.1 cm (20 × 15 in)
Private collection

167 Drawing, 1938
Coloured chalks and wash,
38.1 × 55.9 cm (15 × 22 in)
Collection: Bernard Meadows, London

168 Ideas for Sculpture, 1937
Coloured chalks, 55.9 × 38.1 cm (22 × 15 in)
Private collection

169 Drawing, 1937
Watercolour and pen,
61.0 × 43.2 cm (24 × 17 in)
Collection: Roger Cox

170 Drawing, 1937
Pen and watercolour,
61.0 × 43.2 cm (24 × 17 in)
Private collection

171 Ideas for Metal Sculpture, 1937
Watercolour, 55.9 × 38.1 cm (22 × 15 in)
Private collection

172 Drawing for Metal Sculpture, 1937
Chalk and watercolour,
38.1 × 55.9 cm (15 × 22 in)
Private collection

173 Drawing for Stone Sculpture, 1937
Chalk and watercolour,
48.3 × 59.7 cm (19 × 23½ in)
Private collection

174 Recumbent Figure, 1938
Green Hornton stone, L. 1.40 m (55 in)
Collection: Tate Gallery, London

175 Mother and Child, 1938
Elm wood, H. 91.4 cm (36 in)
Collection: Museum of Modern Art, New
York

176 Reclining Figure, 1938
Lead, L. 33.0 cm (13 in)
Collection: Museum of Modern Art, New
York
Bronze edition of 3
Private collections

177 Reclining Figure, 1938
Lead, L. 14.0 cm (5½ in)
Collection: Robert Lewin, London
Bronze edition of 12
Private collections

178 Mother and Child, 1938
Plaster and twine for lead and wire,
H. 12.7 cm (5 in)
Collection: Mrs Fanny Wadsworth

179 Head, 1938
Elm wood and string, H. 20.3 cm (8 in)
Collection: Erno Goldfinger, London

180 Stringed Figure, 1938
Lignum vitae and string, L. 15.2 cm (6 in)
Collection: John Anthony Thwaites,
Dusseldorf

181 Stringed Figure No. 4, 1938
Lignum vitae and string, H. 38.6 cm (14 in)
Collection: G. Burt, London

182 Stringed Ball, 1939
Bronze and string, H. 8.9 cm (3½ in)
Edition of 9
Private collections

183 Ideas for Sculpture, 1938
Chalk and wash, 55.9 × 38.1 cm (22 × 15 in)
Private collection

184 Four Forms, 1938
Chalk and wash, 27.9 × 38.1 cm (11 × 15 in)
Private collection

185 Ideas for Sculpture, 1938
Pen and wash, 38.1 × 55.9 cm (15 × 22 in)
Collection: National Art Gallery of New
South Wales, Sydney

186 Drawing for Metal Sculpture, 1938
Chalk and watercolour,
38.1 × 55.9 cm (15 × 22 in)
Private collection

187 Ideas for Sculpture, 1938
Chalk and wash, 38.1 × 55.9 cm (15 × 22 in)
Private collection

188 Figures with Architecture, 1938
Pen and wash, 55.9 × 38.1 cm (22 × 15 in)
Private collection

189 Drawing for Metal Sculpture, 1938
Chalk and watercolour,
38.1 × 55.9 cm (15 × 22 in)
Collection: Carl O. Plate, Sydney

190 Ideas for Sculpture, 1938
Chalk and wash, 55.9 × 38.1 cm (22 × 15 in)
Private collection

191 Ideas for Sculpture, 1938
Chalk and wash, 55.9 × 38.1 cm (22 × 15 in)
Private collection

192 Pictorial Ideas, 1938
Ink, chalk and watercolour,
25.4 × 43.2 cm (10 × 17 in)
Collection: Gordon Onslow-Ford, USA

193 Mechanisms, 1938
Crayon and wash,
39.4 × 55.9 cm (15$\frac{1}{2}$ × 22 in)
Collection: Ronald Bottrall

194 Five Metal Forms, 1938
Watercolour, 55.9 × 38.1 cm (22 × 15 in)
Collection: Wakefield City Art Gallery and
Museum

195 Project for Relief Sculptures, 1938
Chalk, pen and wash,
37.5 × 26.7 cm (14$\frac{3}{4}$ × 10$\frac{1}{2}$ in)
Collection: Sir Philip Hendy, London

196 Drawing, 1938
Pen, wash and watercolour,
25.4 × 43.2 cm (10 × 17 in)
Private collection

197 Drawing, 1938
Watercolour and chalk,
55.9 × 38.1 cm (22 × 15 in)
Private collection

198 Project for Figure in Lead, 1938
Watercolour and pen,
55.9 × 38.1 cm (22 × 15 in)
Collection: Miss Isobel Walker

199 Landscape with Figures, 1938
Chalk and watercolour,
38.1 × 45.0 cm (15 × 17$\frac{3}{4}$ in)
Collection: Edward Carter

200 Reclining Figure, 1938
Chalk, pen and wash,
38.1 × 55.9 cm (15 × 22 in)
Collection: Lord Clark of Saltwood

201 Ideas for Metal Sculpture, 1938
Pen and wash, 38.1 × 55.9 cm (15 × 22 in)
Collection: Lord Clark of Saltwood

202–3 Reclining Figure, 1939
Elm wood, L. 2.08 m (81 in)
Collection: Detroit Institute of Art, USA

204 Stringed Figure, 1939
Lead and wire, H. 21.6 cm (8$\frac{1}{2}$ in)
Collection: Selden Rodman, New York
Cast in bronze 1968, edition of 8
Private collections

205 Mother and Child, 1939
Bronze, L. 19.1 cm (7$\frac{1}{2}$ in)
Edition of 7
Private collections

206 The Bride, 1939–40
Lead and wire, H. 24.2 cm (9$\frac{1}{2}$ in)
Collection: Museum of Modern Art, New
York

207 Mother and Child, 1939
Lead and wire, H. 17.8 cm (7 in)
Destroyed

208 Head, 1939
Lead and string, H. 14.0 cm (5$\frac{1}{2}$ in)
Collection: Mrs Irina Moore
Cast in bronze 1968, edition of 6
Private collections

209 Stringed Reclining Figure, 1939
Lead and string, L. 28.6 cm (11$\frac{1}{4}$ in)
Collection: Mrs Irina Moore
Bronze edition of 7
Private collections

346

210 Three Points, 1939–40
Cast Iron, L. 19.1 cm (7½ in)
Collection: Mrs Irina Moore
Lead, collection: Mrs Alan Best
Bronze edition of 10
Collections: Kunsternes Hus, Oslo; private
collections

211 Stringed Figure, 1939
Lead and wire, L. 25.4 cm (10 in)
Collection: Mrs Irina Moore
Bronze edition of 9
Private collections

212 Another view of Plate 211

213 Reclining Figure, 1939
Bronze, L. 33.0 cm (13 in)
Edition of 9
Private collections

214 Reclining Figure, 1939
Bronze, L. 22.9 cm (9 in)
Edition of 9
Collections: British Council, London; Mrs
Irina Moore; private collections

215 Reclining Figure, 1939
Lead, L. 25.4 cm (10 in)
Collection: Lord Clark of Saltwood

216 Ideas for Sculpture in Metal, 1939
Chalk, pen and watercolour,
25.4 × 42.5 cm (10 × 16¾ in)
Collection: Mrs Benjamin Watson, New
York

217 Reclining Figure, 1939
Lead, L. 29.9 cm (11¾ in)
Collection: Victoria and Albert Museum,
London
Bronze edition of 2
Collections: British Council, London; Mrs
Irina Moore

218 Ideas for Sculpture, 1939
Chalk, pen and watercolour,
25.4 × 43.2 cm (10 × 17 in)
Collection: George Dix

219 Reclining Figures, 1939
Pen, pencil, chalk and wash,
26.0 × 43.2 cm (10¼ × 17 in)
Collection: Roger Senhouse, London

220 Ideas for Metal and Wire Sculpture, 1939
Pen and watercolour,
27.9 × 38.1 cm (11 × 15 in)
Collection: Dr W. R. Valentiner, Los
Angeles

221 Reclining Figures (drawing for lead sculp-
tures), 1939
Pen and wash, 38.1 × 27.9 cm (15 × 11 in)
Collection: Mrs Irina Moore

222 Study for a Reclining Figure in Wood, 1939
Charcoal and wash,
38.1 × 55.9 cm (15 × 22 in)
Private collection

223 Drawing for Sculpture, 1939
Chalk and pen, 43.2 × 25.4 cm (17 × 10 in)
Private collection

224 Reclining Figures (drawing for sculpture),
1939
Chalk, pen and wash,
27.9 × 38.1 cm (11 × 15 in)
Collection: Mrs Irina Moore

225 Sculptural Object in Landscape, 1939
Chalk, pen and watercolour,
38.1 × 55.9 cm (15 × 22 in)
Collection: Sir Robert Sainsbury, London

226 Figures in a Setting, 1939
Chalk, pen and watercolour,
27.9 × 38.1 cm (11 × 15 in)
Private collection

227 Two Women (drawing for sculpture com-
bining wood and metal), 1939
Chalk and watercolour,
44.5 × 38.1 cm (17½ × 15 in)
Collection: Lord Clark of Saltwood

228 Stringed Figure, 1939
Bronze and string, H. 22.9 cm (9 in)
Edition of 9
Private collections

229 Figure, 1939
Lead, H. 40.7 cm (16 in)
Collection: Mrs Patricia Strauss, London

230 Heads, 1939
Pen, coloured inks and chalk,
43.2 × 25.4 cm (17 × 10 in)
Private collection

231 Drawing (sketch for lithograph), 1939
Chalk and wash, 36.8 × 31.8 cm (14½ × 12¼ in)
Collection: Mrs Irina Moore

232 Interior Figure, 1940
Cast in bronze 1959, H. 26.7 cm (10½ in)
Edition of 2
Private collections

233 Heads (drawing for metal sculpture), 1939
Chalk and watercolour,
17.8 × 25.4 cm (7 × 10 in)
Collection: Lord Clark of Saltwood

234 The Helmet, 1940
Lead, H. 29.2 cm (11½ in)
Collection: Sir Roland Penrose
Bronze, collection: British Council, London

235 Reclining Figures, 1940
Chalk and wash, 38.1 × 55.9 cm (15 × 22 in)
Collection: C. Pritchard, London

236 Pointed Forms (drawing for metal sculpture), 1940
Coloured chalks and wash,
25.4 × 43.2 cm (10 × 17 in)
Private collection, USA

237 Heads (drawing for sculpture), 1940
Chalk, pen and watercolour,
25.4 × 43.2 cm (10 × 17 in)
Private collection

238 Reclining Figures (drawing for wood sculpture), 1940
Chalk, pencil and wash,
17.8 × 27.9 cm (7 × 11 in)
Collection: Mrs Irina Moore

239 Reclining Figure, 1940
Chalk, pen and wash,
27.9 × 38.1 cm (11 × 15 in)
Collection: Sir Robert Sainsbury, London

240 Sculpture in Landscape, 1940
Watercolour, 55.9 × 38.1 cm (22 × 15 in)
Collection: Wright Ludington, Santa Barbara, California

241 Mother and Child (drawing for sculpture in wood and string), 1940
Chalk, pen and watercolour,
27.9 × 38.1 cm (11 × 15 in)
Collection: James Johnson Sweeney, New York

242 Standing Figures, 1940
Chalk, pen and watercolour,
43.2 × 25.4 cm (17 × 10 in)
Collection: Mrs Irina Moore

243 Ideas for Sculpture, 1940
Chalk, pen and watercolour,
43.2 × 25.4 cm (17 × 10 in)
Collection: Perry T. Rathbone, Missouri

244 Seated Figure and Pointed Forms, 1939
Pencil, chalk, pen and watercolour,
43.2 × 25.4 cm (17 × 10 in)
Collection: Lady Penrose, London

245 Standing Figures (drawing for sculpture), 1940
Pen and watercolour,
38.1 × 27.9 cm (15 × 11 in)
Collection: Lord Clark of Saltwood

246 Three Women with a Child, 1940
Chalk and watercolour,
17.8 × 25.4 cm (7 × 10 in)
Collection: Professor Bonamy Dobrée, London

247 Two Standing Figures (drawing for sculpture combining wood and metal), 1940
Chalk, pen and watercolour,
49.9 × 37.5 cm (19⅝ × 14¾ in)
Collection: Lord Clark of Saltwood

248 Two Women and a Child, 1940
Chalk, pen and watercolour,
38.1 × 25.4 cm (15 × 10 in)
Collection: Lord Clark of Saltwood

249 Artist and Model, 1940
Gouache and pastel,
36.8 × 27.9 cm (14½ × 11 in)
Collection: Whitworth Art Gallery, Manchester

250 Two Standing Figures, 1940
Chalk and watercolour,
55.9 × 38.1 cm (22 × 15 in)
Private collection

251 Study of One Seated and Four Standing Figures, 1940
Chalk, wax, pen and watercolour,
17.1 × 25.4 cm (6¾ × 10 in)
Collection: British Council, London

252 Standing, Seated and Reclining Figures against Background of Bombed Building, 1940
Watercolour and pen,
27.9 × 38.1 cm (11 × 15 in)
Collection: Lady Keynes, Cambridge

253 Two Seated Women, 1940
Chalk, pen and watercolour,
27.9 × 38.1 cm (11 × 15 in)
Collection: Lord Clark of Saltwood

254 Two Seated Women, 1940
Chalk, pen and watercolour,
17.8 × 27.9 cm (7 × 11 in)
Collection: Tate Gallery, London

255 Page from Shelter Sketchbook, 1940–1
Chalk, pen and wash,
21.0 × 16.5 cm (8¼ × 6½ in)
Collection: Mrs Irina Moore

256 Brown Tube Shelter, 1940
Chalk, pen and wash,
27.0 × 37.2 cm (10⅝ × 14⅝ in)
Collection: British Council, London

257 Page from Shelter Sketchbook, 1940–1
Chalk, pen and wash,
21.0 × 16.5 cm (8¼ × 6½ in)
Collection: Mrs Irina Moore

258 Page from Shelter Sketchbook, 1940–1
Chalk, pen and wash,
21.0 × 16.5 cm (8¼ × 6½ in)
Collection: Mrs Irina Moore

259 Two Women on a Bench in a Shelter, 1940
Chalk, pen and wash,
34.3 × 40.6 cm (13½ × 16 in)
Collection: Lord Clark of Saltwood

260 Shadowy Shelter, 1940
Chalk, pen, wash and watercolour,
26.0 × 43.8 cm (10¼ × 17¼ in)
Collection: Graves Art Gallery, Sheffield

261 Group of Figures in Underground Shelter,
1941
Watercolour, chalk and pen,
38.1 × 55.9 cm (15 × 22 in)
Collection: Contemporary Art Society,
London

262–6 Pages from Shelter Sketchbook, 1941
Chalk, pen and wash,
21.0 × 16.5 cm (8¼ × 6½ in)
Collection: Mrs Irina Moore

267 Tube Shelter Perspective, 1941
Chalk, pen and watercolour,
47.6 × 43.2 cm (18¾ × 17 in)
Collection: Tate Gallery, London

268 Shelter Scene: Two Swathed Figures, 1941
Chalk, pen and watercolour,
27.9 × 38.1 cm (11 × 15 in)
Collection: City Art Gallery, Manchester

269–70 Pages from Shelter Sketchbook, 1941
Chalk, pen and wash,
21.0 × 16.5 cm (8¼ × 6½ in)
Collection: Mrs Irina Moore

271 Women in a Shelter, 1941
Watercolour, 55.9 × 38.1 cm (22 × 15 in)
War Artists, official purchase

272–5 Pages from Shelter Sketchbook, 1941
Chalk, pen and wash,
21.0 × 16.5 cm (8¼ × 6½ in)
Collection: Mrs Irina Moore

276 Sleeping Shelterers, 1941
Chalk and watercolour,
38.1 × 55.9 cm (15 × 22 in)
Collection: Lady Keynes, Cambridge

277 Shelter Drawing, 1941
Chalk, pen and watercolour,
38.1 × 55.9 cm (15 × 22 in)
Collection: Sir William Walton

278 Four Grey Sleepers, 1941
Chalk, pen and wash,
43.2 × 50.8 cm (17 × 20 in)
Collection: Wakefield City Art Gallery and
Museum

279 Two Women and Children in a Shelter,
1941
Watercolour and pen,
38.1 × 48.3 cm (15 × 19 in)
Private collection

280 Studies of Miners at Work, 1942
Chalk, pen and watercolour,
60.3 × 43.8 cm (23¾ × 17¼ in)
Collection: Philip L. Gibbons, London

281 At the Coal Face. Miners Fixing Prop, 1942
Chalk, pen and watercolour,
34.3 × 55.9 cm (13½ × 22 in)
Collection: Leeds City Art Gallery

282 At the Coal Face. Miner Pushing Tub, 1942
Chalk, pen and watercolour,
33.0 × 63.5 cm (13 × 25 in)
War Artists, official purchase
Collection: Imperial War Museum, London

283–4 Studies of Miners (two pages from sketch-book), 1942
Chalk, pen and wash,
24.1 × 16.5 cm (9½ × 6½ in)
Collection: Kunstmuseum, Basel

285 Figures in Settings, 1942
Chalk, wash and pen,
25.4 × 19.1 cm (10 × 7½ in)
Collection: Mrs Irina Moore

286 Three Figures in a Setting, 1942
Chalk, pen and watercolour,
45.7 × 43.2 cm (18 × 17 in)
Collection: Wright Ludington, Santa Barbara, California

287 Figures in a Setting, 1942
Pen and watercolour,
40.6 × 53.3 cm (16 × 21 in)
Private collection

288 Three Figures, 1942
Watercolour, chalk and pen,
48.3 × 43.2 cm (19 × 17 in)
Collection: Herman Shulman, Stanford, Conn.

289 Figures in a Room, 1942
Pen and watercolour,
38.1 × 53.3 cm (15 × 21 in)
Collection: Karl Nathan, New York

290 Crowd Looking at a Tied-up Object, 1942
Chalk, pen, wash and watercolour,
43.2 × 55.9 cm (17 × 22 in)
Collection: Lord Clark of Saltwood

291 Group of Women, 1942
Watercolour, chalk and pen,
40.6 × 55.9 cm (16 × 22 in)
Private collection

292 Two Women Winding Wool, 1942
Chalk, pen and watercolour,
45.7 × 55.9 cm (18 × 22 in)
Collection: Louis Svern, New York

293 Figures in a Setting, 1942
Pencil, chalk, wax and watercolour,
24.1 × 59.1 cm (9½ × 23¼ in)
Collection: Sir Allen Lane, London

294 Arrangement of Figures, 1942
Black chalk and pen,
55.9 × 34.3 cm (22 × 13½ in)
Collection: Mrs Irina Moore

295 Women Reading, 1942
Watercolour, chalk and pen,
17.8 × 25.4 cm (7 × 10 in)
Private collection

296 Seated Figures, 1942
Chalk, pen and watercolour,
61.0 × 45.7 cm (24 × 18 in)
Private collection, USA

297 Seated Figures, 1942
Chalk, pen and watercolour,
61.0 × 45.7 cm (24 × 18 in)
Collection: Museum of Modern Art, New York

298 Three Seated Women, 1942
Watercolour and pen,
43.2 × 53.3 cm (17 × 21 in)
Collection: Mrs Murray Crane, New York

299 Seated Woman with Children, 1942
Watercolour, chalk and pen,
55.9 × 45.7 cm (22 × 18 in)
Private collection

300 Ideas for Sculpture. Reclining Figures against a Bank, 1942
Chalk, pen and watercolour,
55.9 × 43.2 cm (22 × 17 in)
Collection: James Johnson Sweeney, New York

301 Drawing, 1942
Pen, chalk and watercolour,
43.2 × 25.4 cm (17 × 10 in)
Collection: James T. Soby, New York

302 Ideas for Sculpture (page from sketchbook), 1942
Pen and watercolour, 22.9 × 17.8 cm (9 × 7 in)
Collection: L. J. Salter, New York

303 Ideas for Sculpture, 1943
Pen and wash, 17.8 × 26.7 cm (7 × 10½ in)
Private collection, USA

304 Three Reclining Figures (study for sculpture), 1942
Pen and wash, 22.9 × 17.8 cm (9 × 7 in)
Collection: Mrs Irina Moore

305 Ideas for Sculpture (page from sketchbook), 1942
Pen and wash, 22.9 × 17.8 cm (9 × 7 in)
Private collection

306 Group of Figures with Architectural Background, 1943
Chalk, pen and wash,
44.5 × 63.5 cm (17½ × 25 in)
Private collection

307 Mother and Child with Reclining Figures, 1942–3
Chalk, pen and watercolour,
27.0 × 24.8 cm (10⅝ × 9¾ in)
Collection: Sir Robert and Lady Sainsbury, London

308 Madonna and Child, 1943
Terracotta, H. 14.6 cm (5¾ in)
Collection the artist
Bronze edition of 7
Collection: Tate Gallery, London; private collections

309 Madonna and Child, 1943
Terracotta, H. 15.9 cm (6¼ in)
Private collection

310 Study for Northampton Madonna, 1942
Watercolour, ink and crayon,
22.9 × 17.8 cm (9 × 7 in)
Private collection

311 Madonna and Child, 1943
Terracotta, H. 15.9 cm (6¼ in)
Collection: Miss Mary Moore
Bronze edition of 7
Private collections

312 Madonna and Child, 1943
Terracotta, H. 14.0 cm (5½ in)
Private collection

313 Madonna and Child, 1943–4 (in progress)
Hornton stone, H. 1.50 m (59 in)
Collection: Church of St Matthew, Northampton

314 Madonna and Child, 1943–4
Hornton stone, H. 1.50 m (59 in)
Collection: Church of St Matthew, Northampton

315 Two Seated Figures, 1944
Pen, chalk and watercolour,
40.6 × 40.6 cm (16 × 16 in)
Collection: Ralph Keene

316 Family Group, 1944
Terracotta, H. 15.6 m (6⅛ in)
Collection: Miss Mary Moore
Bronze edition of 7
Private collections

317 The Family (project for sculpture), 1944
Ink, chalk and wash,
61.0 × 48.3 cm (24 × 19 in)
Collection: Sir Michael Balcon, London

318 Family Group, 1944
Pen and wash, 38.1 × 35.6 cm (15 × 14 in)
Collection: Ken Annakin

319 Family Group (drawing for sculpture), 1944
Pen and watercolour,
50.8 × 36.8 cm (20 × 14½ in)
Collection: Mrs Irina Moore

320 Family Group, 1944
Terracotta, H. 19.0 cm (7½ in)
Collection the artist
Bronze edition of 7
Private collections

321 Family Group (model for stone sculpture), 1944
Terracotta, H. 16.2 cm (6⅜ in)
Collection the artist
Bronze edition of 9
Private collections

322 Family Group, 1944
Terracotta, H. 15.6 cm (6⅛ in)
Collection the artist
Bronze edition of 9
Private collections

323 Family Groups, 1944
Chalk, pen and watercolour,
22.9 × 17.8 cm (9 × 7 in)
Private collection

324 Family Group (drawing for sculpture), 1944
Pen, chalk and watercolour,
46.0 × 35.6 cm (18¼ × 14 in)
Collection: Robert H. Tannahill, USA

325 Family Groups, 1944
Chalk, pen and watercolour,
49.5 × 31.8 cm (19½ × 12½ in)
Collection: Miss Jill Craigie

326 Three Women and Child, 1944
Chalk and watercolour,
38.1 × 55.9 cm (15 × 22 in)
Private collection.

327 Draped Standing Figures in Red, 1944
Chalk, pen and watercolour,
38.1 × 32.4 cm (15 × 12¾ in)
Collection: The Hon. Lady Cochrane, Heckfield, Hants

328 Woman and Child with Bath, 1944
Watercolour, chalk and pen,
43.2 × 55.9 cm (17 × 22 in)
Collection: Lord Clark of Saltwood

329 The Toilet, 1944
Chalk, pen and wash,
35.6 × 35.6 cm (14 × 14 in)
Collection: Miss Polly Hill

330 Family Groups in Settings, 1944
Pen, chalk and watercolour,
61.0 × 43.2 cm (24 × 17 in)
Private collection

331 Mother and Child, 1945
Pen, chalk and watercolour,
17.8 × 25.4 cm (7 × 10 in)
Private collection

332 Mother and Child, 1944
Pen, chalk and wash,
17.8 × 26.7 cm (7 × 10½ in)
Private collection

333 Family Groups, 1944
Pen, chalk and wash
Private collection

334 Three Women and a Child, 1944
Chalk and wash,
39.4 × 54.6 cm (15½ × 21½ in)
Collection: Swindon Arts Centre

335 Group of Red-draped Figures, 1944
Gouache and pastel,
41.9 × 31.8 cm (16½ × 12½ in)
Collection: Miss Lois Orswell, Rhode Island

336 Illustration for The Rescue by Edward
Sackville-West, 1944
Ink, crayon and watercolour

337 The Death of the Suitors. Illustration for
The Rescue by Edward Sackville-West, 1944
Ink, crayon and watercolour

338 Drawing, Reclining Figures, 1944
Red chalk and watercolour,
38.1 × 55.9 cm (15 × 22 in)
Private collection

339 Reclining Figures (ideas for stone sculpture),
1944
Chalk, pen and wash,
38.1 × 55.9 cm (15 × 22 in)
Collection: Z. Ascher, London

340 Reclining Figures, 1944
Chalk, pen and watercolour,
38.1 × 55.9 cm (15 × 22 in)
Private collection

341 Reclining Figures, 1944
Pen, chalk and watercolour
Private collection

342 Reclining Figure, 1945–6
Elm wood, L. 1.90 m (75 in)
Collection: Cranbrook Academy of Art,
Michigan

343 Family Group, 1945
Bronze, H. 14.6 cm (5¾ in)
Edition of 9
Private collections

344 Drawing, Seated Figures, 1945
Pen, chalk and watercolour,
17.8 × 25.4 cm (7 × 10 in)
Private collection

345 Two Seated Women and a Child, 1945
Terracotta, H. 17.1 cm (6¾ in)
Collection: Miss Mary Moore
Bronze edition of 7
Private collections

346 Two Seated Women with Child, 1945
Pen, chalk and watercolour
Private collection

347 Four Figures in Setting, 1945
Chalk, pen and watercolour,
38.1 × 55.9 cm (15 × 22 in)
Private collection

348 Sketches, 1945
Watercolour, crayon and ink,
70.5 × 48.3 cm (27¾ × 19 in)
Private collection

349 Reclining Figure, 1945
Bronze, L. 40.7 cm (16 in)
Edition of 7
Private collections

350 Reclining Figure, 1945
Bronze, L. 44.5 cm (17½ in)
Edition of 7
Private collections

351 Reclining Figure, 1945
Bronze, L. 17.8 cm (7 in)
Edition of 10
Private collections

352 Memorial Figure, 1945–6
Hornton stone, L. 1.42 m (56 in)
Collection: Dartington Hall, Devon

353 Two Reclining Figures, 1946
Chalk, pen and watercolour,
17.8 × 25.4 cm (7 × 10 in)
Private collection

354 Family Group, 1946
Terracotta, H. 44.2 cm (17$\frac{3}{8}$ in)
Collection: Denis Nahum
Bronze edition of 4
Collection: Phillips Memorial Gallery,
Washington, DC; private collections

355 Family Group, 1946
Chalk, pen and watercolour,
55.9 × 38.1 cm (22 × 15 in)
Collection: Joseph Burke

356 Family Group, 1945
Bronze, H. 24.2 cm (9$\frac{1}{2}$ in)
Edition of 9
Private collections

357 Three Women Round a Table, 1946
Chalk, pen and wash,
38.1 × 55.9 cm (15 × 22 in)
Collection: Mrs D. Raphael, USA

358 Two Women Bathing a Baby, 1946
Chalk, pen and watercolour,
17.8 × 25.4 cm (7 × 10 in)
Collection: Mrs Catherine Walstron

359 Mother and Child on a Sofa, 1946
Crayon, watercolour, brush and black line,
37.8 × 55.6 cm (14$\frac{7}{8}$ × 21$\frac{7}{8}$ in)
Collection: British Council, London

360 Standing Figures with Rock Background,
1946
Chalk, pen and watercolour,
38.1 × 55.9 cm (15 × 22 in)
Collection: Viscount Moore

361–2 Reclining Figure, 1946–7
Brown Hornton stone, L. 68.6 cm (27 in)
Collection: Henry R. Hope, Bloomington,
Indiana

363 Three Standing Figures, 1947
Chalk and pen, 29.2 × 24.1 cm (11$\frac{1}{2}$ × 9$\frac{1}{2}$ in)
Private collection

364 Family Group, 1947
Bronze, H. 40.7 cm (16 in)
Edition of 7
Private collections

365 Three Standing Figures, 1947–8 (in progress)
Darley Dale stone, H. 2.15 m (84 in)
Battersea Park, London

366–6 Three Standing Figures, 1947–8
Darley Dale stone, H. 2.15 m (84 in)
Battersea Park, London

368 Studies of the Artist's Child, 1947
Pencil, pen and watercolour,
29.2 × 24.1 cm (11$\frac{1}{2}$ × 9$\frac{1}{2}$ in)
Collection: Miss Mary Moore

369 Studies of the Artist's Child, 1946
Pencil, 38.1 × 27.9 cm (15 × 11 in)
Collection: Mrs Irina Moore

370 Studies of Hands, 1947
Pen and wash, 29.2 × 24.1 cm (11$\frac{1}{2}$ × 9$\frac{1}{2}$ in)
Private collection, USA

371 Girl Reading, 1947
Gouache, chalk and ink,
29.2 × 24.1 cm (11$\frac{1}{2}$ × 9$\frac{1}{2}$ in)
Private collection

372 Girl Reading to a Friend, 1947
Pen and chalk, 15.2 × 20.3 cm (6 × 8 in)
Collection: Roger Wood, London

373 Seated Figure Knitting, 1950
Pen, chalk and watercolour,
29.2 × 24.1 cm (11$\frac{1}{2}$ × 9$\frac{1}{2}$ in)
Private collection

374 Two Women Bathing a Child, 1948
Chalk, pen and watercolour,
69.2 × 57.2 cm (27$\frac{1}{4}$ × 22$\frac{1}{2}$ in)
Collection: Mrs Irina Moore

375 Ideas for Sculpture (internal and external
forms), 1948
Chalk, pen and watercolour,
29.2 × 24.1 cm (11$\frac{1}{2}$ × 9$\frac{1}{2}$ in)
Collection the artist

376 Drawing for Metal Sculpture (internal and
external forms), 1948
Chalk, pen and watercolour,
56.5 × 57.8 cm (22$\frac{1}{4}$ × 22$\frac{3}{4}$ in)
Collection: William D. Hutchinson

377 Seated Figure, 1948
Chalk, pen and watercolour,
55.9 × 58.4 cm (22 × 23 in)
Private collection, USA

378 Two Women and Child, 1948
Chalk, pen and watercolour,
50.8 × 61.0 cm (20 × 24 in)
Private collection

379 Women Winding Wool, 1948
Chalk, pen and watercolour,
55.9 × 63.5 cm (20 × 25 in)
Private collection

380 The Rocking Chair (ideas for metal sculpture), 1948
Chalk and watercolour,
50.8 × 69.9 cm (20 × 27½ in)
Collection: The Hon. Lady Cochrane,
Heckfield, Hants

381 Seated Figures, 1948
Pen, chalk and watercolour,
29.2 × 24.1 cm (11½ × 9½ in)
Private collection

382 Seated Figure (study for stone sculpture),
1948
Chalk and watercolour,
59.1 × 57.8 cm (23¼ × 22¾ in)
Collection: Dr Henry Roland, London

383 Family Group, 1948
Chalk, pen and wash,
55.9 × 68.6 cm (22 × 27 in)
Private collection, USA

384 Seated Woman Doing Her Hair, 1948
Chalk and watercolour,
70.4 × 57.2 cm (27¾ × 22½ in)
Collection: National Gallery of Canada,
Ottawa

385 Ideas for Metal Sculpture, 1948
Chalk, pen and watercolour,
38.1 × 55.9 cm (15 × 22 in)
Collection: Milo Cripps, London

386 Reclining Figures, 1948
Chalk and watercolour,
27.9 × 24.1 cm (11 × 9½ in)
Private collection

387 Standing Figures (ideas for metal sculpture),
1948
Chalk and watercolour,
29.2 × 24.1 cm (11½ × 9½ in)
Private collection, USA

388 Seated Figure, 1949
Bronze, H. 22.9 cm (9 in)
Edition of 7
Private collections

389 Seated Man, 1949
Plaster, H. 1.55 m (61 in)
Unique bronze cast 1964
Collection: Corpus Christi College,
Cambridge

390–1 Family Group, 1948–9
Bronze, H. 1.52 m (60 in)
Edition of 4
Collections: Barclay School, Stevenage;
Museum of Modern Art, New York; Tate
Gallery, London; Nelson D. Rockefeller,
New York

392 Seated Figure, 1949
Bronze, H. 43.2 cm (17 in)
Edition of 5
Collection: British Film Academy; private
collections

393 Seated Figures, 1949
Chalk, pen and wash,
28.6 × 23.5 cm (11¼ × 9¼ in)
Collection: Ronald Crichton

394 Claydon Madonna and Child, 1948–9
Hornton stone, H. 1.22 m (48 in)
St Peter's Church, Claydon, Suffolk

395 Reclining Figure, 1949
Hornton stone, L. 76.2 cm (30 in)
Collection: R. Sturgis Ingersoll, Philadelphia

396 Detail of Plate 394

397 Rocking Chairs, 1949
Chalk, pen and watercolour,
57.2 × 39.4 cm (22½ × 15½ in)
Collection: Mrs List-Israel, New York

398 Rocking Chair No. 1, 1950
Bronze, H. 33.0 cm (13 in)
Edition of 6
Private collections

399 Rocking Chair No. 2, 1950
Bronze, H. 28.0 cm (11 in)
Edition of 6
Private collections

400 Rocking Chair No. 3, 1950
Bronze, H. 31.8 cm (12½ in)
Edition of 6
Private collections

401–2 Helmet Head No. 1, 1950
Lead, H. 34.3 cm ($13\frac{1}{2}$ in)
Collection: Mrs Irina Moore
Bronze edition of 9
Collection: Tate Gallery, London; private collections

403 Maquette for Openwork Head No. 1, 1950
Bronze, 17.8 cm (7 in)
Unique cast
Private collection

404 Openwork Head No. 2, 1950
Bronze, H. 39.4 cm ($15\frac{1}{2}$ in)
Unique cast
Collection: Wakefield City Art Gallery and Museum

405 Head and Shoulders, 1950
Bronze, H. 15.2 cm (6 in)
Unique cast
Collection: R. Sturgis Ingersoll, Philadelphia

406 Five Figures (interiors for helmets), 1950
Lead, H. 12.7 cm (5 in)
Collection the artist

407 Helmet Head No. 2, 1950
Lead, H. 39.4 cm ($15\frac{1}{2}$ in)
Collection: Staatsgalerie, Stuttgart
Bronze edition of 9
Collections: National Gallery of New South Wales; Stadtische Kunstgalerie, Bochum; private collections

408–9 Standing Figure, 1950
Bronze, H. 2.23 m (87 in)
Edition of 4
Collections: W. J. Keswick, Dumfries; Dr Van der Wal, Amsterdam; private collections

410 Double Standing Figure, 1950
Bronze, H. 2.23 m (87 in)
Edition of 2
Collections: S. J. Salter, New York; Vassar College, New York

411 Another view of Plate 408

412 Another view of Plate 410

413 Animal Head, 1951
Bronze, L. 30.5 cm (12 in)
Edition of 8
Private collections

414 Sculpture in Landscape, 1950
Watercolour, 55.9 × 38.1 cm (22 × 15 in)
Private collection

415–6 Reclining Figure, 1951
Bronze, L. 2.31 m (90 in)
Edition of 5
Collections: Arts Council of Great Britain, London; Musée d'Art Moderne, Paris; Dr Van der Wal, Amsterdam; Mrs Gates Lloyd, Pennsylvania; Norton Simon, Los Angeles

417 Maquette for Reclining Figure, 1950
Bronze, L. 43.2 cm (17 in)
Edition of 6
Private collections

418 Maquette No. 1 for Reclining Figure, 1950
Bronze, L. 24.1 ($9\frac{1}{2}$ in)
Edition of 9
Private collections

419 Detail of Plate 415

420–1 Working Model for Reclining Figure (internal and external forms), 1951
Bronze, L. 53.4 cm (21 in)
Edition of 8
Collections: Fine Art Museum, Montreal; Kunsthalle, Mannheim; Niedersachsische Landesgalerie, Hanover; Arts Council of Great Britain, London; private collections

422 Upright Internal Form (Flower), 1951
Bronze, H. 57.2 cm ($22\frac{1}{2}$ in)
Edition of 6
Private collections

423 Ideas for Sculpture, 1951
Pencil and wash,
29.2 × 22.9 cm ($11\frac{1}{2}$ × 9 in)
Collection: Mrs Irina Moore

424 Five Figures, 1951
Pen, chalk and watercolour,
29.2 × 24.1 cm ($11\frac{1}{2}$ × $9\frac{1}{2}$ in)
Private collection

425 Helmet Heads, 1951
Chalk and wash, 29.2 × 24.1 cm ($11\frac{1}{2}$ × $9\frac{1}{2}$ in)
Private collection

426 Reclining Figure in Landscape, 1951
Pen, chalk and watercolour,
42.5 × 34.3 cm ($16\frac{3}{4}$ × $13\frac{1}{2}$ in)
Private collection

427 Seated Figures, 1951
Chalk and watercolour,
29.2 × 24.1 cm (11½ × 9½ in)
Collection: David Popper, Rickmansworth,
Herts

428 Woman Reading in Bed, 1951
Chalk and watercolour,
71.1 × 61.0 cm (28 × 24 in)
Collection: Andrew Revai, London

429 Mother and Child on Ladderback Rocking
Chair, 1952
Bronze, H. 21.0 cm (8¼ in)
Edition of 9
Private collections

430 Drawing, 1937–51
Pen, pencil and watercolour,
17.8 × 19.0 cm (7 × 7½ in)
Collection: Mr and Mrs Robert Melville,
London

431 Mother and Child on Ladderback Chair,
1952
Bronze, H. 40.7 cm (16 in)
Edition of 7
Collection: Ferens Art Gallery, Hull; private
collections

432 Leaf Figures, 1951
Pen, crayon and watercolour,
29.2 × 24.1 cm (11½ × 9½ in)
Private collection

433 Reclining Figure No. 5, 1952
Bronze, L. 21.6 cm (8½ in)
Edition of 9
Private collections

434 Reclining Figure No. 3, 1952
Bronze, L. 21.0 cm (8¼ in)
Edition of 9
Private collections

435 Leaf Figure No. 1, 1952
Bronze, H. 25.4 cm (10 in)
Edition of 9
Private collections

436 Leaf Figure No. 2, 1952
Bronze, H. 25.4 cm (10 in)
Edition of 9
Private collections

437 Standing Figure No. 1, 1952
Bronze, H. 24.2 cm (9½ in)
Edition of 9
Private collections

438 Standing Figure No. 2, 1952
Bronze, H. 28.0 cm (11 in)
Edition of 9
Private collections

439 Standing Figure No. 4, 1952
Bronze, H. 24.8 cm (9¾ in)
Edition of 9
Private collections

440 Half Figure, 1952
Bronze, H. 17.2 cm (6¾ in)
Edition of 5
Private collections

441 Standing Girl, 1952
Elm wood, H. 1.52 m (60 in)
Collection the artist

442 Relief No. 2, 1952
Bronze, H. 11.4 cm (4½ in)
Edition of 7
Private collections

443 Mother and Child: Corner Sculpture No. 2,
1952
Bronze, H. 17.8 cm (7 in)
Edition of 2
Private collections

444 Goat's Head, 1952
Bronze, H. 20.4 cm (8 in)
Edition of 10
Private collections

445 Relief No. 1, 1952
Bronze, H. 12.1 cm (4¾ in)
Edition of 7
Private collections

446 Helmet Head and Shoulders, 1952
Bronze, H. 16.5 cm (6½ in)
Edition of 10
Private collections

447 Two Women and Child, 1952
Pen and watercolour,
27.9 × 17.8 cm (11 × 7 in)
Private collection

448 Hands Relief No. 1, 1952
Bronze, H. 33.0 cm (13 in)
Edition of 10 cast 1956
Private collections

449 Seated Figure, 1952–3
Terracotta, H. 1.04 m (41 in)
Collection: Museum of Modern Art, New
York
Bronze edition of 5 cast 1963
Private collections

450–1 King and Queen, 1952–3
Bronze, H. 1.64 m (64½ in)
Edition of 5
Collections: Middleheim Open Air Mu-
seum, Antwerp; W. J. Keswick, Dumfries;
David Astor, London; Joseph H. Hirshhorn,
New York; Tate Gallery, London

452 Study for Head of Queen, 1952–3
Cast in bronze, 1959, H. 22.2 cm (8¾ in)
Edition of 4
Private collections

453 Head of King, 1952–3
Cast in bronze, 1962, H. 57.2 cm (22½ in)
Unique cast
Collection: Arts Council of Great Britain,
London

454 Another view of Plate 450

455 Time/Life Screen, 1952–3
Portland stone,
3.05 m × 8.08 m (10 × 26½ ft)
Time/Life Building, Bond Street, London

456 Time/Life Screen, 1952–3 (in progress)

457 Another view of Plate 455

458–63 Draped Reclining Figure, 1952–3
Bronze, L. 1.57 m (62 in)
Edition of 3
Collections: Time/Life Building, London;
City of Cologne, Germany; Joseph H.
Hirshhorn, New York

464–5 Draped Torso, 1953
Bronze, H. 88.9 cm (35 in)
Edition of 4
Collections: Ferens Art Gallery, Hull; Mr
and Mrs Stead-Ellis, Stirlingshire; Sir Robert
and Lady Abdy, Cornwall; A. K. Solomon,
Massachusetts

466 Three Standing Figures, 1953
Bronze, H. 71.2 cm (28 in)
Edition of 8
Collections: Blanden Memorial Gallery,
Iowa, USA; Kunsthalle, Hamburg; private
collections

467 Seated Woman on Bench, 1953
Bronze, H. 21.6 cm (8½ in)
Edition of 9
Private collections

468 Seated Torso, 1954
Bronze, H. 49.5 cm (19½ in)
Edition of 9
Private collections

469 Mother and Child, 1953
Bronze, H. 50.8 cm (20 in)
Edition of 8
Collections: Tate Gallery, London; Joseph
H. Hirshhorn, New York; private collec-
tions

470–2 Reclining Figure No. 2, 1953
Bronze, L. 91.5 cm (36 in)
Edition of 7
Collections: Gallery of Modern Art, Dublin;
Winnipeg Art Gallery, Canada; private
collections

473 Maquette for Warrior with Shield, 1952–3
Bronze, H. 19.7 cm (7¾ in)
Edition of 11
Collection: Blanden Memorial Gallery,
Iowa, USA; private collections

474–7 Warrior with Shield, 1953–4
Bronze, H. 1.52 m (60 in)
Edition of 5
Collections: City of Arnhem, Holland;
Toronto Art Gallery, Canada; Minneapolis
Institute of Arts, USA; City Museum and
Art Gallery, Birmingham, England; Stad-
tische Kunsthalle, Mannheim

478 Warrior's Head, 1953
Bronze, H. 25.4 cm (10 in)
Edition of 8
Collections: Museum of Modern Art,
Brazil; Joseph H. Hirshhorn, New York;
Musées Royaux des Beaux Arts, Brussels;
private collections

479 Another view of Plate 474

480 Reclining Figure, External Form, 1953–4
Plaster for bronze, L. 2.15 m (84 in)

481 Reclining Figure, External Form, 1953–4
Bronze, L. 2.15 m (84 in)
Edition of 6
Collections: Museum of Modern Art, Rome;
Guido de Tella, Buenos Aires; Art Institute

of Chicago; Museum of Fine Art, Toledo, Ohio; Museum of Fine Arts, Richmond, Virginia; University of Freiberg

482 Internal and External Forms, 1953–4
Elm wood, H. 2.64 m (103 in)
Collection: Albright-Knox Art Gallery, Buffalo

483 Working Model for Internal and External Forms, 1951
Bronze, H. 61.6 cm (24½ in)
Edition of 7
Collections: Rhode Island School of Design, USA; Kunstmuseum, Basel; Art Gallery, Toronto; private collections

484 Another view of Plate 482 (in progress)

485 Detail of Plate 482

486 Reclining Figure No. 4, 1954
Bronze, L. 58.5 cm (23 in)
Edition of 7
Collections: Musées Royaux des Beaux Arts, Brussels; Joseph H. Hirshhorn, New York; private collections

487 Reclining Figure No. 6, 1954
Bronze, L. 21.6 cm (8½ in)
Edition of 12
Private collections

488 Fabulous Animals, 1954
Chalk and watercolour,
29.2 × 24.1 cm (11½ × 9½ in)
Private collection

489 Bird Table, 1954
Terracotta, H. 1.55 m (62 in)
Collection the artist

490 Bird, 1955
Bronze, L. 14.0 cm (5½ in)
Edition of 12
Collection: Zoological Society of London (T. H. Huxley Award); private collections

491 Harlow Family Group, 1954–5
Hadene stone, H. 1.64 m (64½ in)
Collection: Harlow New Town, Essex

492 Wall Relief: Maquette No. 2, 1955
Plaster for bronze,
33.0 × 44.5 cm (13 × 17½ in)
Bronze, edition of 10
Private collections

493 Wall Relief: Maquette No. 6, 1955
Plaster for bronze,
34.3 × 47.0 cm (13½ × 18½ in)
Bronze, edition of 10
Private collections

494 Wall Relief: Maquette No. 7, 1955
Plaster for bronze,
34.3 × 47.0 cm (13½ × 18½ in)
Bronze, edition of 10
Private collections

495–6 Wall Relief, 1955
Brick, 8.69 × 19.20 m (28½ × 63 ft)
Bouwcentrum, Rotterdam

497 Head: Lines, 1955
Bronze, H. 29.9 cm (11¾ in)
Edition of 7
Private collections

498 Mother and Child (petal skirt), 1955
Bronze, H. 16.5 cm (6½ in)
Edition of 6
Private collections

499 Another view of 497

500–1 Seated Figure: Armless, 1955
Bronze, H. 44.5 cm (17½ in)
Edition of 10
Private collections

502 Three Forms, Relief, 1955
Bronze, H. 19.1 cm (7½ in)
Edition of 12
Private collections

503 Upright Motive No. 1: Glenkiln Cross, 1955–6 (detail)
Bronze, H. 3.35 m (11 ft)
Edition of 6
Collections: W. J. Keswick, Dumfries; Joseph H. Hirshhorn, New York; Kröller-Müller Museum, Otterlo; Folkwang Museum, Essen; Amon Carter Museum, Fort Worth, Texas; Stadtische Galerie, Hanover

504 Upright Motive: Maquette No. 3, 1955
Bronze, H. 25.4 cm (10 in)
Edition of 9
Private collections

505 Upright Motive No. 5, 1955–6
Bronze, H. 2.13 m (84 in)
Edition of 7
Collection: Norton Simon, Los Angeles; private collections

506 Upright Motive No. 8, 1955–6
Bronze, H. 1.98 m (78 in)
Edition of 7
Collections: National Museum of Wales,
Cardiff; Fogg Art Museum, Harvard University, Cambridge, Mass.; Norton Simon,
Los Angeles; private collections

507 Upright Motive No. 7, 1955–6
Bronze, H. 3.20 m (12½ ft)
Edition of 5
Collections: Amon Carter Museum, Fort
Worth, Texas; Kröller-Müller Museum,
Otterlo; Dr Stähelin, Zürich; private collections

508 Seated Figures, 1956
Chalk, pen and wash,
30.5 × 20.3 cm (12 × 8 in)
Collection: Mrs Treiman, Los Angeles,
California

509 Ideas for Sculpture, 1956
Pen and watercolour,
22.9 × 17.8 cm (9 × 7 in)
Private collection

510 Mother and Child No. 2: Crossed Feet, 1956
Bronze, H. 22.9 cm (9 in)
Edition of 9
Private collections

511 Mother and Child No. 3: Child on Knee,
1956
Bronze, H. 19.1 cm (7½ in)
Edition of 9
Private collections

512–3 Mother and Child No. 1: Reaching for
Apple, 1956
Bronze, H. 55.9 cm (22 in)
Edition of 10
Collection: Poole College, Dorset; private
collections

514 Mother and Child No. 4, 1956
Bronze, H. 19.1 cm (7½ in)
Edition of 9
Private collections

515 Seated Woman: One Arm, 1956
Cast in bronze, 1964, H. 20.3 cm (8 in)
Edition of 9
Private collections

516–7 Figure on Steps, working model for Draped
Seated Woman, 1956
Bronze, H. 64.8 cm (25½ in)
Edition of 9
Collections: Art Gallery, Aberdeen; Milwaukee Art Center; Ray Stark, Los Angeles;
private collections

518 Seated Girl, 1956
Bronze, H. 21.0 cm (8¼ in)
Edition of 9
Private collections

519 Mother and Child, 1956
Cast in bronze 1965, H. 24.8 cm (9¾ in)
Edition of 6
Private collections

520–2 Reclining Figure, 1956
Bronze, L. 2.44 m (96 in)
Edition of 8
Collections: Akademie der Kunste, Berlin;
Ted Weiner, Fort Worth, Texas; Mrs
Harvey E. Doniger, New York; Sir Robert
and Lady Sainsbury, London; National
Gallery of Western Australia, Perth; Robert
B. Mayer, Winnetka, Illinois; Mr and Mrs
Albert List, New York; Norton Simon,
Los Angeles

523 Maquette for Seated Figure against Curved
Wall, 1956
Plaster for bronze, L. 28.0 cm (11 in)
Bronze edition of 10
Collection: Fitzwilliam Museum, Cambridge; private collections

524 Draped Seated Figure against Curved Wall,
1956–7
Plaster for bronze, H. 22.9 cm (9 in)
Bronze edition of 12
Private collections

525 Family Group, 1956–7
Plaster for bronze (not cast)

526 Mother and Child against Open Wall, 1956
Plaster for bronze, H. 20.3 cm (8 in)
Bronze edition of 12
Private collections

527 Two Seated Figures against Curved Wall,
1956–7
Plaster for bronze (not cast)

528 Another view of Plate 523

529 Family Group, 1956–7
Plaster for bronze (not cast)

530 Maquette for Unesco Reclining Figure, 1956
Plaster for bronze, L. 21.6 cm (8½ in)
Bronze edition of 6
Private collections

531–4 Woman, 1957–8
Bronze, H. 1.52 m (60 in)
Edition of 8
Collections: Museum des 20. Jahrhunderts,
Vienna; Ted Weiner, Fort Worth, Texas;
Otto Preminger, New York; Gustav Stein,
Cologne; Mr and Mrs Samuel J. Zacks,
Toronto; Arnold Maremont, Chicago;
British Council, London

535–7 Seated Woman, 1957
Bronze, H. 1.45 m (57 in)
Edition of 6
Collections: Lester Avnet, Great Neck,
New York; Mr and Mrs W. R. Servaes
Send, Surrey; Joseph H. Hirshhorn, New
York; David Finn, New York; Dr Hans
Neumann, Caracas, Venezuela; Galerie des
20. Jahrhunderts, Berlin

538–40 Falling Warrior, 1956–7
Bronze, L. 1.47 m (58 in)
Edition of 10
Collections: Joseph H. Hirshhorn, New
York; The Dean of Chichester; Maurice
Cooke, Bangor, Wales; Clare College,
Cambridge; Nathan Cummings, Chicago;
Mr and Mrs Max Wasserman, Chestnut
Hill, Mass.; Walker Art Gallery, Liverpool;
Municipality of Zollikon, Zürich; Glypto-
thek, Munich; Huddersfield Art Gallery

541 Reclining Figure, 1957
Bronze, L. 69.9 cm (27½ in)
Edition of 12
Private collections

542 Draped Reclining Figure, 1957
Bronze, L. 73.7 cm (29 in)
Edition of 11
Private collections

543 Drawings for Unesco Figure, 1957
Black chalk, wash and pencil,
29.2 × 24.1 cm (11½ × 9½ in)
Collection: Mrs Irina Moore

544 Another view of Plate 541

545–8 Working model for Unesco Reclining
Figure, 1957
Bronze, L. 2.39 m (94 in)
Edition of 6
Collections: Carnegie Institute, Pittsburgh;
Mrs Alan Wurtzburger, Baltimore; Art
Institute of Chicago; Stedelijk Museum,
Amsterdam; Kunsthaus, Zürich; Tate Gal-
lery, London

549 Girl Doing Homework, 1956
Pen, 29.2 × 23.5 (11½ × 9¼ in)
Collection: Miss Mary Moore

550 Woman with Cat, 1957
Cast in bronze 1959, H. 21.6 cm (8½ in)
Edition of 2
Private collections

551 Armless Seated Figure against Round Wall,
1957
Bronze, H. 28.0 cm (11 in)
Edition of 12
Collection: Boston University; private col-
lections

552 Seated Woman on Curved Block, 1957
Cast in bronze 1965, H. 20.3 cm (8 in)
Edition of 6
Private collections

553 Seated Figure on Square Steps, 1957
Bronze, L. 23.5 (9¼ in)
Edition of 11
Private collections

554 Seated Woman with Crossed Feet, 1957
Cast in bronze 1965, H. 19.0 cm (7½ in)
Edition of 6
Private collections

555 Seated Figure against Curved Wall, 1956–7
Bronze, L. 81.3 cm (32 in)
Edition of 12
Collections: Arts Council of Great Britain,
London; Museum of Fine Arts, Boston;
National Gallery of South Australia, Ade-
laide; private collections

556–9 Reclining Figure, 1957
Roman Travertine marble,
L. 5.08 m (16 ft 8 in)
Unesco Building, Paris

560–2 Draped Seated Woman, 1957–8
Bronze, H. 1.86 m (73 in)
Edition of 6
Collections: City of Wuppertal, Germany;

London County Council (Stifford Estate, Clive Street, Stepney); Musées Royaux des Beaux Arts, Brussels; Yale University, New Haven, Conn.; National Gallery of Victoria, Melbourne; Hebrew University, Jerusalem

563 Draped Reclining Woman, 1957–8
Bronze, L. 2.08 m (82 in)
Edition of 6
Collections: Dr W. Stähelin, Zürich; Edward Albee, New York; Neue Staatsgalerie, Munich; Sir Robert and Lady Sainsbury, London; Gustav Kahnweiler, Gerrard's Cross, Bucks.; Federal Parliament, State of Baden-Württemberg, Stuttgart

564 Fragment Figure, 1957
Bronze, L. 19.0 cm (7½ in)
Edition of 10
Private collections

565–8 Other views of Plate 563

569 Maquette for a Draped Reclining Woman, 1956
Bronze, L. 19.0 cm (7½ in)
Edition of 9
Private collections

570 Girl Seated against Square Wall, 1957–8
Bronze, H. 1.02 m (40 in)
Edition of 12
Private collections

571 Round Sculptural Object, 1959
Bronze, H. 11.4 cm (4½ in)
Edition of 7
Private collections

572 Three Motives against Wall No. 1, 1958
Bronze, L. 1.07 m (42 in)
Edition of 12
Collections: Victoria and Albert Museum, London; Museum of Modern Art, New York; private collections

573 Three Motives against Wall No. 2, 1959
Bronze, L. 107.3 cm (42¼ in)
Edition of 10
Private collections

574 Animal Form, 1958
Bronze, H. 34.3 cm (13½ in)
Edition of 8
Collection: Zoological Society of London (Stamford Raffles Award); private collections

575 Bird, 1959
Bronze, L. 38.1 cm (15 in)
Edition of 12
Private collections

576 Horse, 1959
Bronze, H. 19.1 cm (7½ in)
Edition of 2
Private collections

577 Mother and Child: Hollow, 1959
Bronze, H. 31.8 cm (12½ in)
Edition of 12
Private collections

578–81 Two-piece Reclining Figure No. 1, 1959
Bronze, L. 1.93 m (76 in)
Edition of 6
Collections: Lambert Airport, St Louis; Lehmbruck Museum, Duisburg; Chelsea School of Art, London; Maurice Ash, Ashprington, Devon; Walter Carsen, Don Mills, Ontario; Albright-Knox Art Gallery, Buffalo

582 Relief No. 1, 1959
Bronze, H. 2.24 m (88 in)
Edition of 6
Private collections

583 Two-piece Reclining Figure No. 2, 1960
Bronze, L. 2.59 m (8½ ft)
Edition of 7
Collections: Lambert Airport, St Louis; National Gallery of Scotland, Edinburgh; Tate Gallery, London; Kröller-Müller Museum, Otterlo; Museum of Modern Art, New York; Mr and Mrs Milton Sperling, California

584 Two-piece Reclining Figure: Maquette No. 1, 1960
Bronze, L. 24.1 cm (9½ in)
Edition of 12
Private collections

585–8 Other views of Plate 583

589 Fledgling, 1960
Bronze, H. 8.3 cm (3¼ in)
Edition of 9
Private collections

590 Animal: Horse, 1960
Cast in bronze 1965, H. 17.8 cm (7 in)
Edition of 6
Private collections

591 Two Seated Figures against Wall, 1960
Bronze, H. 48.3 cm (19 in)
Edition of 12
Private collections

592 Seated Figure: Arms Outstretched, 1960
Bronze, H. 16.5 cm (6½ in)
Edition of 9
Private collections

593 Seated Figure: Shell Skirt, 1960
Bronze, H. 22.2 cm (8¾ in)
Edition of 12
Private collections

594 Maquette for Seated Woman: Thin Neck, 1960
Bronze, H. 25.4 cm (10 in)
Edition of 11
Private collections

595 Maquette for Reclining Figure, 1960
Bronze, L. 21.0 cm (8¼ in)
Edition of 9
Private collections

596 Reclining Figure: Bowl, 1960
Bronze, L. 28.0 cm (11 in)
Edition of 3
Private collections

597-9 Upright Figure, 1956–60
Elm wood, H. 2.74 m (9 ft)
Collection: Solomon R. Guggenheim
Museum, New York

600-1 Reclining Figure on Pedestal, 1959–60
Bronze, H. 1.30 m (51¼ in)
Edition of 9
Collections: Gunnar Didrichsen, Helsinki;
Museo de Bellas Artes, Caracas, Venezuela;
private collections

602 Helmet Head No. 3, 1960
Bronze, H. 29.2 cm (11½ in)
Edition of 12
Collections: Arts Council of Great Britain,
London; Fitzwilliam Museum, Cambridge;
private collections

603 Three Part Object, 1960
Bronze, H. 1.23 m (48½ in)
Edition of 9
Collections: Mr and Mrs Albert List, New
York; private collections

604 Square Head, 1960
Bronze, H. 28.0 cm (11 in)
Edition of 9
Private collections

605 Sculptural Object, 1960
Bronze, H. 46.3 cm (18¼ in)
Edition of 10
Collections: Arts Council of Great Britain,
London; Ministry of Works, London; Smith
College Museum of Art, Northampton,
Mass.; private collections

606 Three-quarter Figure, 1961
Bronze, H. 38.1 cm (15 in)
Edition of 9
Private collections

607 Seated Figure: Cross Hatch, 1961
Bronze, H. 13.3 cm (5¼ in)
Edition of 9
Private collections

608 Small Head: Strata, 1960
Bronze, H. 12.1 cm (4¾ in)
Edition of 9
Private collections

609 Head: Cross Hatch, 1961
Cast in bronze 1964, H. 13.3 cm (5¼ in)
Edition of 9
Private collections

610 Emperor's Heads, 1961
Cast in bronze 1967, L. 20.9 cm (8¼ in)
Edition of 7
Private collections

611 Two-piece Reclining Figure: Maquette No. 2, 1961
Bronze, L. 25.4 cm (10 in)
Edition of 9
Private collections

612 Two-piece Reclining Figure: Maquette No. 3, 1961
Bronze, L. 20.3 cm (8 in)
Edition of 9
Private collections

613 Two-piece Reclining Figure: Maquette No. 4, 1961
Bronze, L. 21.0 cm (8¼ in)
Edition of 9
Private collections

614–6 Two-piece Reclining Figure No. 3, 1961
Bronze, L. 2.39 m (94 in)
Edition of 7
Collections: Ted Weiner, Fort Worth,
Texas; University of California; S.I.T.O.R.,
Turin; City of Gothenburg, Sweden; London County Council (Brandon Estate,
Southwark); Museum of Fine Arts, Dallas,
Texas

617 Heads: Ideas for Sculpture, 1961
Crayon and watercolour,
29.2 × 22.9 cm ($11\frac{1}{2}$ × 9 in)
Private collection

618 Split Head, 1961
Cast in bronze 1964, H. 10.2 cm (4 in)
Edition of 6
Private collections

619 Reclining Mother and Child, 1960–1
Bronze, L. 2.20 m ($86\frac{1}{2}$ in)
Edition of 7
Collections: Walker Art Center, Minneapolis; Mr and Mrs Albert List, New York;
Carleton Byron Swift, Washington, DC;
Taft Schreiber, Beverly Hills, California;
Mrs Sara Hilden, Helsinki; Minerals Separation, London

620 Maquette for Stone Memorial No. 1, 1961
Bronze, H. 13.3 cm ($5\frac{1}{4}$ in)
Edition of 9
Private collections

621 Maquette for Stone Memorial No. 2, 1961
Bronze, H. 9.5 cm ($3\frac{3}{4}$ in)
Edition of 9
Private collections

622–4 Two-piece Reclining Figure No. 4, 1961
Bronze, L. 1.09 m (43 in)
Edition of 8
Collections: Seymour Knox, Buffalo; J. A.
MacAulay, Winnipeg; Stedelijk Museum,
Amsterdam; Taft Schreiber, Beverly Hills,
California; Bo Boustedt, Kungalv, Sweden;
Sir Colin Anderson, London; Wakefield
City Art Gallery and Museum; Gordon
Bunshaft, New York

625 Reclining Figure, 1961
Crayon and watercolour,
29.2 × 24.1 cm ($11\frac{1}{2}$ × $9\frac{1}{2}$ in)
Private collection

626 Seated Figure: Armless, 1961
Bronze, H. 12.7 cm (5 in)
Edition of 7
Private collections

627 Two Reclining Figures, 1961
Crayon and watercolour,
29.2 × 24.1 cm ($11\frac{1}{2}$ × $9\frac{1}{2}$ in)
Collection: Mrs Irina Moore

628 Stone Reclining Figure, 1961
Crayon and watercolour,
29.2 × 24.1 cm ($11\frac{1}{2}$ × $9\frac{1}{2}$ in)
Private collection

629 Two Draped Reclining Figures, 1961
Crayon, ink and watercolour,
29.2 × 24.1 cm ($11\frac{1}{2}$ × $9\frac{1}{2}$ in)
Private collection

630 Draped Seated Figure: Headless, 1961
Bronze, H. 20.3 cm (8 in)
Edition of 9
Private collections

631–2 Seated Woman: Thin Neck, 1961
Bronze, H. 1.62 m (64 in)
Edition of 7
Collections: Mr and Mrs Max Wasserman,
Chestnut Hill, Mass.; Skidmore, Owings
and Merrill, New York; Des Moines Art
Center, Iowa; Dr and Mrs Aerol Arnold,
Beverly Hills, California; Laing Art Gallery,
Newcastle-upon-Tyne; Dr A. Zaffaroni,
Palo Alto, California; Gordon Bunshaft,
New York

633 Standing Figure: Knife-edge, 1961
Bronze, H. 2.84 m (9 ft 4 in)
Edition of 7
Collections: Frank Stanton, New York;
Perini-San Francisco Associates, Golden
Gateway Project, San Francisco; Bruce
Dayton, Minneapolis; City of Essen, Germany; M.C.A., Universal City, California;
David Lloyd Kreeger, Washington, DC;
Norton Simon, Los Angeles

634–6 Working model for Knife-edge Two-piece,
1962
Bronze, L. 71.1 cm (28 in)
Edition of 10
Collections: Tate Gallery, London; British
Council, London; Arts Council of Great
Britain, London; Kunsthaus, Zürich; Gemeente Museum, The Hague; Rochester
University; private collections

637 Two-piece Reclining Figure: Maquette No. 5, 1962
Bronze, L. 15.2 cm (6 in)
Edition of 9
Private collections

638 Three-piece Reclining Figure: Maquette No. 1, 1961
Bronze, L. 19.7 cm (7¾ in)
Edition of 9
Private collections

639 Three-piece Reclining Figure: Maquette No. 2, 1962
Cast in bronze 1964, L. 21.6 cm (8½ in)
Edition of 9
Private collections

640 Two Reclining Figures, 1962
Conté crayon and wash,
29.2 × 24.1 cm (11½ × 9½ in)
Collection: Miss Mary Moore

641 Maquette for Slow Form: Tortoise, 1962
Bronze, L. 21.6 cm (8½ in)
Edition of 9
Private collections

642 Three Reclining Figures, 1961
Watercolour, 29.2 × 24.1 cm (11½ × 9½ in)
Private collection

643 Reclining Figure, 1962
Coloured wash, 29.2 × 48.3 cm (11½ × 19 in)
Private collection

644 Two Torsos, 1960
Cast in bronze 1962, L. 20.3 cm (8 in)
Edition of 9
Private collections

645 Mother and Child: Wheels, 1962
Bronze, H. 27.9 cm (11 in)
Edition of 9
Private collections

646–9 Three-piece Reclining Figure No. 1, 1961–2
Bronze, L. 2.87 m (9 ft 5 in)
Edition of 7
Collections: National Bank of Canada, Montreal; Bart Lytton, Los Angeles; William H. Weintraub, New York

650 The Wall: Background for Sculpture, 1962
Bronze, L. 2.13 m (84 in)
Edition of 2
Private collections

651–3 Three-piece Reclining Figure No. 2: Bridge Prop, 1963
Bronze, L. 2.51 m (99 in)
Edition of 6
Collections: City Art Gallery, Leeds; Joseph H. Hirshhorn, New York; Dr and Mrs Renker; private collections

654–5 Large Torso: Arch, 1962–3
Bronze, H. 1.98 m (78 in)
Edition of 6
Collections: Museum of Modern Art, New York; Dr W. Stähelin, Zürich

656 Head: Cyclops, 1963
Bronze: H. 20.3 cm (8 in)
Edition of 9
Private collections

657 Head: Boat Form, 1963
Bronze, L. 15.2 cm (6 in)
Edition of 9
Private collections

658 Helmet Head No. 4: Interior/Exterior, 1963
Bronze, H. 47.6 cm (18¾ in)
Edition of 6
Private collections

659 Mother and Child: Round Head, 1963
Bronze, H. 28.6 cm (11¼ in)
Edition of 6
Private collections

660–2 Divided Head, 1963
Bronze, H. 34.9 cm (13¾ in)
Edition of 9
Collection: Kunsthaus, Zürich; private collections

663 Mother and Child: Bone, 1963
Bronze, H. 19.0 cm (7½ in)
Edition of 6
Private collections

664–5 Two-piece Reclining Figure No. 5, 1963–4
Plaster for bronze, L. 3.73 m (12 ft 3 in)
Bronze edition of 3
Collections: Agnelli, Turin; Louisiana Museum, Denmark; Festspielhaus, Recklinghausen

666 Two Reclining Figures, 1964
Collage and watercolour for lithograph,
63.5 × 52.1 cm (25 × 20½ in)
Private collection

667 Eight Reclining Figures, 1964
Wash and ink, 29.2 × 24.1 cm (11½ × 9½ in)
Private collection

668 Eight Reclining Figures, 1964
Wash and ink, 29.2 × 24.1 cm (11½ × 9½ in)
Private collection

669 Five Reclining Figures, 1964
Collage and watercolour for lithograph,
63.5 × 52.1 cm (25 × 20½ in)
Private collection

670 Five Reclining Figures, 1964
Collage and watercolour for lithograph,
63.5 × 52.1 cm (25 × 20½ in)
Private collection

671–3 Reclining Figure (working model for Lincoln Center sculpture), 1963
Bronze, L. 4.27 m (14 ft)
Collection: Mr and Mrs Albert List, New York

674–5 Reclining Figure, 1963–5
Bronze, L. 9.14 m (30 ft)
Unique cast
Collection: Lincoln Center, New York

676–8 Working model for Locking Piece, 1962
Bronze, H. 1.07 m (42 in)
Edition of 9
Collections: Lehmbruck Museum, Duisburg; Frank Stanton, New York; private collections

679 Three-way Piece No. 1: Points, 1964
Bronze, H. 1.93 m (76 in)
Edition of 3
Collections: Columbia University, USA; Fairmount Park, Philadelphia; Mr and Mrs Leigh Block, USA

680 Another view of Plate 676

681–2 Locking Piece, 1963–4
Bronze, H. 2.93 m (9 ft 7½ in)
Edition of 3
Collections: Banque Lambert, Brussels; Gemeente Museum, The Hague; Tate Gallery, London

683–5 Moon Head, 1964
Bronze, H. 57.2 cm (22½ in)
Edition of 9
Private collections

686 Archer, 1965
White marble, H. 91.4 cm (36 in)
Collection: Gunnar Didrichsen, Helsinki

687 Working model for Three-way Piece No. 2: Archer, 1964
Bronze, H. 77.5 cm (30½ in)
Edition of 7
Private collections

688 The Archer, 1964–5
Bronze, L. 3.25 m (10 ft 8 in)
Edition of 2
Nathan Phillips Square, Toronto; National Museum, Berlin

689 Two Three-quarter Figures, 1965
Cast in bronze 1969, H. 19.4 cm (7⅝ in)
Edition of 9
Private collections

690 Standing Girl: Bonnet and Muff, 1966
Cast in bronze 1968, H. 24.1 cm (9½ in)
Edition of 7
Private collections

691 Two-piece Reclining Figure, Maquette No. 8, 1966
Bronze, L. 24.1 cm (9½ in)
Edition of 6
Private collections

692 Helmet Head No. 5, 1966
Bronze, H. 41.9 cm (16½ in)
Edition of 2
Private collections

693 Anvil, 1966
Bronze, L. 57.1 cm (22½ in)
Edition of 6
Private collections

694 Interior Form, 1966
Bronze, H. 33.0 cm (13 in)
Edition of 6
Private collections

695 Globe and Anvil, 1966
Bronze, H. 20.3 cm (8 in)
Edition of 9
Private collections

696 Owl, 1966
Bronze, H. 21.6 cm (8½ in)
Edition of 5
Private collections

697–8 Two Forms, 1963–6
White marble, L. 45.7 cm (18 in)
Collection: The Dean of Chichester

699 Thin Standing Figure, 1965
Cast in bronze 1968, H. 19.0 cm (7½ in)
Edition of 6
Private collections

700 Two-piece No. 7: Pipe, 1966
Bronze, L. 94.0 cm (37 in)
Edition of 9
Collection: Whitworth Art Gallery, Manchester; private collections

701 Reclining Form, 1966
White marble, L. 1.14 m (45 in)
Collection the artist

702 Torso, 1966
White marble, H. 78.7 cm (31 in)
Collection: Dr W. Stähelin, Zürich

703–4 Double Oval, 1966
Rosa Aurora marble, H. 61.0 cm (24 in)
Collection: Mr and Mrs James Clark, Dallas, Texas

705 Double Oval in shelter, 1967 (detail)
Plaster, H. 3.96 m approx. (13 ft)

706 Upright Form, Knife-edge, 1966
Rosa Aurora marble, H. 60.3 cm (23¾ in)
Collection the artist

707 Sundial, 1965–6
Bronze, H. 3.66 m (12 ft)
The Times Building, London

708 Sundial *in situ* (installed November 1967)
Bronze, H. 3.66 m (12 ft)
The Times Building, London

709 Three Rings, 1966
Red Soraya Travertine marble,
L. 2.69 m (8 ft 10 in)
Collection: Mr and Mrs Robert Levi, Maryland, USA

710–1 Three Rings, 1966
Rosa Aurora marble, L. 99.1 cm (39 in)
Collection: Gordon Bunshaft, New York

712–3 Atom Piece, 1964
Bronze, H. 1.19 m (47 in)
Edition of 6
Collections: Nelson Rockefeller, New York; Frank Stanton, New York; private collections

714 Nuclear Energy, 1965–6
Bronze, H. 3.66 m (12 ft)
Unique cast
Collection: University of Chicago

715 Black Seated Figure on Orange Background, 1966–7
Lithograph, 17.1 × 15.9 cm (6¾ × 6¼ in)
Edition of 180
Private collections

716 Two Reclining Figures in Yellow and Red, 1967
Lithograph, 34.3 × 30.2 cm (13½ × 11⅞ in)
Edition of 50
Private collections

717 Picture Book, 1967
Etching, 9.9 × 13.0 cm (3⅞ × 5⅛ in)
Edition of 60
Private collections

718 Eight Reclining Figures, 1966–7
Lithograph, 27.9 × 26.0 cm (11 × 10¼ in)
Edition of 75
Private collections

719 Reclining Figures with Blue Central Composition, 1966–7
Lithograph, 34.3 × 30.2 cm (13½ × 11⅞ in)
Edition of 75
Private collections

720 Reclining Figures: Cloak, 1967
Bronze, L. 36.8 cm (14½ in)
Edition of 9
Private collections

721 Doll Head, 1967
Cast in bronze 1969, H. 10.5 cm (4⅛ in)
Edition of 9
Private collections

722 Standing Figure: Shell Skirt, 1967
Bronze, H. 17.8 cm (7 in)
Edition of 9
Private collections

723 Torso, 1967
Bronze, H. 1.07 m (42 in)
Edition of 9
Private collections

724 Girl: Half Figure, 1967
Rosa Aurora marble, H. 88.9 cm (35 in)
Collection the artist

725 Bust of a Girl: Two-piece, 1968
Rosa Aurora marble, H. 78.1 cm (30¾ in)
Collection the artist

726 Two Forms, 1966
Red Soraya Travertine marble,
L. 1.50 m (59 in)
Collection: Dr and Mrs W. Stähelin, Zürich

727 Sculpture with Light and Hole, 1967
Red Soraya Travertine marble,
L. 1.22 m (48 in)
Collection: Kröller-Müller Museum,
Otterlo, Holland

728 Two Nuns, 1966–8
White marble, H. 1.51 m (59½ in)
Collection the artist

729 Divided Oval (Butterfly), 1967
White marble, L. 91.4 cm (36 in)
Collection the artist

730–1 Two-piece Carving: Interlocking, 1968
White marble, L. 71.1 cm (28 in)
Collection: Miss Mary Moore

732 Mother and Child, 1967
Rosa Aurora marble, H. 1.30 m (51¼ in)
Collection: Mrs Irina Moore

733 Large Totem Head, 1968
Bronze, H. 2.44 m (96 in)
Edition of 8
Collection: Museum of Fine Arts, Montreal;
private collections

734 Reclining Interior: Oval, 1965–8
Red Travertine marble, L. 2.16 m (85 in)
Collection the artist

735 Stone Memorial, 1961–8
Travertine marble, L. 1.80 m (71 in)
Collection the artist

736 Maquette for Two-piece Reclining Figure:
Points, 1968
Bronze, L. 14.0 cm (5½ in)
Edition of 9
Private collections

737 Reclining Figure: Arch Leg, 1969
Bronze, L. 18.4 cm (7¼ in)
Edition of 9
Private collections

738 Maquette for Reclining Figure, 1969
Bronze, L. 15.2 cm (6 in)
Edition of 9
Private collections

739 Three Upright Motives, 1968
Polystyrene for bronze,
H. 3.66 m approx. (12 ft)

740 Two-piece Reclining Figure No. 9, 1968
Bronze, L. 2.49 m (98 in)
Edition of 7
Collection: City of Camberra, Australia;
private collections

741 Working model for Oval with Points, 1968
Bronze, H. 1.09 m approx. (43 in)
Edition of 10
Private collections

742 Square Form with Cut, 1969
Bronze, L. 16.5 cm (6½ in)
Edition of 9
Private collections

743 Spindle Piece, 1968
Bronze, H. 78.7 cm (31 in)
Edition of 7
Private collections

744 Two-piece No. 10: Interlocking, 1968
Bronze, L. 91.4 cm (36 in)
Edition of 7
Collection: National Gallery of Norway,
Oslo; private collections

745 Architectural Project, 1969
Bronze, L. 66.0 cm (26 in)
Edition of 12

746 Pointed Torso, 1969
Bronze, H. 53.3 cm (21 in)
Edition of 12

747–52 Progressive stages in the modelling of
Three-piece No. 3: Vertebrae, 1968–9
Plaster for bronze, L. 6.10 m approx. (20 ft)

753 Large Arch, 1963–9
Polystyrene for bronze,
H. 6.10 m approx. (20 ft)

754–5 Large Two Forms, 1966–9
Polystyrene for bronze,
L. 4.72 m approx. (15½ ft)

PHOTOGRAPH ACKNOWLEDGEMENTS

With few exceptions, all of the photographs reproduced are from Henry Moore's archives. Unless noted in the following list, the photographs were taken by the artist.

I. Bessi, Carrara: 701, 706, 734, 735

Paul Bijtebier, Brussels: 91

Brenwasser, New York: 34

British Council: 210

Alfred Carlebach, London: 35, 288, 291, 292, 297, 299, 301, 307

A. C. Cooper, London: 17, 93, 121, 130, 231, 306, 308, 311, 315

Alfred Cracknell, London: 13-4

Cross Brothers, London: 237

Harriet Crowder: 608, 644

Crown Copyright: 282

Walter Dräyer, Zürich: 507

Max Dupain, Sydney: 185

Foto-Gnilka, Berlin: 563, 565-8

John Hedgecoe, London: 489

Imperial War Museum, London: 256, 260, 268, 271, 278, 281

Errol Jackson, London: VI, XIII, 8, 9, 76, 147, 234, 360, 391, 487, 510, 511, 513, 520, 542, 554, 590, 609, 620, 621, 637, 638, 657, 679, 681-2, 691, 692, 693, 694, 696, 697-8, 702, 725, 727, 731

Basil Langton, New York: 675

Lidbrooke, London: 31, 49, 177, 211, 253, 322, 343, 407, 478, 481, 485, 490, 491, 494, 500-1, 504, 516-8, 523-30, 535-7, 551, 555, 569

E. J. Mason, London: 56

City Art Gallery, Manchester: 1

James Mortimer, London: 24, 40, 110, 127, 197

O. E. Nelson, New York: 674

Rheinisches Bildarchiv, Cologne: 321

Barnet Saidman, London: 456

Adolph Studly, New York: 139, 250, 310, 348

Tate Gallery, London: 65, 267

The Times, London: 708

Robert Title, Toronto: 519

John Underwood, London: 455, 457

Louise van der Veen, Amsterdam: 443, 550, 571, 576, 694, 596

John Webb, London: III, XVIII, 430

Whitworth Art Gallery, Manchester: 249

ILLUSTRATIONS TO INTRODUCTORY ESSAY (Numbers refer to pages)

Arts Council of Great Britain: *Ingres*, 30

British Council: *Drawing for Sculpture*, 21

Giraudon, Paris: *Fontainebleau School*, 20

Errol Jackson, London: *Composition 1931*, 18; *Courbet*, 19; *Reclining Figure*, 21; *King and Queen*, 24; *Warrior with Shield*, 25; *Torso*, 30

Lidbrooke, London: *Bird Basket*, 21; *Working model for Draped Seated Woman*, 27

Metropolitan Museum of Art, New York: *Monet*, 29

Tate Gallery, London: *Seurat*, 28

Marc Vaux, Paris: *Picasso*, 19